Pervasive Animation

This new addition to the AFI Film Readers series brings together original scholarship on animation in moving image culture, from classic, experimental and independent shorts to digital animation and installation. The collection aims to foreground new critical perspectives on animation, connect them to historical and contemporary philosophical and theoretical contexts and production practice, and expand the existing canon. Throughout, contributors offer an interdisciplinary roadmap of new directions in film and animation studies, discussing animation in relationship to aesthetics, ideology, philosophy, historiography, visualization, genealogies, spectatorship, representation, technologies, and material culture.

Suzanne Buchan is Professor of Animation Aesthetics at Middlesex University, London. Her research investigates animation as a pervasive moving image form across a range of platforms and media. She teaches history, theory and aesthetics of cinema, digital screen arts, and animation, and she is active as a curator. Suzanne is editor of *animation: an interdisciplinary journal*. Her publications include *The Quay Brothers: Into a Metaphysical Playroom* (2011); *Animated 'Worlds'* (ed. 2006); journal and catalog essays, and chapters in scholarly collections.

Previously published in the AFI Film Readers series
Edited by Edward Branigan and Charles Wolfe

Pervasive Animation

EDITED BY
SUZANNE BUCHAN

Routledge
Taylor & Francis Group

NEW YORK AND LONDON

First published 2013
by Routledge
711 Third Avenue, New York, NY 10017

Simultaneously published in the UK
by Routledge
2 Park Square, Milton Park, Abingdon, Oxon OX14 4RN

Routledge is an imprint of the Taylor & Francis Group, an informa business

Library of Congress Cataloging in Publication Data
Pervasive animation / edited by Suzanne Buchan.
pages cm. – (AFI film readers)
Includes bibliographical references and index.
1. Animated films–History and criticism. I. Buchan, Suzanne, editor of compilation.
NC1765.P47 2013
791.43'34–dc23 2012051326

ISBN: 978-0-415-80723-4 (hbk)
ISBN: 978-0-415-80724-1 (pbk)
ISBN: 978-0-203-15257-7 (ebk)

Typeset in Spectrum MT
by Cenveo Publisher Services

Dedicated to Dick Arnall in memoriam

contents

plates and figures

plates

1 The semantic field to which animation belongs: Semantic
Field and Relations. Diagram by Siegfried Zielinski: *anima* (f.):
breath, pneuma, wind, breeze, principle of life, soul; *animate*:
stimulate, move, motivate (motus = movement), life, breathe
into; *animus* (m.): spirit, *nous*, feeling, power (*virtus*) of thinking, desire,
soul; *animal(istic)*: reacting to sensory stimulation, animalistic, driven,
biological principle of life.

2 Thematic Field. Diagram by Siegfried Zielinski.

3 Animated man and animated woman, tactile object by the
Švankmajers, 1996. Photograph: Archive Zielinski.

4 Egyptian doll with moveable limbs from Hawara, fourth century,
in the Flinders Petrie Museum of Egyptian Archaeology,
University College London. ©Petrie Museum of Egyptian
Archaeology, University College, London, UC28024.

5 'The Little King': an artificial baby Jesus of painted wood with
glass eyes and natural fiber for hair, created as a cute object of
religious passion and longing; southern Italy, late eighteenth
century. Archive Zielinski.

6 Nude kinetic jointed doll of a saint, seventeenth century, probably
from western Italy or France. "The head has eyes made by reverse
painting on glass and it is *animated* through air holes bored through
the nose and mouth." (*Ebenbilder*, ed. Jan Gerchow, Ostfildern-Ruit:
Hatje Cantz, 2002; p. 25). Private owner. *Source*: Hirmer Fotoarchiv
München.

7 Perpetual flute player: The programmable mechanical heart of
the music automaton by the Banū Mūsā brothers (reconstructed
under the direction of Fuat Sezgin at the Frankfurt Institute of the
History of Arabic-Islamic Science), Baghdad, mid-ninth century.
Photograph: Siegfried Zielinski.

8 A writing automaton by Friedrich von Knaus, presented at the
Vienna court, October 4, 1760. *Source*: Technisches Museum Wien,
Inventory No. 14069. Photographer: Peter Sedlaczek (TMW).

9 The automatically preaching monk automaton with a casing of wood in the Deutsches Museum, Munich (*ca.*1560, probably built in Spain or southern Germany. (Deutsches Museum, München. Inventory Nr. 1984–18; Bild-Nr. *R3102).

10 Driveshaft with the disc for controlling the eye movements. (Deutsches Museum, München. Inventory Nr. 1984–18; Bild-Nr. BN45801).

11 Spinet player, 'The Lady Musician' by Henri-Louis Jaquet-Droz, 1774 (Musée d'art et d'histoire, Neuchâtel (Suisse), Inventory Nr. AA1). Photograph S. Iori.

12 'The Lady Musician' by Henri-Lous Jaquet-Droz, 1774. The interior with horizontally built-in cam cylinder carrying the program (Musée d'art et d'histoire, Neuchâtel (Suisse), Inventory Nr. AA1). Photograph S. Iori.

13 'The Lady Musician' by Henri-Lous Jaquet-Droz, 1774. The naked mechanical hand stripped down to its technical limbs (Musée d'art et d'histoire, Neuchâtel (Suisse), Inventory Nr. AA1). Photograph S. Iori.

14 CyberSM: A cult diploma work submitted to the Academy of Arts and the Media Cologne by Stahl Stenslie and Kirk Woolford in 1993/94. The underwear of the test person was fitted with electric sensors, which a second test person, who was also wearing such a garment, could activate via ISDN and control intensity. The body of the other person was animated telematically through electricity. cyberSM, Courtesy and ©Stahl Stenslie, 1994.

15 Blooming Life and Death: the difference is the interval and the time between two images. Dissolving set 'Dance of Life and Death'. Wooden framed. 10.5 × 17.5 cm. Courtesy and ©2012 by Auction Team Breker, Köln/Germany (www.Breker.com).

16 Daniel Crooks, micro-temporalities of the pictured world. *Static No. 13* (2005 continuing). Courtesy of Daniel Crooks and Anna Schwartz Gallery.

17 *Kaeru no kenpō*, dir. Ashida Iwao, 1933.

18 A vital machine in a window display (a) that moves in the same rhythm as the rubber band machine; a flap opens and an ice cube materializes as it freezes from a pool of water (b). Screen shots from *Street of Crocodiles*, Quay Brothers, 1986.

19 The anthropomorphic 'light bulb man' polishing bulbs (a); as the vitality of the realm subsides at the end of the film, the 'boy' holds the extinguished 'light bulb man' (b). Screen shots from *Street of Crocodiles*, Quay Brothers, 1986.

20 Švankmajer's fast-food vending machine, *Food*. Jan Švankmajer, 1992.

21 Factory for ghost dubbing: (a) a gynomorphic type of android in need; (b), *Ghost in the Shell 2: Innocence*. Oshii Mamoru, 2004.

22 (a) Dave Dellinger and (b) Abby Hoffman speaking to the
Festival of Life crowd. Screen grabs from Brett Morgen,
Chicago 10, 2007.

23 (a) Top: Abby Hoffman and Judge Hoffman; (b) Bottom:
Hoffman and Jerry Rubin wearing judges robes over police
uniforms. By selecting this particular performative moment
from the many parodic events of the trail, Morgen insightfully
emphasizes, through visual synecdoche, the pivotal issue contested
in Chicago 68, the 'trial' of the 'agonistic system' comprised of
popular, political, legal (including its policing) dissent and judgments.
All screen grabs from Brett Morgen, *Chicago 10*, 2007.

24 Ng'endo Mukii, 'She Wears the Jacket and Enters the Futurenow,'
Ng'endo Mukii, 2012, after Stan VanDerBeek's drawing, *TV-Information
Jacket*, 1970. The latter included the following text handwritten
on VanDerBeek's drawing, corresponding to the numbered
components in Mukii's drawing: 1. EEG readout for feedback control
of picture on TV/sound and circadian rhythm; 2. stereo phones, can we
separate heartbeat and blood sounds on different side of the body; 3. low
voltage eye pads and temple pads to induce 'visualizing' with the eyes
closed; 4. heart microphone; 5. pulse microphone; 6. interconnection
with TV controls: (a) contrast, (b) brightness, (c) color (separation is
important) for mood color, (d) volume OR optional sound from special
tape that reinforce the image, all 'controlled feedback' by cybernetic
devices on jacket. Courtesy of Ng'endo Mukii© 2012.

25 Stan VanDerBeek's *Poemfields #2*, 1967, produced with Ken
Knowlton's digital imaging program, Bflix, at Bell Laboratory,
programmed by VanDerBeek, and colorized later by Olgivy and
Brown. Sequence of 16 figures derived from the author's analysis
of the 'film', and is not sequentially accurate. All frame grabs from
Stan VanDerBeek DVD, *Electronic Arts Intermix*.

26 Still: *Razzle Dazzle: The Lost World*, Ken Jacobs 2006, color. Film/Video
composite. Courtesy of Ken Jacobs.

27 Still: *Razzle Dazzle: The Lost World*, Ken Jacobs 2006. Film and digital
composite. Courtesy of Ken Jacobs.

28 Gregory Barsamian in his Brooklyn studio, 2010. Photo courtesy of
George Griffin.

29 The interior of *Artifact*, Gregory Barsamian, 2010. Photo courtesy of
Gregory Barsamian ©2010.

30 Detail of Loplop's Nest, Brothers Quay, 1997. Installation shot
at Kunsthal Sint-Pieters, Gent, 1998. Photograph: Edwin Carels.

31 Floats, exhibition view at CAPC in Bourdeaux, 2010. Courtesy
GB Agency, Paris. Photograph: Edwin Carels.

32 'Annlee', as seen in a videostill from *Anywhere out of the World* (2000),
the first episode of *No Ghost, Just a Shell*, directed by Philippe Parreno

and Pierre Huyghe. ©Philippe Parreno. Courtesy of the artist and
Friedrich Petzel Gallery, New York.

figures

book collection. Her virtuoso playing of the harpsichord—on a special instrument made for her by Pleyel—which she plays with the precision of a machine, survives in her historic *Complete European Recordings*. The record label (united archives/harmonia mundi) named the album *The Well-Tempered Musician: Wanda Landowska*, identifying "this genius of the keyboard" with the perfection of Bach. Photograph of Wanda Landowska in 1920. Archive Zielinski. 42

plates and figures

xvi

acknowledgments

I face an impossible task: how to thank the dozens, hundreds of people who have contributed in many ways to this book? It is the result of a testing of ideas, discussions and debates with many, many thinkers and makers, and, with skeptics, enjoyable arguments about the value of animation in moving image culture. We, and our students, have collectively profited from a community of ideas shared across nations, disciplines and forms of practice. Because of the sheer numbers of scholars, students, filmmakers, artists, and curators, many of whom are both co-conspirators and friends, they will remain unnamed here: they know who they are. I will mention only a few individuals who were incisive in this book's development. Gratitude is due to all authors for engaging with the concept of 'pervasive animation' to apply their intellects, political sensitivity, and (inter)disciplinary expertise to an area of image-making that is beginning to garner academic attention to match its popularity and, indeed, its pervasiveness across many platforms. Stuart Comer gave me the opportunity to explore initial concepts at Tate Modern, London, in 2007, and his untiring curatorial efforts to screen experimental and animation film is unmatched internationally. Dick Arnall was a champion of independent and experimental animation, and his vision (and polemics) improved regard for animation: he is deeply missed. For their commitment, advice and constant encouragement throughout I thank AFI Film Reader Series Editors, Edward Branigan and Charles Wolfe. At Routlege, Editor Erica Wetter's support has been invaluable, and I thank the Production team, Margo Irvin and Apurupa Mallik, especially for the extensive work on this book's many images. I am grateful to the University for the Creative Arts who provided funding for a sabbatical, for color images and part of the indexing. And finally, I thank the animation filmmakers, whose gifts are stored in the thousands of films in my own memory's visual archive.

introduction: pervasive animation

suzanne buchan

Animation is pervasive in contemporary moving image culture. It is transforming cinema, is the basis for computer games, is used throughout the web, and advertising and propaganda learned early on of its power to astonish, influence and coerce. Animation has many formal, aesthetic and critical intersections with 'experimental' film and digitally rendered features, it is figuring in changing 'high/low' art economies and dominating information technology interfaces. Especially since the digital shift, animation is implemented in many ways in many disciplines and on multiple platforms. Alongside 'pure' pre-digital (celluloid) and digital animation shorts and features, artists increasingly incorporate animation in installations and exhibitions, and it has myriad applications across a wide band of creative, scientific and professional practice and industrial implementation. As screens become part of everyday life—phones, laptops, pads, and future technologies to come—animation will increasingly influence our understanding of how we see and experience the world visually.

What remains distinctive about animation in its over 100 years of celluloid-based production, is its unlimited potential to visually represent events, scenarios and forms that have little or no relation to our experience of the 'real' world. This has not changed; on the contrary, CGI digital tools are enabling filmmakers to create a whole new experience of on-screen 'realism' that is increasingly gaining on photo-indexicality, until now the exclusive domain of photochemical celluloid. Yet, while artists have been quick to embed the techniques, scholars are only beginning to deeply engage with a cinematic form that can have more to do with sculpture, algorithms or painting than with the genres of narrative live-action cinema. The expansion of animation in visual culture and its cultural difference and distinctiveness puts into question whether we can be 'purists' with regard to what is deemed a subject for critical evaluation and analysis for film studies. Animation, after all, is as much a cinematic and digital technology as it is an art form and artistic medium. An effective approach to this complexity is to use pluralist and interdisciplinary methods in a similar way that film studies did in its formative years and, to develop approaches that take into account the differences between celluloid and digital film experience and the platforms these technologies and techniques use.

Scholars working on animation in the early years often did so as a tangent to their disciplines, more often than not through cultural studies, literary theory, or art and film history, and there were few research-specific or theoretical book-length publications on animation. Until the 1990s, its integration into film studies was slow, not least because of its close relations with fine arts practice, and many authors writing about it were practitioners without formal academic training or awareness of scholarly contexts. Academic texts on animation were scattered in film and experimental cinema anthologies and journals, or published in non-cinema journals and collections. The 1990s saw a rash of animation anthologies and popular books, including a few that theorized animation. Many articles relating to animation film can be found in the FIAF *Index to Film Periodicals*, and in academic journals in disciplines of architecture, art history, graphic design, literature, performance, and others. Pre-digital experimental animation film enjoyed critical attention in experimental film theory. Some books from the 1970s to 1990s explore aesthetic implications of techniques other than planar (painted and drawn) animation, intersections with the avant-garde and experimentation in animation by fine-art practitioners. Many were solidly grounded in film theory and focused on perception, aesthetics and artistic practice, and often reflect on the personal experience of watching these films. Remarkable is that most of these books were written over a particularly productive period of experimental filmmaking, and that many authors took the opportunity to historicize animation's genealogies.

the 'problem' of animation, canons and genres

In an earlier essay discussing the 'problem' of animation as a category and its definitions, I commented that it is, "much like the term 'experimental film' … an unsatisfying, fuzzy 'catch-all' that heaps an enormous, historically far-reaching and artistically diverse body of works into one pot" (Buchan 2010: 175). Such ambiguity is symptomatic: animation's widely divergent pro-filmic materials (objects, drawings, sand, painting, puppets), can be allocated to almost all film genres; besides shared use of animation techniques, determining a unifying feature applicable to all it forms is questionable.[1] The Library of Congress Moving Image Genre-form Guide allocates animation to a sublist, as one of three appendices (the others are experimental and advertising), that is classified in 10 subdivisions solely according to techniques and technologies. Other genres are described with historical, ideological, aesthetic, or content-based terminologies.[2] In libraries, titles on animation are often cataloged under 'Genre', sharing shelves with the western, the horror film and film noir. Others classify these texts within film studies, while still others allocate them to sections on graphic design, illustration or comics. This indicates another symptom of the problem of definition (both of genres themselves and of animation film): Is animation a genre?—A technique?—A mode of film?—An art form? What, if any, characteristics does it share with other types of film besides its distinct technical and material aspects? Can the conventional definitions of genre apply to individual sets of films based on their ideologies, iconography and narrative content?

As a visual experience, animation has a history that precedes photographic film and its cinematic forms developed concurrently with moving image photography. Writing on pre-cinema and early cinema techniques in *Animated Pictures*, Charles Francis Jenkins notes the relationship between the historical context of animation and developing technologies: "To give life to inanimate things has been the dream of philosophers for ages, but to paint pictures and imbue them with animation, is the ambition of more practical investigators, and the evidence of the success of such endeavors is their daily accomplishment" (1898: 1). Like many of his contemporaries, Jenkins makes no distinction between trick effects and live-action, as the novelty of cinema had not yet distinguished the Méliès/Lumiére, fantasy/reality, stop-motion/continuous shooting dichotomies that differentiated into myriad genres and sub-genres of contemporary cinema studies in film content, genre and production methods. His idea that cinema is 'painting pictures' gives a sense of the newness of visual cinematic experiences of the time. With some exceptions, dominant contemporary cinema theory originated in early texts on aesthetics, ideology and genre classification and analysis of classic narrative cinema. These theories have been developed and modified to accommodate other forms, modes and genres, such as

experimental or *auteur* films. While live-action film eventually differenti-
ated into different genres, and critics began engaging with it as an art form,
as Kristin Thompson has noted, animation was eventually sidelined in the
service of Hollywood film. Anticipating Lev Manovich's 2002 polemic on
reversing the hierarchies of (digital) animation and cinema (298–300), in
Implications of the Cel Animation Technique, Thompson suggests that "[i]f
technology were the only factor determining the creation of motion
pictures, animated films would logically share a prominence equal to that
of live-action films in the history of cinema" (1980: 106). She argues that an
"ideology of realism" led to the "decline of the novelty effect in live-action
films" as narrative cinema developed, and wishing to conceal its own
constructedness from audiences, that the magical novelty and the
foregrounding of techniques in animation that disrupted, "an ideological
view of cartoons as comics developed" (108–111).

While animation has received some attention in film studies, until
recently it has rarely been the main topic of book-length studies; more
often than not, authors have expressed puzzlement, rarely delving deeply
into it. One example is in realism debates about the ontology and truth of
film, and I will briefly discuss three major contributions here. As Stanley
Cavell famously wrote:

> [T]here is one whole region of film which seems to satisfy
> my concerns with understanding the special powers of film
> but which explicitly has nothing to do with projections of
> the real world – the region of animated cartoons... If this
> region of film counters my insistence upon the projection
> of reality as essential to the medium of the movies, then it
> counters it completely. (Cavell 1979: 167).[3]

D. N. Rodowick, in his exploration of the "philosophical consequences
of the disappearance of a photographic ontology for the art of film and the
future of cinema studies" (2007: vii), discusses animation in the context of
the celluloid film strip. He observes that "succession means that funda-
mentally every film is an animated film as the automated reconstitution of
movement from a succession of still images" (53). In a note, he states that
his "position [on animation] does not vary greatly from Cavell's own
distinction of animation in *The World Viewed* 167–174" (53 FN 12). There is a
missed opportunity here: echoing Jenkins, Rodowick acknowledges the
shared fundamental frame-by-frame basis of animation and of film, but he
does not engage in why his position is similar to Cavell's.

In *What Cinema Is!*, Dudley Andrew engages occasionally with animation
and describes (cel) animation thus:

> Cel animation has always amounted to a camera-less
> cinema anyway. Designed on two-dimensional surfaces,
> thousands of pictures are then manipulated and sequenced

to appear alive and moving in three-dimensional space when presented full-speed on screen. This is one reason, though not the most essential, that Sean Cubitt has declared all cinema to be fundamentally a version of animation, rather than the reverse. (Andrew 2010: 2–3).[4]

Andrew then writes that "[i]f until recently cameras were required for the fabrication of animated as well as standard films, it was merely to conveniently render the artist's handiwork on celluloid for projection" (3). Andrew later suggests "[f]ilms exhibit tension between the human (imagination, intention) and the recalcitrant chunks of recorded reality; the type or quality of that tension defines the styles, genres, and periods of film history" (30). Animation removes this tension. The 'ideology of realism' disavows the viewer's other creative modes of perception and mental activity, such as pre- and non-verbal thought, inner speech, dreams and the ability to engage with non-indexical mimetic and abstract art forms that are understood co-creatively. Andrew notes however that:

> [a]nimation is one ascendant category, promoted by some to the top of the hierarchy of film styles today. As it was put to me not long ago: 'animation is cinema in its purest form,'[5] for unencumbered images outrun photographically generated shots, which are held back by the drag of ordinary space and time. Under the new [digital] regime, all films, not just animated ones, should be viewed and assessed as efforts to respond to the imagination, liberated from mundane constraints. (Andrew 2010: 30)

Referring to Edgar Morin, Andrew notes his insistence that "while all the arts project our dreams and desires, cinema is unique in doing so through the material world itself, or, more precisely, through a double of that world" (xviii–xix). Animation uses almost all the arts, and their materials, and has long responded to the searching the world of imagination and of dreams and desires.

Both Andrew and Rodowick raise the issue of photo-indexicality. Andrew asks "[d]oes not cinema require a source or referent in the world?" (3). Whether, cels drawings, or objects or puppets (that require complex pro-filmic mise-en-scène in miniature), that are all 'in the world', pre-digital animation frame-by-frame photography records these referents, as 'stuff' from the material world to visually represent artistic interpretations of *inner worlds* not otherwise perceived by sensory modalities used in the physical world (sight, touch, etc.). Regardless of the technique used, animation has also long been liberated from the 'mundane constraints' of ordinary space and time, realism, and depictions of the natural world, but its photographic celluloid works belong in the ontology of the photographic image that Rodowick and Andrew are interested in. Rodowick also raises a

pervasive debate in animation studies about differences between animation and live-action. He suggests "a distinction between realistic and fantastic uses of the filmed image [is misleading]" (121). Rodowick then rightly points out that:

> Regardless of the wonderfully imaginative uses to which they are put, and the spatial plasticity they record, cell [sic] animations obviously have a strong indexical quality. Simply speaking, each photographed frame records an event and its result: the succession of hand-drawn images and cells reproduced as artificial movement through the automatism of succession. Here, as in all other cases, the camera records and documents a past process that took place in the physical world. (Rodowick 2007: 121)

While all three of these important works are epistemological investigations of an ontology of cinema with an emphasis on realism, they seem ambivalent about animation as a mode and a cinematic form, including and excluding it from photo-indexical representations of the physical world as the defining quality of cinema; note they also concentrate exclusively on planar, cel and drawn animation.

The hegemony under which animation has been theorized is not limited to problems of material specificity; it is determined also through canon-making practices, still too often governed by unquestioned, reductionist orthodoxies. As Tom Gunning observes: "The history of cinema, like the history of the cinema generally, has been written and theorized under the hegemony of narrative films" (1986: 64). The largely exclusive focus on commercial narrative cel animation, and some so-called 'experimental' and avant-garde animation, has led to the omission of independent and non-commercial animation production and determined what is written about and taught.[6] The naming of genres, 'schools' and styles of animation was concurrently a canon-forming exercise. And again, the concentration on graphic animation— cel, drawn, cartoons—leaves out a multitude of other styles and techniques. Inclusion of animated films by women in canons is still a serious problem today, and is a dilemma this publication cannot resolve. While there is now digital and online ease of access to a wide variety of animation films, canons are still dominated by male, white Western directors. The same problem appertains to many academic syllabi, where it is common to find Cohl, Fleischer, Disney, MacLaren, UPA, Pixar, but not Ruth Lingford, Marie Menken, Janie Geiser or Mary Ellen Bute, all award-winning animators who have been screened internationally, but have received modest critical attention outside festival publications.[7]

In the past 30 years, digital technologies have increasingly encroached upon traditional forms of non-representational moving image-making, and the introduction of (animated) digital cinema has engendered

significant debates, some about the potential of this technology, others raising concerns about the dissolution of celluloid. Because much of digital cinema's technology and styles originates in animation practice, in my view, animation belongs at the heart of these debates. But this is rarely the case, and it is often erroneously conflated with digital techniques that aspire to 'the projection of the real world', to realism. The digital also informs the current crisis in film studies around the loss of its object of study (celluloid) and truth values of the photochemical index. As early as 1998, Thomas Elsaesser suggested that:

> [a]ny technology that materially affects [the status of indexicality], and digitization would seem to be such a technology, thus puts in crisis deeply-held beliefs about representation and visualization, and many of the dis-courses – critical, scientific or aesthetic – based on, or for-mulated in the name of the indexical in our culture, need to be re-examined. (Elsaesser 1998: 202)

Responses to this 'crisis' are manifold in Film Studies and are provoking valuable debates that aim to move on from Manovich's polemic that deems cinema a subset of (digital) animation (see Rodowick and Andrew). Andrew states that "the academic profession appears disoriented, at least momentarily, as questions of new media and of digital processes have sidelined or pre-empted other theoretical topics in journals and at confer-ences ... [and calls for us] to use the occasion of cinema's undeniable digital inflection to rethink the art's past and its potential" (xvii–xviii). Yet, writings on pre-digital animation have been eclipsed by this emphasis on digital technologies. What is at stake here is the critical revaluation of the limitations of animation histories and canonization, and the illumination of animation's formal and aesthetic characteristics beyond reduction to concerns of medium specificity. It is essential to fill the several significant gaps in our understanding, a few of which I have outlined here, as well as to how pre-digital animation, in terms of its development and its relation-ships to other art forms, is part of an ongoing continuum that includes, but is not reduced to, digital animation production.

re-positioning animation

The uneasy positioning of animation within film studies, therefore, needs urgent, critical re-examination. What qualities or aesthetic possibilities do animation films present that transcend or subvert those of live-action film? How does animation film affect the difficult concept of 'cinematic reality'? And what is the attraction of these films for an audience on the whole more accustomed to fictional or documentary representations of external real-ity, of the world they inhabit physically? Such questions touch on the

aesthetics of cinema as a whole, and on discourses around reality and perception, and as formal queries, take us into fields of philosophy, narratology, critical and fine-art theory. In a discussion about the auteur in commercial and creative cinema, Gilles Deleuze suggests a way to distinguish between them, that is useful when thinking about the art of animation:

> A work of art always entails the creation of new spaces and times (it's not a question of recounting a story in a well-determined space and time; rather, it is the rhythms, the lighting, and the space-times themselves that must become the true characters.... A work of art is a new syntax, one that is much more important than vocabulary and that excavates a foreign language in language. (Deleuze, in Flaxman 2000: 370)

Deleuze sees a value of creative works in their multiplying, liberating and inventing new emotions (ibid). Many non-conventional, hyperrealist animation films create visual neologisms in the particular animated space-time that are the true 'characters' of the films. In the critical language used to describe such works, theorists need to develop a 'new syntax', in other words, new ways of writing about animation that reflect on the very different perceptual and emotional experiences the form elicits and even constructs. This can be encouraged by considering what Noël Carroll regards as central activities of criticizing artworks: description, classification, contextualization, elucidation, interpretation, and analysis (2009: 13), and he emphasizes artistic evaluation as the *primus inter pares* (9) central to the critic's role. Since animation can pose an aesthetic puzzle not fully solved by live-action based film studies approaches and methodologies, and because animation films also develop intimate relations with fine art, literature and other creative practices, besides cinema theory, this means also exploring other avenues that produce hybrid approaches for a hybrid form. Scholars and practitioners are increasingly using inter- and cross-disciplinary methods in their writing and creative work, and animation is a fecund object through which to explore and expand the effectiveness of other disciplines when applied to the moving image in general.

Until quite recently, 'animation studies' was rarely taught at university levels. Now, due to changing university skill and knowledge requirements, and with the push to 'multiversities', traditionally practice-based animation courses are increasingly offering a theoretical component to study programs and vice-versa.[8] Beside practice-based programs, animation studies is usually a component of film studies and media studies programs, although it is included in curricula as diverse as comparative literature or contemporary history. There is also an observed growth in animation-based PhD projects, both practice and theory-led, that embrace concepts with wider spectral implications and interdisciplinary methods of investigation.

The study of animation is thriving with potential opportunities for diversifying its methods and approaches, analogous to how film studies developed an enormous range of academic expression by drawing on related disciplines. This is one of the editorial strategies of this AFI reader. Its genesis began in 2007 with the 'Pervasive Animation' symposium held at the Tate Modern, London.[9] A collaboration between myself and Stuart Comer, the name of the symposium and of this publication originated in a larger research project I was then developing, that continues: the next project is an exhibition at the Museum for Design Zurich. Only a handful of theoretical collections have been published in the last 15 years, and as demand from higher education for new and critical writing on animation grows, a new reader of animation theory is long overdue. While readers versed in animation studies will recognize some names, many of this AFI reader's authors are not nominally known as animation scholars.[10] They were invited to contribute to this volume based on their expertise in film studies and in other disciplines and thematic fields, as well as for their interest in animation outside the dominant canons; many of the works they examine have rarely been discussed in animation studies writings. Their contributions will help to further differentiate and articulate what is meant by 'animation', and provide new ways of thinking about the form as well as its impact and effect on contemporary audiences. This is in keeping with my concept of 'pervasive animation', that aims to increase and embed critical reflection on the pervasive impact of animation in visual culture, including ethical responsibility of its makers, distributors and consumers. The writings in this collection may offer models for scholars as to how to apply their own particular intellectual engagement to their interest in animation: to widen their 'visual radar', so to speak.

pervasive animation: an overview

One of the challenges of planning this book was preparing its cover; how to choose one single image to represent 'animation'? In lively e-mail discussions with some of the authors about options I selected, we decided on Cathy Joritz's *Negative Man* (1979), a film virtually unknown in film studies, but one that electrifies audiences when it is screened. Working with a piece of found footage, an instructional film from the 1950s for social workers, Joritz used the direct animation technique—scratching the film strip—to add visual information that embellishes the speaker with stark white and vibrating appendages: devil's horns, a punk Mohican haircut, steam, a penis placed in a suggestive gesture of the speaker's hand, an atomic bomb blasting out of his head, or ray-gun eyes that scan a paper. Joritz created a witty, polysemic cinematic text, adding visual commentary that expands what the original material rather dully communicates. We felt that this image worked for a number of reasons: it suggests some of the

main issues raised by the notion of 'pervasive animation'; potential readers may recognize themselves in the image for how they feel when they encounter compelling writing; it has sociocritical and political content; it is a brilliant example of creative economy of means; it complicates live-action film with invasive animation, and like many of the works discussed in this book, it is also outside the typical canons.

The book is mainly structured according to a chronological timeline—from animation pre-history to current exhibition practice—and investigates the aesthetic, stylistic and technical diversity of animation film in research, commercial, independent, avant-garde communities around the world. Most of its contributors are widely renowned and respected scholars from cinema and media studies and animation studies, others are new and strong voices in the intellectual community. Before introducing each contribution in the next section, I will comment on the main themes of the book that address and expand prevailing topics and themes in writing on animation, and while section names are a roadmap, I will suggest further thematic interlinking between the authors that may be helpful to readers. There are chapters on precursors and alternatives to cinematic animation and their cultural, scientific and philosophical concepts and impact (Zielinski, Gunning, Griffin). The troubled notion of the illusion of life in animation is thematized, and alternate approaches offered (Zielinski, Lamarre, Buchan), as are investigations of photo-indexicality and of documentary (Gunning, Skoller, Bartlett, Ehrlich). Some authors take a notably political or cultural stance to challenge hegemonies of technology and culture (Zielinski, Cubitt, Kim), comment on sociocritical and ecocritical aspects of power, technology, labor, death and war (Leslie, Cubitt, Skoller, Ehrlich, Ward), or question systems of history and historiography (Zielinski, Bartlett, Skoller). There are contributions concerned with the effects of stillness, duration and movement (Leslie, Lamarre), and the perceptual and aesthetic experience of these in both theatrical and alternate settings (Buchan, Skoller, Griffin, Carels). The materials of animation are examined (Cubitt, Buchan, Griffin, Carels) as are graphic cinema and the line (Cubitt, Leslie, Lamarre), as well as animation technologies and medium specificity (Lamarre, Bartlett, Griffin) and animation as process (Ward, Griffin). Almost all engage with the viewer/observer/spectator, often with an interest in the non/post/contemporary human condition. Some refer to existing methodologies, others offer new exemplars or introduce new concepts, terms and approaches. Readers will notice that authors' references augment both film and animation studies with writings from a wide range of related disciplines.

section one: 'mechanics and magic'

The history of animation before photography has a tendency to focus on laterna magica and nineteenth century Victorian/European optical 'toys'.

In "Expanded Animation: A Short Genealogy in Words and Images", media archaeologist Siegfried Zielinski discursively expands this notionally Occidental pre-history to include a range of examples from around the world (which is a strategy of his inclusive and corrective concept of 'Variantology'). His interest here is in "the sensational phenomenon of animation [in] the broader context of the deep time relations of arts, sciences, and technologies" (26). Zielinski demonstrates prismatically how philosophy, theology, media theory, engineering, natural sciences, and histories of technology meet and overlap in animation and automatons, where the animating principle is fulfilled not through cinematic techniques, but rather through hydraulics, pneumatics, mechanics, electricity, gravity. With this richly illustrated illustrated chapter Zielinski's 'deep time' of animation effectively expands the received pre-histories of cinematic animation and challenges the hubris of the West as the main inventor of non-cinematic animated forms.

In "The Transforming Image: the Roots of Animation in Metamorphosis and Motion", Tom Gunning also addresses non-cinematic objects. He starts by proposing a rethinking of questions about the hierarchies of animation and photographic cinematography, and raises a pervasive debate in animation studies, namely the expressive possibilities available in drawn or painted animation, compared to the photo-indexical 'constraints' of photography (and film). After discussing the transformative powers of animation and metamorphosis, he moves from this macro-debate to a micro-focus on two particular 'devices of wonder': the blow or flick book and the flipbook (*aka* thumb book). Contextualized with Pre-Enlightenment and later scientific texts and other Philosophical Toys (also known as Victorian optical toys), Gunning demonstrates the pre-photographic flipbook as belonging to a lineage of animated drawings, rather than to pre-cinematography, as is usually the case in writings on the flipbook. He argues that these and other philosophical toys manipulated perception, and that they have a place in thinking about animation now. Ending with a discourse on George Méliès' trick films, Gunning shows the relevance of the magic of transformation in the realistic representation of motion and the transformative power of the single frame in today's digital image making.

section two: 'material culture'

Following on from Zielinski and Gunning's innovations and precursors to photographic cinema, this section specifically treats the technologies, matter and materialities of animation within political, aesthetic and eco-critical frameworks. Esther Leslie's "Animation's Petrified Unrest" considers early animation as a form of production—consumption. She investigates the closely bound relations between stillness—the single frame, and movement—the illusion of projection—and how animation reverses the

process of things that once moved becoming petrified: in animation, unmoving things become mobilized. Worked through in the theories of visual perception are notions of empathetic projection and kinesthetic vision, which segue with the new experiences brought about by optical technologies of leisure. She then turns to the line, one of the most central elements of any drawn animated film. As Vivian Sobchack writes, "the single line … foregrounds animation's own internal metaphysics and para-doxes, its own ontology (however qualified in terms of cinema), its own sufficient conditions for being the 'what' that it is" (2008: 252–253).[11] Leslie examines the line in the swirling curves of a drawing of Loïe Fuller (*The Serpentine Dance*) and the shape-shifting of Early Cinema, to then discuss how animated drawings create this through drawing. She shows how movement and stasis is apparent in chronophotography, and how Marey's use of dots would be taken on in *Felix the Cat* cartoons. Leslie introduces a Marxist interpretation to draw an analogy between the freedom of these forms in cartoons and a freedom of movement in labor collectives. She ultimately shows how the labor world of flowing and punctuation, or stopping and starting, is taken up or worked through in the animated culture of the early years of twentieth century.

Sean Cubitt's "Ecocritique and the Materialities of Animation" posits how technologies and techniques of animation express social construc-tions of the human–natural relation. Reminding us of the ecological and industrial impact of animation's materiality, Cubitt then proposes three modes of animation as evolving, related forms: direct, profilmic and vector. He sees direct animation in a continuum with animation's earliest forms and describes a shared coincidence of temporalities and artisanal faithful-ness to materials that results in a mediation of the human–environment relation. Cubitt's next object is pro-filmic animation: he draws out a relation between production modes and methods in the differences between the individual artist and industrial, studio-based labor. Then he shifts to his third mode: vector animation, and through a contemporary interactive artwork by Daniel Rozin, Cubitt shows how the digital pixel and the pinscreen use similar principles as the two previous modes. After a helpful, brief introduction to the physics and math of vectors, Cubitt quickly moves to locate the aesthetics and technology of this mode in early animation (Émile Cohl) and William Hogarths' 'line of beauty'. He then evaluates how lines and vectors create human gesture and allow additional freedoms with subjects' relationships to environments, and concludes with how these three modes influence new, interactive and exterior environ-ments. His contribution gives pause for thought about an ecological and historical approach to the materials of animation as crucial for the development of an ecocritical tradition. Cubitt provides a useful ecocritical and political methodology for approaching these works as they become more and more pervasive in visual culture.

section three: 'life and non-life'

The 'illusion of life' is defined variously in many writings on animation, but it is and remains a somewhat vague notion, especially with regard to the variety of techniques and materials used. The three authors in this section take on how life, and non-life, are represented, thematized and technically created in animation filmmaking. In "Coming to Life: Cartoon Animals and Natural Philosophy", Thomas Lamarre reiterates a number of concepts of 'bringing to life' in animation. Making clear he is not engaging with essentialist, medium-specific debates, he focuses on a wider problematic of movement-as-life through two lines of inquiry: cel animation and natural philosophy. Using 1930s Japanese cartoons as his examples, Lamarre highlights the relation between non-localized movement (compositing) and localized or embodied movement (character animation), a defining feature of full or classic cel animation. He asks questions about the relation between these two types of movement, and the tendential privileging of the effects of characterization. Lamarre's second line of enquiry explores how localized non-movement is the key to understanding the tendency to see an animistic or vitalist worldview in animation. He suggests the movement-as-life problematic resonates with a natural philosophy approach rejecting dualism and substantialism that refuses a divide between matter and energy, body and mind, space and time. Lamarre's biopolitical discussion of this 'reality/fantasy divide' reflects on natural and artificial perception of cartoon animals. Lamarre applies this to a discussion of animation and how its 'species' creates values of empire, and how, through contemporary digital compositing, animation breaks out of its medium specificity. He ends with a biopolitical critique of the genealogy of contemporary media politics and claims that we must address cartoon animals as forms of life rather than deceptive illusions.

My own contribution concentrates on puppet and object (stop motion) animation, a technique that receives less investigative attention than cel or drawn planar animation. In "A Cinema of Apprehension: A Third Entelechy of the Vitalist Machine", I develop four proposals. The first takes into account the materiality of the animated object and develops a typology of the Quay Brothers' non-anthropomorphic 'vitalist machines'. It is informed by vitalist principles and Bruno Schulz's concept of *generatio aequivoca* (spontaneous generation or self-reproduction), a main inspiration for *Street of Crocodiles* (1986) and later films. Working with Aristotle's philosophical concepts of entelechy, I then sketch out an ontology of these animated objects as a category of *soulless* being that is rooted in a material objecthood, to offer an alternative to the prevalent concept of animism. The third proposal deals with how the viewer engages with features of the Quay Brother's constructed puppets and objects, and I suggest how these portmanteau objects are visual metaphors that engage the viewer co-creatively.

Fourth, I develop a somatic, epistemological and aesthetic proposal for the viewer's reaction to these vitalist machines: what I call 'a cinema of apprehension', a performative and actively engaged paradigm of spectatorship for puppet animation distinct from live-action cinema, and animistic animation. I conclude with how naïvety and enchantment can be useful to understand our perception of animated matter.

Continuing the section theme of life and non-life, in "The East Asian Post-human Prometheus: Animated Mechanical 'Others'", Joon Yang Kim takes an anti-Orientalist/postcolonial approach to dealing with animated texts produced in East Asian countries. Kim starts with a politically informed analysis of the unfavorable representation of East Asian military in Western cartoons made in the 1930s and 40s, noting the predominance of repetitive, mechanical movement. He works with Rey Chow's conception of E. T. A. Hoffman's mechanical doll Olympia as a cultural metaphor for Orientalist discourse, applying this to the West's first reactions to *anime* and Japan's instrumentalization of these. Kim then addresses his main topic: the figure of the android, robot and cyborg in East Asian animation, through stylistic, philosophical and literary frameworks. He effectively analyzes genders and stereotypes and their origins in Korean and Japanese cultures, industries, and ideologies, linking these to the films' Lamettrian machine-based figures' ontological dilemma: they strive to be human, in other words, East Asian 'robots', or 'Others', that want to be accepted by the West. Kim provides insights into Eastern poly/pantheistic traditions that offer alternate concepts of humanity and post-humanism. His final section considers ethics and the android 'commodity' as a post-human, mechanical 'Other' to draw comparison with the situation of Korean migrant and female workers in South Korea. Kim concludes by asking if we have the empathetic capacity to hear the 'voices' and understand the injustice these animated and real-world figures experience.

section four: 'history, documentary and truth'

Although rarely invoked in animation studies, the notion of blending media is pervasive in animation filmmaking as it has always been a collaborative part of the interdisciplinary contagion and hybridity that defines so much of our visual culture. This section features three authors working with distinct forms of animated documentary; they analyze a range of documents 'blended' and hybridized with animation, to disentangle histories, documentary 'truth' and aesthetics to demonstrate political and philosophical agendas. In "Socialimagestics and Cinemasymbiosis: The Materiality of A-Realism", Mark Bartlett develops a philosophy of animation that aims to circumvent the ideological dualisms and reductive humanism inherent to established cinema theories and discourses. Bartlett provides an alternative, binocular perspective of historiography/historicity

and materiality/technicity through an intersectional reading of Hayden White, Paul de Man, Walter Benjamin, and Stan VanDerBeek. He offers White's concept of figural realism as a mediator between the binaries of what he calls hybrid states of fictional-facts and factual-fictions. He aligns these to de Man's radical interpretation of Kant's aesthetic judgment in order to argue for a non-dualist conception of materialism that opposes the cinematic humanism that the discourse network he cites brought under radical critique. Bartlett shows how de Man's conception of materialism is a performative, formal force and 'technological will' historically determined first by modernist cinema, then by information and computing technologies, that produced a radical historical break with auratic precinematic aesthetic states of subjectivity. Asking what epistemological work does *some* animation do, he explains that *some* animated films (e.g., Brett Morgen's *Chicago 10*, which hybridized indexical live-action and animation's phantasmic imaginary), produce an aesthetic state constituted by fictional-facts and factual-fictions that is completely consistent with a figural realism grounded in de Man's performative materialism that Bartlett calls 'a-realism'. He concludes by demonstrating that VanDerBeek's neologistic theory of socialimagestics and practice of cinemasymbiosis, as exemplified by the latter's drawing of the "TV-Information Jacket" and his computer-generated film series, *Poemfields 1–8*, also squares perfectly with the philosophy of a-realism. Animated audiovisuality articulated with indexical, live-action visuality, in his view, is potentially its best post-humanist and political exemplar, most in sync with today's historicity and technicity.

The relationship between history, indexicality and the ideological potentialities of animated digital technologies are the subject of Jeffrey Skoller's chapter, that concentrates on a filmmaker who works with and reworks artifacts from Early Cinema. "ReAnimator: Embodied History, and the Post-Cinema Trace in Ken Jacobs' 'Digital Composites'" explores the ways in which digitalization can complicate notions of photographic indexicality as historical trace. Skoller begins with examining the traditional symptomatic divide between the politically engaged film and animation, arguing for the latter's 'radical promise' in a context of Modernism, and he asks pertinent question about how the digital is transforming what we think animation is. Skoller then explains why Jacobs is an exemplary film maker to discuss animation aesthetics and radical media practice. Working beautifully with Walter Benjamin's figure of 'the brooder' (1999), Skoller locates Jacobs' concerns, that are deeply bound to a respect of images from the past, in a wider historical urgency. He then discusses (re-)animation of imagery in a range of Jacobs' works, working here and later with the Deleuzian concept of 'the fold'. Skoller then explains Jacobs' recent engagement with digital, to then raise questions about the current reconsideration of animation in film studies and practice.

He introduces a new term, the 'digital temporal composite' (that he also calls a fold), to clarify a distinction to other terms used to describe analog or digital temporal multiplicities. He then shows us in detail how Jacobs' films demand a rethinking of the photo-index. In his analyses Skoller articulates a powerful mix of technical perspicacity, aesthetic evaluation and political contextualization that enhance the term 'animation' with new meaning beyond a technique. Skoller's proposition of re-animation thorough a continuum of analog and digital techniques and technologies opens up radical ways of thinking about animation beyond traditional frame-by-frame shooting.

Animation has long been used in documentary film, often as an inserted graphic, cut-out or digitally modelled 3D sequence.[12] Animated documentary has many uses, including creating imagery for unrecorded events and for depicting human experience that take place outside our geographic limitations, and it is receiving increased attention in film studies.[13] In "Animated Documentaries: Aesthetics, Politics and Viewer Engagement", Nea Ehrlich begins by considering a number of important factors for any documentary film, and proposes others that are specific to the animated form: degrees of agency and representation, the effects of aestheticization, questions of realism and indexicality, correlation of the animated images with source materials, and the consequences of these on a work's sociopolitical intent. Ehrlich concentrates on identity politics and the 'other', authenticity, and the aesthetic/political ramifications of animation when used to create a documentary film. She then shifts her attention to online communities and 'serious' games demonstrating how games can satisfy Michael Renov's functions of documentary and Vivian Sobchack's notions of empathetic recognition. Ehrlich argues how engaged participation in games can enhance and intensify the user's sociopolitical engagement, and how this is in part achieved through the game's animated graphic simplicity. She proposes a holistic approach to the avatar/player connection, and that the consequences of losing promote identification with and ethical responsibility for the 'here and now' situation of the 'other' in the game. Ehrlich's contribution embeds animated documentary and games in the wider debates around political film documentary. It also draws attention to the millions of online users around the world (and the victims of war depicted in the games) who are rarely considered in these debates.

section five: 'display, process and practice'

This final Section concentrates on alternate displays and creative processes of animation as a practice and an art form. In the arts economies, museum and gallery exhibition and installations of mainly conventional and commercial work persists. Curation of independent and non-commercial animation, that provides alternatives to popular canons, and enhances the

public's understanding of animation as *process*, is relatively rare.[14] Himself a pioneer of animation installation, in "Take the B Train: Reconstructing the Proto-cinematic Apparatus" artist and filmmaker George Griffin further develops his notion of "concrete animation"[15] in non-theatrical and site-specific animation installation. Griffin elegantly works with a New York transport system analogy; he invites us to step off the 'A Train' of popular animation film to take the 'B Train' to the alternate territory of an emerging artistic practice. Discerning between kinetic sculpture, performance and urban installation, Griffin describes how different technologies result in different, unmediated temporal and physical experiences distinct from time-based animation projection. He begins with Gregory Barsamian, emphasizing the materiality and labor of Barsamian's work, explaining how non-cinematic moving sculpture is animated by a carefully timed strobe light. His next subject is Eric Dyer, a film experimentalist whose non-filmic cinetropes and sculptures rely on light rather than projection. Dyer also creates standalone films for projection based on his installations. Returning to the B Train, this time literally, Griffin's third and final subject is Bill Brand, who created the kinetic concrete animation installation *Masstransiscope* in an unused station in the New York subway system's B Train route.[16] Griffin places Brand in a lineage with Eadweard Muybridge and pre-cinema optical apparatus, as well as in recent public art canons. Griffin's conclusion gives us pause for thought on how academia has focused overtly on cinematic and screen-based animation, and by providing valuable insights into these artists' philosophical concepts and creative processes, he generates new thinking about the notion of the 'in-between'.

The production process of most pre-digital animation requires a material base: drawing, paintings, cels, objects and other artistic media are used to create the films. There is an opportunity for physical proximity to the material base of pro-filmic materials used to craft animation, and this has featured in a number of more recent exhibitions.[17] In "Spaces of Wonder: Animation and Museology", Edwin Carels' understanding of animation as both technology and metaphor for curation is applied to the museal 'white cube' and its staging of a spatial and temporal agency for manipulation of intervals in four artists' works. First, he locates the Quay Brothers' film set displays in a contemporary dialectic based in the tradition of seventeenth century *Wunderkammer* and Norman Klein's notion of 'scripting space' (2004: 2). He then considers sculpture and animation through Robert Breer's minimalist aesthetics and preference for so-called 'primitive' animation techniques. A discourse around Marcel Duchamp questions the dissociation of animation from twentieth century art, and Carels shows how Breer's works are in a lineage with 1920s avant-garde. His third subject is Phillipe Parreno and Pierre Huyghe's installation works, and Carels usurps the animation term of 'in-betweening' to explain the temporal, spatial and art world mediation in the artist's curation

17

of their works. Here, as elsewhere, Carels points out how museological codes are addressed by these artists. He then discusses Anthony McCall's light projections as para-cinematic animations, showing how the artist's structuralist alignment and theoretical aims demand a rethinking of these codes. Again, Carels expands the canons, this time by introducing McCall into pre-cinematic magic lantern and other ephemeral, non-cinematic nineteenth century projection techniques. He embeds McCalls' 'solid light sculpture' in historical debates around the apparatus and its resulting immaterial *dispositif*, noting the recent revival of interest for artists' cinema. Carels' question throughout is to what extent the practice of animation brings in its own set of paradigms, and whether these are really new, or rather rooted in the past.

Animation production is now a significant industry worldwide, and this raises questions about practice and training at art schools and universities, as many are developing strong relations with studios and industry. With this economic and cultural impact in mind, and supported by a range of cultural, pedagogical and social theorists, in "Animation Studies as an Interdisciplinary Teaching Field", Paul Ward undertakes an enquiry into pedagogical methods and strategies for teaching practice and theory at university level. He begins with some observations on relations between animation and other disciplines, introducing a number of uses of interdisciplinarity put forth by other authors. He suggests that animation theory and practice itself has emerged from a disparity of disciplines, developing into nodes of enquiry with relations to other fields, and that it should not be regarded as a discipline. Ward explores a variety of epistemological models to develop a set of problems for knowledge production in animation, proposing this can be resolved through a critical and discursive dimension. Through a comparative framework of performance studies, he suggests how animation can be understood in dynamic and dialogic relations between theory and practice. With an emphasis on practice, Ward raises the innate differences between 'classical' and vocational training, registering a stronger tendency for the latter. He then reviews teaching strategies of a number of animation programs, and of other disciplines make use of animation in courses, to then suggest how recontextualization of animation can make a contribution to other discipline-specific knowledge. Ward concludes that courses offering animation theory and practice should not enthral themselves to satisfying only industry needs, and rather be aware of how the interdisciplinarity of animation impacts a range of knowledge, cultures and practices.

Pervasive Animation is a contribution towards bridging the enormous gap in dialogues between burgeoning animation film production and its critical counterparts. It responds to existing theoretical stances, investigates radical contemporary practice and creative innovations and foregrounds specific disciplines and their interrelations with animation. We hope that this

anthology of new writing—that is also a philosophy of animation—provides a holistic set of tools and resources for students and researchers; it aims to be forward-looking, in that it proposes a wide range of exemplary approaches and critical methodologies to build upon for future research. The book also challenges Western and commercial hegemonies and cliched conceptions about animation, to widen the scope of our creative and intellectual capital to a larger cultural mediation. We hope to stimulate much-needed dialogue and new perspectives centered on the pervasive and multidisciplinary nature of animation, its future development and its ethical responsibilities for spatial politics and moving image culture.

notes

1. Exceptions include any genre that is exclusively based on live-action shooting, for instance direct cinema or theater performance.
2. *The Moving Image Genre-form Guide*, http://www.loc.gov/rr/mopic/migsub. html#Animation (Accessed November 27, 2012).
3. For an extended discussion of Cavell, that includes Alfred Sesonske's response to Cavell's comments on cartoons, see Buchan 2006: 16–18.
4. Note 2 in Andrew: Sean Cubitt, *The Cinema Effect*. Cambridge MA: MIT Press, 2004: 97.
5. Note 6 in Andrew: "This point was well made and well defended by Adam Rosadiuk in a symposium at Concordia University in Montreal, organized by Martin Lefebvre, March 2005." (Andrew, 61)
6. For an extended discussion of this, see Buchan, "Animation, in Theory", in *Animating Film Theory*, Karen Beckman (ed). Durham NC: Duke University Press, forthcoming.
7. The editor of this book sought authors to write about women in animation, but unfortunately was not able to confirm them as contributors.
8. Animation World Network Schools directory lists over 900 animation courses worldwide, 399 with a theoretical component, 324 undergraduate, 197 masters and 60 PhD programs. Animation World Network Schools Directory, http://schools.awn.com/ (Accessed December 9, 2012).
9. The full 3-day symposium webcast can be watched on the Tate Channel, http://www.tate.org.uk/search/Pervasive%20animation
10. Nine of this book's authors have published in *animation: an interdisciplinary journal*, nine are members of the journal's Editorial Board, and 10 have been speakers at symposia and conferences the editor organized.
11. See also Vivian Sobchack's talk at the Pervasive Animation symposium, http://www.tate.org.uk/context-comment/video/pervasive-animation-part-3
12. Examples include development political or battle situations on a map, visualizing the biochemical functions of cellular DNA or mitochondria, transporting the viewer from macro-spatial organization of galaxies to demonstrating how nanoworlds work.
13. In 2011, *animation: an interdisciplinary journal* published a Special Issue on the topic, guest edited by Jeffrey Skoller.
14. Alternatives to cinematic projection and to the 'white cube' include public art; installations in other environments include projections on buildings (Blinkenlights, Rose Bond, Marina Zurkow), or animation and performance (Miwa Matreyek, Cathy Rose).

15. See Griffin's essay, "The Anxious Pencil", in *Trickraum:Spacetricks*, 2005: 14–19.
16. A version of the work can be seen on Brand's website, http://www.bboptics. com/. Over the years, the installation was damaged by graffiti and was restored by Brand in 2008.
17. Examples are *Trickraum:Spacetricks* (Suzanne Buchan and Andres Janser: Zurich and touring 2005–6); *Watch Me Move* (Greg Hilty and associate curators: Barbican, London 2011 and touring); *Borderline Behaviour* and *Graphology* (both Edwin Carels, Rotterdam and London respectively), and *The Quay Brothers: On Deciphering the Pharmacists Prescription for Lipreading Puppets* (Ron Magliozzi: MOMA, New York 2012–13).

references

Andrew, Dudley. 2010. *What Cinema Is! Bazin's Quest and its Charge*. Malden, MA: Wiley Blackwell.

Benjamin, Walter. 1999. *Selected Writings, 1931–1934*, Cambridge, MA: Belknap Press of Harvard University Press.

Buchan, Suzanne. Animation, in Theory. In *Animating Film Theory*, ed. Karen Beckman. Durham, NC: Duke University Press: forthcoming.

—— 2010. 'A Curious Chapter in the Manual of Animation': Stan VanDerBeek's Animated Spatial Politics. *Animation: an interdisciplinary journal*, Vol. 5, No. 2: 173–196.

—— 2006. The Animated Spectator: Watching the Quay Brothers' 'Worlds'. In *Animated 'Worlds'*, ed. Suzanne Buchan. Eastleigh: John Libbey Publications: 15–38.

Buchan, Suzanne and Andres Janser, eds. 2005. *Trickraum:Spacetricks* (German/ English). Zurich/Basel: Museum für Gestaltung Zürich and Christoph Merian Verlag.

Cavell, Stanley. 1979. *The World Viewed: Reflections on the Ontology of Film*. Enlarged edn. Cambridge, MA: Harvard University Press.

Carroll, Noël. 2009. *On Criticism*. Oxford: Routledge.

Deleuze, Gilles. 2000. The Brain is the Screen. An interview with Gilles Deleuze. In *The Brain is the Screen. Deleuze and the Philosophy of Cinema*, ed. Gregory Flaxman. Minnesota: University of Minnesota Press.

Elsaesser, Thomas. 1998. *Cinema Futures: Cain, Abel or Cable* Amsterdam: Amsterdam University Press.

Flaxman, Gregory, ed. 2000. *The Brain is the Screen. Deleuze and the Philosophy of Cinema*. Minnesota: University of Minnesota Press.

Griffin, George. 2005. The Anxious Pencil. In *Trickraum:Spacetricks*, eds Suzanne Buchan and Andres Janser. [German/English] Museum für Gestaltung Zürich and Christoph Merian Verlag: 14–19.

Gunning, Tom. 1986. The Cinema of Attraction: Early Film, Its Spectator and the Avant-Garde. *Wide Angle*, Vol. 8, No. 3/4: 63–70.

Heath, Stephen and Teresa de Lauretis, eds. 1980. *The Cinematic Apparatus*. London: MacMillan.

Jenkins, Charles Francis. [1898] 1970. *Animated Pictures*. Washington: H. L. McQueen. Facsimile reprint. New York: The Arno Press and *The New York Times*.

Klein, Norman. 2004. *The Vatican to Vegas: A History of Special Effects*. New York: The New Press.

Manovich, Lev. 2002. *The Language of New Media*. Leonardo Book Series. Cambridge: MIT Press.

Rodowick, D. N. 2007. *The Virtual Life of Film*. Cambridge MA: Harvard University Press.

Thompson, Kristin. 1980. Implications of the Cel Animation Technique. In *The Cinematic Apparatus*, eds Stephen Heath and Teresa de Lauretis. London: MacMillan: 106–119.

mechanics and magic

expanded animation

a short genealogy in words and images

one

siegfried zielinski

methodological prefix

> The origin always precedes the Fall. It comes
> before the body, before the world and time
>
> (Foucault 1977: 143)

This is how Michel Foucault adapted a very old saying[1] for the purposes of his particular work on the layers of the past. In this view, to define the origin of a phenomenon in which one is interested is hubris. For such an action asserts that one is in possession of the truth; truth that can only emanate from the gods. One has certain knowledge from whence the phenomenon originates and, of course, one knows where it's going. Or—what is even worse—one starts from a particular point in the Here and Now and comprehends it as history that can be recounted logically; how from its origin this point had to develop systematically into the phenomenon we know today. The concepts of origin and teleology are closely connected. The definition of a beginning and the idea of a certain end are linked together.

In modern astrophysics, the theory of the Big Bang is one such concept of determination. In the fields of art and media one can take an example that concerns projection. Current praxes of projection are defined as the systematic production of illusions of the real using certain optical techniques and it is maintained that this has always been the case.[2]

In his philosophical ideas about science, Friedrich Nietzsche offered a way out of this dilemma, which was taken up appreciatively by Foucault in his later writings. Foucault's concept of genealogy does not ask about the one and only origin from which everything is supposed to have developed; instead, it investigates the disparate sources of a phenomenon and traces how the different lines of descent have developed. The labyrinth of processes and events in the past is, from this perspective, not merely a collection of facts that have been determined once and for all. Rather, what lies behind us in the past becomes a possibility-space, like that which lies before us already is. To understand the past as a "potential space" (as described by English pediatrician and psychoanalyst Donald W. Winnicott), which can be unfolded pleasurably, means that we keep the option open of discovering something new in the old, time and again. Martin Heidegger even went so far as to maintain that future and origin are identical.[3] Animation has a profound and ramified past, and likewise a vibrant future.

the semantic field

With regard to cinematography in the narrower sense, animation is clearly a heterogeneous phenomenon and not a single case of techno-aesthetic theory and praxis. Cutout animation, graphic animation, sand animation, and pixilation are the names of just some of the techniques which are used to create illusions of movement between two-dimensional image realities. Photo animation and full animation, like the traditional cartoon, have now become simply sub-genres of animation. I shall leave this discussion to the experts. My interest in the sensational phenomenon of animation is the broader context of the deep time relations of arts, sciences, and technologies.

From this perspective, animation is a complex and sensational phenomenon. This means that it is composed of very different dimensions of reality. One could also call these dimensions discourses. Then animation would be an interdiscursive phenomenon. In its prismatic existence philosophy, theology, media theory, engineering, natural sciences, the history of technology, aesthetics, and ethics meet and overlap. Let us now both describe and open up the semantic field (See Plate 1), create a free space for animation so that it may take place and unfold as a sensational phenomenon.

Anima animus animation ... is the title that the Czech surrealists Eva Švankmajerová and Jan Švankmajer gave to their joint Prague exhibition

siegfried zielinski

26

of 1997 (**See Plate 2**). In Latin *anima* means physically breath, wind, air, and in a figurative sense the divine breath of life that blows through the subconscious of man, which is very close to the definition of soul. In Latin, *anima* is also feminine; *animus* is its masculine counterpart. It is the breath that constitutes the soul of a man and which suffuses the feminine. As in Asian and Chinese philosophy, this is not primarily about biological gender differences and their compatibility or incompatibility. Yin and yang are contrary principles. In animation they are both at work.

In a figurative sense both *anima* and *animus* stand for the vital principle and the life force. These connotations also resonate in "animal". Both *anima* and *animus* are strangers to the physical; they are its opposite but at the same time they provide for its vitality. This paradox can be understood if we make a brief detour into so-called body–soul dualism, without which the concept of animation makes no sense at all. The concept of body–soul dualism is not confined to Christianity but is also found in Islamic and Judaic culture. With regard to the relationship between life, the animate, (*bios*) and machines (*techne*, which for the ancient Greeks was art or craft), which both originated from the divine animating principle (*logos*), one can construct the following operational hierarchy:

At the very top is the ineffable, which was given a name (JAHWEH) so that it could be vocalized. God is absolutely at rest and at the same time creates all movement. If we project the idea of God almighty onto our semantic field, then this results in the mover of all things. "Deus est semper movens immobilis—God is the eternal unmoved mover": this is the 19th answer of the 24 philosophers in a famous medieval book,[4] to the question "What is God?" Expressed in technological terms, one could say that God is the eternally moving meta-automaton.

The perpetual mover is also the motivator (from Latin *motus*, motion, movement) and the creator of everything. God created the first humans,[5] forming them from water and earth, who—because He gave them a soul—arrogantly called themselves *homo sapiens* and raised themselves above all other creatures. With this, the original metaphysical split between mind and body arose, which cannot be overcome in reality, only in the imagination where cinema and other artificial paradises are at home. The ponderous, lethargic physical material is moved by the meta-physical soul, becomes flesh, has desires and hunger, struggles, suffers, loves, and dies. The soul is inside humans. Therefore, the soul is a self-actuator, and this gives rise to a complex theological question. This question concerns free will and the way in which it could function in the concept of the omniscient one. In technological terms, one could say that humans are God's automatons.

According to Thomas Aquinas (1224–1274), all other creatures are also self-actuating, but only relatively. They are not endowed with the "natural gift of judgement" through reason (*per rationis inquisitionem*), thus they are

not free in their kinetic activities but act through instinct (von Aquino 1985: 233). To these belong, according to Aquinas who was canonized by the Roman Catholic church 50 years after his death, the automatons that are children and animals, or "beast machines", as Derek J. de Solla Price calls them in an excellent essay on *simulacra* and *automata* in the context of mechanistic philosophy (de Solla Price 1964: 9–23). From a Christian and Western perspective their degree of freedom is less than that of an adult human being. They do not operate consciously but follow an instinct or rules of an authority; they act according to a program. To be precise they do not move themselves, they are propelled. Animal and child automatons are God's second-class automatons. After the intermediate plant kingdom, the bottom step of the Aristotelian order of creation is occupied by the dry hard matter of crystals and rocks, to which products of technical craft belong. On their own they are lifeless; they cannot move. Only through human intervention in this material, through inserting an artificial soul and thus *animating* them, does the technology become a machine and then an automaton. The most perfect automaton of all is the *perpetuum mobile*. It has been thought about for centuries, but never built successfully, only as "believing machines".[6]

thematic connections

If we think of animation in the context of an expanded phylum of living apparatuses or machines mimicking life functions, then we discover a fascinating fabric of themes which for me is associated with extraordinary objects, writers, artists, and inventors (**See Plate 3**). This world full of bachelor machines and mechanical brides (Marcel Duchamp) is populated by dolls and dummies, mannequins, masters with marionettes and shadow puppeteers, masques and *travesti*. They have either fallen victim to the Pygmalion effect or have made the seductively beautiful artifices their obsessive raison d'être.

One of their greatest European heroes is the Polish poet and artist Bruno Schulz (1892–1942), who celebrates a fantastic re-animation in the filmic oeuvre of the Brothers Quay. The protagonists of his *Zimtläden* ("Cinnamon Shops"; collection of stories, including one of the same name, published in English as *The Street of Crocodiles*) are artificial beings, shop-window mannequins, seductive anthropomorphic clothes stands, and mythical creatures that he awakens to phantasmal life. While Bruno Schulz was describing his mannequins in the small Galician town of Drohobycz, then part of Austro-Hungary, now in the Ukraine, Felisberto Hernández (1902–1964) was engaging with his own in faraway Uruguay. With comparable poetic intensity and in a style that literary critics have called 'magic realism', Hernández, writer, pianist, and casual worker, was writing a novella about the 'hortensias', as he called the graceful shop window dummies.

Hortensia, Hernández's name for these artificial beauties, is in fact the second name of the protagonist's beloved wife Maria and of the author's mother in her youth. (Graziano 1997: 201)

Hans Bellmer, who came originally from Katowice in Poland, studied engineering at the Technical University Berlin in the 1920s. In 1933, he began his curious Pygmalion project. In a small ground-floor apartment at Ehrenfelsstrasse 8, Berlin-Karlshorst, using wood and black human hair he constructed a beguiling doll, "as non-acceptance of Fascism and the prospect of war: cessation of all socially beneficial activities," Bellmer announced (Aufenanger 2008). The first version of the doll of 1934 contains a media device. The doll's stomach, which otherwise "has no function at all" (Bellmer 1962: 52), is an automatic peep show. A push button on the doll's left breast activates a rotating panorama. Through the navel the voyeuristic gaze can see shameless, technically produced images. However, the entire object is an animation. In 1948, after 10 years in exile in Paris, Bellmer broke his long silence (and ended the period of being hushed up) by writing about his project in a brochure entitled *Les jeux de la poupee/Die Spiele der Puppe* ("The games of the doll"). His text focuses on the mechanisms and ball joints of the kinetic artifact **(See Figure 1.1)**, whose precursors Bellmer locates in the automatons of Byzance and even Jewish mysticism: "the construction of the device resembles that of an incense thurible, which rotates as it is swung but still remains in balance" (49). In the opening sentences, which were probably written before the outbreak of the Second World War, Bellmer gives an intriguing interpretation of his project:

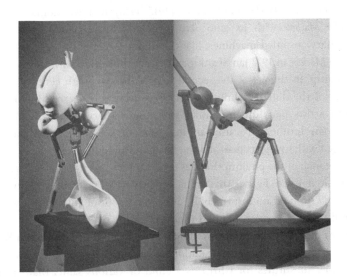

Figure 1.1

Hans Bellmer, "La mitrailleuse en état de grâce" (Woman Machine-Gunner in a State of Grace) (1937), two views. Archive Zielinski.

Games belong to the genre of experimental poetry; thus toys could be called *poetry-arousers*. The best games do not necessarily seek to result in anything; rather, their passions become inflamed at the thought of their own unknown continuation like a promise. Thus the best toys are those that are incognizant of any pre-determined way of functioning that is always the same; toys so rich in possibilities and flukes, like the humblest rag-doll, and challenging, like a divining rod, which confront the world in order to hear the feverish answers here or there to what has always been expected, that anyone is capable of repeating: the sudden pictures of the 'you'. (Bellmer 1962: 29)[7]

Bruno Schulz and Hans Bellmer are just two examples that convey an inkling of the complexity that attaches to an expanded concept of animation. To stay with the Polish tradition of the twentieth century, the theater director Tadeusz Kantor, with his *Machine of Love and Death* (1987),[8] is definitely a part of it. The essay by Heinrich von Kleist "On the Marionette Theatre" (*Über das Marionettentheater*, 1810) has become a bible of the animators of the real, as well as E. T. A. Hoffmann's story "The Sandman" (*Der Sandmann*, 1817) with its sensational artificial heroine, Olimpia. Villier de L'Isle Adam's "The Future Eve" (*L'eve future*), written in the 1880s, belongs to it, as well as Thomas Alva Edison's phonographic talking doll. The first avant-garde of the twentieth century followed up this fascination with the artificial of the industrial age. In Marcel Duchamp's *The Large Glass, aka: The Bride Stripped Bare by Her Bachelors, Even,* (1915–1923) the lower domain of *The Bachelor Machine* with its 'chocolate grinder' at the center consists of imaginary ensouled machines, like the upper *Domain of the Bride*. With his *Ipsation Machine* of 1972 Jan Svankmajer clearly linked up with the work of Duchamp. In the art of the second half of the twentieth century, "The games of the doll" (Bellmer), from the travesties of Pierre Molinier to photo artists like Jürgen Klauke and Cindy Sherman or the British Chapman brothers, became an independent sub-genre where artists engaged with living artifices and the mechanisms of life.

A branch of the phylum that has been explored even less so far, are the movable doll-like figures that archaeologists have traced back to ancient Egypt. "Primitive animism may lie at the very root of animation", writes Derek de Solla Price in his 1964 essay (11), with reference to Indonesian shadow puppetry that was moved by leather straps. In the Christian West there is a strong and rich tradition of creating figural simulacra, for example, substitutes for Christ as a child or various saints that can be touched by the devout **(See Plates 4 and 5)**. These effigies were carved from wood with great care and devotion, painted, decorated, and ensouled in many ways through being used by worshippers. One region that has an

abundance of variations and a veritable cult surrounding these doll-like objects is southern Italy and Sicily. As substitutes for the desired body of Christ they have a strong physical presence and overt sexual connotations (See Plate 6). Art history has examined these artifacts thus far as images, but neglected to treat them as three-dimensional haptic sensations.

techno-souls in the history of technology

Objects need energy to set them in motion, and organic or technical transmission that supplies the object to be moved with energy. Technological features take the place of the human soul. The earliest forms of such artificial souls were made of water or air in conjunction with basic mechanics, often combinations of hydraulics and pneumatics. Rotating components of machines were powered directly by falling water, or water vessels emptying generated air pressure, which then powered the object to be moved (See Figure 1.2). In the Byzantine, Greek and Hellenistic, Alexandrian, and Mesopotamian traditions, a great number of such technical solutions were developed that over the course of the centuries—up to the first renaissance from the ninth to the thirteenth century in the Arabian-Islamic countries—became enormously sophisticated and elaborated.

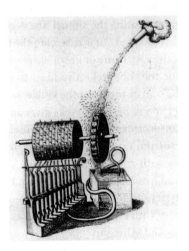

31

Figure 1.2
"'Lord Auch (aux chiottes)'—Georges Bataille chose this pseudonym in 1928, when he published his other story of the eye. In this illustration, God appears to be ejaculating directly onto the water wheel attached to the organ, powering it, and giving it soul. Robert Fludd had the copper engraving made in the early seventeenth century, obviously based on a drawing in Giovanni Battista Della Porta's three books on pneumatics (*Pneumaticorum libri tres*) from 1601, p. 61. Archive Zielinski.

At the latest, since the fifteenth century, explosives and fire were used to animate inanimate matter in Europe. Pyrotechny, on the other hand, is a close neighbor of the form of energy that has become the soul of all modern machines and automatons; namely, electricity and electronics. Initially still closely allied with the concept of magnetism, electricity was celebrated as being capable of moving anything, and in this sense was even an object of religious worship. The distinct movement of *theologi electrici* developed during the European Enlightenment in the tradition of physico-theology in Germany, Switzerland, and also England, whose adherents perceived electricity to be the material presence of God in the world.

John Freke (1688–1756) for example, was a theologically well-versed English surgeon who worked at St Bartholomew's Hospital in Smithfield, City of London. His special area was diseases of the eye, and he invented a number of medical instruments. He also caused a stir with an early natural philosophical essay on electricity in which he argued theologically: in 1746 Freke sent his "A Treatise on Electricity" to the Royal Society in London. To Freke, electricity is the most noble thing that exists in the sublunary world of the earthlings, "the First Principle in Nature", which obviously is responsible for all movement (Freke 1746: 59). Freke places particular emphasis on stating that the "electrical fire" does not originate in the "apparatuses" or in any of their physical components. Instead, electricity resides in the air, which he refers to as "paebulum vitae" (3–4), nourishment or food of life. Thus for Freke, electricity is inextricably bound up with all things living, permeating the animal, the vegetable, and the mineral alike. It makes the blood red ("it is rubefying the blood") and is therefore "flamma vitalis", the very flame or fire of life (4). Analogous to Robert Fludd's designation for the sun, Freke also liked to refer to electricity as "anima mundi", as the soul or mover of the visible world.

In the technical section of his essay, Freke gives an exact description of what happens when an electrified body meets a non-electrified body; when electricity jumps over from one body to another and the electrical fire discharges acoustically with a "crack" and optically with a "spark" (Freke 1746: 23): electrical audiovision in its earliest form. However, one of the most striking and mysterious formulations of a theology of electricity is found in Freke's Preface. With electricity one becomes acquainted with the immediate "*Officer* of God Almighty" (V). The term 'officer' not only implies the execution of a function, but also contains the notion of an indicator: electricity becomes the visual display of the actions of God Almighty, the medium of his ensoulments.

My short genealogy of six thematic cases of animation that follows is not structured along the lines of various solutions for techno-souls—which could be an interesting alternative—but with regard to the hierarchy described in the context of the body–soul/mind–matter dualism. It presents particular strands of a techno-cultural fabric, which I am proposing with a

view to achieving a broader understanding of our sensational phenomenon for investigating it.

1. archaic: animating hard, dry, physical matter through technological interventions

"If the servants of God only knew how God delights in when his Earth is made to come alive, there would be no barren spot on the face of the Earth".[9] As long as anyone can remember, Mesopotamia has suffered from the extreme aridity of its soil, and periods of drought accompany its history. All of the automatons, which the Kurd Ibn al-Razzāz al-Jazarî (1136– ca.1206) from the El-Jezireh region designed and actually built, he also created to the glory of Mohammed, and the honor of the prophet's powerful representatives on Earth, who gave the engineer his commissions. Many of the machines, however, had functions that went beyond this, which were in direct competition with divine omnipotence. Ostensibly, the purpose of many of his hydraulic and pneumatic automatons was to make the guests at feasts drunk as quickly as possible. However, the filigree devices intervened in the existing natural conditions and changed them considerably to the advantage of their inhabitants by turning arid terrain into blooming landscapes. For this, water had to be brought up to the surface from the deepest depths. These are cases of animation in the most direct sense of the word: ensoulment as life-giving. The origins of the devices can be traced back to the ancient Egyptian, Byzantine, and Hellenistic civilizations.

Geographical and political hotspot of knowledge and learning in the *l'âge d'or* of the Arabic-Islamic sciences was the *Bait al-hikma*, the 'House of Wisdom', in ninth-century Baghdad. Its founder Caliph Al-Ma'mun (786–833) commissioned the translation of numerous Classical Greek texts on natural philosophy into Arabic, and encouraged young men hungry for knowledge to think independently and to approach the world through experiment.

Among those who profited from this were three brothers: Muhammad, Ahmad, and al-Hasan, the sons of Musa bin Shakir, whose mini-cooperative encompassed an entire universe of scientific qualifications: mathematics and geometry, astronomy, natural philosophy and medicine, music, and the art of engineering. The brothers have gone down in the history of science and technology as the Banū Mūsā brothers. They had the texts of the great constructor of automatons, Heron of Alexandria, translated from Greek into Arabic. Ahmad is considered to be the greatest engineer of the three princes. He is thought to be the main author of their brilliant work *Kitab al-Hiyal* (*Book of Ingenious Devices*) written in the mid-ninth century. The book is a compendium filled with sketches and exact instructions for building around 100 models (*shakl*); a variety of artifacts, devices, and

their components; kinetic sculptures and automatons, the latter in the direct sense of devices that move of their own accord: filling devices and drinking devices operated hydraulically and mechanically, animals driven pneumatically that make noises, oil lamps that not only fill up automatically, but also have self-adjusting draught shields so that the flame remains protected and burns eternally.

It was evidently very important to the Banū Mūsā brothers that things should be in perpetual motion, without any interruption. One of their masterpieces has this characteristic; although it is not included in the surviving copies of the *Book of Ingenious Devices*, expert historians of the Arabic-Islamic sciences attribute the device to Prince Ahmad. The device is simply described as a continuously playing flautist. "The instrument, which plays by itself" (*Al-alat illati tuzammir binafsiha*) is the name the Banū Mūsā gave their device, thus underlining its character as an automaton (Farmer 1931: 88) **(See Figure 1.3)**. The title evidences that they ascribed universal meaning to the technology they sketched out; apparently, they wanted their invention to be understood independently of any specific form of its realization, such as the flute player. Birds and flute players, powered by water and moved pneumatically, are known from ancient Chinese literature as well as from classical Greek authors such as Archimedes, Apollonius the geometer and carpenter, and the Alexandrian Heron. With regard to the mechanisms, the technologically most advanced solutions are attributed to Apollonius. He had already developed a hydraulic-pneumatic mechanism of such complexity that his anthropomorphic figure could play the flute endlessly—as long as provided with a constant flow of water. Due to a type of circular construction, whereby a second water container filled up while the first was emptying and air was pressed out for the flautist, the automaton had a constant energy supply in the most direct sense.

The three princes from the House of Wisdom in Baghdad not only improved and developed the hydraulic and pneumatic mechanisms; they described and constructed a complete music automaton, which could vary the rhythm of the music—it was even possible to feed it with different melodies **(See Plate 7)**. In his English translation of parts of the manuscript, Farmer quotes the intention of the Banū Mūsā brothers: "We wish to explain how an instrument [...] is made which plays by itself continuously in whatever melody [...] we wish, sometimes in a slow rhythm [...] and sometimes in a quick rhythm, and also that we may change from melody to melody when we so desire" (Farmer 1931: 88).

The heart of the automaton is a hydraulically driven cylinder. On the surface of the cylinder are bands made of wood or metal, which carry small protruding pins of different lengths. Depending on how these pins are positioned on the bands and how the bands are arranged in relation to one another, mechanical power transmission opens or closes the valve of the

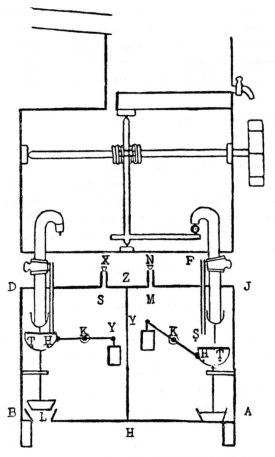

Fig. 8.—THE BANŪ MŪSA AUTOMATIC HYDRAULIC
ORGAN. (Reconstructed.)

Showing the three cisterns, (a) The water-cistern, (b) The water-
wheel and valves cistern, (c) The air-compressing cisterns, open
and shut.

Figure 1.3

The hydraulically and pneumatically driven component of the continuously
playing music automaton. A diagram showing how the mechanism of the
pinned cylinders opens and closes the valve (in this case) of the flute.
Drawing by George Farmer, 1931 in *The Organ of the Ancients from Eastern Sources*
(Hebrew, Syriac, Arabic). London: William Reeves, 1939. Archive Zielinski.

35

flute, the pipes of an organ, or moves another sound-producing element.
Prographein means to prescribe. The way the pins are arranged on the cylinder
formulate the musical prescriptions or instructions, the *program* of the
instrument; the pins and bands are notation translated into hard material.
The hardware is virtually identical to the revolving cylinders with pins that
were used 500 years later in the European *glockenspiel* of the late Middle

Ages, and again even later in the mechanical organs of the second (European) Renaissance, as well as for writing automatons and automatic music instruments in the Age of Enlightenment. I shall return to these anthropomorphic automatons. The universal playing automaton of the Banū Mūsā brothers did not necessarily require a humanoid form.

2. death on view. animating life in such a way that it appears to be over

An image that especially stands out in medieval horror scenarios, particularly in the Christian tradition, and that has undergone continual updating far into the era of modern technical media, is the skeleton as a trivial allegorical representation of death. Human skeletons—whether still or moving—are one of the most popular genres in the genealogy of projection. In projection's early years of powerful displays, when one could unleash shocking effects on the audience with a laterna magica, in the seventeenth century Athanasius Kircher used pictures of purgatorial fire and the grim reaper. In Robert Houdin's magic theater, the headless skeleton belonged to the standard repertoire. Georges Méliès staged the grim reaper in many scurrile varieties.

La capriola dello scheletro (the caprioles of 'the skeleton') is the name that Giovanni Fontana from Padua gave to a wooden box-type object that is intended to depict a sarcophagus. Concealed within the box is a wheel that Fontana compares to a clockwork mechanism (**See Figure 1.4**). In the lid of the sarcophagus are recesses from which a wooden skeleton with movable extremities makes repeated appearances. When the wheel inside the dark box is turned—following the logic of the pyrotechnical romantic Fontana's world of devices probably heralded by an explosion—it automatically moved 'the articulated limbs of the dead'. Thus, with considerable din, the dead celebrated their rebirth, a re-animation. As the entire thing was intended as an affect-machine to scare the enemy, the still-living perpetrators of future military action were given a sarcastic reminder of what potentially awaited them. Fontana imagined the wheel of his device as a clockwork. "Time to watch"—with this phrase Roland Barthes referred to the productions of early chronophotography. Fontana's rotating skeleton tells a minimal story of death and resurrection.

In Part XXII of *Oeuvres Complètes* by the Dutch physicist Christiaan Huygens (1629–1695), held in the library of the Rijksuniversiteit Leiden, there is an unremarkable sheet of paper from 1659 with nine drawings of a human skeleton in various poses (**See Figure 1.5**). Which of these drawings was actually transferred to glass by Huygens to be projected with a magic lantern (*tovernlantaarn*) is not entirely certain, only that he certainly did so. In different parts of his collected works Huygens comments on the "*projectie-lantaarn*" and in a later drawing shortly before his death, he also

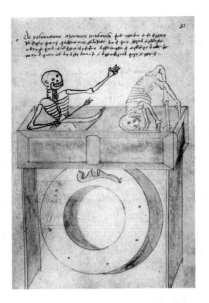

Figure 1.4

'De resurrectione mortuorum artifitiosa' (of the artificial resurrection of
the dead), p. 51 of the Munich autograph by Fontana *ca.* 1420. Except for
the Latin title of the machine, the text above the picture is written in a
secret code, which, however, was easy to decipher. Archive Zielinski.

Figure 1.5

Drawings of magic lantern hardware and software by Christiaan Huygens
from 1694 (top) and 1659 (bottom). Archive Zielinski.

made a technical sketch of it. The sketch dates from 1694; the glass slide (*lantaarnplatje*) is referred to on it as *"pictura a pellucida"*.

3. God's automaton constructs lower species after his own model: beast machines/animalogic automatons

Chirping birds, dragons that spit fire, or crabs that can crawl across the floor already existed in ancient times in various cultures, from Egypt to Byzantium, from Greece to the Arabic-Islamic countries of southwest Asia. At the latest once *homo sapiens*, after the second Renaissance in Europe, had been identified in European Modernity as a divine automaton, members of the species attempted to create four-dimensional monuments of their kind. Using precision engineering and mechanics they produced kinetic objects, which seemed like models of creatures created by their Maker. These were clocks that could be seen *and* heard, for the master machine of the modern age was clockwork that kept regular and precise time.

The most vulgar forms of these automatons could demonstrate how digestion and defecation works, as in the famous duck by Jacques Vaucanson built in 1735. Thus, the Age of Enlightenment announced its arrival with stench and feces. Or at least in the imagination, because in reality, the duck did not digest anything. Vaucanson staged the biological processes as a fake. We have been treated to descriptions and pictures of Vaucanson's digesting and shitting duck *ad nauseam* in books on the history of living automatons. Usually, though, in the form of drawings, which have only very little to do with the built construct: the artifact itself is not included. We know it only in a parlous state in the fantastic book *Les automates* by Alfred Chapuis and Edmond Droz of 1949. The duck that we encounter there as a skeleton is a monster (**See Figure 1.6a**), not unlike the early kinetic metal birds built by Swiss artist Jean Tinguely. After the Second World War, it only survived as technical trash, before it was entirely scrapped. Earlier depictions uncover the secret of its animation. In the profile of the functioning device, we at first think we recognize a construction similar to Fontana's skeleton theater (**See Figure 1.6b**). The minimal effect of eating the balls, their transport, and the beating of the metal duck's wings are brought about by an enormous driving mechanism. The heart of the organized—one could also say: intelligent—movement, however, is a "tambour à cames dirigeant tout le mécanisme", a drum with cogs, a cam cylinder we are familiar with from the Banū Mūsā brothers' artifacts in ninth-century Baghdad (**See Figure 1.6c**).

After letting the techno-beasts engage in basic human activities, God's automatons, or rather the engineers of the species, turned their attention to imitating activities, which until then had been considered the exclusive privilege of *homo sapiens*: writing, speaking, making music, and, ultimately, thinking—in the form of chess-playing automatons. In order that the

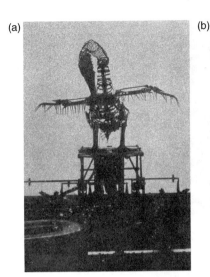

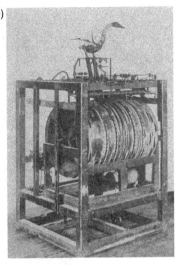

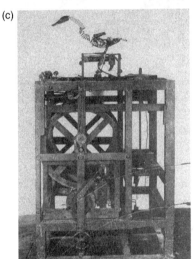

Figure 1.6
(a–c) From Alfred Chapius and Edmond Droz (1949) *Les Automates.*
Neuchatel: Editions du Griffon, pp. 233–238. Photographs: Archive Zielinski.

technical wind-up artifacts could not be confused with the creatures of the
eternal meta machine, who are smart and equipped with a soul, they were
often given the appearance of monstrous animals, bears that drum, roar-
ing lions and tigers. The violin-playing monkey belongs to this category of
beast machines (**See Figure 1.7a**). Several models exist. The
hermetic-alchemistic notion of a monkey as the embodiment of cleverness
and artistry is combined with the technical abilities of God's automatons
and the commandment that they should not create any images of

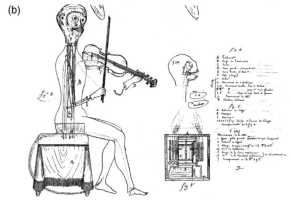

Figure 1.7

(a) A music-making monkey automaton. Archive Zielinski.
(b) Théroude's patent application of July 22, 1862, for a music-making monkey, in which the works are concealed in the seat. Archive Zielinski.

their Creator. The creature with the horrible countenance of the new is a relatively recent automaton. In 1862, his patent was submitted by Alexandre Nicolas Théroude, whose workshop was in the rue Montmorency in Paris, and who was one of the best automaton builders in Europe. The mechanism of the artificial animal violinist is entirely concealed in the seat and the monkey's body **(See Figure 1.7b)**. This animation, too, was about the organization of affects. The marvelling audience was on no account to see or hear the origins of the automatic effects; the same as with the beast machines that inhabit classic Hollywood cinema—black box drama.

4. images/likenesses: anthropomorphic machines

The automaton that executes one of the most noble activities of *homo sapiens*, namely, writing, appears as though it was created by God himself in the drawing by its creator. And that is just how Friedrich von Knaus designed

the blueprint for the first series of this device. The artifact originates from the ineffable shown at the top of the drawing, the all-seeing eye of God symbol with an eye surrounded by rays of light enclosed by an equilateral triangle. The black box is open and one can investigate the mechanical heart (**See Plate 8**), which makes up the larger part of all models of von Knaus' writing automaton.

The 39cm-tall figure of a speaking monk from around 1560 is thought to be one of the earliest automatons that can move fairly precisely, both as an entire human figure as well as its separate limbs (**See Plates 9 and 10**). It is driven by a key-wound spring, which had been used since the fourteenth century in timepiece technology. "The monk rolls around a 60-cm-square; when the spring is fully wound, he walks the square three times. While walking his arms and feet move, he turns and nods his head, rolls his eyes, and mouths silent obsequies…" (Friess 1988: 40ff).[10] The mechanical soul is organized like a control program (**See Figure 1.8**). For this reason, the speaking monk automaton is exhibited in Munich's Deutsches Museum in the section for mathematical instruments, computers, and microcomputers.

However, the mechanical anthropomorphic all-rounders did not achieve utmost perfection until about 300 years later, in the Age of Enlightenment. This is the same period in which theoreticians of power, such as Michel Foucault, see the disciplining of the human body as developing most forcefully. The highly organized body that runs through La Mettrie's *Machine* Man (*L'homme machine*, 1747) or the novels of the Marquis de Sade and the construction of near-perfectly functioning androids, of human-like automaton genies, are closely connected. So, too, the increasingly exact measurement of time represents techno-aesthetically

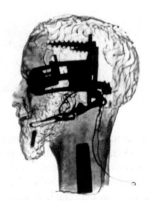

Figure 1.8
X-ray profile of the speaking monk's head showing the large screws in the brain and the levers for the mouth and eye movements (Deutsches Museum, München. Inventory Nr. 1984–18; Bild-Nr. BN28597).

an important dimension of the temporalization of static objects and images, which are referred to as animation.

The Jaquet-Droz family came from the country that was home to the high mechanical arts of clock-making and tatting, Switzerland; where master mechanics also developed the Bolex, the best of the narrow film cameras. To this day, their writing, drawing, and music-making androids are considered as the prototypes of creative robots, which are elegant and also meet aesthetic requirements. I shall briefly focus on the female musician of a mechanical trio. The body of the spinet player is very gracefully designed, and one almost fancies seeing the technology breathe when it executes the program, which works through a pinned cylinder concealed under her body (**See Plates 11–13**). Similar to how in the twentieth century intelligent machines were supposed to serve as a models of how we should think in a faster and more effective way, the female musician constructed by the engineers Jaquet-Droz from Neuchâtel demonstrates how *homo sapiens* and *homo ludens* are supposed to function at the interface with a device in the future: highly concentrated, with a straight back like Daniel Gottlob Schreber's son, mastering one's own motor skills perfectly, continuously, without any sign of fatigue.

While Wanda Landowska was perfecting her technique on the harpsichord (**See Figure 1.9**), in the laboratories of Moscow, St Petersburg, and

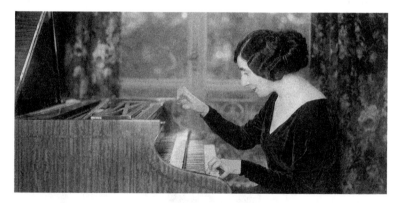

Figure 1.9

The Jewish-Polish (later naturalized French) pianist Wanda Landowska (1877–1959) fled to the USA in 1942 from the advancing Nazis. Her house in Saint-Leu, France, was completely looted of everything—the old instrument museum, the manuscripts, the book collection. Her virtuoso playing of the harpsichord—on a special instrument made for her by Pleyel—which she plays with the precision of a machine, survives in her historic *Complete European Recordings*. The record label (united archives/ harmonia mundi) named the album *The Well-Tempered Musician: Wanda Landowska*, identifying "this genius of the keyboard" with the perfection of Bach. Photograph of Wanda Landowska in 1920. Archive Zielinski.

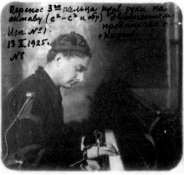

Figure 1.10

Copy of a photographic plate related to the research project developed by
N. A. Bernstein and T. S. Popova at the GIMN (the Russian abbreviation
of the State Institute of Musical Science) in Moscow in 1925. The GIMN
collaborated with Aleksej Kapitanovich Gastev's CIT institute for
investigating the time processes involved in labor. Copy from the original
photo plate from Andrey Smirnov's collection at the Theremin Center
Archive, Moscow. Courtesy Andrey Smirnov.

Kazan scientists were observing and analyzing precisely the events that
took place at the human being–technical instrument interface.[11] The goal
was to improve motion sequences involving biological and technical
bodies. Friction in the relations between human and machine were to be
kept to a minimum, and accidents, interference, and blurring eliminated.
For filming and photographs, the extremities of the test persons were fitted
with phosphorescent dots, or wired so that the movements could be
recorded electromagnetically and transformed into graphic images, in the
tradition of Etienne-Jules Marey, Christian Wilhelm Braune and Otto
Fischer (**See Figure 1.10**). Filmic movements of drawn figures can be inter-
preted as re-animations of such graphic structures generated at the end of
the nineteenth century by the physiologists and chronophotographers,
parallel to the industrialization of the idea of moving images called cinema.

5. (re-)animations of dead bodies

43

The eighteenth century is also known as the Age of Enlightenment because
in this period engineers and physicists succeeded in taming the electrical
forces of nature and in producing artificially non-tangible and invisible
electrical energy. In research on natural electricity, animation practices
already played an important role (**See Figure 1.11**). In a direct sense,
the Italian physician and physicist Luigi Galvani (1737–1798) made
muscles from frogs, sheep, and other animals he had dissected, that is, dead
meat, move in exciting ways through the influence of electric current.

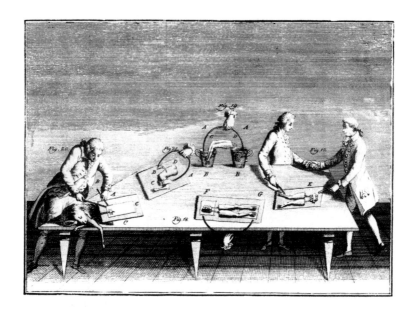

Figure 1.11
One of Galvani's experiments from 1792. Photograph: Archive Zielinski.

He either used the high voltages discharged by nature during thunder storms, or he experimented with various metals, which, brought into contact with electrolytes (the salty liquid in animal muscle), produced an electro-chemical reaction. In this way, the animal's muscles achieved the status of an oscillator in which one could observe the electrical charge.

Giovanni Aldini (1762–1834), Galvani's efficient nephew who was also an able showman, went much further down the path of a brutal resurrection culture. He toured through parts of Europe, particularly in England, putting on spectacular events to demonstrate the vitalizing forces of electricity to audiences of political, economic, and scientific leaders of the time. His performance on January 17, 1803, in front of the President of the Royal College of Surgeons in London was especially impressive for our thematic context. He hooked up parts of the corpse of an executed murderer to a large Galvanic battery, and animated it in the most direct way (See Figure 1.12): "On the first application of the process to the face, the jaw of the deceased criminal began to quiver, the adjoining muscles were horribly contorted, and one eye was actually opened. In the subsequent part of the process, the right hand was raised and clenched, and the legs and thighs were set in motion." (Morus 2002: 97)[12] The killing of living bodies by electrocution is the other end of this extreme. Thomas Alva Edison (1847–1931) not only produced technical installations, he also gave public demonstrations to show that using the AC current of his competitor Nikolas Tesla would have fatal results. From a Christian

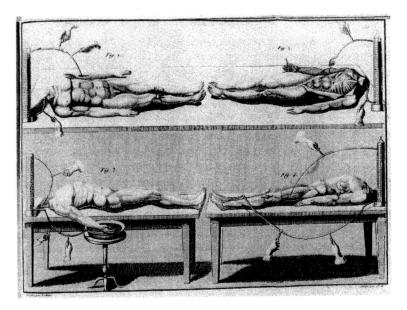

Figure 1.12
Aldini's electro-physiological treatment of an executed murderer.
Source: Aldini, J. *General views on the Application of Galvanism to Medical Purposes; principally in cases of suspended Animation.* London, 1819. Archive Zielinski.

perspective, the biological death of a person also means that the soul leaves the formerly divine receptacle of the body in order to ascend into Heaven.

At the zenith of industrialization, Guillaume Duchenne de Boulogne (1806–1875), immortalized in the names of the muscular diseases that bear his name, undertook experiments to discover how specific movements of muscles produce facial expressions in people and then to systematically categorize them in a kind of encyclopedia of emotions and related facial expressions. He attached electrodes to certain points of the facial muscles, which triggered muscular contractions and produced expressions of happiness, pain, suffering, depression, and panic (**See Figure 1.13**). Towards the end of the twentieth century, computer animation began to work along similar lines, with the major difference that animated faces are image structures based on mathematical calculations and do not belong to real bodies.

6. the animation of hysterical and tormented bodies. bodies as media, as extensions of the machine. computing the physical

From that point onward—one could even say—everything was cinema. It was then possible to concentrate on the variants of filmic animation that the preceding 120 years had produced. Parallel to the establishment of the cinema as a new cultural technique for the subjects of the waning Industrial

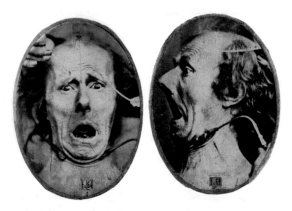

Figure 1.13

Two examples of electrical manipulation of the face. Duchenne de Bologne, *The Mechanism of Human Facial Expression* (Paris 1862). Photographs: Archive Zielinski.

Age, and later also parallel to the electronic variants of motion picture technology, there are many other thematic fields which should be investigated from the perspective of an expanded concept of animation that I can only briefly touch upon here.

The figures of the "major, total, and regular hysterical attack" (Didi-Huberman 1997: 37) as presented by Paul Richer in synoptic tableaus in the 1880s, which became famous through Georges Didi-Huberman,[13] can also be read as notations anticipating a practice that was gradually established in the late 1920s. With the aid of electric current, interventions were made in the electromagnetic states of the brain to achieve desired psycho-physical effects. The use of the bodies of animals as media took on bizarre forms in the experimental practice of early German radio. In 1924, the official radio magazine *Der Deutsche Rundfunk* reported on a series of experiments, in which earthworms that were especially good conductors were used as biological exciters in acoustic environments (**See Figure 1.14a**). And continuing in the tradition of Galvani's experiments, in 1924 a German engineer seriously proposed a telegraphic device in which electrified frog legs would be used as living membranes in signal transmission (**See Figure 1.14b**). Electrotherapy for cramp, which was developed in the 1930s, is a form of manipulative and animating intervention in the movements or static of the brain, which to this day is controversially used. Here, the human body and soul are degraded by being hooked up to an object. Antonin Artaud's completely shattered condition after years of treatment in a psychiatric unit is just one of the many eloquent testimonies to the effects of this instrumentalization.

From the rigorous disciplining of the body during the Second World War, to the establishment of the grammatical man—the highly organized

(a)

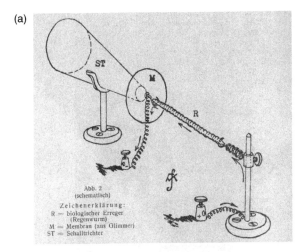

(b)

Figure 1.14

(a) *Source*: Der Deutsche Rundfunk, 1924. R, biological exciter; M, membrane; ST, acoustic funnel. (b) *Source*: Der Deutsche Rundfunk, 1924.

individual by means of language and knowledge—I shall end with an experiment of the early 1990s. In the meantime, the disciplined individuals are connected with each other and sedated via electronic networks, where through consumption of images from digital body banks and by means of electro-sensors they are stimulated to physical movement (**See Plate 14**). Now, in a direct sense, media connections achieve the status of a massage, as Marshall McLuhan announced in the 1960s albeit metaphorically.

When this point was reached, the genealogy of expanded animation described one of the ellipses, which are characteristic of these developments. From here the concepts become effective in which physical hardware is moved by algorithmic control. Computing the physical—with

Roboter: Eiserne Lady mit ebensolchem Partner

Figure 1.15

Welcome to the centenary of Orwell's *Nineteen Eighty-Four*. Archive
Zielinski.

circularity and full consistency—the former British Prime Minister
celebrated such cybernetic triumphs already in 1984 (**See Figure 1.15**).
With its handshake the iron hand of the robot Charlie manages to put a
smile on the face of Margaret Thatcher, the power and war automaton of
the British government.

But we should conclude with beauty and dignity. The time that is
objectified in automatons that move and produce sounds has a cyclic
character. As long as the mechanical heart is supplied with energy, the
mechanical body executes the movements for which it is programmed at
regular intervals. The most important criterion for assessing the complex-
ity of an artificial being is the number of different movements that it can
execute. When it functions well it is this complexity that constitutes the
elegance of the animated artificial beings in which we can see and hear time
passing—our time, the time of Kronos. For the time of an automaton
tends toward the Aionic and can far exceed the human life-span.

The Spanish dancer with tambourine (**See Figure 1.16**) is a simple
musical automaton manufactured in the second half of the nineteenth
century. She makes four movements:

With a pendulum movement, the upper body swings from left to right
and from right to left. Technically this is a simple sinusoidal movement
produced by an eccentric plate. The graceful movement is enhanced by the
dancer's head inclining to the left and the right in the opposite direction to
the movements of her body. When the upper part of the body swings to
the right, the dancer slightly raises her left, bent arm with its outstretched
slender fingers. The right lower arm makes a rapid turning movement

Figure 1.16
Spanish dancer with tambourine. Archive Zielinski.

which causes the tambourine to jingle. A hectic zig-zag movement is combined with a much slower swinging movement. Put in technical terms, the continuous sinusoidal movements of the torso are connected to the simple movements of the left arm and the head, which can be described as long frequencies. In contrast to this are the rapid back and forth movements of the right lower arm, where in the first phase of the movement a recoil spring is compressed and then released at the climax of the movement thus accelerating the speed of the shaking of the tambourine.[14]

The interplay of the two speeds is the secret of the mechanical being's gracefulness. Thus for the most part, it is the production and perception of time. The richness of vivid experiences consists mainly in the interplay of different time modes. The tension, even to breaking point, between the delimited Kronological and the unbounded Aionic is only endurable when these two major figures of time are counteracted, and thus rhythmized, by the moment, Kairological time. The most minimal presentation I have found for this is a colored, framed painting on glass for a *Laterna Magica* projection (**See Plate 15**). It originates from the time when simple projection techniques were expanded by so-called insets, during the mid-nineteenth century. Through a single dissolve the graceful tambourine dancer is transformed into a skeleton, and so brings us back to the beginning of our genealogical excursion. Youthful beauty is accompanied by the shadow of death. As Martin Heidegger liked to say, thrown into life we fall towards death.

Consciousness and free will are opposites in a complementary relationship. They both have need of each other. It is the same with regard to programmes and their relationship with imagination and intuition. The actions of an individual are integrated in the culture of commands and instructions. Imagination and intuition always attempt to cross over and break open the constraining framework of what is determined. Animated objects have souls whenever and wherever this transgression is successful.

49

acknowledgment

Translation from German: Gloria Custance.

Many thanks to Daniel Irrgang for his invaluable and substantial support, especially with the illustrations.

notes

1. "Pride goes before destruction, a haughty spirit before a fall." Proverbs 16:18. Bible, New International Version.
2. In detail cf. S. Zielinski, Designing & Revealing: Some Aspects of a Genealogy of Projection, in: M. Blassnigg (ed.), *Light, Image, Imagination: The Spectrum Beyond Reality and Illusion* (Amsterdam University Press, 2013).
3. See the essay by Elmar Holenstein, Von der Zukunft unserer Herkunft, in: *Perspektiven interkulturellen Philosophierens: Eine Bestandsaufnahme* (working title). Festschrift für Franz Martin Wimmer (Vienna) zum 70. Geburtstag (2013 forthcoming).
4. Anon.: *Liber XXIV philosophorum* (Book of the 24 philosophers, 12th century); translated into English from the German edition by Kurt Flasch (trans.) (Munich: Beck, 2011), p. 64; see *Bryn Mawr Classical Review* 2010.10.11. for an informative review of a recent French study, text, and translation of the *Liber* by Françoise Hudry.
5. "So God created man in his own image, in the image of God he created him; male and female he created them." (Gen. 1) *English Standard Version of the Bible,* 2001.
6. "Die Glaubensmaschine" is the name of a beautiful electromagnetic apparatus secretly driven by a computer. Artist and musician Sven Hahne invented and built it in 2004.
7. Bellmer in the Foreword to *Les Jeux de la poupée/Die Spiele der Puppe* [Paris 1949], in Bellmer, *Die Puppe,* 1962. In the French version of the text, which Bellmer wrote with Nora Mitrani, the delightful expression "Poesie-Erreger" (poetry-arouser) is not included. The excellent special issue of *Obliques—numéro spécial Hans Bellmer* (Paris, 1987)—unfortunately contains many errors in the German texts; cf. Sigrid Schade, Hans Bellmer: Die Posen der Puppe, *kairos,* no. 1/2, 1989, p. 19f.
8. This is also the title of a catalog published by the Marionette Museum in Palermo, Sicily, in honor of the Polish master.
9. Conrad Matschoss cites this quotation by an unknown Arab scholar in his book *Geschichte des Zahnrads,* 1976.
10. See Peter Friess, Restaurierung einer Automatenfigur. In: *Uhren, alte und moderne Zeitmessung.*
11. This issue is discussed in detail in the chapter on Gastev in my book *Deep Time of the Media* (Cambridge MA and London: The MIT Press, 2006).
12. From *Tilloch's Philosophical Magazine,* no. 14, 1802, on Galvanism, quoted by Iwan Rhys Morus in his fantastic essay A Grand Universal Panacea, in *Bodies/Machines,* 2002. Morus also analyzes the execution methods using alternating current that were implemented at the end of the nineteenth century. These represented, of course, a reversal of the principle of resurrection.
13. See Didi-Huberman's studies on hysteria as a syndrome that is also constituted by media technology: *Erfindung der Hysterie,* 1997 (*Invention de L'Hysterie. Charcot et L'Iconographique de la Salpetriere. Paris: Macula, 1982*); on

Richer see particularly his Tableau synoptique de la "grande attaque hystérique complète et régulière"avec positions typiques et "variantes" of 1881, reprinted in Didi-Huberman, 1982, 114–115.

14. See Christian Bailly, *Automaten: Das Goldene Zeitalter 1848–1914* (Munich, Hirmer 1988)

references

Aufenanger, Jörg. 2008. Hans Bellmer und Unica Zurn. *Musenblätter*, http://www.musenblaetter.de/artikel.php?aid=1864

von Aquino, Thomas. 1985. *Summe der Theologie 1: Gott und Schöpfung*. Neudruck der 3. Auflage. Autorisierte Ausgabe. Übersetzt und herausgegeben von Joseph Bernhart. Kröners Taschenausgabe 105. Stuttgart: Kröners.

Battisti, Eugenio e Giuseppa Battisti. 1984. *Le macchine cifrate di Giovanni Fontana*. Milano: Arcadia Edizione.

Bellmer, Hans. 1962. Introduction to *Le Jeux de la poupée/Die Spiele der Puppe* [Paris 1949], *Die Puppe*. Berlin: Gerhardt Verlag.

De Solla Price, Derek. 1964. Automata and the Origins of Mechanism and Mechanistic Philosophy. *Technology and Culture*, Vol. V, No. 1: Winter.

Didi-Hubermann, Georges. 1997. *Erfindung der Hysterie. Die photographische Klinik von Jean-Martin Charcot*. Trans. Silvia Henke [from original, *Invention de L'Hysterie. Charcot et L'Iconographique de la Salpetriere*. Paris: Macula, 1982] München: Wilhelm Fink.

Farmer, Henry George. 1931. *The Organ of the Ancients from Eastern Sources (Hebrew, Syriac, Arabic)*. London: William Reeves.

Foucault, Michel. 1977. Nietzsche, Genealogy, History. In *Language, Counter-Memory, Practice: Selected Essays and Interviews*, ed. D. F. Bouchard. Ithaca: Cornell University Press: 139–164.

Freke, John. 1746. *An Essay to Shew the Cause of Electricity and why some Things Are Non-Electricable*. London: W. Inns.

Friess, Peter. 1988. Restaurierung einer Automatenfigur. In *Uhren, alte und moderne Zeitmessung*. München: Callwey.

Graziano, Frank. 1997. *The Lust of Seeing: Themes of the Gaze and Sexual Rituals in the Fiction of F. Hernandez*. Cranbury, NJ: Associated University Presses.

Matschoss, Conrad and Karl Kutzbach. [1940] 1976. *Geschichte des Zahnrades. Nebst Bemerkungen zur Entwicklung der Verzahnung von Karl Kurtzbach*. Berlin: VDI-Verlag. (Reprinted by H. A. Gerstenberg, Hildesheim.)

Morus, Iwan Rhys, ed. 2002. *Bodies/Machines*. Oxford: Berg.

_____ 2002. A Grand Universal Panacea. In *Bodies/Machines*, ed. Iwan Rhys Morus. Oxford: Berg: 93–123.

the transforming image

the roots of animation in

metamorphosis and motion

t w o

t o m g u n n i n g

Dedicated to Master Linus Bukatman, welcome!

beyond the picture: the transforming image

In recent years, a Copernican revolution has taken place in attitudes towards
animation. I believe a polemical statement by Lev Manovich in his *The
Language of New Media* exemplifies (and possibly even triggered) this reorienta-
tion. Manovich claimed that animation, far from being a marginal topic in
media theory, of interest mainly to children and few devotees, should be
recognized as the super-genre of moving image media, of which cinema,
understood as the photographically-based form of moving images, could be
seen as merely a subgenre (2002: 298–300). This bold statement has the fresh-
ness that seminal insights should always possess, calling received opinions
into question, disturbing previously unquestioned hierarchies, and simulta-
neously initially counter-intuitive, and yet ultimately—almost obvious.

Historians and theorists of film had relegated animation to a minor role
in their programs, limited in scope and possibilities, amusing primarily for

its technical innovation. Confined to childhood fantasy or adolescent cleverness, animation remained exiled from the serious claims of film either as art or as philosophy. The manner in which cinematography had fulfilled photography's claim to capture reality by adding the aspect of motion seemed out of reach for a genre limited to the fantasy of bringing drawings to life. Film theory primarily ignored the unique nature of animation, while film history posited animation as a minor industry with a major one, a divertissement from the main event. Major theorists, such as Siegfried Kracauer and André Bazin and perhaps most explicitly Stanley Cavell, derived the nature of cinema from the ontology of the photographic image, and animation appeared irrelevant.[1]

However, historical change drives transformations in film theory (as Bazin would have been the first to admit). Manovich's redefinition of the moving image derived from changes in the way films are now made and exhibited, as new digital technology re-tooled the way images were created and made them available in multiple forms (or 'platforms'). Historical change also inspired a millennialist speculation whose apocalyptic proclamations of the end of previous media prematurely ruptured our sense of continuity, even as they productively cleared the air. While as a historian, I would certainly distance myself from fiery proclamations of the end of cinema (ranging from Siegfried Zielinski's relegation of cinema and television to "entr'actes in history"—to quote the title of one of his works, to Dudley Andrew's recent proclamation in his book *What Cinema Is*, that cinema is what cinema was during its classical period, of feature length narrative filmmaking and that both new media and early cinema remain exiled from this essential phenomenon). Nonetheless, the technological and economic transformations brought on by the digital remind us of the eternally protean nature of the moving image. Film history has been a history of continuous change and transformation. Asserting a pattern of change implies continuity as well as transformation, and the role of a media historian lies in tracing those continuities rather than abolishing them. The history and theory of moving image media right now must avoid either nostalgia for a familiar past, or greeting each new technological practice as a new dispensation and eclipse of everything that has gone before. Likewise, simply reversing the values and placing animation in a position of dominance over photographic cinema can be as limiting as the previous prejudice. Instead, forging a new history and seeing how it redefines our sense of media theory becomes the paramount task of our generation, a process of both renewal and rediscovery. A door has opened, which not only allows a new understanding of animation, but also a offers a new sense (and possibly even a new definition) of the moving image medium and its history, encompassing both animation and cinematography.

Two immediate issues arise from rethinking the hierarchy of animation and photographic cinematography. One is to question the concept

(especially in the restricted form it has been used in film studies) of indexicality as master key for understanding cinema (and the necessity of film's identification with the photographic). Second, a new acknowledgment (or rather a re-acknowledgment) of the role of movement as central to the medium becomes necessary. I have written essays on both these issues and their intertwining and am currently writing a book that will try to sketch the history and theory of the moving images in its long *dureé*, (which includes its relation to photography, without privileging this aspect over others).[2] But while the moving image and its projection forms the central theme of my larger investigation, in this chapter, I want to extend the pre-history of the moving image and especially animation by exploring an *Ur*-ground of the moving image that I feel has not received the attention it deserves. This involves a sort of prologue to the moving image, intimately bound up with the fascination the animated image exerts.

If Manovich makes us aware that all moving images could be considered forms of animation, this insight should not erase the important distinction between motion picture photography and traditional animation. Derived from freely composed images (whether drawn, painted, or computer generated) rather than photographs, animation lacks the claim of photography to capture reality. For Cavell, this lack restricts animation from a claim to be "a succession of automatic world projections," the quality central to his theory of cinema (Cavell 1979: 201).[3] At the same time, traditionally, animation has claimed an ability to conjure a world of fantasy through the freedom a drawing offers. Certainly, these respective claims have been debated and are arguably more due to historical practices than inherent natures, and one must resist creating a rigid dichotomy between realism and fantasy. The distinction I wish to maintain, however, is formal, contrasting the freedom of reference possible in drawn or painted animation versus photography's automatic reference to some prefigured reality. Both tendencies can be mitigated and complicated, but they are difficult to eradicate.

Perhaps the most fertile theory of animation comes from Sergei Eisenstein, whose wonderful writings on Disney introduced a theory of the plasmatic. This force, which Eisenstein sees as driving the animated cartoon, asserts "a rejection of once and forever of allotted form, freedom from ossification, the ability to dynamically assume any form." (1988: 21). While plasmatics celebrates precisely animation's capacity for fantasy, it is rooted in a phenomenology of our bodily experience, our desire to stretch the flesh and form and reshape matter to the contours of desire (such fantasies of deviant and impossible bodies also inhabit the critical work of Scott Bukatman on cinema's unique play with physical embodiment).[4] Rachel Moore seized on the possibilities of this essay from the 1940s in her study of cinema as modern magic, *Savage Theory*, describing it as "the very attraction of attractions" (2000: 122). However, while I strongly want to

align my treatment of the transforming image in relation to this portrayal of a protean body, I want to emphasize less its representation of a possibly archaic physical experience than its basis in the process of perception, the viewer's experience of a new form of image obtained by technology.

Thus, I want to place the defining aspect of animation—its creation of a moving image—in relation to perhaps a more fundamental, if less immediately evident, impulse: the ability of an image to transform. The plastic manipulation of the drawn line yields the plasmatic and unbounded bodies that Eisenstein celebrated and that are so evident in the work of Winsor McCay, Emile Cohl, the Fleischer Brothers, Disney and the Golden Age of American animation. But I want to trace this impulse further back, even before the invention of celluloid film, and highlight its sources of fascination in the portrayal of metamorphosis. If the history of photography could be approached as the attempt to fix forever the fugitive image of the camera obscura through freezing the instant in a picture, one might describe the invention of cinema as the unfreezing of the image, its return to the complex transformations underlying motion.

Rather than describing cinema as 'capturing motion', which places motion pictures primarily within the scientific genealogy of Etienne-Jules Marey and Eadweard Muybridge, what if we approached it as rooted in a fantasy of metamorphosis, of change and mutability, in ways unconfined by the forms of actuality? Following this clue, we could even move beyond Eisenstein's plasmatic force of continuous morphing and stretching bodies, back to magical transformations, the sudden 'presto-chango' of one thing becoming another.

Ideal types can bound the full gamut of the transforming image, even if ultimately I will reunite these opposing poles into a continuous trajectory. On the one extreme would be the sudden effect of transformation, the Méliès-like trick of one thing becoming something else. At the other extreme would be the flow of continuous motion in which the thing moves rather than changes its identity, caught up in a Bergson-like course of motion: never static, yet nonetheless consistent in identity. Full capturing of motion by the cinema usually plays a realistic role, representing and conveying the motions already inherent in the natural world. While this pronounced naturalism forms one pole of animation, that of the recognizable and familiar, the wonder and fantasy aspect of animation derives from the other pole: the fantasy of endowing something inert with life and movement in a way that exceeds the natural: toys that come to life, everyday objects that dance and sing, bodies whose contours exceed the possible, that swell and expand, or collapse and shrink fantastically. Imagine that prior to the illusion of fully developed naturalistic motion of bodies moving through space we have an image filled with an endless potential for various motions, in effect vibrating with the possibility of change, unstable in its identity and clearly different from the inert and

static form of the traditional picture. This transforming image relates less to the goal of accurately portraying moving objects than to magical metamorphosis, to potentiality more than actuality. Ultimately these types of change shade into each other, and animation plays between these two poles. To explore and describe them specifically and historically, I will examine in the remainder of this chapter two different devices, related partly because they both make use of the form of the book as an apparatus to create the transforming/moving image: the blow or flickbook; and the flipbook or thumb book (both used interchangeably in this chapter).

My project of reconfiguring the moving image historically has been inspired by the culture of contemporary new media, which extends moving images beyond the previously dominant forms of celluloid films. The technology and reception of moving images seems itself to be engaged in a plasmatic process of transformation. We are currently witnessing a multiplication of forms and media that make the modernist ideal of medium specificity increasingly untenable. Liberated from dedication to a monotonous purity, this new model of productive multiplicity can be read backwards as well as forwards. A serious consideration of post-cinema should open up a new conception of pre-cinema (although the implied teleology of both these terms disturbs me and I hope to avoid them). By tracing the experience of a transforming image through these two devices, I hope to show how animation derives not only from a fascination with the moving image, but also with a fantasy of metamorphosis or the potential for transformation. The moving image has a history that begins long before the 1890s.

"not painted thus as some of you may suppose": the blow book

Moving backwards in the history of the moving image, especially tracing its roots in the optical and mechanical devices of the sixteenth and seventeenth century, we enter the realm of Natural Magic. This complex and somewhat oxymoronic term can be used to trace the emergence of a scientific worldview from a magical and cosmological one. Thus, we move from Giambattista della Porta's 1584 book *Magiae naturalis*, which described the magical virtues of plants, gems and animals as well as the contrivances of optics and mechanics, to David Brewster's 1834 *Letters on Natural Magic* which strove to expose how magicians and priests had bamboozled the masses for centuries through devices that could actually be explained rationally and scientifically. While these two works are nearly antithetical in their understanding of the nature of the universe, from della Porta's doctrine of supernatural influences pervading the created cosmos to Brewster's enlightened and mechanistic view of a material and scientifically explainable universe, they share a fascination with the way optical devices, such the camera obscura, mirrors and lenses, can transform

human perception. Natural Magic's fascination with the effects of wonder generated by technical devices working on human perception constitutes the fertile ground from which cinema and animation spring.[5]

Let me begin with the older and explicitly magical device. I first wrote about the flick or blow book about a decade ago, after encountering it through the Getty Institute's exhibition and catalog *Devices of Wonder* put together by Barbara Stafford and Frances Terpak (see Gunning 2004; Stafford and Terpak 2001). Since then, I have learned more about it, partly from the research of my student Colin Williamson[6] and from actually getting a chance to watch Ricky Jay demonstrate a blow book at a workshop I arranged at the Getty in 2010. This demonstration was essential for my understanding of the device, since written descriptions are often confusing and my own attempts to operate Jay's modern edition showed me once again why I never could give a convincing magic show or play the piano (and made me appreciate the Zen-like precision of Jay's hand, truly quicker than the eye). Jay, a superb scholar as well as practitioner of the art of conjuring, has written the only thorough study of the blow book, and describes it as the "oldest manufactured conjuring prop," offered for sale as early as 1584 (Jay 1994: 1). The Natural Magician Girolamo Cardano had described this device even earlier, in 1550, saying "conjurors show different and always unlike pictures in one and the same book" (cited in Jay 1994: 2), a succinct description, but which makes sense only if one already knows what a blow book was. Frances Terpak gives a clear and concise definition: "a type of bound manuscript or printed book, that in the hands of a skillful practitioner offers, at one pass, a series of identical images, and, at another pass nothing but blank pages" (Stafford and Terpak 2001: 252). An extremely simple device, the blow book relies on the codex form of the bound book to allow a series of pages to be riffled through rapidly. But this is a trick book, in which a series of notches or tabs have been arranged on the pages, so that the magician can flip through a separate series of pages in a way that remains unperceived by the spectator. Thus, one set of notches would allow the conjuror to display only pages whose pictures show a particular motif, say images of demons; flipping another set of notches would yield a different set of images: angels, or animals or flowers, or—perhaps most dramatically—blank pages with no images whatsoever.

The classic description of a blow book comes from Reginald Scot's 1558 book, in which he sought to reveal the trickery behind most appearances of sorcery, *The Discoverie of Witchcraft*:

> Ye hab they saie a booke whereof he would make you think first, that everie leafe was cleane white paper; then by vertue of words he would shew you everie leafe to be painted with birds, then with beasts, than with serpents, then with angel &c. (Scot 1972: 195)

As Scott indicates, the sudden appearance, transformation or disappearance of the images in the book was the effect given by its skillful manipulation by a showman magician. The "vertue of words" refers undoubtedly to the magical incantations the conjuror would intone, as well as his patter, which would provide a bit of misdirection away from what his fingers were doing. Jay quotes the famous seventeenth century 'how to' book of magic, *Hocus Pocus Junior, the Anatomie of Legerdemain or, The Art of Juggling* from 1634, which described the proper way of handling what it referred to as "a juggling book,"

> ... your thumb set upon the parchment stayes, shew them orderly and nimbly, but with a bold and audacious countenance, for that must be the grace of all your trickes: say this book is not painted thus as some of you may suppose, but it is of such a property, that whosoever bloweth on it, it will give the representation of whatsoever he is naturally addicted unto. (Jay 1994: 8–9)

The action of blowing on the pages provided another bit of showmanship and misdirection, as if the magician's (or onlooker's) breath either brought the pictures into being or blew them off the page, hence one of its names: 'the blow book'. (Curiously, this name misdirects one from the true nature of the trick, while the alternative term 'flickbook' basically gives its means of manipulation away.) The blow book plays a role in *Der seltzame Springinsfeld* (translated by Michael Mitchell as *Tearaway*) from 1670, one the series of picaresque novels by the German baroque master Johann von Grimmelshausen. Simplicissimus, the vagabond protagonist of this series of novels, obtains a magic book, which he displays for money.

Since the blow book is not a book to be read but an optical device to be seen and manipulated, we must quote von Grimmelshausen's description of its operation at length. The performance Simplicissimus puts on before a curious market crowd explains Hocus Pocus Junior's obscure claim "that whosoever bloweth on it, it will give the representation of whatsoever he is naturally addicted unto" (Jay 1994: 8–9). Flipping through them with the aid of the tabs, Simplicissimus first shows the crowd that the pages of his book are blank; then he asks a member of the audience to blow into it. Riffling the book by means of another set of tabs, it seems to the audience that this act has generated a series of images, as Simplicissimus now reveals the pages show images of weapons. Based on this evidence—the images apparently caused by the onlooker's breath—he declares the man to be a rowdy soldier; the next onlooker blows and images of cavaliers and their ladies appear on the pages flipped through, prompting the showman to declare: "the gentleman enjoys the delights of lovemaking", while the breath of a rich burgher produces images of coins; another onlooker blows

up images of cards and is pronounced a gambler, and so on (von Grimmelshausen 2003: 56–58).

Taken together, these descriptions from the sixteenth and seventeenth century give us some idea of the principle of the blow book, but the actual effects remains a bit obscure and, of course, were intended to seem magical and wondrous. Although the blow book's effect of transformation between different images is fairly straight forward, I believe there is another optical aspect to the trick, one dependent on the virtual image created by the rapidly flickering pages. The flipping displays multiple pages to the crowd (at least seven pages for each image, in Scott's description) but each page show the same image. The blow book was not designed to produce a moving image as the flipbook, I discuss later, does (although Jay theorizes that the blow book described by Jean Prevost in 1585 may have tried to create movement effects) (Jay 1994: 7). Instead of movement, one saw the same image repeatedly appearing in the flicking of the pages for each series. With each new presentation, marked by the showman's patter and the selected onlooker blowing into the book, a different series of identical images were flipped through. The magical transformation came from the conjuror's concealed switch of his thumb from one set of notches to another, which revealed a different series of images. Thus, flicking through these pages made images *transform*, vanish or appear, a variation on the central tricks of most conjuring ("Now you see it, now you don't!" "Presto Chango"—modern magical incantations that were applied to commercial forms of the blow book in the nineteenth century) (Jay 1994: 58). The apparently random flipping of pages gave the viewer the impression that she is seeing every page in the book and that they all have the same image— until the next blow or incantation summons up a different image— demons, or cards, or purely blank pages. But if the blow book produced transformations rather than an illusion of motion, its optical effects I claim included more than simply one image magically replaced by another. Besides misleadingly seeming to show all the pages, fanning the pages, while displaying more or less identical images, triggered the perceptual effects of persistence of vision (or flicker fusion), as the rapid succession of individual pages blended into a single composite, yet somehow insubstantial, image. I would claim this flickering image possessed its own optical fascination, and aided the apparently magical effect of transformation by creating a mysterious virtual image, rather than a single picture already somewhat unreal.

Persistence of vision, or flicker fusion, by which rapidly presented successive images tend to fuse into a single impression in our perception, contributes, of course, to the production of moving pictures by such later devices as the phenakistoscope or Zoetrope or even the cinema. (We now know that persistence of vision is only one factor in creating the appearance of motion, which comes from a confluence of perceptual processes,

but that's another issue.)[7] But the blow book does yet cross this threshold of apparent motion. However, it seems to me to present a perfect example of what I described as an image of potential motion, not yet actually in motion, but already liberated from the inert quality of a single material picture. Its flickering appearance is no longer embodied on a surface, but seems to float before us, lifted off the page, fused from the rapid flicking of pages reproducing the same image. In other words, when Simplicissimus displays the image of coins after the burgher blows in his book he does not show a single page, but flicks through a number of pages similarly picturing coins. I believe the flickering image produced by the various leaves visually sets up the onlooker for the subsequent illusion that the image itself has transformed into another image, when the magician switches from one image series to another. The strange semi-transparent quality of the image produced by the pages flicking before the viewer introduces an unfamiliar optical realm that could seem almost unreal. Thus, I would claim the blow book, through its use of the after-image created by fanning the pages, introduces not simply a sleight of hand (like the conjurer's cup and ball trick), but an optical phenomenon caused by a rapid succession of images. Even if an actual appearance of motion was neither sought nor achieved, a new sort of insubstantial, entirely optical, image was produced by flipping the pages of the blow book. This rather insubstantial, purely perceptual image, pregnant with the possibilities of appearance, disappearance and transformation, embodies for me the *Ur*-form of the animated image.

This visual magic extends the conjuror's tricks. The after-image produced is actually perceived and introduces a different sort of visual experience, visible but untouchable, like a reflection or a shadow. When Simplicissimus explains how the book functions to his companion, Tearaway, he asks:

> "But what about that book?", Tearaway asked. "Isn't that sorcery? Isn't there just a bit of magic there?"

To which Simplicissimus replies:

> "What about conjurers and sharpers? Isn't that all sleight of hand, childish tricks that amaze simple fools like you because you haven't got the intelligence to see what's really going on?" (von Grimmelshausen 2003: 63)

Later Simplicissimus, hoping to convert Tearaway from his cynical irreligious beliefs, uses the blow book to persuade him to repent, showing him the blank pages as the emblem of the white garment of innocence he gained at baptism and which he has since stained with the many sins (the images of the various pleasures, cards, money, women) (65–67). The production of these visually transforming images exerts a rhetorical force that adds to Simplicissimus' moral argument.

Thus the blow book possesses a force of fascination that intensifies, through a perceptual manipulation, the conjuror's allegories of the nature of God's cosmos and man's place within it. This recalls the way Natural Magicians such as Athanasius Kircher used their various devices.[8] The blow book was primarily a conjuror's device, relying on a simple mechanism, deft manipulation and the power of misdirection. But it was used by practitioners of Natural Magic to demonstrate the powers that lay hidden within creation as well. The heir and disciple of Kircher, the great explicator of the Grand Art of Light and Shadow in the seventeenth century, Casper Schott, in his compendium of Natural Magic *Magiae Naturalis Centuria Tres* from 1664 reported: "among the secret manuscripts that I have found in the papers of Father Athanasius Kircher in Rome there is one in which a book is so constructed that when the leaves are turned they show images of every kind and yet [the images] of one kind only appear in one and the same turning of the leaves" (cited in Jay 1994: 91), a description that might be incomprehensible if one did not know the nature of the blow book. Schott and his works present a fascinating image of the gradual transformation of magic into technology. Along with the volume cited, which collected 300 magic tricks, Schott assembled two multi-volume "books of secrets", dedicated to "whatever in the universal nature of things is occult, paradoxical, prodigious and like to miracle", *The Universal Magic of Nature and Art* and *Curious Physics or Marvels of Nature and Art*, partly drawn from the notes left by his master Kircher (Thorndike 1958: 590–91). Schott not only made the traditional distinction between natural magic (explicating the secrets embedded in creation by God, the sacred hieroglyphics of the Creator) and the evil demonic magic (which comes from concourse with demons), but added a third category, "artificial magic", which describes the creation of magical devices or machines manufactured through human ingenuity. Schott's books deal equally with the virtues of plants and stones (some of which he denounces as simply superstitious beliefs); the effects of optics and acoustics; and such mechanical devices as gears and jacks. From a twentieth century perspective, Lynn Thorndike, the great historian of magic and experimental science, commenting on the combination of descriptions of magical practices and mechanical effects found in these seventeenth century books of secrets, objected to this inclusion: "Machinery and magic do not go together. Magic may employ sleight of hand, but not the monotonous regularity of impersonal mechanics, which is the very antithesis of magic" (1958: 621). I believe this judgment not only depends on one's historical perspective, but also whether one stands in the position of viewer or practitioner. For an onlooker the mechanic of a blow book may seem quite magical. But what happens if viewer and practitioner merge? Can one trick oneself? That seems to be the question raised by the trick of optical movement as the perceptual image created in the flickbook takes on an even greater degree of transformation in the nineteenth century.

the mechanics of motion held in your hand: the flipbook

If the now unfamiliar flickbook may be hard for a contemporary reader to imagine, it is also easy to confuse it with the later (and still current; you can buy one in most museum gift shops) flip or thumb books. But the two devices remain very different items and their difference illuminates how in the nineteenth century optical toys transformed older traditions of conjuring and visual illusions by focusing increasingly on new issues of the body and perception with the purpose of enlightenment and education, rather than bafflement. The blow book maintained different levels of knowledge between the canny manipulator of the book and its duped viewer. The magician never let the magic book out of his hands and he alone knew its secret, its concealed system of notched pages and the proto-cols of their display.[9] Further, he possessed the dexterity to accomplish the flick of the pages (and the theatrical panache to stage-manage the blowing) in order to present the illusion as a spontaneous transformation. The showman of a blow book literally juggled its pages, while the spectator, misdirected by the magician's patter, watched his gestures and his stage presence (such as "a bold and audacious countenance", recommended by Hocus Pocus Junior). The device and its performance remain firmly in the realm of stage magic and illusion.

A different mode of presentation and attitude toward the perceptual image prevail with the thumb book, more suited to the post-Enlightenment era and its Philosophical Toys, which pedagogically demonstrated principles of perception rather than mystifying onlookers. We move here from the theatrical form of spectacle to an individual process of manipula-tion and observation. As its name indicates, this device is easily grasped between fingers and thumb and nothing remains hidden. Even a small child can operate it. The "simplest of optical toys" (as the historian of the flipbook, Pascal Fouché, calls it), the flipbook relies only on the craft of binding the pages together so they can be flipped rapidly, and on the arrangement of the images it contains (Fouché 2012). Rather than a series of differing images or blank pages, the flipbook follows the innovation of the Phenakistoscope and presents a series of images of the same figure in close succession portraying the sequential stages of a motion. When these pages are flipped, no complex manual 'juggling' of varied tabs is necessary, just a simple movement of the thumb. The rapidly passing pages produce, not a metamorphosis, but a moving image performing a brief action, usually of a rather common and quotidian nature.

The date of the invention of the flipbook remains elusive; given their fragile nature and simple technology (and their frequent confusion with the flickbook) it has sometimes been speculated that they might date from before the nineteenth century.[10] Fouché points out that drawings executed in series are almost as ancient as the art of depiction, and certain illuminated

manuscripts, such as the epic of Sigenot in the Codex Palatinus germanicus 67 from 1470 held in the Heidelberg Library, portray stylized actions such as swords fights and a journey on horseback in such consistent framing, and with such short intervals between actions, that their resemblance to a flipbook has been noted.[11] (Indeed, author Theodore Roszak (2005) has even written a fascinating novel, *Flicker*, which speculates that the medieval heretics, the Cathars, had actually produced flipbooks in the thirteenth century.) Technologically speaking, medieval flipbooks would not be impossible, since the only technology needed is the codex book form, which dates from antiquity, but they remain unlikely for other reasons. The flipbook reflects an attitude towards the analysis of motion and of brief intervals of time, which appears with a modern sense of the instant, and seems lacking before modern innovations in clock-making and the division of time into regular instants smaller than a second (the crucial 1/10 of a second which Jimena Canales (2011) has chronicled). Even the rather careful analysis of action found in the illustrations for Sigenot would not produce continuous moving images if flipped. The degree to which movement has to be broken into individual images to produce the phi phenomenon needed for apparent motion could hardly have been imagined before a modern mastering of instants (Canales (2011) dates the ability to measure the tenth of second to the mid-nineteenth century). Although the flipbook does not use the shutter or aperture systems devised by Michael Faraday, Peter Mark Roget and Joseph Plateau in the 1820 and 1830s in order to break down vision into its briefest increments, the rapid flipping of the pages achieves such an effect. (Fouché (2012) shows that Werner Nekes' claim of the date 1760 for flipbooks came from a confusion account of Loutherberg's Eidophusikon, which has nothing to do with a flipbook.) The breakdown of movement into instants of stillness involves not only a modern conception of time, but a technological conception of the analysis of action into component parts, which, while evolving since the Renaissance, appears, it would seem, only in the nineteenth century as a result of the scientific analysis of perception through the use of machines. The blow book's illusion of metamorphosis through sudden appearances and disappearances presented a very different conception—wonder at the sudden discontinuity of a magical transformation—while the flipbook breaks down and reproduces a continuous flow of action. However, I do wonder if the persistence of vision effect that fanning the pages produced in the blow book may not have inspired the flipbook. Crucially however, the blow book produced a persistent and *still* after-image, while the flipbook crossed the threshold into apparent motion.[12]

The earliest documentation of a flipbook comes surprisingly late, from a British Patent granted to John Barnes Linnet in 1868, which described his device as an improvement for producing optical illusion, "by presenting to the eye in rapid succession a series of pictures of objects representing the

objects in several successive positions they occupy when in motion, and thereby producing the impression of moving objects" (Barnes Linnet 1868). The principle had already powered the Phenakistoscope and Zoetrope, and Linnet's innovation lay in the use of flexible leaves "similar to the leaves of a book" which can then be flipped by hand rather than the more complex earlier devices (Barnes Linnet 1868). Therefore the simplicity of the flipbook seems to come *after* its more complex predecessors, but to have been inspired by the principle they had demonstrated. Linnet's surviving flipbooks, with their woodblock image, have a primitive charm and the analysis of motion they offer is rather rudimentary compared to that produced by many Phenakistoscopes or Zoetropes (indeed Linnet's flipbook of dueling cavaliers seems rather similar to the sword fights in Sigenot). An American patent of a few years later granted to Henry van Hoevenbergh in 1882, specified it as an improvement to the class of optical toys "which depend for their actions upon the well known phenomenon technically termed 'persistence of vision'" (van Hoevenbergh 1882: 1). One of the subjects van Hoevenbergh illustrated in his patents drawings was "the illusion of a rapidly approaching locomotive" (van Hoevenbergh 1882: 2), a recurring theme in the modern development of the moving image, from its use in Zoetropes to the early films of trains made by the Edison, Lumière and the Biograph Companies.

The flipbook when it first appeared relied on drawing and seems therefore solidly within the lineage of animated drawings (and Manovich's broad category of animation), rather than cinematography. But the device soon made use of both technologies (and in contemporary flipbooks both drawing and photographs appear, with different effects). Tracing the point where the flipbook introduced photographs may prove elusive. In 1868, the date of Linnet's patent, which used drawings exclusively, the mastery of instantaneous photography which could breakdown the phases of motion with exposures of less than a tenth of a second had not yet been achieved. (Muybridge's first photographs of the galloping horse date from a decade later.) Drawings which portrayed individual phases of action (usually highly mechanical and schematic sorts of motions, such as sawing wood or juggling) were the only option. Flipbooks may have used staged photographs before the mastery of instantaneous photography in the 1870s, just as Coleman Sellers did with his kinematoscope from 1861, which animated a series of specially posed photographs within a Zoetrope, or Henry Heyl who projected such posed stages of an action in 1870 his phasmatrope, which used a Phenakistoscope-like disc. As Charles Musser stresses, these devices remained somewhat primitive since the ability to photograph actions continuously and instantaneously had not yet been achieved and the photographs posed only approximated natural motions (1994: 43–47). However, I have never seen a photographic flipbook that was produced before the mastery of motion photography.

After the introduction of chronophotography and motion photography in the 1890s, the photographic flipbook had a golden age, with most of the nascent manufacturers of moving pictures offering flipbooks along with their peepshow or projection devices, often recycling scenes available in the other formats. Lumière, Edison, Gaumont, Skladnowsky, American Mutoscope and Biograph all marketed flipbooks at the turn of the century and as well as viewing devices which made the flipping of the leaves a bit smoother (such as the Kinora of Lumière, the British Filoscope, most of them small enough to fit in the hand). The Mutoscope of Herman Cassler, perhaps the earliest device using flipping cards on reels, offered a particularly resilient if unwieldy form, with reels still being produced in the 1930s and machines still in use today in some penny arcades, as a bit of nostalgic visual culture (for instance, Ernie Gehr's 2001 film, *Cotton Candy* documented Mutoscopes in use at the Musee Mechanique, now housed at Pier 45 in San Francisco). Like other early moving image devices, flipbooks offered only brief snippets of motion. Initial versions, such as Linnet's, stuck close to the repetitive actions that were familiar from the Phenakistoscope or Zoetrope (a sailor's hornpipe, a dancing skeleton, a woman churning butter, the sails of a windmill turning, or a seesaw moving up and down). But especially after the introduction of motion photography, these moving images no longer were limited to the circular and endless actions of the Zoetrope bands or Phenakistoscope discs. Actions actually might progress and come to a climax (May Irwin got kissed, women got undressed for bed, men fell off benches). The photograph, as Roland Barthes (1979) has argued, tends to present the singular, the specific and unique moment, and the photographic flipbook often presents a complete action rather than an endless cycle. At the same time, even if potentially liberated from the Sisyphean cycle of earlier devices, these unique moments could always be repeated, starting once more at the flick of the thumb. Even more than the previous devices, the flipbook placed the moving image within reach. As Mary Ann Doane has said in her penetrating essay on the flipbook, the device represents a moment when the manipulator "seemed to hold movement in his or her hands"(2006).[13]

from metamorphosis to morphing: the transforming image as modern magic

I want to stress both continuity and a fundamental difference between the sixteenth and seventeenth century magical blow or flickbook and the nineteenth and twentieth century flipbook. The former relates to the specific confluence of wondrous appearances and mechanical contrivances that defined Natural Magic, in which concealed workings produced a theatrical spectacle that expressed the mysterious nature of the cosmos. The flipbook, on the other hand, displayed rather than concealed its means

of achieving a perceptual effect (the rapidly flipping pages) and captured the course of everyday motions, even achieving the photographic ideal of realistic motion. Yet in spite of this difference, which marks a basic paradigm shift in attitude toward perception and optical entertainments, they share the discovery of the effect of persistence of vision and the production of a virtual image through a device manipulated at a certain speed.

Modern animation of motion as seen in the flipbook both derives from the magical possibility of metamorphosis and transformation and differs from it. It is not accidental that metamorphosis primarily refers to a mythical potential of moving between species, from man to animal, man to God, man to plant, or inanimate object or vice versa. Doane (2006) has related the flipbook to the childhood fantasy of the toy that comes to life. Thus, optical tricks such as the blow book, the transformation scenes of baroque theater, and the trick magic lantern slide often staged a magical transformation, a fundamental change in being—a wonder. These are transformations, however, rather than movements. The threshold of the modern moving image, which I am claiming the nineteenth century Philosophical Toys ferries us across, consisted of manipulating human perception, rather than stimulating the imagination (not that these can't be combined, but they work in different ways). In the flipbook, one does not see one thing in place of another, as in a magic trick, but rather watches an action transpiring. What is shown is familiar and indeed can be quite common (kissing, dancing, smoking, laughing). The movements of the everyday have become somehow marvelous; the product of a mechanical trick.

If the production of motion rendered the everyday marvelous, nonetheless, as with all technological novelties, familiarity dulls the edge of wonder. If the magic of metamorphosis slumbers in the contemporary moving image beneath its commonplace ubiquity, this does not mean it cannot be reawakened. Establishing a sense of tradition allows us to move along its course, not with the linear inevitability of progress, but with a sense of alternative possibilities. If the photographic cinema moves us towards the referential aspect of indexicality, thinking in terms of animation redirects our attention to the materiality of the technology and its work on human perception. Thus animation may move towards a capturing of the movement of the world, but it may also return us to the wonders of transformation and magic.

Approaching motion photography as a subgenre of animation makes the intimate relation between the production of motion and magical effect more than a sideshow in film history. A brief reconsideration of cinema's prime magician, Georges Méliès, makes this clear. Attending Lumière's first film projections, Méliès was first attracted to cinema as a form of capturing everyday motion but in a novel and wonder-producing manner. After purchasing a movie camera in order to present his own versions of

the Lumière scenes of everyday life (card parties, the arrival of a train, Parisian street scenes) and display them as the latest optical device during entr'actes during the magic shows he staged in his Theater, Robert-Houdin in Paris, Méliès soon discovered cinema's own possibilities of transformation. Besides showing moving images, the camera, he realized, possessed its own capacity for an abrupt 'presto-chango' transformation. Méliès's trick films abandoned the filming of everyday motion for the creation of magical appearances or disappearances, managed, not through flicking pages or complex stage machinery, but through manipulation of the camera (stop–motion) and editing (the substitution splice).[14] Méliès made a number of films, such as *La Livre Magique* (*The Magic Book* 1900) that invoked the transformations offered by earlier technology such as the blow book, but he accomplished this metamorphosis through film. Indeed filmmakers began to realize that the successive frames of film, the still images that the motion picture camera registered on the strip of celluloid, parsed action into manipulatable units that could recreate motion—or create impossible transformations. Each individual film frame could function like a single page in a blow book; only now the secret tabs lay in the hands of the cinema technician, mechanized by the camera and projector. Thus, the continuous flow of film frames that creates apparent motion and the sudden transformations of magic achieve an enduring synthesis in cinema's special effects. Moving image technology, including the contemporary uses of computer generated images (CGI) that control not only frames that constitute an action, but the pixels that form an image, moved from an ability to reproduce movement to a capacity to reformulate and reconfigure the image itself. Thus, the protean transforming image, the very nature of visible form itself, becomes subject to technical manipulation and the moving image becomes endowed with the possibility of constant metamorphosis: a brave new world of Gods and monsters, engaged in potentially endless transformation. Form is motion; motion is form.

notes

1. See: Siegfried Kracauer, *Theory of Film* (Princeton: Princeton University, 1997); Andre Bazin, The Ontology of the Photographic Image. In *What is Cinema* Vol. 1 (Berkeley: University of California Press, 1967), and Stanley Cavell, *The World Viewed: Reflections on the Ontology of Film* Enlarged edn. (Cambridge: Harvard University Press, 1979).
2. See: What's the Point of an Index? Or Faking Photographs. In *Still/Moving: Between Cinema and Photography*, eds. Karen Beckman and Jean Ma (Durham: Duke University Press, 2008: 23–40); and Moving away from the Index: Cinema and the Impression of Reality. *Differences* Vol. 18, No. 1: Spring 2007: 29–52.
3. See the discussion of this issue in Cavell's *The World Viewed*, 167–173.
4. Scott Bukatman, *The Poetics of Slumberland: Animated Spirits and the Animating Spirit* (Berkeley: University of California Press, 2012).

5. See: Siegfried Zielinski's contribution to this book and also his work in tracing this tradition in *Deep Time of Media: Towards an Archaeology of Seeing and Hearing* (Cambridge: MIT Press, 2008).

6. Colin Williamson, The Blow Book, Performance Magic, and Early Animation: Mediating the Living Dead. *animation: an interdisciplinary journal*, July 2011; Vol. 6, No. 2: 111–126

7. See: Joseph and Barbara Anderson, The Myth of Persistence of Vision Revisited. *Journal of Film and Video*, Vol. 45, No. 1, Spring 1993: 3–12

8. See for instance, the description of Kircher's sunflower clock given in Thomas L. Hankins and Robert Silverman, *Instruments and the Imagination*. (Princeton: Princeton University Press, 1995: 14–36).

9. As Suzanne Buchan pointed out to me, the manipulator of the blow book seems to share the knowledge of the animator, as the audience never sees 'behind the scenes' of the pro-filmic animation process.

10. The great collector of optical devices, Werner Nekes, in his 1986 film *Was geschah wirklich zwischen den Bildern?* claimed the flipbook dates to 1760, but as Fouché has pointed out, this was based on a misreading of a description of the Eidophusikon. In a more fanciful vein, Theodore Roszak dates the flipbook to the middle ages in his 1991 novel *Flicker* (reissued by Chicago Review Press in 2005).

11. This codex is available at http://digi.ub.uniheidelberg.de/diglit/cpg67/0001

12. Interestingly, many optical devices of the nineteenth century used persistence of vision to produce still, rather than moving, images, such as the Thaumatrope, Plateau's Anorthoscope and certain revolving wheel experiments of Faraday. (See: Laurent Mannoni's masterful *The Great Art of Light and Shadow: Archaeology of the Cinema* (Essex: University of Essex, 2001). But that is a different essay ...

13. I have used a manuscript kindly supplied by the author of the original English version "Movement and Scale: From the Flip-book to the Cinema", and use the page numbers from that manuscript. This quote appears on p. 23 of the manuscript.

14. See my essay: Primitive Cinema, a Frame-up? or The Trick's on Us. *Cinema Journal*, 28/2 Winter, 1989: 3–12; Matthew Solomon's work on Méliès and magic, especially 'Twenty-Five Heads Under One Hat': Quick-Change in the 1890s. In *Meta-Morphing: Visual Transformation and the Culture of Quick-Change*, ed. Vivian Sobchack (Minneapolis: University of Minnesota Press, 2000: 2–20), and the recent *Disappearing Tricks: Silent Film Houdini and The New Magic of the Twentieth Century*. (Champaign Urbana: University of Illinois Press, 2011).

references

Barnes Linnet, John. 1868. British Patents: AD 1868, 18th March, No. 925 *Producing Optical Illusions*, http://www.flipbook.info/brevets/brevet_linnett.htm (Accessed March 6, 2012).

Barthes, Roland. 1979. *Camera Lucida: Reflections on Photography*. New York: Hill and Wang.

Canales, Jimena. 2011. *A Tenth of a Second: A History*. Chicago: University of Chicago Press.

Cavell, Stanley. 1979. *The World Viewed: Reflections on the Ontology of Film*. Enlarged edn. Cambridge, MA: Harvard University Press.

Doane, Mary Ann. 2006. Movement and Scale: Vom Daumenkino zur Filmprojektion. In *Apparaturen bewegter Bilder, Kultur und Technik*, Vol. 2, ed. Daniel Gethmann. Munster: LIT Verlag: 123–137.

Eisenstein, Sergei. 1988. *Eisenstein on Disney*, ed. Naum Kleinman New York: Methuen.

Fouché, Pascal. 2012. *Flipbook.info*, http://www.flipbook.info/history.php (Accessed March 6, 2012).

von Grimmelshausen, Hans Jakob Christoffel. 2003. *Tearaway* (Original title: *Der seltzame Springinsfeld* 1670). Trans. Mike Mitchell. London: Dedalus.

Gunning, Tom. 2004. Flickers: On Cinema's Power for Evil. In *Bad: Infamy, Darkness, Evil and Slime on the Screen*, ed. Murray Pomerance. Albany: SUNY Press: 21–37.

van Hoevenbergh, Henry. *Optical toy*. Specification forming part of Letters Patent No. 258,164, dated May 16, 1882. United States Patent and Trademark Office. Patent Full-text databases, http://www.uspto.gov/index.jsp

Jay, Ricky. 1994. *The Magic Magic Book*. New York: Whitney Museum.

Manovich, Lev. 2002. *The Language of New Media*. Cambridge: MIT Press.

Moore, Rachel. 2000. *Savage Theory: Cinema as Modern Magic*. Durham: Duke University Press.

Musser, Charles. 1994. The Emergence of Cinema: The History of the American Screen to 1907. *Scribner's History of American Cinema*, Vol. 1. New York: Charles Scribner's and Sons.

Roszak, Theodore. 2005. *Flicker: A Novel*. Chicago: Chicago Review Press.

Scot, Reginald. 1972 [1558]. *The Discoverie of Witchcraft* (reprint edn). New York: Dover Books.

Stafford, Barbara and Frances Terpak. 2001. *Devices of Wonder: From the World in a Box to Images on a Screen*. Los Angeles: Getty Research Institute.

Thorndike, Lynn. 1958. *History of Magic and Experimental Science*, Vol. VII. New York: Columbia University Press.

material culture

animation's petrified

unrest

three

esther leslie

times, spaces and layers

Pauvre Pierrot, by Charles-Émile Reynaud, marks a certain beginning of a form of entertainment that will come to be known by various names, including trick-film, cartooning and animation. Reynaud's hand-drawn, hand-colored moving pictures of Pierrot, Columbine and Harlequin were first shown in Paris, in October 1892, in the Cabinet Fantastique at the Musée Grévin. An audience watched a screen on which events unfolded, and behind which stood Reynaud, the operator of the projection. One of the characters, that hapless clown Pierrot, was, by then, long known in Paris, for he had been a part of the Commedia dell'Arte travelling shows and his story of unrequited love was often repeated. Pierrot loves Columbine and she breaks his heart again and again because she favors Harlequin. Pierrot is the sad clown, a mute naïf, the butt of pranks, but eternally hoping and trusting. In the five-minute fragment that remains of the original fifteen or so of Reynaud's *Pauvre Pierrot*, the audience sees Harlequin wooing Columbine. Pierrot visits Columbine's house to serenade her.

She spurns his advances. He returns drunk and tries again to win her affection. Harlequin is hiding in the garden and he scares Pierrot by poking him from behind with a sword. Pierrot flees. Harlequin and Columbine embrace. The setting—Columbine's yard with a wall—does not change, though there are small alterations in what can be seen of it on the screen. A portion of it is suddenly enlarged, as we move in for a closer view of the clown and his would-be lover. At another point, we close in on the moon, one of Pierrot's few friends. It hangs in the sky, forlorn like him. At another moment, more dramatically, a door appears from nowhere in the wall and Pierrot enters and exits, casting a shadow. The space in which the action occurs has depth and the propensity to change, but only minimally. In front of this more or less constant background, this stillness that guarantees a space of action, the figures move around jerkily. In spite of the jitteriness of the moving parts, the leading French newspaper, Le Figaro, enthused the next day (though the copy may have been paid for, making it effectively advertising): "By an ingenious method, M. Reynaud created characters with expressions and movements so perfect that they give the complete illusion of life" (quoted in Schwartz 1999: 180). Other commentators likewise noted the lifelikeness of the characters, "their fleshliness and bloodiness, their captivating abilities to simulate movement, going, coming, moving, posing", as Henri de Panville put it in a review (quoted in Schwartz 1999: 182). And all of this lifelikeness was deployed for something hitherto unseen in mechanical optical entertainment devices. These apparently full-bodied figures are involved in a storyline. Their seeming liveliness goes together with their capacity to live a life, that is to say, to be part of a developing story. At the end of it, they are not the same as they were at the beginning. The animated world that is brought into being by Reynaud has, like the world in which the audience sits and just as complicatedly, time and space, stillness and movement. Out of all of this and into all of this animated nature and more is thrown.

Earlier devices that deployed animated effects, such as Reynaud's own praxinoscope, which he patented in 1877, spun a paper strip of images affixed to a cylinder. In these devices, the action was looped. For a second or two the characters perform their acts—a girl feeding chickens, a couple waltzing, a horse galloping. And then, in the next seconds, they perform that same act again and, then, again and again. Movement in, and of, the image occurs and then, rapidly, that movement is repeated. The repetition undermines the movement, which becomes an ever-turning on the same spot, a locked in-ness. Movement that repeats is movement only in the simplest, most mechanical sense.[1] That is to say, it cannot extend to action, which would be movement that leads somewhere. The space in which the movement takes place is never-changing (or virtually non-existent). Time's passing in the image is cancelled through repetition. Repeated movement is a type of stasis.

Reynaud's next invention, the Théâtre Optique, on which he showed his own *Pauvre Pierrot* and other animations, broke with the repetitive nature of the movement. This time, a concatenation of stillness and movement allowed the unfurling of a story, and supported developments. In order to execute what he called his 'luminous pantomimes', whose luminosity derived from his use of one of the first electric arc lamps, Reynaud invented a device that unleashed a band of images in a linear fashion through a mechanism. On gelatine squares, fastened between leather bands and metal strips with holes, were series of painted images. The metal strips aligned each image with a facet of the mirror drum and so introduced the use of sprocket holes or perforations that would later be essential to frame-by-frame exposure and film projection (see Myrent 1989). This new mode of optical entertainment presented a complex line of development, and it also produced a new type of mobility within the setting. Reynaud's device worked on the principle of a double projection, which meant that two images were projected onto one space, creating a layering within that space. One projector cast what appeared to be the background, a more or less static environment in which the action takes place. Another projecting system cast the moving elements—the figures that juddered and danced—through a directional mirror onto the background. The animator manipulated this second layer, and so subjected it to double movement. The figures seemed to move because of the rapid passing through the mechanism of the sequences of drawings. The figures moved too because the animator manipulated the projector and ran the action backwards or forwards as he desired, in order to nuance the story. In one scene, while projecting it in the Musée Grévin, Reynaud is said to have indicated Pierrot's hesitation by reversing the direction of the strip as he climbed a wall, and dropped down again. Finally the forwards direction resumed as he emboldens himself. In addition, these character movements could be shifted around the background layer, for the animator could angle the projector in various ways. The flexible band of animated images could be as long as the drawing animator could bear, for more seconds of storytime could be gained with the addition of each further drawing. There were between 500 and 700 mobile images in Reynaud's luminous pantomimes, and each would twinkle on the screen for a second or two (see Auzel 1992). This length of time and ability for variety turned movement into action. It permitted the telling of a story, with a beginning, middle and an end. The twists of the band made possible the twists of a narrative. It produced time and filled it with activities. It also consumed minutes, not seconds, of attention. With this gain in time, the questions begin of what a story might be, and unhappy endings, in these early days, were as likely as happy ones. Animated optical culture begins to tell stories. Inaugurated in this is a certain imbrication of two types of inscription, image and story, or the visual and the verbal, or the film and the book.

Animated culture begins its drawn-out and never completed fate: to supplant the book.

stillness and movement, space and time

The mechanism of animation is, in various ways, a combination of movement and stillness. It is a combination of movement and stillness in space and time that produces shifting, time-tied activity within a constant context. In addition, in animation, as in film, something still is propelled into liveliness, in various ways. With the film strip, the still frames made of an original action are printed onto a flexible band and coiled through a mechanism to make stillness reconstitute the movement it once possessed. In animation, the still frames of drawings, or single images of objects are brought into movement through the same principle—though in this case movement arises as an addition, as there was no movement in these images prior to their dashing through the machinery. Animation is not a matter of movement alone, but a matter of movement set in relation to stillness. Stillness and movement in combination coalesce at the origins of this mechanical optical entertainment culture. The first films began in stillness, a static scene, and were cranked in full view of the audience into vivacity. The drama was intensified by viewing the transition from stillness to movement, or, in other words, the actual event of the inputting of seeming life. This movement between stillness and movement is especially pertinent for animation. The question that animation poses again and again, and answers in its various ways is: how does a concocted substance or thing that is apparently inert begin to move, become restless? How does something immobile and partial transform into the complexity and chaos of physical phenomena—something that moves in a plausible world? Things that once moved, but over time are stilled into stoniness, become petrified. In animation, the process is reversed: things that never moved by themselves are mobilized into movement. An originary petrification is jiggled into unrest.

The first animations turned this transition between states of rest and unrest into the very motif of the drama. For example, in Georges Méliès' *The Magic Book*, from 1900, an oversized book is placed on a stand and opened. The drawings inside, of Punch, Harlequin, Pierrot, a young woman, and an old man, are brought to life, with a trick of the camera, switching the drawn image into a registration of a dressed-up human being, who climbs out of the book. The drama unfolds, with human relations becoming complex, until the magician decides to return the cast to their static drawn state inside the book. In the same year, J. Stuart Blackton's *The Enchanted Drawing* depicts a man sketching a figure in chalk on a blackboard. The man sketches a bottle of wine and a glass. Suddenly he snatches at the wine and it takes on solidity, comes to life, in as much as an

inanimate object can, or, perhaps better, it comes into life and is drunk. The same happens later to a hat. In 1906, Blackton's *Humorous Phases of Funny Faces* moves back and forth between the stillness of the drawing and two types of animation of the drawing. First, the audience sees the drawing appearing on the screen, as the sketcher creates it. His hand moves. It is static. Then the hand retreats and the drawing begins to, as it were, develop itself. In a third stage, the drawing is fully formed as an entity and begins to move. At various points the animator intervenes, to nudge it on, or to obliterate. The hand of the animator withdraws for the most part, and animation's forms and figures assume a quasi-life, an impression of self-propulsion. The drawing, figure and ground, is made of lines and dots. Played out is the stillness, the moveability through manipulation, as well as the apparent self-mobility of lines and dots.

What the line could conjure up; whether dynamism could be suggested in its curves and jagged edges; whether a line that is still could suggest a contour of movement, a line of force; how three dimensional space, the volume of a world, can be suggested, when the image exists as a two-dimensional plane; how elements of form can intimate space and time, stillness and movement: all these concerns with volume and movement, flatness and stasis were discussed by art historians of the same epoch. How could the two-dimensional and still painting persuade the viewer that it combined several planes in which movement occurred? How could a static painting render not a frozen moment snatched from time, but a portion of time, in which a process is unfurling? These were questions addressed in particular at the close of the nineteenth century by the burgeoning formalist movement. One influential figure was the artist and theorist Adolf von Hildebrand. His book, *The Problem of Form in Painting and Sculpture*, the first edition of which appeared in 1893, analyzed how form was pertinent to art, but it devoted much space to matters of sensuous perception for artists and audiences alike. Hildebrand's was a defense of the artistic vision, on the basis of an analysis of physical vision, which it argued was insepara-ble from the mental operations that interpreted what was seen. The physiological process of viewing is also a psychological process and it is these two aspects that, for Hildebrand, any artistic representation must address. Seeing involves the receipt of an image by the eye, but this data is made sense of through the exercise of reason or mental operations. "The life of Nature", he notes, "is, in reality the animation of Nature through our ideas" (von Hildebrand 1907: 102). Hildebrand was curious about the ways in which art's modes supplement the blindspots of natural viewing and thread the optical act of vision through ideas, rendering perception as conception. This is apparent, especially in relation to the representation of movement. Natural vision, that is our everyday vision, sees movement as a blur, notes Hildebrand. The legs of a dog running merge into vague and indefinite streaks or shadows (109). In representing this movement, an

artist usually renders the idea, not the percept, showing the leg clearly, in one position, and foregrounding, in this way, form rather than the blur of movement through time. Photography, he observes, is inadequate to the task of artistic representation. It snatches only a single moment, an isolated perception, mechanically attained, and is unable to render anything like our idea-imbued perception of the world. The camera sees without concept, unlike us: "We are not an instantaneous camera for observing Nature, but beings who combine ideas and who use isolated perceptions only for the purpose of weaving them into ideational content" (110). It is this 'animation' of the represented object, through the 'vitalizing force of our ideas' that allows an experience of art to occur (104). The human traits of mimesis and identification allow viewers to bring themselves "into relation with everything and to saturate each object with our bodily feelings" (104). Through a combination of intellectual and bodily empathy the artwork is enlivened. This empathy extends to all objects in nature. Animators found it could extend into the unnatural world too, under certain conditions.

This mimetic sense is what endows the artwork with a temporal aspect, annexed to action. A gesture, a posture, a curve of a line should, for Hildebrand, suggest an axis of past, present and future within the representation (101). For artists, the task is to consider how a single image might convey a sense of time's passing, a sense that the artwork partakes of a moment connected to those that come before and those after. Hildebrand explains how this is achieved by drawing on a widespread theory of the time: viewers project their own sensations and their knowledge of functions onto an appearance. Mobilizing a knowledge of stereotypes, the viewer assumes that a long fingered hand carries in itself 'the impress of action' even when at rest—a hand like that will grasp and stretch. A strong jaw suggests force and energy. Prominent muscles on the forehead indicate determination. Mobility is suggested even in stillness.

In addition to the meshing of physical receptivity of the world on the eye and the exercise of reason and imagination upon it, Hildebrand considered the roles of movement and stillness in the act of seeing. Hildebrand used an example from everyday seeing. He asked his readers to imagine looking at a close object set against a distant background. In one glance, the background is taken in, with the eyes remaining at rest. The background is perceived as flat, two-dimensional. The eyes rest for a moment on this depthlessness, with little to explore. The object that is close at hand, though, is perceived with a different type of vision. Its full form is constructed only out of several views. The eye that perceives is restless, flickering around the object, taking in different depths, facets, aspects (21–22). This repeated visiting of the eye on the object is compared to a kind of touch, a haptic activity. Movement and stillness are properties of the eyeball, as much as of the field that is represented.

These two types of seeing, one visual, one kinaesthetic, are annexed to modes of art making and perceiving. The painting partakes of the surface, flattened views. The sculpture partakes of the three-dimensional, mobilized view. A third form considered by Hildebrand, the relief, oscillates between the flat surface of painting and the volume of sculpture. In the relief, at least one background layer and one foreground layer are combined. Hildebrand's aesthetic theory brings to the fore the relations between surface and depth conceived as series of layers. For him, all art forms emerge out of drawing. A sculpture begins as a series of flat surfaces, out of which the sculptor creates depth or volume. It is a drawing given depth— this Hildebrand equates to an "animation of a surface" (125). Sculpture is conceived as layer after layer of drawings and what occurs in each plane has to be completed by the artist, and the viewer too, before proceeding to the next layer.

A painting or sculpture or drawing is, in actuality, a static replication of a world that we experience and perceive through moving around and touching. The successful artist is able to recreate the viewer's projected freedom of movement and point of view, even though the means are static. The well-accomplished painterly picture awakens a space and time that is not the same as natural space and time. It is space and time as experienced. The underlying assumption of such theories of perception is that the optical data that presents itself to the eye is two-dimensional (21). The viewer receives a flat picture on the retina as 'actual impression' of the world. For Hildebrand, to bring life into that flatness, a viewing individual has to move, has to supplement the thing seen in its flat stasis with the restless movements of the human body, in a kinaesthetic vision (22).[2] Kinaesthetic vision is the vision that we use in the world. It is our supplementation of the basic optical data of vision. Kinaesthetic vision is what the artwork strives to emulate. Painterly vision is vision interpreted kinaesthetically. The successful artist, according to Hildebrand, possesses the ability to manipulate lines, curves, shapes, colors, on the basis of an understanding of the physiology of perception and the workings of the mind. The artist does this, in order to produce in the viewer a sense of volume, a sense of movement and a hint of time passing. The visual arts suggest lines of movement in their very matter of composition, be that the graphic outline, the shifting densities of chiaroscuro or the eye-directing distribution of forms throughout the volume of a painting. Kinaesthetic vision is vision in movement and time, apprehending movement and time through movement and time. This kinaesthetic vision depends on the multiplication of perspectives to observe an entity in its three-dimensionality. This kinaesthetic vision does not allow something to be glimpsed all at once, but works through time, building up a series of successive impressions. The complex space of figure and ground, stillness combined with immobility, and the time-based concepts of perceptual delay and

fusion of afterimages are aspects that were explored in the various types of perceptual research in this epoch. Such theories of vision, drawn out at the beginnings of cinema, intimate some of what will be understood as film's structuring modes: time-based vision, a succession of impressions, a multiplicity of perspectives, a mobilized gaze. Worked through in the theories of visual perception devised by art historians are notions, such as empathetic projection and kinaesthetic vision, which segue with the new experiences brought into being by optical technologies of leisure.

Hildebrand's theory posited a visual tussle between the flatness of the purely optical and the three-dimensionality of the viewed scenario situated in time and space. The successful work marries 'vital functioning', that is movement through time and space, with 'spatial unity', that is an optically plausible world (17). Hildebrand's discussions weave around two- and three-dimensionality, around the construction of an image of space and the ways in which art forms might 'stimulate spatial ideas in us' (55). A discussion of the sometimes poorly managed manipulation of spatial illusioning in panoramas (which leads to dizziness and nausea) sets out the stakes of mediating between visions of depth and distance in nature and artworks (62). The viewer is part of the arrangement: everything depends upon the 'vitalizing force of our ideas' (104). The conception of space as layered, action situated in space and time, the possibility of suggesting a past, a present and a future: these themes all pertinent to Hildebrand's discussions become practical, technical matters in Reynaud. Reynaud's layering and attempted connection of background and foreground and his development of time into sequences of actions operate within a similarly delineated field: his means constitute his technical fixes, in order to approximate an experience of reality. However distant the worlds of high art and popular visual culture, the desire to recreate the mobile and time-bound elements of perception are common to both.

moving lines, still lines

The line that implies movement is deployed to startling effect in Will H. Bradley's print of Loïe Fuller dancing. Published in an issue of *Chap-Book* in December 1894, the black-and-white image drew the dancer as a swirl of lines. Fuller was a sensation in late nineteenth century culture. She let the fabric draping her body be the surface for magic lantern projections. She flung around her meter after meter of crepe de Chine, which twirled and let through the light. What her serpentine and butterfly dances represented was 'an art of motion', a continual overcoming of staticness, which retained moments of stillness in order to re-persuade the audience again and again of the wonders of mobility. The poet Stéphane Mallarmé described her as a "phantasmagoria of dusk and grotto" (1945: 308).

Henri de Toulouse-Lautrec intimated this twinkling evanescence in color lithographs of Fuller, a fuzz of splattered ink blot, dusted in gold and silver powder to reflect the light. Fuller froze her fabric into the shapes of orchids, clouds, butterflies, and later, more and more abstractly, she evoked snowstorms or rippling water. Fuller was motion. Or more precisely, Fuller was rapid successions of fixed images, each superimposing swiftly on the last. Bradley's drawing of Fuller, entitled *The Serpentine Dance*, is a swirl of curves in black and white. In the bottom corner, two black-and-white shoed feet are the only indication of the initial source of the motion that it attempts to render. The illustration, like animation so often does too, quivers between abstraction and concretion.

Fuller's mobility and shape-shiftingness—a quality intimate to all animation—was in turn captured by the moving arts of film recording, just as imitators captured it. Edison and Biograph released several versions of a serpentine dance by Annabelle Whitford. One of Edison's could be viewed at the first kinetoscope parlour in London, which opened in October 1894. The Lumière brothers made a film recording of a Fuller-like serpentine dancer in the last years of the nineteenth century. The filming captures 50 seconds of swirl on a wooden stage. Each frame was doused in bold colors by applications of ink directly on film stock. As the dress swooshes, it emanates a succession of colors. Even the colorful surface is enlivened. In such a film and the countless ones like it, the women's bodies disappear, or are simply parts that enable the endless animated flow of material to twist and turn and display its material qualities. At points, the dancer is entirely subsumed by her material. The shapes made by the material imprint on the eye of the viewer, like a series of stills, rapidly superimposing on each other. Stillness converted into movement is the mechanism. Visual fascination in movement and stillness is the machine's output.

Drawing and painting, on the one hand, and filming, on the other, find ways to represent the dynamic flows of the serpentine dance. In one, the artist's line makes efforts to capture lines of motion, to render through them movement in space and time in static form, in the line that seems to billow, in the flows of color that wash beyond any outline and expose that surface as the result of moving gestures. In film, the original movement is recomposed from its static frames, its stillness. Animation, perhaps, at least in its early days, features as a combination of both of these modes. It has the movement that film has, likewise, at the moment of projection. But, as a form of drawing, it is comprised only of lines that appear to move or are moved, or are still. Sometimes a line of force, a line indicating movement, is not invisible, embodied subtly in a stance, as it might be in painting, but rather it is added to the image, as in the speed lines or motion streaks, such as Walt Disney used copiously in *The Tortoise and the Hare* (1935) and, after Disney, Tex Avery.

81

science's moves

It was not just in late-nineteenth century art and animation that an interest developed in the representation of the line of movement, the animate line moving in layered space and through passing time. It was also of interest to the scientific experimentation of the time. Étienne-Jules Marey, for one, broke down movement into its component parts in chronophotography. He superimposed single movements in one frame. Twelve movements were depicted, such as of a beating wing, an acrobat jumping or a figure pole-vaulting. Marey developed his work towards abstraction in the 1890s, devising black suits with white paper strips or reflective metal pieces or dots that caught the light and turned movement into intricate static patternings. Animated lines were arrested and caught in a spatial whirl. Movement and stasis were crucial in the construction of the image. Chronophotography brought out most graphically the relations between movement and stillness, for Marey noted,

> when a machine is in motion, there are certain parts of it which are only visible when they reach their dead points, that is to say, for the brief moment when the direction of movement is changed. And this is also the case with certain movements in man. (Marey 1895: 177)

Movement is blur. It is only in its arrest that something like the mechanism of movement can be seen or represented. Such points of transitions of movement into stasis, or life into death, leave 'the most intense impressions on the sensitised plate', as they last longer. These moments become in Marey's terminology the "positions of visibility" (1895: 179).

Like Hildebrand, but for different reasons, Marey doubted that a photographic capturing of movement as lines caught everything that was pertinent to movement. The moments of immobility that the camera needed to register mobility, but which it also produced as image, scuppered the efforts to render a complete picture of movement. It turned movement only into multiple points of stillness. Marey recognized that, however minutely calibrated his registration of movement was, it missed something. He made efforts to reduce the interstices between each fixed moment. But he could never capture movement in its objective fullness, nor indeed the way in which the eye perceived it. He concluded from this that he had—contra scientific method—produced an imaginative concoction that eliminated time and only partially conveyed the arcs of movement.

> Although chronophotography represents the successive attitudes of a moving object, it affords a very different picture from that which is actually seen by the eye when

looking at the object itself. In each attitude the object appears to be motionless, and movements, which are successively executed, are associated in a series of images, as if they were all being executed at the same moment. The images, therefore, appeal rather to the imagination than to the senses. (Marey 1895: 304)

Far from appreciating the imaginative component of visioning, as had the art historian Hildebrand, Marey cast suspicion on the images, certainly in terms of their value as scientific data. Movement through time is caught only as spatialized registrations. If Marey's images of locomotion in a motion capture suit drew on the death of movement, it could also be said that, with their white lines and dots, they turned living torsos into something reduced, something reminiscent of skeletons. But even more than insinuating that which survives the living self, the lines and points resemble the dots and points that comprise punctuation. Such figurations would find their way into cartoons, where animated punctuation marks— exclamation marks, question marks and the like—as much as any other character might play a role in a story. These punctuation marks might be formed of hooks, batons or walking sticks, or they might simply emanate out of the top of characters' heads (Idea!!,?,!, $), thereby expressing the conceptual through the perceptual. Take Felix the Cat, for example, in *Felix Finds 'Em Fickle* (1924), when the exclamation mark that leaps out of his head, upon seeing an angry bear, is used by Felix as a weapon.

animation and punctuation

It would not have surprised Marx some years earlier in the middle of the nineteenth century to see a being related to or reduced to punctuating marks. What animation began to render in its analysis of the world as lines impelled into movement coincided with Marx's analysis of modern industrialized selfhood as an attenuation of the self. The serpentine dancer elided the self that produced movement, an energetic laboring self, smothering it in fabric and billowing outlines. The factory system was predicated on a depreciation of the self—reduced to 'hands' or even less than that. This was the fate of the self that he had observed and had depicted as the destiny of more and more people in the spreading factory system. Twice in *Grundrisse: der Kritik der Politischen Ökonomie (Foundations of the Critique of Political Economy)*, he used the metaphor of punctuation to describe the status of the human exposed to capitalist relations of production. The first usage, in Notebook IV, written between mid-December 1857 and 22 January 1858, presented the worker beholden to a capitalist to whom he or she has sold labor power. This worker is alienated from the self, from those workers with who he or she is compelled to work and, also, from the product on which he or she labors. The result is that the worker's energetic efforts appear

subservient to and led by an alien will and an alien intelli-
gence—having its *animating unity* elsewhere—as its material
unity appears subordinate to the *objective unity* of the *machin-
ery*, of fixed capital, which, as *animated monster*, objectifies the
scientific idea, and is in fact the coordinator, does not in
any way relate to the individual worker as his instrument,
but rather he himself exists as an animated individual
punctuation mark, as its living isolated accessory. (Marx
1973: 470)

The worker externalizes and sells off to the capitalist his or her physical
and mental vitality, his or her animation. The capitalist, as "animating
unity" (*seelenhafte Einheit*) appropriates and directs these various animated
impulses, in the form of multiple discarded wills, intelligences and sources
of energy. The machine, an "animated monster" (*beseeltes Ungeheuer*), takes
on liveliness and, rather than being the instrument of the worker, reverses
the relation, such that the worker is nothing more than "an animated
individual punctuation mark" (*beseelte einzelne Punktualität*), which is to say, a
moving dot or trembling line, which inhabits a process as its dead point.
The worker performs a function at the end of the line. This punctuation is
but an interruptive moment in time, not an act emergent from workers'
self-directedness. The worker punctuates, which is to say terminates a
process, but in terminating it, enables it to begin again, to repeat and
keep on going. Such punctuation might allow only a looping of the act, a
repetition of the gesture, or, possibly, as literature attests, might allow the
development of a narrative.

In his next notebook, written at the end of January 1858, Marx returned
to the metaphor. He uses the same word, *Punktualität*, to describe the separa-
tion of the "mere free worker" in the capitalist system: it is rendered in the
main English translation as "dot-like isolation" (1973: 485). There is a
formal freedom—the worker is not bound as a serf or slave. This gives a
certain room for maneuver. But the freedom is limited by economic needs.
The dot-like isolation of which Marx writes is real and unreal simultane-
ously. The free worker is isolated, unbound to others, free to sell labor
power to anyone. But the freedom is also illusory: as soon as the worker
enters into a situation of labor, the worker becomes, in actuality, part of a
complex, a collective, a combination of efforts. It is only the abstract—not
concrete—worker who exists prior to and independently of all social
relations. The ensemble of social relations is our matrix. Perhaps the
cartoon could be seen in analogous ways. There is a formal freedom for the
dots and lines—they appear not to be bound to an existing system of
representation, such as realism. These lines and dots could move or be
moved anywhere. They could form anything. They seem to be autono-
mous. But that they form anything at all is the result of a combination of

efforts, including labor power (animator, projectionist), of technological development (optical devices), of architectural development (theaters and cinemas), of audience attention.

In the nineteenth century, an economic system, with its machinery and structures of labor, arises, in which it would appear that those who have nothing to sell but their labor power—their muscle-power, dexterity or brain-power, their energy, in short—become nothing more than moving dots and lines, syncopated to the rhythm of the moving machine. Walter Benjamin would later, in 1931, observe of Mickey Mouse cartoons that their "huge popularity" is simply a result of "the fact that the public recognizes its own life in them" (1999: 545). Marey's chronophotographs, a few decades after Marx's comments, unintentionally, supplied a visual analogue to this modern laboring self, with figures converted into white strips and dots, dancing before the machine. Marey stripped back the volume of bodies moving through space and time. He spatialized time, in fixing a stream of movements as points of light in a single image. Some years later Georg Lukács characterized time in industrial capitalism as spatialized. Since the advent of systems of measurement of time, universally present through the clocks dotted in the urban landscape or attached to pockets and wrists, time is spatialized, which is to say, in its initial manifestations, before digitality, it appears as a disc divided into equal portions, according to whose calibrations industrialized work and life dances. Spatialized time is the time of the machine, made by machines and used by them. For Lukács, such a spatialization is synonymous with reification or alienation of the self, from nature, from other beings, from the output of one's energies:

> time sheds its qualitative, variable, flowing nature; it freezes
> into an exactly delimited, quantifiable continuum filled
> with quantifiable 'things' (the reified, mechanically
> objectified 'performance' of the worker, wholly separated
> from his total human personality): in short it becomes
> space. (Lukács 1972: 90)

Marey's images spatialize time in breaking down movement into calibrated markers for purposes of analysis. It is no surprise that such technologies of light registration and human bodies were soon hitched to discovering fluid economies of time and motion to the advantage of industry, as represented in the time-cycle images of Frank and Lillian Gilbreth. The Gilbreths' time-motion studies devised ways to capture photographically light traces of the lines of movement undertaken in work tasks, in order to decide upon the 'One Best Way', in a quest for labor efficiency (see Brown 2008).

Marey made graphic inscriptions. The graphic, in this case, means a hesitation between image and language, drawing and writing. An image

might be directly legible. A language might need interpretation or transla-
tion. Marey's registrations were visual and verbal, much like a punctuation
mark is too. The graphic took on various shapes in his work, depending on
the mode of capture he employed. In the 1860s, he found ways of register-
ing the pulsations of a heartbeat or muscles or the flapping of a bird's wings
with an adapted myograph and a sphygmograph. Both contraptions linked
a mechanism to a stylus and some smoke-blackened paper. Marey read the
peaks and troughs of the lines that resulted. In a lecture on his practice, in
1867, Marey compared the work of natural science to the work of archaeo-
logists who decipher inscriptions that have been written in an unknown
language (1868: 24). He was recording the unknown language of bodies in
movement, or, as he put it, the language of life itself. It was unknown
because it had not been seen before in this way, broken down into smaller
parts, translated into a continuous graphic representation. In time, Marey
developed photographic means to record movement. Photography: this
was writing in light. Marey wrote in the 1880s of his "methode graphique".
The name underlined the writing or drawing at the base of the method.
His "photographic rifle", from 1882, captured 12 instants of time, at 1/720th
of a second, on a rotating disc behind the lens. It did not register the
continuous flow that the earlier graphing methods caught, as a bird's wing
or the like twitched a stylus on the paper. Transferred to a phenakisto-
scope, the motion could be resynthesized, though not analyzed. To
measure the movement, to capture it mathematically and analytically,
Marey had to lay out the successive movements like letters of a word on a
page, in an effort to display the various phases of the wing's movement and
to emulate roughly the bird's trajectory through space. Later that same
year, Marey invented a photographic contraption that could register time
on the successive images and he incorporated a clock face into the result-
ing images. In 1883, the suit with bright points and lines appeared. The
subject wrote itself across the glass plate, as time translated into the form
of a small wheel of black-and-white spikes, and movement arrested was
laid bare for deciphering.

animated dottiness

Animation, the hand-drawn in particular, transfers its characters into
animated lines and dots inhabiting landscapes of dots and lines and,
sometimes, as in the Felix the Cat series, engaging with animated punctua-
tion marks as props and commentaries.[3] These lines and dots are the
abstracted forms of organic and non-organic entities. They are always a
reduction of the world that appears to the everyday eye in all its colors and
textures. Perhaps Walter Benjamin captures something of the phenome-
nological meaning of this stripping back of the self, this conversion into
sign, when, in 1931, in his notes a conversation about cartoons with two

friends, he observes: "The route taken by Mickey Mouse is more like that of a file in an office than it is like that of a marathon runner" (1999: 545). The animated character is unheroic, banal, like an office file. The file moves short distances at the behest of the slow rhythms of bureaucracy, in an arena devoid of atmosphere. The files, whose modes are said to resemble Mickey Mouse, are periodically placed in filing cabinets according to systems of alphabetic organization. The file and Mickey Mouse are minimal, minimized entities, collations of linguistic signs, reduced human beings, overseen all the way. In 1922, Max Weber's study *Economy and Society* characterized the dehumanized mechanisms of bureaucracy, which are based upon the written documents, or files. These files demand "a staff of subaltern officials and scribes of all sorts" (Weber 1978: 957). Benjamin notes that the audiences of cinema enthusiasts in the early 1930s—characterized by interwar intellectuals in Germany as a white-collar, office-based mass—recognizes its own reduction and alienation in Mickey Mouse and adores him. That is to say, they daily identify with the files, and their interrupted rhythms, that they administer. They recognize their own lives in them, much as later, and more sado-masochistally, Adorno and Horkheimer would observe in his essay on the culture industry from the 1940s, *Enlightenment as Mass Deception*, that Donald Duck must always be seen to be beaten (1995: 138). The lesson is taught that life is about taking your punishment and laughing at the misfortune of others.

The self is bureaucratized, written up, made into a case file. The self as a graphic, to be read, analyzed; the self as a punctuation mark at the end of sentences that are composed by others. These are the figures that are proposed from various quarters in the heart of the industrialized and bureaucratized cities in the epoch of capitalist modernity. The punctuation mark is an interruption of a flow. The office file is captured by the glare of bureaucracy and lands on desk after desk. The fluid motion of the living body is broken down into frozen moments photographically. Marey pointed to a certain kind of stop–startingness that was revealed by chronography and chronophotography. In his studies of humans running, he noted that locomotion is, once registered and scrutinized, shown to be an ambivalent act. Running is comprised of contact with the ground and suspension in the air: "The periods of contact are short, and separated from one another by intervals during which neither foot is in contact with the ground—a period of suspension" (Marey 1895: 8). He concludes from this that "one of the characteristics of running, and even of walking, is to maintain a continuous position of unstable equilibrium" (1895: 172). The figure who lives is hesitant between movement and stillness, balance and tumbling. This only becomes fully legible once recorded photographically. It only becomes fully thinkable once recorded and thereby makes itself available to become emblematic of something else.

Unstable equilibrium is just one figure of stopping and starting that appears out of analytical observation in this period. Analysts of perception registered—and later recorded—just such a movement in relation to eye movements. Ophthalmologists observing the eye movements of people reading silently noted a continual jerkiness (Wade et al. 2003: 793–804). The eye wobbles constantly in small jerky movements, saccades, punctuated by stops, or fixations. As Alexander Crum Brown put it in his Robert Boyle lecture of 1895:

> We fancy that we can move our eyes uniformly, that by a continuous motion like that of a telescope we can move our eyes along the sky-line in the landscape or the cornice of a room, but we are wrong in this. However determinedly we try to do so, what actually happens is that our eyes move like the seconds hand of a watch, a jerk and a little pause, another jerk and so on; only our eyes are not so regular, the jerks are sometimes of greater, sometimes of less, angular amount, and the pauses vary in duration, although, unless we make an effort, they are always short. During the jerks we practically do not see at all, so that we have before us not a moving panorama, but a series of fixed pictures of the same fixed things, which succeed one another rapidly. (Brown 1895: 4–5)

Brown evoked the image of a clock face. Our eyes become its second hands moving with a judder around its disc, syncopated with a somewhat flexible time. From the 1870s onwards scientists had observed saccadic movements of the eye. Ewald Hering, a German scientist of color vision and spatial perception, even heard them. He placed a tiny listening device, like a stethoscope by the eyes, in order to hear the sounds of the ocular muscles and noted in 1879:

> The momentary sounds are demonstrably the conse- quence of unintentional, jerky movements of the eyeballs. When attending to the continuous sounds, one is not at all conscious that the eyes are constantly engaged in this restless activity, and especially not that their movements occur jerkily. If one fixates a point quite steadily, then the momentary sounds disappear, only reappearing as soon as fatigue or temporary inattention results in further move- ments of the eyeballs. (Hering, quoted in Tatler 2003: 177)

Louis-Emile Javal did most to forward the recognition of a discontinuity of eye movements as the normal operation of the eye. The term saccade derived from the rapid movements of a horse's body during dressage, the sort of movements that the photography of one such as Eadweard

Muybridge would fix in his serial photography (Wade 2005: 150). In the late 1870s, Javal analyzed the operations of the eye while reading. Watching the eye as it read was not enough and he considered attaching a feather to the eye so that movements could be recorded on a smoked drum (Wade 2005: 149).

Many wrote about eye movements in relation to the traditional technology of the book, including those such as Raymond Dodge and Benno Erdmann who took this science of eye movement into the twentieth century. This was an epoch in which various optical machines developed that depended on stop–startingness for capturing and resynthesizing a flow of images. Across this same period, Reynaud adapted his Praxinoscope from 1877 into a projector at a size suitable for presentation to a large audience, in order to show *Pauvre Pierrot* in the 1890s. A mode of viewing meets a technological form, film, especially in the guises of the various forms of animation that crowd early cinema, based on saccades and fixations, on starting and stopping, movement and stillness, on stillness animated into life, on the jerkiness of sudden movement that always falls back into stillness, on mobility and its impediment, energy and rest, repetition of sheer movement, every again starting and stopping and re-showing. The optical devices that synthesized or re-synthesized movement relied upon a flaw inherent in vision: that viewers do not, at a certain hertz, see the gaps between the still frames, which allow the snatched moments of time to be restrung through flicker fusion.

By the early 1920s, devices had been invented that could register eye-movements cinematically. In the work of Guy Buswell and Charles Judd, a beam of light was reflected onto a reading subject's cornea from silvered glass mirrors and then, through a camera lens, onto moving kinetoscope film. The shifts in position of the light beam were recorded on the film strip, showing the position and duration of each fixation of the eye. Cinema provided evidence of the stops and starts of the eye, as it provided a surface on which this movement and non-movement could be converted in light lines. Such are the experiments of science. And the science of experiments might argue that it moves according to its own logic, has its own dead-ends and breakthroughs. It stops and starts. Curious only is it to note that the model of eye movements, their stops and starts, occur at just the time when stop-startingness emerges as a type of sensibility and as a mode of technological performance.

If the saccadic might be seen as a kind of oscillation, a tremble, a phrase that Walter Benjamin took from Gottfried Keller's poem *Verlorenes Recht, Verlorenes Glück* (Lost Right, Lost Happiness) comes to mind—'petrified unrest' (2002: 319). It proposes in one and the same breath stillness and movement, the static and the fizzing. Benjamin used this phrase to describe two things: the melancholy cosmology of jaded revolutionary vanguardist Louis-Auguste Blanqui (1805–1881) and the life history of the progenitor of

the avant garde Charles Baudelaire (1821–1867). According to Benjamin, for Blanqui, towards the end of his life, after years in prison and years of failed revolution, petrified unrest presents itself as the state of the cosmos. The world is a place of frenetic activity in which nothing ever happens, an eternal return of the ever-same. Everything is ruined. This is modern time—it promises progress, movement, but it is stuck in repetition. All is stasis. Benjamin's petrified unrest also describes Baudelaire's life history: the repetitions that he engaged in, ever again going to market, ever again falling back, ever again gambling, ever again living but frozen into place, like the stars and knowing no development (2003: 171). This, argues Benjamin, is an allegory for the doomed and damning forces of capitalism, a world space in which there is only the endless production of commodities, be they shoes or poems or animations. He diagnoses it as an effect of the post-revolutionary bourgeoisie's lack of interest in the fate of the productive forces it has unleashed. It requires a repetition of the conditions of production. Keller's poem associates 'petrified unrest' with the gaze of a Medusa, arresting the passage of time, the movement of all caught in her glare. In *Berlin Chronicle*, Benjamin reflects on "the most fascinating ring" he ever saw. It was from the Roman imperial period and showed a Medusa's head cut from a garnet. It was best viewed by holding it up to the light.

> As the different strata were unequally translucent, and the thinnest so transparent that it glowed with rose hues, the somber bodies of the snake seemed to rise above the two deep, glowing eyes, which looked out from a face that, in the purple-black portions of the cheeks, receded once more into the night. (Benjamin 1999: 616)

There is something reminiscent of mechanical optical culture here. The ring lets the light stream through in order to make its features seen. And as for Hildebrand and Riegl and the other art theorists of vision, here the concern is with layers, with depth and recession, and time—day turns into night—on the more or less flat and static surface. The sight that turns all that see her to stone, catches them in their petrified unrest, is itself like those screens of petrified unrest born, like Benjamin, in the 1890s. Petrified unrest, once captured as an image, as an allegory, as an emblem, exposes something—perhaps unintentional—to knowledge.

In Reynaud's *Pauvre Pierrot*, the viewer sees a composite animation, with a background and foreground, or, in other, art historical terms, a figure and a ground. The two planes exist, to some extent, independently of each other. This does not mean that they are discrete. The figure and the ground co-exist in space, but each has a space for itself. Each also has its own time too. While the background is almost static, timeless, the foreground is speedy or fleeting. Occupying two times and two spaces, the layers exist

indifferently to each other. They share a space but have a space to themselves. They exist at the same time, but each has its own tempo. Such diremption was not intended by the animator, who sought as best he could to suggest a three-dimensional world with its same apparently uniform volume and tempo. Yet the mobile figures move but seem ungrounded in their ground. They do not stand with their feet on solid ground. They float over the background. In fact, the figures are not fully there. The background shines through them slightly (or is visibly overlaid on them), making them ghostlike. These phantoms shudder a little as they move. They are never still—not just because of the movements that we are supposed to believe are their own self-motivated ones, but because of the jitter that occurs between the images that flash past and superimpose on one another. The figures float and flow in permanent motion. The background is held immobile. Frenetic, restless activity takes place in a petrified environment. Such a style of composition holds sway for a long time in animated culture, for it is one of the mechanisms used to industrialize drawn animation, as in John Randolph Bray's 1914-patented method of placing a translucent 'background' over a character drawing. Backgrounds are static, or repetitive (of course this can also extend to foregrounds in various modes of labor-saving limited animation). Figures move, or at least parts of them move, and, in their moving, they progress a story or a gag. What the audience might perceive too in the luminous pantomimes, as later in the cartoons, is the combination, in one vista, of stillness, or punctuation, and movement, or animation. *Gertie the Dinosaur* (1912), drawn by Winsor McCay, lumbered through a static landscape, which had been retraced by hand for each shot. The foibles of the hand meant that the static background wiggled and wobbled slightly. In the years that followed, Betty Boop, Bobby Bumps and Koko the Clown and the rest would shimmy through stilled landscapes that had been laid to rest with the minimum effort possible. There is that active, jittering, figure moving through space—cipher for the self—and there is the world, this cumbersome, unmoveable, even intractable environment, amongst whose edges and shapes the mobile self is compelled to exist. The luminous pantomime, the animated strip reveals more than might be imagined.

Optical entertainment develops in the latter part of the nineteenth century with the promise of development, of non-repetition, of full-bodiedness, the simulation of life. From Reynaud onwards, the animated body has seeming fullness, the animated world has a quasi-three-dimensionality, the storyline develops the non-repeatability that life itself has. In time, these elements will pervade. Most film now incorporates animated aspects, through Computer Generated Imagery, in order to conjure dreamt reality. Conversely, this animated culture, pushes into new forms of repetition, such as repeated backgrounds or segments or the deployment of cliché in the place of innovation, and new forms of disembodiment.

Animation's petrified unrest is a formal sign of its ambivalent renderings of the real—it is stuck in a form of life and world simulation, which can be read symptomatically—or critically—as an inability to move on socially, to sketch out new lives and worlds. In early optical culture it is still possible to discern something of the future possible that comes into being. For all the spin around liveliness, depth, development, it is what it is—a movement mobilized by the machine and a vision of the self as nothing but a mark, a dot, a line.

notes

1. For a discussion of circularity in optical devices, see Dulac and Gaudreault 2006.
2. Laura U. Marks discusses the relationship between film spectatorship and theories of tactile, kinaesthetic and proprioceptive theories of vision—known as 'haptic' vision— predominantly in relation to art historian Alois Riegl in Marks 2000.
3. This practice finds a continuity in video gaming where, for example, colored exclamation marks appear above characters' heads, in *Pokemon*, *Warcraft*, *Paper Mario* and so on, to indicate they have been spied or suchlike.

references

Adorno, Theodor W., and Max Horkheimer. 1995. *Dialectic of Enlightenment*. London: Verso.

Auzel, Dominique. 1992. *Emile Reynaud et l'image s'anima*. Paris: Du May.

Benjamin, Walter. 1999. *Selected Writings, 1931–34*. Cambridge, MA: Belknap Press of Harvard University Press.

——— 2002. *Arcades Project*. Cambridge, MA: Belknap Press of Harvard University Press.

——— 2003. *Selected Writings, 1938–1940*. Cambridge, MA: Belknap Press of Harvard University Press.

Brown, Alexander Crum. 1895. *The Relation between the Movements of the Eyes and the Movements of the Head*. London: Henry Frowde.

Brown, Elspeth H. 2008. *The Corporate Eye: Photography and the Rationalization of American Commercial Culture, 1884–1929*. Baltimore: Johns Hopkins University Press.

Dulac, Nicolas and André Gaudreault. 2006. Circularity and Repetition at the Heart of the Attraction: Optical Toys and the Emergence of a New Cultural Series. In *The Cinema of Attractions Reloaded*, ed. Wanda Strauven. Amsterdam: Amsterdam University Press.

von Hildebrand, Adolf. 1907. *The Problem of Form in Painting*. New York: GE Stechert and Co.

Lukács, Georg. 1972. *History and Class Consciousness: Studies in Marxist Dialectics*, Cambridge, MA: MIT Press.

Mallarmé, Stéphane. 1945. *Oeuvre completes*. Paris: Gallimard.

Marey, Etienne-Jules. 1868. *Du mouvement dans les functions de la vie: Leçon faites au College de France*. Paris: Germer Baillière.

——— 1895. *Movement*. Trans. Eric Pritchard. London: William Heinemann.

Marks, Laura, U. 2000. *The Skin of the Film: Intercultural Cinema, Embodiment and the Senses*. Durham: Duke University Press.

Marx, Karl. 1973. *Grundrisse, Foundations of the Critique of Political Economy*. Harmondsworth: Penguin.

Myrent, Glenn. 1989. Emile Reynaud: First Motion Picture Cartoonist. *Film History*, Vol. 3, No. 3: 191–202.

Schwartz, Vanessa. 1999. *Spectacular Realities: Early Mass Culture in Fin-de-siècle Paris*. Berkeley: University of California Press.

Tatler, Benjamin and Nicholas Wade. 2003. On nystagmus, saccades, and fixations. *Perception*, Vol. 32: 167–184.

Wade, Nicholas J., Benjamin Tatler and Dieter Heller. 2003. Dodge-ing the issue: Dodge, Javal, Hering, and the measurement of saccades in eye-movement research. *Perception* Vol. 32: 793–804.

Wade, Nicholas. 2005. *Perception and Illusion*. New York: Springer.

Weber, Max. 1978. *Economy and Society: An Outline of Interpretive Sociology*. Vol. 2. Berkeley: University of California Press.

ecocritique and

the materialities

of animation

f o u r

s e a n c u b i t t

introduction

Ecocriticism has, in general, limited itself to a hermeneutics of texts with more or less explicit environmental themes. But if ecological criticism is to live up to its name, it needs to embrace not just aesthetics, ethics and the interpretation of texts, but analysis of the environmental responsibilities of material media. Nor should this theme privilege non-human environments. This chapter addresses how animations represent ecologies and ecological relationships, and how those who work in animation can be included in a critical project that takes on the name 'ecological'.

The planetary ecology is deeply affected by anthropogenic change and human history. Climate and food chains involve everyone: cities are landscapes filled with animals, insects, and organic processes just like the countryside, which too is full of human activity. Technological forms are deeply implicated in weather, food and landscape formation, as are media technologies and the practices and techniques that employ them. The present chapter tests the thesis that technologies and techniques of

animation express social constructions of the human–natural relation, quite as deeply as they express the political economy or gender relations explored in Marxist and feminist critiques. Ecocritique should be no less ambitious. Historical analysis is especially relevant because the transitions from industrial to information capital, and from disciplinary to biopolitical government, are not only expressed in media formations but are carried out through—mediated by—evolving media forms. It is this history of the mediation of environmental politics through the material media of animation that occupies this contribution to animation studies and ecocritique.

All animation, including animation pre-dating the invention of cinema, requires only two raw materials: light and time. But each form requires other media. In this chapter, I concentrate on visual media, though sound is an integral part of most animation and deserves a parallel account. Animation's visual media include everything that has been used to create visual art and communication from charcoal to software, with many techniques, such as puppetry, developed in the 'deep time' (Zielinski 2006) of animation. The history of these media must include histories of their extraction from the environment, manufacture, use and recycling. This is equally true of charcoal made from ivory as it is of mining rare earths for computers; of the toxicity of the white lead used by the old masters as it is of the arsenic used in doping chips; and of recycling silver from redundant film stock as of lithium from discarded batteries. In this history, human energy can be budgeted in the same terms as water, wind, steam and electric power, with comparable environmental effects.

Animation techniques are highly material in an environmental sense, as well as in terms of labor and toxicology. But *animation* asks us to consider aesthetic form. Form itself is material in the broad scientific sense of the word 'in*form*ation': animation orders light and time through material practices against the entropic principle of the Second Law of Thermodynamics, according to which both energy and order run down over time. In giving form, animation draws on a history of formative activities enshrined in language and technology. Like language, technology enshrines in material form the practical knowledge of our ancestors. This is what Karl Marx calls 'dead labour' ("the accumulation of knowledge and skill of the productive forces of the social brain … absorbed into capital", Marx 1973: 694). But like language, technology is subject to evolution, and like language and perhaps even more so, it evolves according to the demands of the age. Animation technologies are no exception.

Breathing life into the spirits of the dead—not least those entombed in our machines—is as general a definition of animation as might be desired. Like our relationship with the environment, our relations with the dead have undergone historical transformations. I suggest that there have been three major modes of animation technology: direct, pro-filmic, and vector. I will argue that these modes correspond to particular constructions of the

human-environment relation. Moreover, each mode corresponds to large scale historical shifts relating to the construction of the human. The chapter opens with a discussion of evolving forms of animation as *techne*, as technology and technique, before opening these material practices of mediation to ecocritical analysis.

direct animation

Direct animation describes practices that involve direct action on the medium. It is the oldest form of animation, though it persists in the technique of working directly on the film strip (Len Lye, Stan Brakhage, Barbel Neubauer) or videotape (Nam June Paik, Joan Jonas). Such vanguard practices reprise the oldest forms of animation: shadows from firelight, walking by torchlight through the illuminated cave, puppetry. We can have little idea of the meanings of the earliest animations, only that they existed. Their record appears already thoroughly criticized in accounts such as Plato's unmistakable description of a shadow theater in *The Republic*'s myth of the Cave (Plato 2004: Bk VII). A problem, we might surmise, for Plato, is the coincidence of a real object—a hand playing the part of a puppet, say—with the thing it represents. This ontological hybridity was certainly anathema to the accounts of poetry and painting in *The Republic* (Plato 2004: Bk X). Yet there is another ontological property that Plato, tellingly, does not dispute, which is the coincidence of the movement of the real thing with the movement of what it represents. This is as true of a sock-puppet as it is of scratching or painting directly onto the surface of film. In direct animation, motion is unified: what we perceive, the medium and the movement depicted in the medium, are all of a kind, whether performed live or built into some form of photochemical or digital storage. This unity at first and for the bulk of human history belonged to performance. Complicit with the ephemerality of performance, and in the form of masks, mimes and other non-representational forms, in many senses the essential art of movement in the centuries prior to industrialization, live direct animation lives in real time.

It is easy to romanticize the closeness to nature of our ancestors, and to over-simplify the changing social and media forms through which they lived. This capacity of direct animation, to unify the movement of the medium with the movement of what it represents, belongs with sympathetic magic, which attempts to control the excessive meaning of the world, and its violence, by picturing and narrating it. In this art, the fundamental relationship underlying performance is the coincidence—Frazer (1922: Ch. 3, s.3) would call it 'contagion'—of environmental and human time, time of objects and time of the depicted. This stabilization of temporalities is the medium through which communication with ancestors or rivers or animals could be effected. It is probable that for much of this history, the

relation between human and environment was antagonistic: gods overcame forests and seas or succumbed to them. But the struggle could continue, and the end always be postponed, by maintaining the mediation of direct animation as terrain on which the conflict could be enacted.

When cinema first embraced animation, it did so as recordings of pro-filmic events, events set up for the lens. But direct animation was never far away. When it returned as action on the film strip, it was often in association with the more mystical and visionary proponents of the art, like Brakhage in the cycle *Dog Star Man* (1961–4) for example, with its explicitly ecological themes (Cubitt 2011) and in his likewise explicitly ecological *Mothlight* (1963). This evocation of the cosmic labors at the same coincidence of temporalities that has always defined direct animation: the time of the marks is the time of their projection, and the two cannot be deciphered or distinguished as separate entities in different times. Though inspection of the film strip of *Mothlight* demonstrates the process of its making and the structures of the component leaves, insect wings and garden bric-a-brac from which it was composed, it says nothing of the fluttering, the fatal attraction of light, the ephemerality of life at all scales, that we experience in the projected film. Similarly, inspecting the 8 mm film strip of *Dog Star Man* does not reveal the nuances of emulsion scars, or permit the viewer to parse the relation between these scratched passages and the found footage of solar flares at other junctures in the film, or the passage from macro- to micro-scale, or the co-temporality of cosmic events and events in the leaf-mould of the forest floor. While some direct animation leans towards the more purely formalist concerns of structural-materialist cinema (the late George Landow/Owen Land's *Film In Which There Appear Edge Lettering, Sprocket Holes, Dirt Particles, Etc* (1965–66) or Tony Conrad's 1966 *The Flicker*), even here the simultaneity of the film with its presentation, of the objects of animation and the medium of animation, are of the essence, even though the self-reflexive and abstract motifs appear to have little interest in the question of the co-presence of human and environment.

The structural-materialist variant of direct animation emphasizes a crucial element of this oldest mode of animation: its faithfulness to materials. Just as the modernist principle of truth to materials informed the early twentieth century rediscovery of 'primitive' art, animators would find in direct animation a means to close the gap between representation and represented. Where once this had appeared magical, now it appeared ontological, while at the same time directing attention to the central fact of film itself considered as material practice: "light moving in time" (Wees 1992). The scratched emulsion made art from the layers of tripack film, and from the judder inherent in the intermittent motion of the film strip passing the lens under control of the Maltese cross. So direct cinema lived out the contradiction between the presence of the film and the presence of what it depicted as a property of the material process of film-making.

97

Such films, and with them such masterpieces of direct animation as Len Lye's 1937 *Trade Tattoo*, speak to the evolving mediation of the human-environment relation. During the industrial revolution, of which cinematography is the prototypical and in many respects the highest expression, technology began to move from the human side of the divide to the environmental. Technology, as Marx observed in the "Fragment on Machines" in the *Grundrisse* (Marx 1973: 690–711), came to stand over against the men who used it in factories. This relation was very different to the relation between tools and artisans in earlier modes of production, of the kind celebrated nostalgically by Heidegger (1977). It is to this passage of technology to the industrial 'other' of humanity that is expressed in Landow, Conrad and Lye's films, an assertion of the co-temporality of the human artist (and by implication the viewer) with the newly reformulated 'second nature' of the technological universe. Nowhere is this more explicit than in Lye's *Trade Tattoo*, with its mixture of direct and pro-filmic techniques, whose opening frames animate the phrase, "The rhythm of work-a-day Britain", redeploying Griersonian populism towards an assertion that the working class should aspire, along classical socialist lines, to the ownership of the means of production, a theme also strongly evoked in Gramsci's writings on Fordism (1971), where the unity of workers and machines was a triumphant theme of an innovative, modernist communism. Lye's combination of photography with direct animation seems to enact exactly this utopian unity of human and technological.

pro-filmic animation

If direct animation was the utopian solution—or in later avant-gardes the impossible alternative—to capitalist alienation, pro-filmic animators celebrated that alienation, or worked within its contradictions, to exploit the uncanny liveliness of the cinematic machinery and its static objects. This was the era of objects placed before the lens—drawings (Walt Disney), household items (Emile Cohl), models (Ray Harryhausen), plasticine (Nick Park), pinboards (Parker and Alexeieff), puppets (Jiří Trnka)—all static objects only animated in the motion of the film strip. Here all motion belongs to the apparatus of recording and playback, and to the swift gaze, appropriate to machine-minders, capable of constructing sense out of the hurtling fragments of edited film.

Paradoxically, it is in direct animation that we are most aware of the individual frames. Since the sudden flurry of patents registered in the USA during 1914 geared towards the North American industrialization of cartoon production and the eradication of flicker and judder in animated films, pro-filmic animation settled into an aesthetic of continuity, paralleling the earlier softening of the jarring flicker of pioneer cinema (Burch 1990: 186–201). Direct animation maintains the eternal presence of flux, the

mythic time of undifferentiated perception. This eternal present is the pure expression of subjectivity as experience, a phenomenological and unending becoming shared by the world and our consciousness of it. Pro-filmic animation, orienting the viewer towards the object placed in front of the lens rather than the subject behind it, depends upon differentiating subject from object, and objects from one another. It is characteristically engaged in the motion of figures against grounds, and constructs its typical sequence as a set of causal relations, distinguishing before from after. These distinctions may respect the normal laws of physics and social norms, or they may rebel against them, for example in the magic cinema of Méliès or the anarchy of Felix the Cat, but they operate constantly in the differentia-tion of the film strip from what it portrays. Since this is by far the largest and most familiar form of moving image animation, selecting examples is difficult and unlikely to prove its case. While direct animation is most often artisanal in its mode of production, ready to take apart the apparatus and put it back together in another form, and is often freely gestural, the typical form of pro-filmic animation, at least after the pioneering works of Cohl and Blackton, was increasingly studio-based, with strong division of labor between key-framers and in-betweeners, lead character animators and background artists, inkers and colorists. Especially in the industrial studios of the USA and Japan, the aesthetic lent itself to the modern factory mode of production, with artists placed in a larger production machine in which their individual part was synchronized with the work of others in the chain. This led to such major outbursts of industrial action as the Disney strike (Sito 2006: 101–52) and to the ongoing history of troubled labor relations in the animation industry (Lent 2010). Hierarchical and production line work relations are isomorphic with the typically causal narratives and with the hierarchies visible in the concentration of composi-tions and editing around central characters. These formal characteristics are as visible in the constant foregrounding of Mickey Mouse in 1930s Silly Symphonies as they are in the inventive play on symmetry in compositions for Hayao Miyazake's *Princess Mononoke* (1997).

The 'cartoon look' is premised on the bounding line; and techniques like using saturated color for foreground figures and pale washes for backgrounds amplify the process of distinguishing elements that charac-terizes the pro-filmic mode. The same is true of variants on parallax depth effects, such as the juxtaposition of still and moving elements, as in Lotte Reininger's *Die Abenteuer des Prinzen Achmed* (*Adventures of Prince Achmed*) (1926), as well as many contemporary anime. Similarly differentiation of sharp and soft focus provides distinctions in depth and hierarchic relations in stop-motion narrative films like *Wallace & Gromit: The Curse of the Were-Rabbit* (2006). As André Bazin (1971: 16–40) argued of the use of selective focus in cinema more generally, these techniques guide and structure the viewer's experience of the film, restricting that freedom to range over the whole

frame that his beloved deep-focus and long-take realism aspired to. They are, in short, methods of power.

The most significant of these techniques from an ecocritical perspective are those used to separate figure from ground. In devices like Disney's multiplane camera (Langer 1992), the drawn environment of the diegetic world is placed behind or in front of the active protagonists. Even though these might include dancing flowers or teacups, and in sophisticated examples like *Snow White and the Seven Dwarfs* (1938) interactions between them and the protagonist, the power of narrative action is restricted to the discrete plane of the main character, acted out against an environment that is palpably separate from them. To the extent that these backgrounds are often depictions of wilderness, countryside or gardens, they express the alienation brought about in a much earlier phase of modernity: the feudal enclosures that separated the peasantry from the land that was once held in common (and the later colonial movements that achieved the same thing by destroying indigenous structures of common stewardship). But they also correspond, especially in their mode of production, to the alienation of skill. However, where the Fordist factory had entirely wrested the tool from the hand, that process remained incomplete in the animation industry's dependence on high levels of manual dexterity, even as it sought to suborn them to the industrial discipline of tight production schedules. It is this contradictory remainder from earlier formations of work practice that inform the anarchic humor that we find so charming and joyous in the classical cartoon, and that forms the poetry of work like Lotte Reininger's in the same period.

Clearly, to make such generalizations is to miss the specific attractions and virtues, the intimate and particular aesthetics, of specific animations. One of the most justly celebrated examples of pro-filmic animation from the studio era, Chuck Jones' 1953 *Duck Amuck* is in many respects a standard product of the time: flush with Technicolor, it shows a series of gags focused on an established character, in a narrative which demonstrates the privilege of absolute rule. Yet it is also both a compendium of film technique, and an almost Brechtian reflection on the dominant form of cel animation and the sadism (and incipient horror—think of the sequence when Daffy is about to be buried alive in black goo) of certain modes of slapstick and physical comedy. The 7-minute cartoon format provided a frame as rigid as the 3-minute pop song or the 14-line sonnet. Within those boundaries, however, fantastic invention and variety are possible. And yet, the frame remains as a media form in its own right, shaping whatever is poured into it, and carrying its own significance. The specificity of *Duck Amuck* should not, therefore, deter us from attending to the specificity of the form that it employs and parodies. Indeed, we need to understand, as in the case of the pop song and the sonnet, the internal contradictions of the form that not only permit but encourage invention and variety.

Thus for example, despite the evolution by 1956 of powerful legal protection for patents, the Technicolor dyes used in the imbibition printing process were never patented, by Technicolor or its major supplier Dupont, and instead appear to have been trade secrets, of a kind maintained as far back as the origins of mediaeval craft guilds. The coexistence of such ancient forms of exclusivity, with all their sacerdotal and sovereign connotations, with the ebullient modernity—and anarchic parody of Foucauldian disciplinarity—of Jones' film is just one of the contradictions governing its peculiarly scandalous humor.

These are tendencies rather than absolute boundaries. Thus, Alexandre Alexeïeff and Claire Parker's 1933 pinscreen animation *Nuit sur le mont chauve* (*Night on Bald Mountain*) in many ways resembles Daniel Rozin's contemporary interactive woodblock, woven and other physical mirrors (**See Figure 4.1** and http://www.smoothware.com/danny/). But Rozin's work is clearly an example of direct animation, responding in real time to the actions of its interactors, where the pinscreen of *Nuit* is equally clearly profilmic, an object registered and recorded, its delightful textures a bold technical innovation within the pro-filmic tradition, but still within it, rather than apart from it. It is notable that both works operate on the principle of pixels:

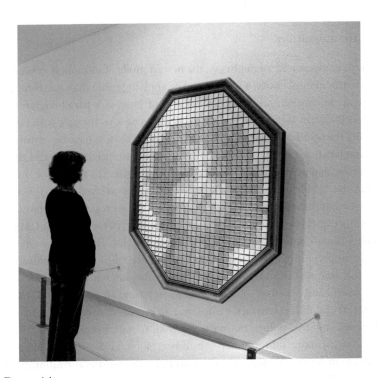

Figure 4.1
Danny Rozin, real-time animation. Wooden Mirror at Israel Museum.
Courtesy bitforms gallery and ITP- NYU.

comprising a grid of points or blocks of light and shade whose varying states of illumination provide the picture.

Tracing the origin of the grid, from Cartesian mathematics to the computer display, is beyond the scope of the present chapter. Suffice it to say that the pixel grid has taken increasingly rigid command of electronic imaging since the cathode ray tube, becoming gradually more and more defined and ubiquitous in its columns and rows. The near-random placing of Alexeïeff and Parker's pins contrast with the formal rectilinearity of contemporary raster displays, much as film's random spatter of light-sensitive molecules contrast with the strict mathematical architecture of camera chips and digital displays. The raster or bitmap has one or two unusual qualities: its love of straight lines (diagonals exhibit 'jaggies', traces of the underlying grid), and its use of whole numbers to calculate the correct condition of each rectangular pixel. As cinemas moves increasingly to Digital Light Programming (DLP) and other forms of data projection, even animations made on film, with its chaotic crawl of silver halide molecules, are constrained to match the requirements of the near-universal condition of digital display, which in turn is the increasingly ubiquitous form of screens. But it would be inaccurate to suggest that all digital animation is bitmap.

vector animation

Vector animation is, we might say, the newest mode of animation. A vector is a mathematical entity, a line created by applying more than one force to a point in motion, an animated version of Newton's parallelogram of forces (Newton 1846: 103–05). The forces acting on a vector vary with time, giving the resulting line curvature and flexibility. Vectors have two unusual characteristics: they have direction, that is an existence in time; and they can be scaled up or down without exhibiting jaggies. The reason for this is that the vector expresses not a series of points arrayed in space, but movement through space. Unlike the whole number regime of the bitmap, vectors depict the 'real' line, the mathematical term for a line containing infinitesimal continuity. The math is straightforward. The whole or count-ing numbers move in steps separated by one unit: 1, 2, 3 ... The continuous or real line is comprised of real numbers, also known as infinitesimals. Between 1 and 2 we find 1.1 and 1.2; between 1.1 and 1.2 we find 1.11111 and 1.121111 and 1.221111. In fact, we discover an infinite number of increments between any two points, no matter how close together they come. And of course many infinitesimals—numbers such as π—are themselves infinite in length. Vector animation occupies the temporal continuity of this real line.

It appears in two distinct forms. One of these is the purely gestural mark-making typical of human drawing. A mark made with charcoal,

pencil or brush as a fluid gesture is subjective, in the sense that it belongs to the time of its making, creating a record of the artist's hand and tool moving over a surface. But it is rather more than that. In the artist Paul Klee's expression, the artist 'takes a line for a walk' (Klee 1961: 105), not necessarily to depict an object, but to allow the line its autonomy: to see what happens when the mark proceeds. To honor the temporal dimension of the gestural mark, and its orientation towards a future which remains unknown at the outset, I refer to the vector as neither subjective, in the manner of direct animation, nor objective in the style of the pro-filmic, but projective.

Though it is possible to trace the vector in hybrid form from very early periods in film history, the purest expression is probably Émile Cohl's brief *Fantasmagorie* of 1906. Although Cohl may very likely have seen examples of Blackton's lightning sketch animations (Crafton 1990: 86–87), he had no access to the technical secrets of the American. Instead, he invented a technique of his own. Positioning a camera above a drawing table, he began drawing a line. At a given point he paused to record a single frame with the camera. Erasing part of what he had done so far, he drew some more, took another frame, and so on. Cohl would have made an educated guess as to the timing he needed: he certainly would not have been able to test his results until he had finished the whole sequence of drawing, when the film went off to be developed. The film has become a classic, not least because of the variety of permutations and metamorphoses that Cohl makes his line undergo, transforming from a canon into a flower into a bottle as the whim takes it. Although there are characters, especially a Pierrot-like figure, the main character of the film is the line itself in its constant changes. And although the film has a conclusion, it is more than likely that it was a combination of a common aesthetic sense that things should have endings with the end of the week which, it is recorded, he spent making the film. In its intrinsic future-orientation, the line gives every impression that it could happily continue its magical transmogrifications to infinity.

There are undoubtedly precursors to this autonomous vector in the fine and decorative arts, including Hogarth's 'line of beauty' (Hogarth 1997) or the older sinuous infinities of Islamic art (Marks 2010: 38ff). The vector seems to enter popular culture late in the nineteenth century where it is shaped by the requirements of mass manufacture, only in the twentieth century avant-gardes taking on the abstraction and temporal orientation of the mathematical vector. Thus, the gestural styles of Klee or Jackson Pollock pay no more heed to the figure-ground relation than does Cohl's morphing line, and the sweep and gestural style of craft animators like Ryan Larkin similarly morph particular lines between the two functions, or leave them wholly ambiguous. Ironically, at the same time that the computer display has become almost exclusively bound to the

Cartesian grid, the vector has become the dominant practice in animation, thanks to the popularity of 3D animation software among producers and audiences.

The variety and history of vector animation makes it hard to offer a precise definition. If in contemporary media it is technically describable as geometrical (as opposed to arithmetic), the sense of motion in time, which the term inherits from mathematics and the physical sciences, also suggests that it offers a very particular kind of movement. The motion of vectors inheres neither in the motion of the film strip itself, as in direct animation, nor in the apparent movement of objects placed before the lens and photographed in step-motion, as in pro-filmic animation, but in the inherent movement of forces acting on a moving point, whether those are physical or simply mathematical expressions—algorithms—defining the displacement of a geometrical entity (a line, a surface, even a point) in time. Though they appear the furthest from the cinematography of reality, in one sense, vector animation comes far closer to cinematography, in that the world it envisions exists in the computer entirely apart from the viewpoint from which it is depicted. The creatures in a Pixar film are genuinely three-dimensional as computer models, even if we only ever see them, courtesy of the virtual camera, in two dimensions.

At the same time, the deep history of vectors allies them with the oldest of all human techniques for making pictures, the gesture of the hand and arm as they make a mark, and especially the time of the gesture, encoded in fluid lines, from the caves at Lascaux to Picasso sketches. Few instances of this collision between high technology and human gesture are as lucid as Chris Landreth's NFB animation *Ryan* from 2004 (**See Figure 4.2**). A critical and popular success (it took the Oscar for best animation), *Ryan* is a portrait of the Canadian animator Ryan Larkin, at the time living as a hobo on the streets of Montreal. Landreth uses surreal deformations of 3D vector graphic portraits of his principal characters—including himself—to express emotional and physical trauma and their effects. The soundtrack is largely composed of interviews with Ryan and his associates, friends and lovers in a chiller variant of the technique made famous by Aardman Animation's *Creature Comforts* (1989), the images revealing the half-truths and self-deceptions of the dialogue, though without *Creature Comforts'* humor. Landreth's film includes, in their entirety, two of Larkin's classic animations from the height of his career, meticulously drawn and observed line animations of bodies in motion. Larkin's *Street Musique* (1972) is one of them, a film that begins with live-action footage of street musicians and a dancing passer-by. That footage is rapidly overdrawn, the characters losing their banality along with their solidity in a stylistic transition that acts as a critique of ontological certainty. Like Richard Linklater's *Waking Life* (2001) but with perhaps more empathy for its characters, Larkin's drawings leave behind their photographic models for pencil studies of walking which

themselves migrate into abstract planes of color, at first washes, then saturated swathes. These shifts from medium to medium match the improvisational dance of the older man in a battered hat, smoking and dancing drunkenly with a female member of the group. Lines and color fields transform into figures, landscapes, a pair of trousers, a bathtub, as in Cohl's *Fantasmagorie*. The restless mutation of style into style—and from Larkin's film to Landreth's—echoes the restlessness of the gesture in Larkin's drawings as they dart in what seems to be real time across the frame, fleeting and visionary. The vector is not only a digital technique, nor restricted to a gestural form of mark-making: it is the spirit of an emergent form of mediation, one whose improvisational and temporal direction makes it unforeseeable, and thus able to image a future on the brink of becoming other than the present. Not just the line, but the transition from line to color, line to field, cel to digital animation allow both Larkin and Landreth's films, even as they recount a past, to take on the freedom and openness of doodling, even in the digital passages, because there is no stable or coherent style—such as we tend to find in feature-length digital animations—to anchor the film in a specific ordering of a fictional world. These qualities of vectoral animation place it apart from the increasingly standardized cellular grid that has migrated from platform of pro-filmic animation to a universal vehicle through which any animation must be viewed.

standards and divergences

The three modes of animation—direct, pro-filmic and vector—may be seen as performing different relationships between humans and their environments. Direct animation works at the identity of representing and the medium of representation; the pro-filmic operates on a distinction between subject and its objects; while the vector points towards unstable mediations that place the human gesture in continuity with the emergence of unforeseeable futures. In introducing these three modes of animation, this chapter has focused on their management of time. Equally significant, especially for ecocriticism, are the different ways they construct space. The historical trajectory of the becoming-environment of nature, technology and information involves not only new constructions of time: the time of our relations with each, from seasons to clock-discipline to the millisecond heartbeat of information economies. It involves too the spatial relations of distance and embodiment expressed in different modes of animation.

Direct animation flattens space to the dimensions of the medium: to the plane of the film strip, the shape of the screen, or for that matter the three dimensions (and shadows) of a hand-puppet or shadow-play beyond cinema itself. Movement, as the root of animation, implies movement in and through, and in this case *of* space. It is in this sense that direct animation

is the most ancient form, the prototype of all manipulations of the environment. This spatial identity of the animation and the animated belongs to a deep belief in the magical properties of animation, of breathing soul (*anima*) into the inert, of occupying the skin of an animal and so the forest or mountain where you live, and finally of animating the dead. In this sense Bazin's (1967) claim that cinema is the culmination of an aeons-long human pursuit of immortality meets its first forebear. It would be wrong to claim that pre-cinema means also proto-cinema: that there is no teleological connection is clear from the continuing traditions of puppetry, mime and ritual into our own era, and in our own cultures. Yet the claim Bazin makes, that this is an *ontological* facet of cinema, points us towards a key to the materialities of animation technologies within and beyond the moving image.

First, it makes apparent that the study of pervasive animation should include non-cinematic direct animation in the form of puppets, shadowgraphy, masks, dolls and other toys, and today anthropomorphic or zoomorphic robots. These processes involve us in transmigration of human perception to non-human sources: animators not only observe but become what they animate (Molloy et al. 2012); no wonder such practices led to accusations of witchcraft, and more recently variations on the Frankenstein theme in science fiction, even as characters like Robbie the Robot or Wall-E are presented as cute companions, mechanical pets. Despite residual anthropomorphic characteristics, actually existing robots are rarely built in organic forms, constructed instead to replace humans, very often whole teams of humans, from the factory floor. Such robots, we

Figure 4.2

Chris Landreth, emergent mediation. *Ryan*, Chris Landreth, 2004.
Courtesy of Chris Landreth and the National Film Board of Canada.

might say, are resolutely technomorphic: machines consciously built to resemble machines. But this brings us to the second aspect of the ecocritical account of the ontological pursuit of immortality: the attempt to reanimate technology itself.

This is where we rejoin the argument made early in this piece, derived from Marx's *Grundrisse*, that technology is the concrete form of the accumulated skills and knowledge of all the dead. In traditional cultures, ancestors are evoked when embarking on a job of work, and recognition of their prior invention of techniques for weaving, fishing or building form an integral part of the deployment of those techniques today (Smith 2005). In Western cultures, however, our ancestors are anonymous, alien, and placed over against us in the form of aggregations of machine systems that confront us as equipment belonging to an oppressive regime of owners and technocrats. These ancestors are doubly dead: beyond their life-spans, and entombed in the concrete materiality of dead labor. Direct animation is a way of injecting a variously ludic, spasmodic or fluid life back into the dead technology of cinema.

We might make a similar claim for software art, especially that which generates visual experience, such as the artificial life animations produced by artists like Mark Guglielmetti, whose *Travelogue: A Recording of Minute Expressions* (2011), exhibited at ISEA2011, uses Turkish census data to seed a virtual world of evolving organisms (**See Figure 4.3**). Here, as in many other data visualization animations, there is an attempt not just to reinvigorate a piece of equipment, but to reanimate the anthropogenic environment. The informatic environment places itself over against the human population in the same way as industrial machinery, offering itself as the

Figure 4.3

Mark Guglielmetti, a-life visualization transforms screen space. *Travelogue: A Recording of Minute Expressions*. Courtesy of Mark Guglielmetti in collaboration with Indae Hwang, ©2011.

assembled mass of unchangeable fact (the meaning of the term 'data', given). That facticity ascribed to information is however not intrinsic to data itself, but to its mediation by political economy, which derives its authority increasingly from the tenet that there is no alternative. If data visualization has become a cliché of digital arts in the current century, it is because of the techniques' ubiquity as an instrument of power. Guglielmetti's work does not attempt to borrow the ostensible persuasive power of scientific economic visualizations, however, as does a film like *An Inconvenient Truth* (Davis Guggenheim 2006). Instead, it unpacks the very technique of that persuasion—unambiguous visual statements of authoritative data—to reveal their effects of scale, of space, of temporality: the basic tools persuasion operates with.

In this sense, direct animation is not so much self-reflexive as integral with itself, or more particularly with one component of the apparatus. In puppetry, audiences and even more so puppeteers identify with the puppet, not the theater or village square; in cinema with the film strip, not the projector; in data visualization with software, not the hardware on which it depends. Pro-filmic animation integrates the whole apparatus, but at the cost of making it, in general, invisible. Pro-filmic animation, which is fundamentally photographic, makes of the cinematic apparatus a coherent whole that acts as the mediator between observing subject and observed object. It is in this mode that animation first engages with representation, taken here as the act of mediation that separates perceiver from perceived in order to mediate the latter to the former. In this process the mediation— which had been the site of identification for the performers of direct animation—becomes more or less invisible. It makes the process of becoming what you want to express far more difficult, removing it to the performance of drawings or manipulated objects in front of the camera, rather than within the process of mediation itself, as in direct animation.

As the dominant form of animation for over a century—both cartoons and stop-motion—pro-filmic animation has thrown up a vast variety of techniques. The invention of layers is one of those: constructions of space by over-layering different drawings made on transparent materials, and using distance, scale or parallax to produce the effect of depth. Layers of course confirm the separation of the observer and observed in terms of figure and ground, and so push on the partition of the world into discrete objects. At the same time, these distinctions for the first time do permit self-reflection, among the finest examples of which, is Chuck Jones' *Duck Amuck*. Here the entire technology of cartooning is forced into the foreground, the unfortunate Daffy subjected to a series of cruel gags each of which exposes another technique, another aspect of the materiality of the film, from ink to frame lines, sync sound to irising and extreme close-up. The vast variety of pro-filmic techniques makes the level of generalization undertaken here a very risky proposition: there can scarcely be a

material that has not appeared as a drawing or shading medium (chalk, charcoal, dust, sand ...), texture (textiles, metals, feathers ...) or in stop motion (fruit, clay, shoes, clothes pegs ...). The formal invention, intelligence and emotional range of these techniques cannot be gainsaid, and are not reduced by suggesting they fall into the realm of the representational, any more than they are reduced by referring to them as animations. This is important when considering works like David Lawrey and Jaki Middleton's *The Sound Before You Make It* (2005), a 3D zoetrope of a scene from Michael Jackson's *Thriller* video from 1982, commissioned to accompany *Eyes Lies and Illusions*, an exhibition of pre-cinematic animation devices from the Werner Nekes collection when it was shown at ACMI (Australian Centre for the Moving Image), Melbourne in 2006. Though the work is constructed of painted plastic figures mounted on a motorized wooden wheel viewed under a strobe light, and is thus entirely non-photographic (see George Griffin's chapter in this book: Ch. 11), it operates in the realm of animation: these figures appear to move of their own accord, but with the motif of zombies, drawn from the source material, linking them to the history of the supernatural in pre-cinema animation, and directly to Bazinian immortality. We could even argue that strobe lights in discotheques and clubs function similarly: to render the dance floor and the individual dancers into animated images of themselves. The most important space in pro-filmic animation is that between the audience and the world presented to them. Giving that world dimensionality and the clarity of the figure-ground distinction is subordinate to this first and founding principle, the principle addressed so well in the last shot of *Duck Amuck*, when Bugs winks at the audience.

Direct animation inhabits its own mediation by working on a core component of the apparatus in order to re-animate the relation between human and natural worlds. Pro-filmic animation makes the apparatus far more coherent but at the same time invisible, in its re-animation of the ancestral dead captured and alienated from us in technology. Both therefore operate as expressions, as symptoms, and as reinforcements of changing relations between human populations and their environments. Vector animation is posited on the incomplete existence of the apparatus, pitching us toward a more problematic but perhaps utopian sense of where that relation might go to next.

To speak of vector animation as incomplete means very simply that the vector, for example as an algorithm, does not exist in its own right but has to be expressed: because it occurs in time, as a becoming, it would be false to describe it as 'being', that is as a fixed essence. At the same time, vectors are determined, or over-determined by multiple forces acting simultaneously, as any gesture of drawing is determined by physiology, by the drawing material, and by the surface you draw onto. Analogously, digital 3D vector graphics are determined by the controls available in the software,

109

and any major (and many minor) examples of digital 3D film are characterized by changes in the software base, with plug-ins constantly developed for specific projects and then made available to other animators, or assimilated into the major program, and occasionally helping bring about major changes in its source code. Since these tools are used not only in classic animations, such as Pixar's, but in increasing numbers of feature films composited with live-action plates, verisimilitude can be a significant goal; but so, equally, can truth to the imaginary world, in films like Tim Burton's *Alice in Wonderland* (2010) or the farmyard of *Charlotte's Web* (Gary Winick 2006), a film which required a typical innovation for producing a dynamic, physically accurate spiderweb that could interact with the mass of Charlotte the spider. The web was not merely drawn, nor merely created in a 3D form in the computer prior to the capture of particular angles and behaviors for the film. It was provided with dynamics: capable of interacting according to physical laws recoded as properties of the 3D model, more or less yielding and bouncy in different areas (webs are made of three types of thread with different properties), with different specularity (highlights, sheen, transparency, qualities of sub-surface reflection and so on) capable of interacting with the weight of the digital spider and with the breezes visible in location plates with which the web had to be composited.

Such complex relations between the elements are core to the practice of vector animation. Since the early days of 1980s billiard ball animation—favored because they had little textural interest and no bounce—the development of complex algorithms for soft objects and the mutual reflections and shadows cast by interacting elements have been integral to vector graphics. This is perhaps most obvious in the development of physics engines in computer games, which allow designers to set the parameters for gravity or visibility in game worlds. What is most extraordinary about these tools is that each object is designed to integrate with everything else it comes into contact with. In the film, the staging of specific events can then go ahead without having to write code for each ripple of wind in the web, each glint of sunshine in Charlotte's slightly eerie almond eyes. The integration of fully-programmed virtual physical characteristics into a diegetic world means that the characters developed can relatively easily be placed into new scenarios, an industrial efficiency, but in the process gives them an ontological status which pro-filmic characters cannot have. The plasticine figurines used for Wallace and Gromit cannot interact with each other without the intervention of an animator. But Charlotte and her web and the virtual wind and sun interact autonomously once the effects programs have been initiated. Results are designed in, but cannot be entirely planned: the number of interactions is too great for that. The well-known story of early experiments with Massive, the engine designed to simulate crowd behaviors for the mass battle scenes of *The Fellowship of the Ring* (Peter Jackson 2001), when numbers of tiny digital

characters were spotted entirely unexpectedly fleeing from the field, is a fine example of just this partial autonomy.

This autonomy unfolds in time. More specifically, it moves towards a future state that is not entirely predictable from the initial conditions. Where this differs from direct animation is the externality of the medium from the animator, who comes to the virtual world—albeit a world of their own creation—as an experimenter. This is the central feature of vector graphics, even in much simpler 2D forms like the once ubiquitous Flash web animations. Here however, we begin to sense the moderation of the utopian potential of the vector, which thus far we have described as a tool for creating unexpected possible futures. Flash and other 2D programmes tend to invite the animator to create keyframes, on the model of cel animation, automating the process of in-betweening. This means that the animator describes not just the start point and path to follow, but the end-state of the action, closing down the dynamic potential for open futurity. This process of key-framing is now embedded in almost all available codecs, the compression-decompression algorithms used to reduce the size of files as they are transferred between digital devices (from chip to memory, memory to applications, applications to store or transmission). On the one hand, this takes us into the corporate territory of proprietary software. Today, three corporations dominate the digital visual landscape: Adobe, Autodesk and Apple (although 3D is sufficiently specialized to allow for a number of smaller players to have a significant role in digital animation). On the other hand, it leads us to the complex world of patent pools and patent wars (especially prevalent in mobile and wireless media), and beyond them into the equally complicated domain of internet governance and global standards bodies.

During the late 1960s and early 1970s, digital animation got its kick-start at the University of Utah, where Henri Gourraud and Bui Tuong Phong devised the shading algorithms, which bear their names, and Ed Catmull did his graduate studies before founding Pixar with Alvy Ray Smith. Other Utah alumni for the same period making major contributions to the foundations of digital graphics included Jim Blinn, Brian Barsky, Jim Clark and James Kajiya. Under Ivan Sutherland, a ferment of invention was underway, which provided one of the many origin myths which still inform digital culture today: the myth of intellectual rigor leading to progressive leaps forward in technique. What is missing from this version of the story is the standardization process that arises from the combination of hoarded intellectual property, the economics of scale and the developing global governance of media technologies.

Keyframing is one of the standardized forms which has migrated from the newly-industrialized animation studios of the 1910s to become a key device in maximizing the efficiency but also stabilizing the fluid, open development of new formats in the digital world. There are other such

evolutions, notably from the delicate handcraft of pin-registration required in cel animation to the critical place of the clock function in digital media. Pin-registration ensured the stability of the framing in successive images, and tied the drawings to a temporal regime in which the first drawing would be replaced by another in exact steps. This is the principle of the scanned electronic image, which erases its predecessor to ensure smooth movement, a process which gave rise directly to the TTL or 'Time To Live' principle used universally in internet communications to ensure that data can be automatically erased if it either fails to reach its destination or is replaced by fresh data. Such controls over the open development of auton-omous mediation are certainly efficient from an engineering point of view, but are now so deeply entrenched that other developments—for example of vector screens—are all but unthinkable. Artists can quiz, challenge, explore and explode these norms in hybrid works like Cory Arcangel's *Colors* (2005), which re-programmes Dennis Hopper's film of the same name to show only one row of pixels at a time, giving the screen the appearance of vertical bars of color, or Daniel Crooks' 'timeslice' works in the *Static* series (2005 continuing): the image is sliced horizontally or vertically, with different slices occupying different moments in time, distending and opening out the micro-temporalities of the pictured world **(See Plate 16)**. But the fact of the matter is that we face a period of consolidation and even universalization of the norms developed out of the pioneering era, which threaten now to close down rather than open up the possibilities of a truly different future. Ecocritique concerns the relationships between humans and their environments. As those environ-ments change over centuries to include not only land but tools and knowledge, as they are removed from the human and placed over against us as things we must both inhabit and conquer, practices like these that re-imagine the relations between people, places, machines and knowing throw into question not just what we now must inhabit, but create visions of alternatives.

Even the strictest inherited parameters nonetheless spawn new art. Consider Golan Levin's 1999 interactive applet *Floccus*, where the user scribbles with the mouse to stimulate a real-time animation (and sonifica-tion) of gesture. The two systems, human and technical, are almost wholly unpredictable, and the results hauntingly simple, beautiful abstract lines ravelling and bursting across a blue screen. In a very different manner, Blu's street animation *MUTO* (2007–2008), a surreal set of transformations drawn on walls in Buenos Aires and elsewhere, transforms the unloved interstices of urban space into realms of fantasy and drama, at once re-animating the inert city and erasing themselves as they evolve. Both Levin's and Blu's works arrive in front of their audiences framed by the normative structure of digital screens: we have in some way to look through or beyond the medium itself to see the art. And yet the structural

difference between the works and the channels through which they are constrained to circulate creates the tensions in these two very different types of animation. Levin counterposes the idyll of idle scribbling to the purposive efficiencies of digital traffic; and in doing so he interrupts the compulsory generation of information which all human populations are now condemned to (Dean 2009) by tempting us to an activity which is not meaningless so much as data-free. Blu reclaims the boundary states of private property and public space for a free play of imagination and protest. Both operate in the new forms of environment—the managed spaces online and in the biopolitical city—where not only the bodies and skills but the knowledge of the living and the dead are increasingly alienated from them in the form of capital and management. An approach to the materials of animation drawing on ecological insights and historical understanding of the evolution of equipment and environment alike is a critical methodology for the development of an ecocritical tradition, and an ecopolitics relevant to the new world we find ourselves inhabiting in the twenty-first century.

acknowledgments

With thanks to Suzanne Buchan for tireless editorial; as ever for Alison.

references

Bazin, André. 1967. Ontology of the Photographic Image. In *What is Cinema?*, Vol. 1, trans. Hugh Gray. Berkeley: University of California Press: 9–16.

―― 1971. An Aesthetic of Reality. In *What is Cinema?*, Vol. 2, trans. Hugh Gray. Berkeley: University of California Press: 16–40.

Burch, Noël. 1990. *Life to Those Shadows*, ed. and trans, Ben Brewster. London: BFI.

Crafton, Donald. 1990. *Emile Cohl, Caricature and Film*. Princeton NJ: Princeton University Press.

Cubitt, Sean. 2011. Affect and Environment in Two Artist's Films and a Video. In *Moving Environments: Affect, Emotion, and Ecocinema*, eds. Alexa Weik von Mossner and Arielle Helmick. Montreal: Wilfrid Laurier University Press.

Dean, Jodi. 2009. *Democracy and Other Neoliberal Fantasies: Communicative Capitalism and Left Politics*. Durham NC: Duke University Press.

Frazer, Sir James George. 1922. *The Golden Bough: A Study of Magic and Religion*. Project Gutenberg, http://www.gutenberg.org/ebooks/3623 (Accessed November 5, 2011).

Gramsci, Antonio. 1971. *Selections from the Prison Notebooks*, eds and trans. Quintin Hoare and Geoffrey Nowell-Smith. New York: International Publishers.

Heidegger, Martin. 1977. The Question Concerning Technology. In *The Question Concerning Technology and Other Essays*, trans. William Lovitt. New York: Harper & Row: 3–35.

Hogarth, William. 1997 [1753]. *The Analysis of Beauty*. Ed., Intro. and Notes Ronald Paulson. New Haven: Paul Mellon Center for British Art and Yale University Press.

Klee, Paul. 1961. *Notebooks Volume 1: The Thinking Eye*, ed. Jürg Spiller, trans. Ralph Mannheim. London: Lund Humphries.

Langer, Mark. 1992. The Disney-Fleischer Dilemma: Product Differentiation and Technological Innovation. *Screen* Vol. 33, No. 4, Winter: 343–360.

Lent, John A. 2010. The Global Cartooning Labour Force. Its Problems and Coping Mechanisms: The Travails of the Marginalised Cartoonist. *Work Organisation, Labour & Globalisation* Vol. 4, No. 2, Autumn: 160–172.

Marks, Laura U. 2010. *Enfoldment and Infinity An Islamic Genealogy of New Media Art.* Cambridge, MA: MIT Press.

Marx, Karl. 1973. *Grundrisse*: Foundations of the Critique of Political Economy. Trans. Martin Nicolaus. London: Penguin/New Left Books.

Molloy, Claire, Steven Shakespeare and Charlie Blake. 2012. *Beyond Human: From Animality to Transhumanism.* London: Continuum.

Newton, Sir Issac. 1846 [1729]. *Newton's Principia: The Mathematical Principles of Natural Philosophy.* Trans. Andrew Motte, Intro. N. W. Chittenden. New York: Daniel Adee. Internet archive, http://archive.org/details/100878576 (Accessed June 18, 2012).

Plato. 2004. *The Republic.* Trans. Benjamin Jowett. Internet Classics archive, http://classics.mit.edu/Plato/republic.html (Accessed June 18, 2012).

Sito, Tom. 2006. *Drawing the Line: The Untold Story of the Animation Unions from Bosko to Bart Simpson.* Lexington, KY: University Press of Kentucky.

Smith, Linda Tuhiwai. 2005. *Decolonizing Methodologies: Research and Indigenous Peoples.* London: Zed Books.

Wees, William C. 1992. *Light Moving in Time: Studies in the Visual Aesthetics of Avant-Garde Film.* Berkeley: University of California Press.

Zielinski, Siegfried. 2006. *Deep Time of the Media: Toward an Archaeology of Hearing and Seeing by Technical Means.* Trans. Gloria Custance. Foreword Timothy Druckrey. Cambridge MA: MIT Press.

life and non-life

coming to life

cartoon animals and natural

philosophy

f i v e

t h o m a s l a m a r r e

introduction

The delight of animation comes of the experience of movement, and the art of animation is, above all, that of *movement*. Attempts to characterize animation, to gauge its marvels, usually speak about the magic of something inanimate *coming to life*, an object, a drawing, strips of paper, a lump of clay. The basic definitions of animation include both bringing to life and making something move (Crafton 2011). Thus, moving and coming to life appear synonymous in animation. This capacity of movement in animation implies a sort of ubiquitous power to bring the most inert, stable, and implausible objects to life. In the context of cel animation, which is the focus of this chapter, the cartoons of Walt Disney are a common point of reference, especially those of the 1930s such as the *Silly Symphonies* in which all manner of inanimate objects start to move, that is, spring to life.

This experience in which 'moving' and 'coming to life' become synonymous has encouraged commentators to see in animation an animistic worldview, a world in which everything is endowed with life force or spirit,

and maybe even soul (Buchan 2011: 33). In his notes on Disney's pre-war cartoons, Sergei Eisenstein writes, "The very idea, if you will, of the animated cartoon is like a direct embodiment of the method of animism" (1988: 44). In animation, movement specifies life, implying a world or worldview in which all nature, all things, all matter, are animate. Different varieties of animation tend to capture different orders of movement, however. Time-lapse photography, for instance, once treated as a variety of animation, captures movements unseen to the human eye. The cartoon animals that come to the fore in cel animation of the 1930s present a very different grasp on nature. Nonetheless, if commentators speak of the animism and vitalism of animation in general, it is because a general experience of 'movement-as-life' seems to underlie these specific forms.

This problematic of 'movement-as-life' is not unknown to film, and from its earliest days, what is now called 'live-action cinema' experimented with in-camera effects and editing techniques that made inanimate objects appear to move and thus to be alive. One might make a case that cinema presents such effects as tricks, thus positing them as supplements to the recording of the movement of actually moving and living entities, whereas animation makes such effects central, thus integrating and normalizing them. But in this context, it isn't especially useful to enter into debates striving to separate animation from cinema definitively, or to subsume one within the other. Film and animation are equally arts of the moving image, with different yet overlapping ways of prolonging the force of movement as it traverses images. Suffice it to say, various conventions, arising around specific materials and techniques, have nonetheless contributed to making movement-as-life a central concern or problematic of animation, and maybe *the* central concern. Yet, I would hasten to add: the specificity of animation does not derive from its materials in a deterministic or teleological fashion. I am not talking about medium specificity per se. The specificity of animation in question here is not confined to those objects identified or cataloged as animated films and animations: it has become localized and condensed in such objects due to various conventions, but ultimately it entails a situation that is not entirely localizable. Animation in this sense may appear in kinds of moving images not classified as animation.

The specification of movement as life brings the problematic of anima-tion close to natural philosophy. The movement-as-life problematic resonates with a philosophical approach rejecting dualism and substantial-ism, refusing a divide between matter and energy, body and mind, space and time, that is, rejecting what Alfred North Whitehead calls the "bifurcation of nature" (from the title of Ch. 2, Whitehead 1920: 26–48). A series of other philosophers also come to mind in the context of such natural philosophy, among them Mikhail Bakhtin, Henri Bergson, Gilles Deleuze, William James, Brian Massumi, Nishida Kitarô, Miki Kiyoshi,

Gilbert Simondon, Isabelle Stengers, and Tanabe Hajime. As such a series of names attests, natural philosophy is not without its difficulties and risks, and I evoke natural philosophy not to give animation a high conceptual gloss, or to announce a neat fit between all animated films and this lineage of natural philosophy. I turn to natural philosophy to find a way into this specific problematic of animation, movement-as-life.

For sociohistorical and technical reasons, to be taken up below, movement-as-life in animation tended to settle on cartoon animals, and has been prolonged and transformed through them, generating series that unfold both with and against historical conditions. As such, even though I will look at animation historically, with an emphasis on Japanese cartoons of the 1930s, my purpose is not entirely or purely historical (if that were in fact possible). Walter Benjamin's admonition here rings true: "criticism is not, as is often thought, to instruct by means of historical descriptions or to educate through comparisons, but to cognize by immersing itself in the object" (Benjamin 1996: 293). Indeed, the goal here is to immerse thought in animation by running a relay between cartoon animals and natural philosophies.

two kinds of movement

If one builds on Bergson's insights into movement, the problematic of animation can be formulated directly and lucidly. Movement is experienced as life in animation, because animated movement resists division into quantifiable units, defying localization. Movement feels like life because it springs forth in a manner that it is not predictable or containable. At the same time, movement in animation is always being distributed and allotted. It is localized, taking up specific kinds of objects and not others. How then are we to understand this localization of the non-localizable, this localized embodiment of a non-localizable life force?

Norakuro nitōhei (*Stray Black, Private Second Class*, 1935) nicely demonstrates these two kinds of movement (localized and non-localized). It is a short animation directed by Seo Mitsuyo, one of many based on the popular manga by Tagawa Suiho, which began serialization in a boys' magazine, *Shōnen Kurabu*, in 1931. The series centers on a stray black dog, Norakuro, who enters the Japanese army, in which all of the soldiers and commanders are dogs. Unlike the other dogs, Norakuro stands out for his blackness and antics; he is always out of step and out of line. While never intentionally insubordinate or disobedient, he never fails to misconstrue orders or to muddle the simplest tasks. Nonetheless, his misadventures invariably win the day, and across the series, Norakuro is steadily promoted in rank. The Norakuro series thus makes light of the regimentation of daily life in the Japanese army at a time when militarism was serious business. While it consistently presents the triumph of Japan's armed forces over its enemies

(presented as pigs, tigers, monkeys, for instance), it attributes such military success not to obedience and regimentation but to humorous and unexpected actions. This is cartoon warfare.

I have chosen this Norakuro animation precisely because it brings into play a political dimension of movement-as-life in animation, which I will discuss later in terms of the biopolitical. Already, in this brief description of the series, it is probably clear that the question of whether the *Norakuro* series is complicit with, or critical of, Japanese militarism and imperialism verges on a false abstraction. The process of circling endlessly around the question of complicity versus critical resistance may afford some awareness of the history of empire, and yet it will ultimately ask animation to prove itself capable of critical reason or communicative reason, which it cannot do. If we are really interested in animation and in the relation between animation and imperialism or militarism, we cannot rest content with reducing animation to the demands of critical reason. We need to look closer at animation as such, at techniques of the moving image, for it is here that life comes into play within animation. If we wish to consider the circulation and distribution of animation (the emergence of national media empires, so to speak), we would still need to consider the relation between the movement 'internal' to animation and its movement 'out there' in the world, because this is how a media world or media ecology arises. Let's look at movement in Seo Mitsuyo's *Norakuro nitōhei* with such concerns in mind.

It opens with the orb of the sun rising in the sky over the countryside. Figures in the foreground, such as the birds that fly out of the trees to greet the morning light, are animated. But the sun here is not. Instead, an orb drawn on a celluloid sheet is moved in relation to the background layer (**See Figure 5.1 a, b**). Consequently, the sun does not change in size, shape, or luminescence as it rises. Effects of the sun changing in size, shape, and brightness could be achieved using techniques of character animation for the sun. But this cartoon takes the simple and direct approach by sliding

Figure 5.1
(a, b) *Norakuro nittōhei*, dir. Seo Mitsuyo, 1935.

layers of the image, and it is the sliding of layers that imparts a sense of *autonomous yet non-localized movement*. The sun layer moves independently of the landscape layer, and palpably so. What is more, because the layers extend beyond the frame of the image, movement seems to extend beyond the image itself, imparting a sense of a 'movementful' natural world. Such movement is autonomous, non-localized, and relative.

Suddenly, with a very distinct cut, the sequence presents a different kind of movement. As the sun tops the trees, the previously featureless and unchanging orb takes on a smiling face (**See Figure 5.2a**), stretches out its arms, and yawns (**See Figure 5.2b**). This is a form of character animation, which localizes movement within some kind of entity, here the sun. The transition between the two kinds of movement is so palpable, which serves as a reminder that these two kinds of movement entail very different sets of techniques. The first form of movement is a matter of compositing (managing the relation between layers of the image under conditions of movement), while the second entails character animation (drawing the movement of a figure frame-by-frame, or more precisely across a certain number of frames).

Historically, the life of animation has been associated with this second kind of movement, character animation. Indeed, in the opening sequence of *Norakuro nitōhei*, it is the animation of entities, the birds flying forth, the sun stretching and yawning, which catches our eye and holds our attention. Throughout the animation, our attention is drawn to the antics of animated characters, rather than compositing. The scene shifts to a white dog soldier sounding reveille on his bugle, and then within the barracks, there are rows of beds with sleeping soldiers. The soldiers are dogs, uniformly white dogs, with the exception of a little white dog with a black spot (who plays the role of the eager but inept runt), and our stray black, Norakuro. The white dogs all leap from bed for roll call, with the spotted dog frantic to keep up with them, but Norakuro remains slumbering peacefully, oblivious. His bed awakens, however: it sprouts arms and face

Figure 5.2

(a, b) *Norakuro nittōhei*, dir. Seo Mitsuyo, 1935.

Figure 5.3

(a, b) *Norakuro nittōhei*, dir. Seo Mitsuyo, 1935.

and tries to awaken Norakuro by pulling down his covers (**See Figure 5.3a**). Unable to wake him, the bed bounds out of the barracks (**See Figure 5.3b**), taking the lazy stray black dog to roll call and bouncing him into his place in line. The delight of these opening sequences comes primarily from using techniques of drawing and film photography to endow objects that are not mobile in everyday life (such as the bed) with movement. Or the sun, an object that moves but is not normally considered alive, comes to life, yawning and stretching. Dogs, usually considered alive, are now endowed with another gradation of life, impersonating humans.

Two general questions about animation thus arise from this sequence. First, there is the question of the relation between the two kinds of movement, between compositing and character animation. Second, there is the question of the effects of character animation as it settles in modes of anthropomorphism or impersonation—dogs acting like human soldiers (or maybe it is human soldiers taking on features of dogs), the sun sprouting arms and other humanoid features, and a bed with humanoid face galloping on four legs.

the primacy of compositing

I begin with compositing, because, as I will show, we cannot treat character animation independently of compositing. Why challenge the received emphasis on character animation or object animation as *the* art of movement in animation? First, when we focus on an analysis of movement on character animation, we restrict the field of empirical analysis to a very limited set of techniques. In the case of cel animation, for instance, the emphasis falls almost exclusively on the art of drawing character movement (for instance, key animation and in-between animation).

Second, when we privilege character animation as the art of animation, we establish a hierarchy in which techniques of full animation are constantly privileged over techniques of limited animation. The distinction

122

between full animation and limited animation is a matter of the number of drawings used per second to animate the movement of characters or other figures within the animated film. Because the projection rate for film is 24 frames per second, the 'fullest' movement would use 24 drawings per second, depicting different instants of the continuous movement in projection. Cel animation rarely used that many drawings. The Disney average, which became the standard for full animation, ran about eighteen drawings per second. We might also think of such full animation as classical animation, in that it set the standards for movement in animation, creating expectations for fluid movement and coherent action.

Limited animation refers to animation that uses fewer drawings per second, and the term is often used too in the context of television animation of the 1950s and 1960s that used as few as eight drawings per second. The most limited animation would use one drawing per second, or maybe one drawing for the entire animation! Clearly, the distinction between full and limited is not absolute or categorical. The distinction between what is full and what is limited is a matter of threshold, and any particular animated film commonly shifts the number of drawings per second for different sequences.

In any case, when we center analysis of movement on character animation first and foremost, we tend to privilege animation that localizes movement in discrete figures or characters, which may rule out a lot of animation in advance. A shift in emphasis to compositing has greater explanatory force in dealing with historical and cultural varieties of animation.

Third, compositing brings into play autonomous non-localized relative movement, which is the ground for the specification of movement-as-life. Character animation localizes movement, but the animation of characters does not have the capacity for an overall composition of the forces of animation. In contrast, compositing affords a key to evaluating the overall coordination of forces in animation, and in that respect, it takes priority over character animation, sequence cutting and editing, and other kinds of technical finesse. Compositing might also be called 'internal editing' or 'internal montage'. Theories of montage can also address the layering or collage-like effects within the image. Nonetheless, because montage theories were primarily developed in the context of the cutting and splicing, I prefer to use the term 'compositing' rather than treat compositing as internal editing or internal montage.

The sequence in *Norakuro nitōhei* in which the bed comes to life confirms this priority of compositing in terms of the experience of movement-as-life. If you look closely at the images in which the bed takes on a face and sprouts arms, the animated bed is clearly layered on top of another layer, a background layer on which the rows of inanimate beds are drawn (**See Figure 5.3a**). Oddly, as the bed comes to life, there are two beds, one

that moves, and one that does not. After the bed has come to life and has begun to gallop out of the barrack, the inanimate bed remains, as if the animate bed were a layer peeled away from the inanimate bed (See Figure 5.3b), as if the animate being of the bed were separable from its immobile existence, like the soul leaving its body! Maybe the animators were cutting corners here: they did not bother to draw a second version of the rows of beds with Norakuro's bed missing. Even if they had done so, the effect would be analogous. The animate bed gains its sense of autonomous movement by separating itself from the background layer. Character animation is *in relation to* the gap between layers of the image, and these layers are what compositing strives to manage. In other words, the animate bed is not simply moving against a static background or inert world. It moves in relation to a world that starts and stops, now moving, now resting. That there are 'accidently' two beds in this sequence merely helps to call attention to the importance of compositing.

In sum, the bed coming to life depends on two sets of techniques: compositing and character animation. Compositing builds on the interval between layers of image, which is where the force of the moving image is keenly felt in cel animation, demanding constant attention on the part of animators. Animators have to be careful not to allow the gap to become too palpable (unmooring the character from its world) or to close it entirely (making the character indistinguishable from its world). Character animation channels the non-localized movement into cartoon bodies, condensing and embodying it in facial expressions and moving limbs. As such, character animation does not happen independently of compositing. Nor is it a supplementation of compositing. It is a *localized prolongation* of the force of moving image spreading across the image, which compositing strives to manage.

Compositing, then, is the general *situation* for cel animation, while character animation is the specific *location*. Consequently, precisely because it localizes movement, character animation tends to catch attention, drawing attention away from compositing. This is one reason why character animation is so often treated as *the* art of animation, while compositing is ignored. It is easier to focus attention on localized movement than on non-localized movement. Character animation is, of course, complex and worthy of attention. But it is not all there is to animation. Character animation is like what Deleuze calls the movement-image in the context of cinema: character animation at once subordinates and coordinates a variety of image types and forms of movement. It affords a relatively stable and organized sensorimotor schema that encourages us to give primary to characters' actions and goals.

Full or classic animation, which dominated production from the 1930s to the 1960s (and remains a major force today), has tended to focus attention on character animation. Walt Disney cartoons, especially *Silly Symphonies*, and Fleischer Bros. cartoons such as Betty Boop, Popeye, and

Color Classics were important in establishing techniques for dealing with movement in animation. These cartoons had a major impact on animation and animation theory in Japan. In fact, it is hard not to detect some similarity between the design of the Stray Black Dog (Norakuro) and the early Mickey Mouse, not to mention Felix the Cat. Significantly, as greater emphasis fell on full animation of characters (Max Fleischer received a patent for rotoscoping in 1915), compositing had to be more strictly managed. Fleischer, for instance, developed the stereoptical process, and Disney the multiplane camera system. These systems strive to stabilize the relation between animated body and animated world, thereby assuring that the goals and actions of cartoon characters are grounded in and against a stable, dimensional world. Even today, despite major technical innovations, Pixar frequently adopts similar strategies, claiming such classic cartoons as a source of inspiration (Iwerks 2007).

Classic cel animation places emphasis on fullness of character animation, which consequently demands stricter management of compositing and thus of non-localized movement. In effect, it entails a strict management of the life of animation, integrating it into bodies in order to allow them to work on worlds. Those who don't like this sort of classic animation object to its sense of seamless fluidity and enchanted plentitude, in which animate bodies feel so well integrated, so full of life, regardless of the signs of distress that occasionally flit across their sweet features, that animation comes to appear blissfully immune to the aesthetic shocks of modernism. Adorno makes this sort of argument, attributing a (false) sense of smooth integration to cinema, sometimes due to soundtracks, and sometimes due to fluidity of movement. In his discussion of Disney animation, he detects schooling in sadistic behaviors, that is, a domestication of what he sees as the basically mechanical, fragmenting, and de-totalizing operations of cinema (Hansen 1993).

Yet there is potentially a shock of the modern here. The shock of cel animation occurs largely where compositing or some other experience of non-localized movement comes to the fore. There are various ways for compositing to run counter to classic animation, and for character animation to disintegrate and fall to pieces. Such a shock (a form of modernism) commonly finds itself in the company of animism and vitalism. This is because such animation affords an experience of autonomous non-localized movement, which verges on, or can be 'mistaken' for, life. As with other forms of modernism, the animism and vitalism of cel animation is two-faced. It may turn toward a shock to thought or toward stupefaction (or even sadism). Oddly enough, however, it is not by treating the experience of life in animation as a mistake or illusion that we will arrive at a shock to thought. Paradoxically, we have to regard animation as genuine life in order to confront its potential. Before returning to character animation, I wish to address the question of the illusion of life.

125

When I challenge the notion of an illusion of life, this does not mean that I think that an animated dog like Norakuro, for instance, is alive in the same way that an actually living dog is. Rather I wish to challenge an approach to animation that posits the experience of animation as fundamentally illusory or deceptive, and by same token, treats cartoon animals as projections or deceptions, fundamentally without reality. My resistance to the illusion-of-life paradigm also comes of my resistance to an increasingly prevalent tendency to psychologize and even pathologize the relations between animation fans and their objects. This tendency for me is particularly evident in discourses and public policies in Japan addressing so-called otaku culture, which are often consonant with a general tendency to criminalize youth (Galbraith and Lamarre 2010). Such discourses are, of course, not limited to Japan, but I am most familiar with them in that context.

When a government appoints a cartoon animal as a cultural ambassador (as the Japanese Foreign Ministry did in 2008 with a popular manga and anime character, the robot-cat Doraemon), the assumption is that the foreign ministry can treat a cartoon character as real because it understands the difference between fantasy and reality, and its gesture is strategic, symbolic. But the otaku who wishes to legalize marriage with a manga or anime character is assumed to have a very weak grasp on reality and symbolic relations, and is assumed to present a potential danger to society, especially to social reproduction. While such examples may appear extreme, it seems to me that any theory of animation that rules out this dimension of experience (the reality of cartoon characters) by positing it as mistaken, erroneous, or illusory, ultimately fails to deal with the reality of animation. Indeed, the very distinction between fantasy and reality in such a context tends to reproduce received hierarchies. In the above instance, the assumption is that government officials have a better grasp on social reality than 'cult fans' when nothing could be less certain.

The reality/fantasy divide is a special instance of the bifurcation of nature, which in the context of animation tends to settle on a distinction between life and non-life, or between animate and inanimate, which is grounded in a contrast between movement and stasis. The illusion-of-life paradigm, as I am defining it, usually focuses on character animation in cel animation—or something analogous to it, such as forms of stop-motion animation or object animation in which an object or figure is shot in a series of poses whose sequence make for movement when projected. Attention falls especially on the transition from stasis to movement, which is taken as an instance of the inanimate becoming animate, of a coming to life. What characterizes the illusion-of-life paradigm is its interpretation of this situation. It concludes that this coming to life is an illusion of life,

because normally teapots don't sing, beds don't leap, for instance. Their movement or life is thus taken as an illusion. Thus the contrast between motion and stillness is gradually mapped onto a dualist opposition between real life versus artificial life, or between a true experience of life versus a false or illusory experience, which in turn brings into play a divide between nature versus culture and between organism versus mechanism. This series of dualisms is built on exaggerating a situation: focusing attention on the moment of coming to life encourages the illusion-of-life paradigm to think of animation in terms of *adding* movement to objects.

Because it shores up a distinction between reality (real life) and animation (illusory life), the illusion-of-life paradigm brings into play a dualist and substantial ontology, enforcing an absolute distinction between reality and illusion that builds on and reinforces a series of other ontological distinctions: matter and form, stasis and movement, nature and culture, nature and technics. It is true that the illusion-of-life paradigm often tries to scramble and confound this ontological distinction, usually by dwelling on the uncanny, on an experience of the animated object as at once alive and dead. But the dice are now loaded: the divide has become insuperable, and even if one speaks of re-animation (it was alive, and then dead, and then brought to life again), the experience of uncanny often remains confined to the realm of illusion, fantasy, representation. Such a paradigm is ill equipped for dealing with cultural ambassador Doraemon.

When the illusion-of-life paradigm encourages us to think in terms of objects artfully brought to life, the 'work' of animation is reduced in advance to objects that are always already related to a perceiving subject. And the spectator, viewer, or user is posited in advance as a subject, as *the* subject. This is surely why the illusion-of-life paradigm confidently declares that the lively movement of animation is a troubling illusion: if the viewer feels that animated things are somehow alive, it is because the subject has been tricked or confounded, unable to detect the truth of the matter—that movement has been added to an object. In effect, the illusion-of-life paradigm adopts a hylomorphic model, whereby form, construed as active, is imposed upon passive matter from without (Combes 1999: 14).

If we want to take animation seriously, we must challenge this received wisdom. We must insist: animation is not a matter of deceiving subjects by skillfully adding movement to non-living objects or images, by imposing active form on passive materials. Movement in animation is not a matter of illusion or representation. Animation does not represent movement any more than it fakes it. It affords a real experience of movement, of actual movement. Even when the animated film highlights the movement of ordinarily inert objects or the coming to life of something pronounced dead, animation is not a matter of adding movement to objects.

an ecology of perception

We know very well that, just because something moves, does not mean that it is alive. A plastic bag borne aloft by the wind, full of air, swirling and dancing—even if it appears full of life, we know it is not. We might safely call this experience an illusion of life. Yet, when we speak of illusion, two very different models of perception can come into play. On the one hand, we might assume that sensations are inadequate: if we see the plastic bag as full of life, it is because our senses do not give us enough data, and so our brains must constantly fill in, correcting, enriching, and compensating for the poverty of actual stimuli. Such an approach is often associated with Richard Gregory (1966), and characterized as a top-down model in which knowledge and cognition are always adjusting and compensating for a constitutive lack at the level of sensation. On the other hand, there is J. J. Gibson's ecological approach to perception (1979) that takes the stance of a mobile exploring organism: perception is not passively dependent on sensations coming to the organism; rather perception actively seeks information and extracts it. In Gibson's approach, which is frequently characterized as bottom-up, the real world is a rich source of information: the organism does not have to compensate cognitively or intellectually for a fundamental lack; rather it moves around and acts, shaping a world from its environment.

In the context of animation, Gibson's model of perception is useful, not because it is more accurate scientifically (although such a case could be made), but because it allows an approach to the problematic of life in animation that does not reduce the illusion of life to constitutive lack but attends to the potentiality of animation. It seems to me that, if we assume that our perception of movement-as-life in animation is the manifestation of a fundamental lack in our relation to the world for which we are constantly compensating, we then situate animation—and maybe even art in general—as a compensatory mechanism, whether cognitive or libidinal. While there is no doubt that animation or art may serve such a function, that is not all that animation can do. The illusion-of-life paradigm severely curtails the potentiality of animation, reducing it in advance to a mechanism of lack and supplementation.

But how are we to deal with illusion within this 'potentiality paradigm'? How do we speak to the fact that we know that a dancing spoon in an animated film is no more alive than the plastic bag caught in a current of air?

It is often remarked that Gibson's ecological approach to perception does not deal very well with tricks and illusions. This is not entirely true, but it is expedient for me to turn here to Isabelle Stengers' account of the perceptual object in Whitehead's philosophy. Differentiating Whitehead from Kant, she explores her perception of a blue jacket, asking whether perception is primarily a matter of judgment or verification.

Stengers (2011) evokes a situation in which she sees a blue coat and reaches out for it, but it is in fact a hologram: "And if my trusting fingers encountered only the void, my shocked surprise would testify to the fact that *the point was not to verify, but to prolong*" (88; my emphasis). Perception is not first and foremost a matter of verifying if something is real or not, of nailing down correlations between perceptual objects and real objects. Rather, as Whitehead (1920) states, "The perceptual object is the outcome of a habit of experience" (155). Lest we fret that Whitehead has thus transformed reality into "mere habit", Stengers reminds us that "Habit presupposes a world in which a sense-object often signifies a perceptual object: it indicates a wager concerning such a world, and is not added to it like a fiction for which the mind alone would be responsible" (2011: 88).

As in Gibson, perception is not a matter of compensating for the poverty of our senses and striving to verify whether an object is real or not. It is a matter of actively seeking and shaping a world by prolonging an experience into habits, which entail a wager about that world. In the context of the experience of movement-as-life in animation, we might begin by thinking of movement in terms of a sense-object that often signifies a perceptual object—and often a living object, or a vital object. The relation between sensation and perception, and the relation between action and emotion, cannot be readily hierarchized or prioritized into formula such as we feel then we act, or we sense and then we perceive (James 1884). Watching animation, we perceive a moving object as somehow alive; the sensation of motion conveys the perception of a vital object, the *animation-object*, which indicates a wager about this animation-world. We are already part of the event.

In the context of film or fiction, the standard objection to such an approach insists on maintaining a divide between reality and fiction, between natural movement and human-made movement, between natural perception and artificial perception. Simply put, cultural objects are considered secondary to natural objects, and thus belabored and derivative, possibly inferior, and usually illusory or unreal. In contrast, if I here adopt something of Whitehead's rejection of the bifurcation of nature and Deleuze's rejection of the distinction between natural and artificial perception in his cinema books, it is because the nature/culture and reality/fiction divides won't take us very far in understanding the actual force and potentiality of animation. They tend toward a mechanistic conclusion— art and fiction entail libidinal or cognitive compensation for human artificiality, for the fall of humans from Nature.

Still, there is no reason to deny a contrast between fiction and reality, or in the context of animation, between the animation-world and the real world, for such distinction allows for a relation between them. If we return to Stengers' example of reaching for a blue jacket and discovering it is a hologram, the relation is initially one of prolongation. Prolongation is

partial; it entails selection; it is a prolongation of a specific relation or set of relations and its terms. In the instance of cartoon animals, there are different kinds of sensory *semblance*, among them, semblance to humans (hands and feet; bipedal locomotion; human activities like singing, dancing, driving), to non-human animals (ears, whiskers, hooves, animal stances, animal-like locomotion, etc.), and to elastic materials (stretching, squashing, bouncing, etc.). The animation character, as a perceptual object, conveys a relation between these sensory semblances, which are terms of the relation. It doesn't make sense to worry endlessly about whether the cartoon animal is 'just' a disguised human, or a misrepresentation of actual animals, or unfaithful to the laws of physics. Or rather, it does not make sense to reduce such characters to misrepresentation or impossibility, unless your goal is, like Plato's, to banish them from the Republic.

Such perceptual objects are the outcome of habits of experience. We would probably be surprised if we reached to grasp the animation-object on the screen, and it responded to our touch in the manner of, say, a real animal or human. As Whitehead stresses, we know we can be fooled, and so we are constantly experimenting to know whether or not we can trust an object, to see if it is illusory or not. The object that emerges victorious from such experimentation, as Stengers reminds us, is what Whitehead calls the physical object. In effect, the animation-object is perceptual object striving to become a physical object but remaining poised between perceptual object and physical object. Thus, animation entails a mode of perceptual experimentation. We experience it as real, for what is staged is our wager. The wager then is *not to verify* the reality of animation-objects but is *how to prolong* the relation between us and the animation world.

plasmaticity

In the remaining drafts and notes for his book on Disney cartoons, Sergei Eisenstein (1988) uses the term 'plasmaticness' to characterize animation. And he devotes a great deal of attention to the elasticity and plasticity of the contour lines of cartoon characters. The deformation and transformation of cartoon characters is one of the major sources of delight in animation—stretching, squashing, inflating, flattening bodies, twisting limbs, and distorting features. But you do not have to stretch, squash, or otherwise deform characters to impart a sense of their vitality. Building on Eisenstein's attention to the elastic contours of characters, we might say that, in the formative years for cel animation in the 1920s and 1930s, there emerged a 'cartoon line' suited to drawing the movement of characters in animation. The contour line of characters had to appear plastic and elastic—able to undergo deformation and to bounce back—in order to assure fluidity of movement across frames. Stiff, rigid lines would have resulted in very different effects—jerky action, quivering contours.

In effect, while there was a great deal of experimentation with drawing styles in the 1910s and 1920s, the art of the hand was gradually adapted to the art of moving images, resulting in conventions of plasmaticness.

In his comments on pre-war Japanese animation and the impact of Disney cartoons, Ōtsuka Eiji (2008) notes that conventions of elasticity impart a sense of the invulnerability and immortality of characters: no matter how violently or cruelly deformed, these forms spring back to life, apparently deathless. We do not expect Norakuro, for instance, to die in battle, any more than the coyote in the *Roadrunner* cartoons or Tom the cat in *Tom and Jerry*. Such animations are very different in tone and technique, but they confirm Ōtsuka's general point about the deathlessness associated with the plasticity of cartoon characters.

Such an outcome—a set of conventions emphasizing the plastic contour line, with animal or animaloid characters, in scenarios full of antic capers, gags, and a sort of slapstick comedy—is not predetermined but historically contingent. It did not have to happen this way. But there are technical factors that guided such developments, making them contingent rather than arbitrary. Particularly important was the use of transparent celluloid sheets (or cels) and the fixity of the camera upon on rostrum in the animation stands that became integral in animation production from the late 1920s. With the camera fixed in place, looking down through the celluloid sheets, there were basically three options for producing a sense of movement. While you could move the camera closer or farther from the sheets, weird effects of depth and focus arose. You could move the camera or any of the celluloid sheets laterally, producing a sliding motion. Although such techniques were used, because they tend to expose the multiple planes of the image, thus undermining a sense of the solidity of the animation world, they were used sparingly in classic cel animation of the 1930s and 1940s. It was not until the rise of limited animation in the television era that sliding cels or moving the drawings began to appear more like art than artifact. And so, in the pre-war era, the art of animation focused largely on the third option—fluid animation of the characters, which meant drawing movement, drawing the shifting position of the character as close to the ideal of frame-by-frame as possible. Thus a great deal of the art of animation came to hinge upon the lines composing the character—the same plasticity that allowed for a more fluid sense of movement also afforded a degree of flexibility encouraging animators to play with fluidity and elasticity, pushing the deformation and transformation of characters. It is not surprising that animation would continually push the limits of elasticity, toying with the affective impact of flattening, twisting, squashing, tweaking, stretching its characters, especially its cartoon animals. Indeed, the use of the plastic cartoon line, with its implied potential for deformation and transformation, tended to make even the human characters appear somehow animaloid, even as cartoon animals

adopted human semblances (humanoid arms and legs, hands and feet, fingers and toes).

Animation differs from cinema in this respect. Jonathan Burt (2002) reminds us that images of animals in cinema have historically evoked concern about cruelty to animals, to the point where we often accept graphic violence to humans on film while balking at intimations of violence to animals. Apparently, North American audiences are fussy about animal cruelty on film, and audiences are given indications that a dog, for instance, is not a real dog before it can be kicked or run over. In contrast, even though animation also places limits on violence to animals, it allows far greater latitude for cruel deformation of animal characters, perhaps because we perceive them as deathless and invulnerable due to their plasmaticness.

This apparent deathlessness or immortality brings us to the paradox of animation: if animated characters are not really alive, why should we worry about their deathlessness? We may be tempted to think of animation as a field from which death has been excluded from the outset, like simulation for Baudrillard (1994). But this is not entirely true. Instead, much like natural philosophy, animation does not begin or end with dualist oppositions, such as life versus death (Cholodenko 2007). If one tries to apply such an opposition to animation, it ultimately turns out that animation is both lifeless and deathless. This does not mean that animation transcends life and death or the opposition between life and death. Instead it means that in animation we cannot sustain the transcendent position guaranteeing such an opposition or bifurcation. The absence of transcendent oppositions does not mean that animation is without distinctions or contrasts, that everything is ultimately life (which would amount to a transcendent unity). It means that animation entertains distinctions without calling for a foundational bifurcation of nature. Even as it proposes contrasts between human and animal, between organic and inorganic, or between organism and mechanism, it tends to generate entities falling between, defying the onset of strict oppositions.

the production of species

We have seen that, in specifying movement as life, animation, as an art of movement, promises to bring anything to life. In effect, the question of life hinges on the potentiality and material tendencies of animation. To explore such potentiality, this chapter has focused on the technical paradigm associated with cel animation, compositing. While I have centered my account on cel animation of the 1930s, I am not trying to account for every animated film produced at that time. Instead, in trying to account for material tendencies, I have highlighted the relation between techniques for dealing with non-localized movement (compositing) and techniques for localizing movement (character animation). I wish to make two basic points.

First, compositing is closer to the operative logic of the apparatus of cel animation, the animation stand. It prolongs and orientates the movement due to film projection (the succession of instants, of images) into non-localized movement between layers of the image. Second, character animation prolongs and orientates the movement of film projection by localizing it in distinct and relatively discrete entities—characters or figures. But at the same time, character animation can only localize movement in relation to a background. It relies on, or situates itself in relation to, compositing. Consequently, compositing entails both a weak or passive synthesis and a strong or active synthesis. It traverses the field of forces of cel animation, providing an overall coordination. As such, the potentiality of cel animation—its 'life'—is not simply a matter of the vitality of its animated characters. The life of animation lies in the reservoir of non-localized movement.

While such insights are derived from the historical formation of cel animation, it should be noted that compositing becomes a matter of great importance in the 1990s as digitally produced special effects and computer-generated imagery became increasingly prevalent in film production. In SFX films, CGI, and digital animation, the question of compositing—of how to hold the layers of the image (and thus the screen world) together—came to the fore. In other words, although these questions of compositing may appear to belong to a lost world, that lost world remains a reservoir of potentiality in the digital era. Indeed, compositing software remains integral to digital animation and cinema.

To return to the question of life, because cel animation entails distinctions or graduations in movement, it tends to introduce distinctions or gradations in life. It does not need a divide between life and death in order to highlight relations between different degrees of life or life forms. Because animation calls attention to relations between life forms, it tends toward evolutionary problematics. This is why it makes sense for an evolutionary biologist like Stephen J. Gould to state parenthetically, all in good fun, "I still prefer *Pinocchio* to *Citizen Kane*" (1980: 100).

Building techniques and conventions for localizing and differentiating forms of movement, animation will frequently gravitate toward certain kinds of scenarios: companion species, human–animal interaction, animal rivalry, love and war between species, human–machine interface, co-emergent entities, and a number of puzzles related to life form interactions. Consequently, the danger faced by animation is similar to those faced by evolutionary theory and natural philosophy, namely, the risk of social Darwinism—the risk of taking life forms (characters) as ideals and thus imposing a hierarchy upon the relation between life forms. We can think about the onset of hierarchy at two levels.

On the one hand, the flexibility of character form makes it potentially available to anyone. Anyone can draw Mickey Mouse and Norakuro, and

even during production, different artists may draw the same character. It is not surprising then that Mickey Mouse and other iconic American cartoon characters (such as Betty Boop and Popeye) begin to appear in Japanese manga and manga films in the 1930s. They are easy to use. What is more, as Miyamoto Hirohito has pointed out, newspapers and children's comic magazines encouraged readers and fans to produce their own stories with popular characters (Miyamoto 2011). Today we are acutely aware of how fans play with characters, because copyright is such a contentious issue, and experimentation with cartoon characters has become a site for appara-tuses of power. Certain kinds of legal regulation, such as copyright, come to animation from without. Yet such regulations quickly become enmeshed with the potentiality of animation, leading to a broader field for the exercise of power. We soon have to ask, 'when is a cartoon mouse not Mickey Mouse?' Internal material limits on deformation or transformation become entwined with external limits—which makes for an apparatus in the Foucauldian sense. The character form comes to oscillate between a sort of aesthetic equality (for everyone) and corporate property (for profit), making its 'individuality' or 'persona' a site of potential regulation and conflict.

On the other hand, distinctions between characters are made in two registers. As cartoon animals attest, characters are frequently individual-ized in terms of species attributes—there are rabbits, birds, dogs, bears, cats, monkeys, humans, and so forth. The interactions of cartoon animals seem to confirm the common sense notion of species—species cannot intermarry. The same time, however, the interactions between these species are so lively and varied that they go far beyond notions of interspe-cies cooperation or interspecies competition. Often, even when prey and predator species are played off one another in chase and flight scenarios, the hunt or chase itself takes on social connotations in which the prey seductively toys with the hunter, and the two embark on a perverse romance. We might attribute such an overcoming of the biological logic of species to a cultural anthropomorphism. After all, so many cartoon animals have human traits. Yet it would be hasty to conclude that cartoon animals are merely an instance of humanism (in the sense of a human-centered order), or anthropomorphism (a projection of the human onto nature), or even a triumph of culture over nature. The humanoid or

anthropomorphic traits of cartoon animals do not center and enthrone the human (Buchan 2012). Instead, the underlying potential for deforma-tion and transformation means that any cartoon 'species' might turn into any other.

Eisenstein notes, "here we have a being represented in drawing, a being of definite form, a being which has attained a definite appearance, and which behaves like the primal protoplasm, not yet possessing a stable form, but capable of assuming any form and which skipping along the rungs of

the evolutionary ladder, attaches itself to any and all forms of animal existence" (1988: 21). It is true that anything can come to life in animation. Yet, when plants and brooms become mobile and animated, they tend to sprout limbs and sport faces, which makes for a sense of animal vitality and mobility. Although the limbs and faces, the fingers and toes, of cartoon animals often evoke the human, Eisenstein is surely correct to conclude that humanity is grounded in animal existence, not the reverse. Much as in evolutionary theory, the human is scandalously dethroned and situated among animals, or more precisely, among species. The human is just another species, a species of animal. The human in animation (and modes of existence in general) will be addressed as species. As such, animation appears resonant with a biopolitical understanding of governance that addresses 'persons' in terms of 'populations'.

the biopolitical

It is at the level of 'human animal species' that we can at last address the question of the relation between animation and empire as posed, for instance, in *Norakuro nitōhei*. Rather than adopt a reflection model in which animation is a reflection or repetition of values articulated elsewhere, we can consider how animation itself—its 'internal operations' so to speak— are part of the process of the creation of value. This is where something is at risk, because the material tendencies of animation cannot be treated in the manner of an autonomous object or physical object, as the prior account of Whitehead and Gibson suggested. The material tendencies of animation entail affective and perceptual experimentation.

In *Norakuro nitōhei*, for instance, the dog regiment, coded as Japanese, runs into trouble with a tiger, which evokes Korea. Norakuro, painted with stripes that make him resemble a tiger cub, is able to approach the fearsome tiger and trick him into swallowing a laughing gas. The dogs cage the tiger and merrily take the tiger into captivity, Norakuro singing and dancing atop the cage in military attire. The animation thus brings into a play a sort of 'speciesism' wherein animals stand into for peoples, cultures, and nations (Lamarre 2008, 2010, 2011). Such speciesism is redolent of racism, particularly insofar as it introduces a hierarchy among life forms, and yet its 'biologization' of difference does not depend primarily on scientific measurement, recording, and classification of physiological or physiognomic differences. Speciesism articulates gradations in animal existence rather than shore up a divide between human and animal in order to dehumanize the enemy. This latter strategy, as John Dower (1986) has shown, was common in American wartime representations of the Japanese enemy, and Warner Brothers and Disney cartoons are no exception.

In contrast, given that the Japanese invasion of neighboring countries was couched in terms of racial liberation, and in light of the general critique

in Japan of the racism implicit in social Darwinism, it is not surprising that Japanese animations, like other cultural productions, would avoid that sort of racism by promoting ideas of coprosperity and pan-Asianism. Indeed, the pan-speciesism of *Norakuro nitōhei* proves surprisingly resonant with pan-Asianism, and its apparently non-technical vitality appears remarkably consonant with Japanese bids for regional prosperity, as in the Greater East Asia Co-Prosperity Sphere. (Under Japanese Empire, and especially in the 1930s, the idea of a Greater Co-Prosperity Sphere—a league of nations autonomous of Western powers, to be led by Japan—gained currency.) But this is not just a problem of Japanese empire. A similar problem troubles the distinction between *zoe* and *bios*, particularly as reinforced by Giorgio Agamben: *zoe* is life as the object of techniques, while *bios* is life as a property of organisms (1998: 11). Agamben famously argues that the nation-state subsumes bare life (*zoe*) under political life (*bios*), and people under the People. As the example of *Norakuro nitōhei* attests, politics of life in animation is situated on the same threshold, and like Agamben (or Antonio Negri), it will run the risk of transcendent universal vitalism when it strives to embody or otherwise localize a non-technicized life in a 'species' or 'people' or 'multitude' in opposition to Western empire.

Animation, however, does not only repeat or reflect social values. It also brings a specific kind of potentiality into play when it shunts the autonomous non-localized movement (life) of compositing into cartoon animals. The danger is that this animal vitality may appear to generate new species and new relations between species (speciesism) in a non-technological manner, without recourse to technique or apparatuses, entirely innocent of its potential and thus of power. Thus the life of animation runs the risk of becoming a universal or transcendent unity that hierarchizes relations as if naturally, organically, beyond technique—in a word, vitalism in the place of social Darwinism. At the same time, the life of animation offers another approach to biopolitics.

It is telling that Eisenstein for instance uses the term plasmaticness, for this term avoids imputing organicism to cartoon animals while highlighting the technicity of their liveliness. Cartoon animals and the associated techniques of character animation are an instance of *bios* in which techniques are applied to life in order to produce new life forms and new relations between them—recalling both eugenics and population management. It is not so surprising then that it is a 'wild type' or 'stray type' (Norakuro) that proves essential to interacting with other species. The other kind of movement, compositing, is akin to *zoe* in that it is prior to and outside character animation. It is not a mere material support for embodied movement. It enables an overall underlying composition of forces, which can be prolonged in different ways, of which cartoon animals are but one. For all that its non-localized tendency may make it feel as if it is a non-technicized life source, it is technicized, yet in a different way than

cartoon animals. Compositing (non-localized movement) troubles the distinction between *zoe* and *bios*, evoking bio-affective technicity rather than sacralizing it.

As the surge in the popularity of animation and the renewed attention to techniques of compositing in digital cinema and animation in the 1990s and 2000s suggests, the implications of this aspect of animation would not be evident until the post-war era, and would be not mobilized until new communications and information technologies made techniques of animation ubiquitous. From the 1960s, cartoon characters became ever more autonomous of their animated films, due in part to multimedia franchising (Steinberg 2012). As the boundaries between media became more tenuous, the 'logic' of compositing was no longer confined to an 'internal' logic of animation but began to enable a new way of composing the material forces that were previously composed within more distinctive media formations (print, television, radio) and sites of production (toy makers, publishers, advertisers). It is not surprising then that species war, interspecies romance, xenocide, genetic manipulation, and extralegal operations against non-legal humans, came to the fore in entertainments using 'expanded' animation—digital animation, SFX films, and video games. For the technical paradigm first articulated in cel animation was primed to address the transformation in the biopolitical from eugenics and population management (and the legacy of the Second World War) toward the bio-affective technicity of contemporary information networks.

coda: new life

A film theorist who wrote extensively on animation and documentary, Imamura Taihei, is credited with the first book-length treatise on animation, *Manga eiga ron* (*On Cartoon Films*) in 1941, revised and republished in 1948 and 1965. Earlier, in 1938, Imamura wrote an essay comparing Japanese cartoons to American cartoons, especially Walt Disney's. Apparently, his viewing of a Japanese short animation, *Kaeru no kenpō* (*Frog Swordsman*), proved so disappointing in its treatment of movement and life that he felt compelled to provide an account of the virtues of Disney cartoons in the hopes of providing some guidelines for improving Japanese animation. He writes,

> In Walt Disney's works, one always feels the vitality and life of movement. The little animals on the screen no longer seem like individual drawings, and everything familiar around us is utterly transformed. Even if the background paintings often look rather mediocre, the joy of life surging up within the moving animals is amazing. As they leap about or lie down, the life force bubbling up on the screen flows through us like wine. It gives arise to the most

delightful feeling of intoxication. Seeing a Disney cartoon even just once, we moderns come to understand what the ancient Dionysian spirit of festive celebration was all about.

These animals are indeed modern-day satyrs. Taken one by one the still drawings do not look particularly lovely at all. A still image of something like Mickey Mouse tends rather to be ugly. How is it that an image crudely drawn in heavy lines without any particular charm, when set in motion, becomes full of life and spirit, and simply put, is no longer a drawing? The secret must lie in movement itself, that which moves the drawings. This secret of movement is the key to what makes Japanese cartoons so dull. (Imamura 1991: 137–138)

Imamura's analysis of cartoons continually stresses that the art of animation lies not in the art of drawing (which he characterizes as spatial) but in movement (which he characterizes as temporal). He argues that animation is, in fact, a temporal art of drawings. As such, cartoons are related to cinema, and Imamura not only uses the term cartoon film or cartoon cinema (*manga eiga*) but also argues that drawings in cartoons are always combined with 'photography' (*shashin*). What precisely Imamura means by *shashin* or photography is a complicated matter, but in this context, it is clear that he wishes to highlight the cinematic 'parsing' (*bunkai*) of movement, that is, the decomposition and recomposition of movement on film. Indeed he frequently qualifies 'photography' as 'photographic filming' (*shashin satsuei*) and argues that truly amazing cartoon sequences use film footage as a model for movement—as with the flight of the Roc at the beginning of the Fleischers' version of *Sinbad the Sailor* (1936).

His analysis here focuses almost exclusively on character animation, and it is in these terms that Japanese animation proves disappointing to him. In fact, as I will show, what Imamura finds disappointing in Japanese cartoons is precisely what orientates them toward the art of compositing rather than character animation. Put another way, he is so interested in the localization of movement that he rules out both non-localized movement and modes of localized movement or embodiment other than those found in Disney and American cartoons (making the classic full animation the standard for judgment). While I do not share his disappointment in Japanese cartoons or his emphasis on full character animation, Imamura's observations on these forms are insightful. And they help to sum up what is at stake in the expanded empiricism of animation that I have undertaken here.

Two aspects of character animation in Japanese cartoons bother Imamura. First, he highlights how movement in Disney cartoons involves a sense of non-arbitrary intentionality, a sort of inner purpose or

psychological motivation. As such, Imamura tends to make goal-orientated action the fundamental criteria for cartoon character movement. Such an emphasis is not so surprising really in his historical context. It is consonant with Deleuze's analysis of a tendency in pre-war national cinemas toward the movement-image, or what other commentators call the classic Hollywood style with reference to American cinema. Imamura's disappointment in Japanese cartoons can be linked to an inability to detect a classic cartoon style (a specifically Japanese tendency of the movement-image) comparable to American cartoons. In historical terms, a Japanese style would not become visible *and* enunciable until the rise of television animation (*telebi anime* or *anime*) in Japan in the 1960s, and its increasingly transnational circulation that led to the global boom in Japanese animation over the past two decades. Because this internationally recognized Japanese style is based largely on techniques of limited animation, Imamura's emphasis on full animation rules out what today interests us.

Second, Imamura champions a sort of 'realism' (*shajitsu*), and his bid for realism builds on 'photography' to address two levels of animation. On the one hand, as we have seen, he champions a cinematic breakdown of movement allowing for frame-by-frame recomposition of cinematic movement in cartoons—an ideal of full animation verging on rotoscoping. On the other hand, he addresses character design. He notes, for instance, that the frog in *Kaeru no kenpō* is not simplified realistically as is the frog in Disney's *The Old Mill* (1937). He suggests that, without some sense of realism in the simplified forms of cartoon characters, their metamorphoses become meaningless, for the character forms are already too close, too similar. Indeed, in **Plate 17**, we see that the frog in *Kaeru no kenpō* is so simplified that it looks akin to the fish it is riding. This tendency is not uncommon in 1930s Japanese cartoons. Take, for instance, *Bōken Dankichi—hyōryūtan* (*Adventurous Dankichi: Adrift*) a short animation from the early 1930s (actual date unknown; based on a manga by Shimada Keizō), in which the context is clearly imperial: the boy hero Dankichi bumps noses with the 'native' chief of South Seas island (**See Figure 5.4**).

Such cartoons suggest that a different set of techniques and conventions were emerging in 1930s Japanese cartoons, which should not be quickly dismissed as being less developed or technically backward, any more than they can be attributed to cultural difference (or 'Japaneseness'), atavistically. The Japanese cartoons make clear that, in character animation, there is always a tension between the degree of 'fullness' of movement and the degree of simplification in character design. In fact, the characters in these Japanese cartoons are at once more simplified *and* more rigid than their Disney or Fleischer counterparts. **Figure 5.4** and **Plate 17** show that plasticity or plastmaticness of line becoming shunted into large bulging eyes and exceedingly rounded shapes, precisely because it is not expressed in the register of fuller movement. As a consequence, as Imamura notes

Figure 5.4

Bōken Dankichi—hyōryūtan (*Adventurous Dankichi: Adrift*), a short animation from the early 1930s (actual date unknown; based on a manga by Shimada Keizō).

disparagingly, such cartoon characters do not tend to impart a strong sense of psychological agency or inner purpose, of motivated or directed action. It is as if their rounded bulges allow them to go in any direction. Not surprisingly, as if in anticipation of the rise of limited animation techniques in the television animations of 1960s Japan, these cartoons frequently use the movement of layers of the image (compositing) to produce a sense of movement rather than character animation. In *Bōken Dankichi* (**See Figure 5.4**) for instance, a somersault is achieved by spinning the character upon the background, and even in the still image from *Kaeru no kenpō* (**See Plate 17**), the image is so planar that you can fairly feel the movement between the background layer and the character layer.

Even though the genuinely delightful artistry of American cartoons (and the massive efforts and capital mobilized to put them on screens across the world) made other kinds of cartoons difficult to appreciate at the time, we can in retrospect see in 1930s Japanese cartoons the articulation of a different way of specifying movement as life, one that would gain in concreteness in the Japanese limited animation of the post-war era. Such cartoons tend to combine 'cute' (bulging eyes, reduced limbs, rounded forms) with hieratic, even rigid linework. They also tend to highlight the planarity of the image and often resort to sliding layers of the image to impart a sense of movement. Paradoxically, while such techniques are associated with limited animation, which implies limited movement, their specification of movement-as-life is not at all limited. On the contrary, as mentioned previously, because movement is not as localized in character

animation in such cartoons, it troubles a neat divide between *zoe* and *bios*, bringing *zoe* to fore as a site of action and thus of the political.

Consequently, rather than bemoan the lack of realism in character design or the lack of full animation in 1930s Japanese cartoons as Imamura does, we might note that, although Disney's *Little Hiawatha* (1937) deploys the realism of movement that Imumura champions, the cartoon does not escape or resolve the issue of American empire. *Little Hiawatha* is not less imperial or more progressive than *Norakuro nitōhei*, *Kaeru no kenpō*, or *Bōken Dankichi*. It presents, in fact, a different conjuncture of imperialism and liberalism.

These 1930s Japanese cartoons allow us to see a different dimension of the biopolitical, one that we might not have noted without studying animation: letting life happen. In contrast with the critical emphasis on, say, overarching imposition of a human techno-scientific instrumentaliza-tion onto the life world and forms of life (Heidegger), or the reduction of humans to 'bare life' (that is, animal life) as in Agamben, such cartoons show us a game of letting life develop, go its way, follow its course. This happens not in accordance to psychological principles but in accordance with principles and mechanisms of reality (Foucault 2007: 48), which here is the ground and the traversal reality of animation, that is, compositing. Ultimately then, this is what is at stake in immersing natural philosophy in animation: we avoid a simplistic interpretation of the politics of life as sheer instrumentalization or massive reduction, which stances tend to spur either greater instrumental intervention or more *laissez-vivre*. Via natural philosophy, we begin instead to understand how a genealogy of our contemporary politics of media, populations, and economies needs to address cartoon characters as forms of life rather than deceptive illusions.

references

Agamben, Giorgio. 1998. *Homo Sacer: Sovereign Power and Bare Life*. Trans. Daniel Heller-Roaszen. Stanford: Stanford University Press.

Baudrillard, Jean. 1994. The System of Collecting. In *The Cultures of Collecting*, eds John Elsner and Roger Cardinal. Cambridge: Harvard University Press: 7–24.

Benjamin, Walter. 1996. Announcement of the Journal *Angelus Novus*. In *Walter Benjamin. Selected Writings*. Vol. 1. 1913–1926. Cambridge, MA: Harvard Belknap Press: 292–296.

Buchan, Suzanne. 2011. *The Quay Brothers: Into a Metaphysical Playroom*. Minneapolis: University of Minnesota Press.

—— 2012. Theatrical Cartoon Comedy: From Animated Portmanteau to the *risus purus*. In *A Companion to Film Comedy*, ed. Andrew Horton and Joanna E. Rapf. London: Wiley-Blackwell: 521–43.

Burt, Jonathan. 2002. *Animals in Film*. London: Reaktion Books.

Cholodenko, Alan. 2007. (The) Death (of) the Animator, or: the Felicity of Felix, Part II. *Animation Studies* Vol. 2: 9–16.

Combes, Muriel. 1999. *Simondon, individu et collectivité*. Paris: Presses Universitaires de France.

Crafton, Donald. 2011. The Veiled Genealogies of Animation and Cinema. *Animation: an Interdisciplinary Journal* Vol. 6, No. 2: 93–110.

Dower, John. 1986. *War without Mercy: Race and Power in the Pacific War*. New York: Pantheon Books.

Eisenstein, Sergei. 1988. *Eisenstein on Disney*, ed. Jay Leyda, trans. Alan Upchurch. London: Methuen.

Foucault, Michel. 2007. *Security, Population, Territory: Lectures at the Collège de France 1977–1978*. New York: Palgrave McMillan.

Galbraith, Patrick W. and Thomas Lamarre. 2010. Otakuology: A Dialogue. In *Fanthropologies*, ed. Frenchy Lunning, Vol. 5. *Mechademia*. Minneapolis: University of Minnesota Press: 360–374.

Gibson, James J. 1979. *The Ecological Approach to Visual Perception*. Houghton Mifflin Company.

Gould, Stephen Jay. 1980. A Biological Homage to Mickey Mouse. In *The Panda's Thumb: More Reflections on Natural History*. New York: Norton.

Gregory, Richard. 1966. *Eye and Brain: The Psychology of Seeing*. London: Weidenfeld and Nicolson.

Hansen, Miriam. 1993. Of Mice and Ducks: Benjamin and Adorno on Disney. *The South Atlantic Quarterly* Vol. 92, No. 1: 27–61.

Imamura Taihei. 1991. Nihon manga-eiga no tame ni. In *Imamura Taihei eizô hyôron*, Vol. 2. Tokyo: Yumani shobô: 137–159.

Iwerks, Leslie, dir. 2007. *The Pixar Story*. Santa Monica: Leslie Iwerks Productions Inc.

James, William. 1884. What is an Emotion? *Mind* Vol. 9: 188–205.

Lamarre, Thomas. 2008. Speciesism Part 1: Translating Races into Animals in Wartime Animation. In *Limits of the Human*, ed. Frenchy Lunning, Vol. 3. *Mechademia*. Minneapolis: University of Minnesota Press: 75–95.

—— 2010. Speciesism Part 2: Tezuka Osamu and the Multispecies Ideal. In *Fanthropologies*, ed. Frenchy Lunning, Vol. 5 *Mechademia*. Minneapolis: University of Minnesota Press: 51–85.

—— 2011. Speciesism Part 3: Neoteny and the Politics of Life. In *User Enhanced*, ed. Frenchy Lunning, Vol. 6 *Mechademia*. Minneapolis: University of Minnesota Press: 110–136.

Miyamoto Hirohito. 2011. How Characters Stand Out. Trans. Thomas Lamarre. In *User Enhanced*, ed. Frenchy Lunning, Vol. 6 *Mechademia*. Minneapolis: University of Minnesota Press: 84–91.

Ōtsuka Eiji. 2008. Disarming Atom: Tezuka Osamu's Manga at War and Peace. In *Limits of the Human*, ed. Frenchy Lunning. Vol. 3 *Mechademia*. Minneapolis: University of Minnesota Press: 111–125.

Steinberg, Marc. 2012. *Anime's Media Mix: Franchising Toys and Characters in Japan*. Minneapolis: University of Minnesota Press.

Stengers, Isabelle. 2011. *Thinking with Whitehead: A Free and Wild Creation of Concepts*. Trans Michael Chase. Cambridge, MA: Harvard University Press.

Whitehead, Alfred North. 1920. Theories of the Bifurcation of Nature. In *The Concept of Nature. Tarner Lectures Delivered in Trinity College, November, 1919*. Cambridge: The University Press: 26–48.

a cinema of apprehension

a third entelechy of the vitalist

machine

s u z a n n e b u c h a n

> Ineluctable modality of the visible, at least that if
> no more, thought through my eyes. Signatures
> of all things I am here to read, seaspawn and
> seawrack, the nearing tide, that rusty boot.
> Snotgreen, bluesilver, rust: coloured signs. Limits
> of the diaphane. But he adds: in bodies.
>
> James Joyce, *Ulysses*, 1922

introduction

Since the digital shift, debates concerning immersion and spectator experience in film and media studies are heavily centered on computer-generated imagery (CGI) and virtual reality (VR). VR and CGI are digital technologies developed from animation, itself an over 100-year-old manipulated moving image form, and the experience of immersion also pre-dates digital technologies. As Tim Recuber explains, the notion of immersion, as it was employed by art critics or historians,

was used metaphorically, to describe the degree to which one was emotionally or intellectually involved with a work of art. Today, this metaphor, and the ideal it represents, is replaced with an actual technological immersion in the lived space of the theatre … new cinema achieves more calculable, predictable absorption of the spectator based not around the vagaries of artistic processes but on the certainties of technological advancements. (Recuber 2007: 320–21)

My focus here is neither the technological advancements of cinema through digital technologies, nor VR, as enablers of immersion. Rather, I explore the viewer's experience of a particular and absorbing 'presence' in celluloid-based films of animated 'actants' made of matter. These actants have everything to do with 'the vagaries of artistic processes', as the pro-filmic materials of animation are employed as artistic media.[1] Pre-digital animation has long generated experiences of a kind Oliver Grau attributes to CGI and VR when he asserts: "In addition to things based on the familiar, computer-generated virtual reality allows the creation of aesthetics that are no longer bound to physical laws" (2003: 203). In this chapter, I explore a cinematic technique that shares a high degree of photo-indexical realism with non-digital live-action film: puppet animation, which has long been unbound from physical laws that VR and CGI are aiming to circumvent. This technique is distinct from planar (2D, cel and drawn) animation—Stanley Cavell's "region of animated cartoons" (Cavell 1979: 167–68)[2]—and from CGI and VR. I make a case for the affective, emotive and *non*-intellective immersive qualities of a type of animated object—what I call *vitalist machines*[3]—that are constructed using inanimate materials: wood, fabric, and inorganic materials, including metal and machine parts (See Figure 6.1).

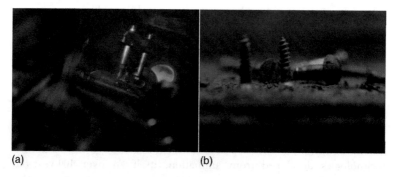

(a) (b)

Figure 6.1
The pumping sewing machine apparatus (a) and screws traveling off-screen (b). Screen shots from *Street of Crocodiles*, Quay Brothers, 1986.

suzanne buchan

Tom Gunning's writings on the viewer's experience triggered some ideas I will discuss here. His ongoing project is widely acknowledged as having profound implications for a wide range of theoretical, philosophical, technical and perceptual reception theories in art history and cinema studies. In a review essay published in *animation: an interdisciplinary journal* on *The Cinema of Attractions Reloaded* (2006), an anthology that responds to and celebrates Gunning's seminal 1986 essay "The Cinema of Attraction[s]: Early Film, Its Spectator and the Avant-Garde", Sean Cubitt suggests that Gunning's writings explain why early cinema "should be prized for what it did set out to do and achieved: to astonish, surprise and amaze its audiences with actions, gestures, movements and effects" (2007: 276). He then asks the question: "what relevance do these concerns have for our field of enquiry [animation studies]?" (276). In answer to his question, he comments: "It is possible that the 'cinema of attractions' thesis might illuminate the historical development and the possibilities for contemporary practice in animation in ways that we are just beginning to explore" (277). As an example, Cubitt describes Vivian Sobchack's contribution to the anthology, noting that her "work on technology [suggests] that there is a complex relationship between the enjoyment of the world figured on screen and enjoyment of the technology that brings it there ... [Sobchack] proposes slow motion as one avenue through which things that have never before existed for human beings come to exist for us" (279–80). Slow motion is, however, just one example of how modifications of real-time cinematic recording can provide us access to other perceptual 'worlds' than the 'real' world. Puppet/stop-frame animation is another.

In his 2007 essay, "To Scan a Ghost: The Ontology of Mediated Vision", Gunning examines the phantasm, claiming that in its intangibility, the phantasm shares immersive properties with VR and CGI imagery. He questions tropes of vision and transparency and focuses on the film medium itself, including its materiality and paradoxical aspiration to immateriality, and the illusion of "technological bodies made of light" (117). Gunning's discussion concerns magic, phantasma, spirits and ghosts, and their "atmosphere of virtuality" (106). In this, he accepts immersions studies' focus on VR, but not in terms of CGI, making it clear that he "is far from proposing ... a project of reenchantment of technology" (100). As will also become clear, I agree with Gunning in this respect. While inspired by his concepts, my focus is distinct from his overarching emphasis on the spectatorial experience of early optical entertainment, magic and illusions created by pre-cinematic and cinematic ephemeral, intangible light projection and trick effects, and their relationships with digital cinema. Rather, I am interested in the viewers' encounter with the non-living animated object through photochemical puppet animation. I will show how we can engage with performances of *things* that are materially extant but not otherwise experienced as moving and 'being' in the physical world.

Using the example of the Quay Brothers 1986 film *Street of Crocodiles*, I will develop four propositions with the aim of sketching a performative paradigm for spectatorship of puppet animation. In response to Gunning's discussions of the phantasm as an ontological alternative to the prevalent Aristotelian concept of the anima in animation studies, my first proposition is based on two concepts: *generatio aequivoca* and the vitalist machine. I will discuss the two principles of Aristotle's notion of entelechy to set the stage for proposing a third principle germane to the spectatorial experience of a paradigmatic set of animated actants made of matter. My second proposition concentrates on the materials, the 'stuff', of the Quay Brother's puppets and objects to show how Bruno Schulz's literary metaphysics on which the film is based, are transmuted, via materials from the extant, phenomenal world, and visual metaphor, into actants in a vitalist cinematic cosmogony. Third, I will develop a somatic, cognitive and aesthetic evaluation of the viewer's reaction to vitalist-cinematic animation to refine a concept of spectatorship that can potentially be applied to other pre-digital artifact-based animation films. I will then conclude with some observations on how naïvety and enchantment can be useful to understand the relationships between animated matter and the viewer's reception of it.

'limits of the diaphane'

> Then he was aware of them bodies before of them coloured.
> How? By knocking his sconce against them, sure
> Diaphane, adiaphane. If you can put your five fingers
> through it is a gate. If not a door. Shut your eyes and see.
> (James Joyce, *Ulysses* [1922] 1986: 31)

In "To Scan a Ghost", Gunning's examples draw mainly on film and photographic media (especially spirit photography). He is interested in the phantasm that "denotes an image that wavers between the material and immaterial and was used by premodern philosophy and science to explain the workings of both sight and consciousness, especially the imagination (*phantasia*)" (2007: 98). This ontology of the intangible, ephemeral spirit, phantasm and ghost is akin to Stephen Dedalus's "limits of the diaphane" (Joyce 1986: 31)—generally regarded as a reference to Enlightenment philosopher George AKA Bishop Berkeley's *esse est percipi* described in the 'Proteus' chapter of Joyce's *Ulysses*.[4] However, Joseph E. Duncan suggests "the references both to [Berkeley] and philosophy show clearly that throughout the opening of this section, the guiding influence on Stephen's thought is not Berkeley, but Aristotle"; and further, "it is [Aristotle's] theory of perception in *De Anima* as well as his idea of modality that Stephen is pondering as he walks along Sandymount strand" (Duncan 1957: 286–287).[5] In the following, I will explore these notions of perceptions and modalities through the difference between translucency and opacity, and

their correlation to intangibility and to palpability, and to non-physical and physical presence, in relation to the animated object.

Gunning's argument relies on a perceptual uncertainty related to "the essential aspect of a ghost ... [and its] problematic relation to the senses" (2007: 103). He suggests this uncertainty can be discussed "in terms of the ontology of the phantom itself, its mode of existence ambiguously perched between the living and the dead, the material and the incorporeal, rather than its mode of being perceived" (103). Yet, such a cinematic phantasm constitutes a limit of the diaphane, and a consideration of the objects used in stop-motion animation begs epistemological questions concerning relationships between matter and mind, of the limits of modalities of seeing, hearing and touch, of what Aristotle referred to as the soul and its affects.[6] The animated object is a category of 'being' that is rooted in a material, empirical existence in the extant world we live in. Unlike the ghostly human form of the cinematic phantasm, it does not originate from a *living* subject (actor); it is not 'perched between the living and the dead' in the same way. I will go beyond the diaphane—the phantasm, ghost and spirit—to investigate the *material object* in animated cinema that, while oscillating between phenomenal physical presence and immaterial on-screen presence, also prompts an engaged viewing experience distinct from live-action cinema, from CGI and from the phantasms Gunning describes: it is an experience of *something else* that is dependent on its *inanimate* objecthood.

between a stone and a hard place: vitalist principles of the *generatio aequivoca*

I now address my first proposition: to determine a typological case for the compelling qualities of a particular form of non-anthropomorphic animated figure, to then propose a vitalist-cinematic dialectic.[7] This dialectic is distinct from concepts of anima and animism that suggest animation 'breathes a soul' into figures; these, in my view, overused terms describe what is generally called the 'illusion of life' in animation studies, and is often used in reference to planar animation.[8] While concepts of anima and animism work for some styles of animation, I want to develop a term specifically for non-anthropomorphic puppet animation. To do this I will invoke both 'animist' and 'naturalistic' varieties of vitalism as proposed by Franz M. Wuketits[9] and summarized by Monica Greco in this way: "the first [variety] is explicitly metaphysical and teleological in orientation, while the second posits organic natural laws that transgress the range of physical explanations" (2005: 16–17). The first is "dependent on a non-physio-chemical entelechy" (Scott and Koch 2009: III) and this describes some of the Quay Brothers' (and some other animators') figures made of non-living matter such as metal, plaster, wood, or cloth. The teleology I will develop is located in the non-natural purpose, and will, of these vitalist machines.

I will now introduce some examples. A 'sewing machine' device (**See Figure 6.1a**) is constructed of metal machine parts, blood and a string-like filament.[10] While not visibly connected to the filament, the repetitive pumping of the machine drives a rotating pulley that transports it through the space and ultimately off-screen. The filament originates from a self-unravelling knot (**See Figure 6.2a**) that runs throughout the film's sets and generates a number of other vitalist machine movements as it travels through them (a screen-lifting mechanism, gears (**See Figure 6.2b**), a number of pulleys). The 'rubber band machine' (**See Figure 6.3a**) is an arrangement of filaments, shafts, wood, wires, rubber bands, and a metal linked extending arm with sharp metal fragments. Its movements are limited by its machine-like construction and its perpetual motion repetitiveness; as each rubber band stretches, breaks and falls (**See Figure 6.3b**), the arms are released from the tension that appears to provide energy for an apparatus that rises to insert another in the shard-like extensions, and the movement is repeated. The sound from this vitalist machine also generates other movements, including a wire and pipe contraption (**See Plate 18a**). Other vital machines include a reverse-melting ice cube (**See Plate 18b**) and a variety of screws (for example, **See Figure 6.1b**), whose movements are both limited and determined by their spiraled shafts that are mostly topped with a flat disc of metal.

These figures form a paradigmatic set for the following reasons, and I will explain what makes these machines specifically vitalist later. They are made of disjunctive fragments of inanimate organic and non-organic materials; they are neither gyno- nor anthropomorphic; they perform self-generating repetitive movements that are closely bound to their design and construction; they are 'autistic' in the sense that they are without self-absorption and do not communicate or interact with other actants; their animated performances cannot be experienced outside

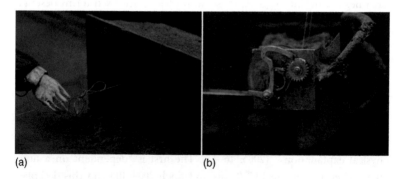

(a) (b)

Figure 6.2

The puppet's touch causes the filament to unravel and begin coursing through the diegesis (a) including through a clockwork gear (b). Screen shots from *Street of Crocodiles*, Quay Brothers, 1986.

(a) (b)

Figure 6.3

The rubber band machine's vertical arm 'inserts' a rubber band in the apparatus (a); as it rhythmically stretches the band, it snaps and falls to join a pile of others (b). Screen shots from *Street of Crocodiles*, Quay Brothers, 1986.

cinematic projection; and, finally, their material forms are extant in the physical world. By way of contrast, in "'Animated Pictures', Tales of Cinema's Forgotten Future", Gunning discusses the magic lantern (which is not a vitalist machine, but rather a mechanism or tool used by humans to project images) as a "confluence" of occult and Natural Magic and scientific discoveries of the Enlightenment. Interestingly, he then refers to Giambattista della Porta's *Magiae naturalis sive de miraculis rerum naturalium* (1589) and "the magical powers of images, stones, and plants" (1995b: 469). His focus is on the first and he doesn't pursue the other two in his argument. Since organic and inorganic materials are the material base for almost all techniques of puppet animation (pixilation of living humans, flora and fauna excepted),[11] these 'magical powers'—and particularly of 'stones'—need to be explored.

The conclusion of Bruno Schulz's "Treatise on Tailors' Dummies, or The Second Book of Genesis", in *The Street of Crocodiles* (1977) includes a description of a *generatio aequivoca*. This Latin term translates as spontaneous generation or self-reproduction, and is a form of Aristotelian abiogenesis that posits that living organisms can be created from the fertile properties of decaying, dead or inorganic matter, spontaneously, that is, independently of biogenetic species reproduction. In Schulz's story, the father describes his own version of this theory:

> Here my father began to set before our eyes the picture of that *generatio aequivoca* which he had dreamed up, a species of beings only half organic, a kind of pseudofauna and pseudoflora, the result of a fantastic fermentation of matter.
>
> They were creations resembling, in appearance only, living creatures such as crustaceans, vertebrates, cephalopods. In reality the appearance was misleading—they were amorphous creatures, with no internal structure, products

149

of the imitative tendency of matter which, equipped with
memory, *repeats from force of habit* the forms already accepted.
(Schulz 1977: 66, my emphasis)

Schulz here suggests the repetitive nature of matter of the vitalist machines, and he extends the concept of the *generatio aequivoca* by attributing vitalist principles to inorganic, non-carbon based matter. His pseudofauna and pseudoflora are 'life' forms that are "mobile, sensitive to stimuli and yet outside the pale of real life ... [and of which] chemical analysis revealed ... traces neither of albumen nor of carbon compounds" (66). Albumen (nucleic acids, animal egg cytoplasm) and carbon compounds are notably the base for embryonic generation and organic chemistry, and it is here that Schulz expands abiogenesis—the *generatio aequivoca*—to include non-physiochemical inorganic matter.

Mikal Oklot attributes Jerzy Jarzębski[12] with suggesting that: "Generatio aequivoca ... comes to Schulz most likely from Schopenhauer, whose thought was critical in shaping the imagination of Russian and Polish writers" (2007: 34). I believe Jarzębski is referring to passages in *The World as Will and Representation* such as the following:

an essential point of my teaching is that the phenomenal
appearance of a *will* is as little tied to life and organization as
it is to knowledge, and that therefore *the inorganic also has a
will*, whose manifestations are all its fundamental qualities
that are incapable of further explanation. (Schopenhauer
1966: 296–97, my emphasis)

Although Schopenhauer's aesthetic and ascetic philosophy paradoxically aimed for a denial of the-will-to-live through the reduction of human desires, his conception of 'will' fundamentally relies on the concept of *generatio aequivoca*:

Let us consider this universal craving for life and see the
infinite eagerness, ease and exuberance with which the
will-to-live presses impetuously into existence under
millions of forms everywhere and at every moment by
means of fertilization and germs, and indeed, *where these are
lacking*, by means of generatio aequivoca, seizing every
opportunity, greedily grasping for itself every material
capable of life (350, my emphasis)

The engrossing vitalism inherent in this description of matter, of all matter, resonates with Schulz's own description of the "fantastic fermentation of matter" he attributes to his father's form of *generatio aequivoca* and to his own particular understanding of the life of objects, to matter's "infinite fertility, inexhaustible vitality" (1966: 59). But he takes it even further than Schopenhauer: the father attributes to matter a quality that transcends 'greedy

grasping'—it is *compliant*, "[w]aiting for the life-giving breath of the spirit, it is endlessly in motion" (59). The filament that courses through the machines (**See Figure 6.2a**) is touched by the puppet, but the 'spirit' it receives is an effective transubstantiation of dead matter that occurs when it is literally taken in hand and, through the animator's agency, manipulated and animated.

This is exactly where we see the impact of Schulz's writings on the Quay Brothers' aesthetic and cinematic understanding of objects. In the year *Street of Crocodiles* was completed, the filmmakers wrote: "We were naturally drawn by [Schulz's] sense of the marvellous, the fabulous, his 'apocryphal thirteenth month,' his, as he called it, 'generatio aequivoca'" (1986: 1). They "grounded [*Street of Crocodiles*] around [Schulz's] very specific treatment of matter, certain metaphysical notions of 'degraded life' ... and his mythopoetic ascension of the everyday" (1). The Quay Brothers' treatment of these concepts cinematically is what many critics call the 'alchemy' of their works, a poetics of cinema that reconciles pre-Enlightenment, pre-positivist and later theories of vision and illusion with vitalism. But they pursue an alternative philosopher's stone than gold: a version of the 'elixir of life', a 'quintessential spirit' that the alchemists thought "was apparently ... identical to the philosopher's stone—to occur not only in plants and animals, but also in inorganic minerals" (Rosenfeld 1985: 1755). It is this third category—inorganic minerals—that distinguishes the Quay Brother's concept of vitalism from animism, their 'stones'—inorganic vitalist machines—from animals and plants. Their animated machines are vitalist precisely in line with Henri Bergson's epistemological concept of matter Randall Auxier summarizes as:

> parts that are subject to being disassembled and re-assembled
> in any order whatsoever to serve the abstract ends of the
> intellect itself or the purposes of the organism that intellect
> serves. 'Matter' in this sense exists as the intellect's infinitely
> malleable servant. (Auxier: 1999, unpaginated)

The Quay Brothers make creative use of this 'servant' and their animation of matter adds qualities to it that imply not just a will, but its surrender: in Schulz's language, "[m]atter is the most passive and most defenseless essence in cosmos. Anyone can mould it and shape it; it obeys everybody" (1966: 59). It is the attribution to matter of passivity that interests me: the Quay Brothers' machines are vitalist in that they produce a kind of 'life' through this passivity and the force of the *generatio aequivoca*. I will now develop this claim further.

matter, animism and a third entelechy

I venture that neither the terms anima—'the animating principle'—nor animism, that are so often used to describe animated figures, nor their etymological extensions to flora, fauna and the chemical and natural

worlds, can be used to describe the forms vitalism assumes in the Quay Brothers' films. An important distinction of the vitalism I am pursuing here, is that while animism and Gunning's investigations of phantasma presuppose a soul, vitalist machines do not. They cannot be said to have a "literal sense of survival after death" (Gunning 2007: 99), or to conform, as Gunning goes on to suggest, to Giorgio Agamben's description of a "system of phantasma as 'a kind of subtle body of the soul'" (106).[13] One of the most striking features of the Quay Brothers' vitalist machines is that, unlike human-based phantasma and most anthropomorphized animated puppets, they do not evoke a paradox that Gunning describes: "Corporeality, the sign of the real and material becomes tricked out in the guise of the incorporeal. The fascination this paradox exerts reveals our discomfort with the original dichotomy of body and soul, material and spiritual" (117). The Quay Brothers' non-anthropomorphic puppets do not project these dichotomies because they *do not* perform a soul and do not, and cannot, die: they exhibit rather Schulz's version of the vitalist *generatio aequivoca* that operates outside natural laws of organic reproduction and death.[14] Because they are autonomous from the physiochemical chain of being through which soul and spirit flow, they are pure material bodies without souls, hence vital.

To make this case more persuasively, I turn by way of contrast to Aristotle's complex concept of entelechy expounded in *De Anima*, a neologism for which Joe Sachs gives a perspicacious, almost Joycean etymology:

> Aristotle invents the word by combining enteles (complete, full-grown) with echein (hexis, to be a certain way by the continuing effort of holding on to that condition), while at the same time punning on endelecheia (persistence) by inserting telos (completion). This is a three-ring circus of a word, at the heart of everything in Aristotle's thinking, including the definition of motion. (Sachs 1995: 245)

In contemporary definitions, entelechy is generally understood as "a hypothetical agency not demonstrable by scientific methods that in some vitalist doctrines is considered an inherent regulating and directing force in the development and functioning of an organism".[15] For Aristotle, entelechy is the principle by which he attempts to reconcile the dichotomy of soul (anima) and matter, and it is the persistent effort to hold onto a particular condition to the end. As Hugh Lawson-Tancred has commented, entelechy "constitutes a comprehensive and convincing basis for an objective analysis of all the phenomena of vegetable and animal life" (1986: 68–69). This leads to the basis for definitions of animation, prevalent in animation studies, that refer to the anima as breathing a soul into things. Anima, originally Latin for the mind or the soul, is defined variously as "the spiritual or immaterial part of a human being or animal,

regarded as immortal [and] emotional or intellectual energy or intensity, especially as revealed in a work of art or an artistic performance" (Oxford Dictionaries).

Entelechy assumes two different forms. Its first form is to perform the actions of a soul "of a natural body endowed with organs" (Lawson-Tancred 1986: 59). The Quay Brothers' vitalist puppet machines, however, while certainly *forms* in action, do *not* perform the actions of a soul, not least because they are not a 'natural bodies' with organs; they are the quintessential bodies without organs. The second entelechy is ambiguous:

> [t]he difference between the first and second entelechy is the difference between possessing a function [Deleuze's *puissance*] and exercising that function [Foucault's *pouvoir*]: it is the difference between possessing knowledge when asleep and knowing when awake. (Randall 1960: 64–65)

This is a crucial distinction; while we *could* say the Quay Brothers' cinematic vitalist machines perform Aristotle's second entelechy, that they exercise the function of knowing (without possessing knowledge) when 'awake', meaning when they are moving; the puppets and machines in fact neither possess a function nor exercise a function. Both functions (*puissance* and *pouvoir*) are created by the animators in the objects' construction and through the technical process of animation, to *achieve* vital *movement* of inanimate matter rather than diaphanous phantasms based on living beings.

A spectator's sensation of movement of inanimate objects takes place through the modality of vision (and of hearing, when sound is assigned to an animated object).[16] Lawson-Tancred's discussion of Aristotle's concept of sense perception is relevant here and worth citing at length:

> an alteration (*alloiosis*) of the sense faculty such that *that which senses becomes like that which is sensed* having previously been unlike it …. Now the alteration that *constitutes an act of sensation* can be represented as the transition from a state of potential similarity with the object to one of *actual similarity*, and this Aristotle can apply to the act of sensation … the notion of the realization of potentiality. This realization, the transition from potential to actual similarity with the sense-object by the sense-organ and the sense faculty, is one instance of the transition from the first to the second entelechy of the body which is the transition from the animal capable of the functions of life to that actually performing them. (Lawson-Tancred 1986: 76, my emphasis)

While anthropomorphic animated puppets can have an *actual similarity* with the sensing viewer, she undergoes a different alteration when experiencing

the Quay Brothers' vitalist machines. Because of the inanimate origins of these animated 'sense objects 'and their mechanical, repetitive movement (**See Figures 6.1a, 6.3a, Plate 18a**) the perceiving viewer does not "become like that which is sensed having previously been unlike it"— there is no self-recognition in the viewer of the vitalist machine—and there is no transition to 'actual similarity' because it (the vitalist machine) has no similarity with organic life. The Quay Brothers' vitalist machines do not attempt to reconcile the dichotomy of soul and matter that Gunning suggests causes us discomfort with phantasma, "with the original dichotomy of body and soul, material and spiritual" (2007: 117). The sense perception is rather determined by the first entelechy of potential similarity—of human life—but not by the second—performing the functions of life. Their animated objects do not presuppose a soul; as the machines do not possess the function of the soul (first entelechy) they cannot exercise it (second entelechy).

Because, according to Schopenhauer, the *generatio aequivoca* has a will distinct from a soul, I propose that this animated matter performs a new, *soulless third entelechy*. And this is the very point of the *generatio aequivoca*—of spontaneous generation. A screw or a gear (**See Figures 6.1b, 6.2b**) does not perform the soul—the anima—or the animus—the mind. A soul is not required, yet vital 'life' is able to emerge from, and after, the shaping and the animating of will-less matter as achieved vital movement. The artists work with 'infinitely malleable' raw material, and through their own will and intention they create spontaneous generation machines that make manifest matter's will. In *Street of Crocodiles*, performance of this third entelechy allows the viewer to experience a non-human, non-physio-chemical, non-anthropomorphic form of soulless vitalist actual similarity. This is not achieved through anthropomorphic identification, but via the technique of animation. It enables reification ('thing-making') of Bruno Schulz's remarkable concept of the *generatio aequivoca* as a cinematic transmutation resulting in movement of organic and inorganic matter.

the animated actant: noncompossibility, portmanteau puppets and disjunctive synthesis

I now turn to my second concern: how does the viewer engage with the state of being of these actant-objects and their material objectness? In "To Scan a Ghost" Gunning's focus:

> precisely targets the phenomenological, how ghosts present themselves to the living, their mode of *apprehension* if not perception. The mode of appearing becomes crucial with ghosts and spirits because they are generally understood, by both believers and skeptics, to be apparitions

rather than ordinary material objects". (Gunning 2007: 103, my emphasis)

The Quay Brothers' objects, however, are not apparitions of this sort; they are experienced as cinematic actants made of ordinary materials that can be modally experienced as physical objects with the material and cultural origins of the matter they are made from intact.[17] For this reason animated puppets are not representations of living beings, nor graphic artistic interpretations, nor illusory diaphanous effects—the animated photo-indexical images are rooted in an objecthood in the physical world. There is a paradox here distinct from Gunning's paradox of corporeality cited above, of "[c]orporeality, the sign of the real and material [becoming] tricked out in the guise of the incorporeal" (2007: 117). In contradistinction, we are here 'tricked' *into* a guise of 'the living': we can hold the inanimate forms in our hands or see them displayed in exhibitions, but we can never experience them as 'living' until they appear in the film in all their cinematic representational 'presence', a presence made possible by the animator's agency. It is these forms and this agency I will explain, before describing the mode of apprehension unique to them.

Discussing Georges Méliès, Gunning acknowledges that "many trick films are, in effect, plotless, a series of transformations strung together with little connection and certainly *no characterization*" (2000: 231, my emphasis). It is specifically this lack of characterization I will address now. In puppet animation, these actor-objects have no character, indeed, no 'life' of their own without the animator's involvement, which creates vitality through manipulations of movement in between stop-motion single frame shooting. As Jean Mitry suggests, "One might say that *any object presented in moving images gains a meaning* (a collection of significations) *it does not have 'in reality', that is, as a real presence*" (1997: 45). But we also have epistemological experience and know that in contrast to live-action figures, off-screen, the Quay Brothers' puppets and vitalist machines do not 'exist'—they are inanimate objects on a shelf or in a box. They cannot be "dissociated from the creative imagination … to have an independent, exclusive existence", a feature Mitry ascribes to actors (50). In fact, the animated actant embodies exactly this 'creative imagination', in that its 'existence' is defined entirely by the conceptual and technical processes of its construction and animation. It does not 'act' until it has been manipulated by the animator's hand, shot in single frame technique and projected.

What might this "collection of significations" be for an animated figure that engages the viewer? In a context of intentions, humanness and non-human actants, Torben Grodal investigates how we understand what he calls a "humanness" that, when not defined through verbal means, can be achieved through visual and narrative means, and "is depicted as a 'felt totality'" (1999: 110) through what he describes as

155

a determination [that] can arise from contrasts and differences to other living beings, as when humanness is determined by delimiting it in relation to a beastly otherness that has its own *raison d'être*, but the determination is often subtractive: the essential human features are implied by describing certain human-like but "non-human" actants, who retain some features comparable to those of humans but who still lack some 'essential' human features. (Grodal 1999: 106)

Grodal also describes two variations of "non-humanness": he connects the first, negative one with the subhuman, and the second with non-human features that he aligns to the superhuman, that can be positive, negative or complex (106). The Quay Brothers' anthro- and gynopomorphic puppets combine objects and human attributes and have some human features (**See Figure 6.4** and **Plate 19**), but their vitalist machines do not. They are animated assemblages of inanimate fragments often salvaged from flea markets: rusty screws, worn fabric, plaster, bent nails, metal, wood and

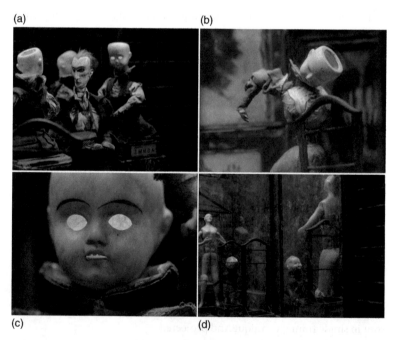

Figure 6.4

Top left to bottom right: Gyno- and anthropomorphic puppets: the 'Bruno' puppet and tailor's assistants (a); repetitive movement reveals the metal armature (b); porcelain doll's head filled with cotton wool and lit from above to suggest soullessness (c), and the 'boy' confronted with an eroticized 'female' puppet (d). Screen shots from *Street of Crocodiles*, Quay Brothers, 1986.

mechanical parts. Grodal continues: "if we isolate the component parts and functions from the totality, the components are often felt to have a non-human quality which is normally connected with lower-life forms, things, and mechanical devices" (110). The vitalist machines are actants that belong to a third variant of non-humanness, a category of the soulless third entelechy, and are constructed of nonhuman, inanimate component parts, which I will now describe in more detail.

The Quay Brothers' puppets and sets are mostly made of the 'detritus' Walter Benjamin speaks of in "Old Forgotten Childrens' Books" where he describes how children use waste materials to "bring together, in the artifact produced in play, materials of widely differing kinds in a new volatile relationship" (2004: 408).[18] Here we hear echoes of Schulz's comment that matter obeys everyone (even children and animators), and of Bergson's notion of matter as 'the intellect's infinitely malleable servant'. But the unruly, often disjunctive materials that comprise the Quay Brothers' animated actants 'obey' not through verbal commands, but through the artists' use of visual metaphors. But how do such metaphors function with respect to the spectator? To explain this 'volatile relationship' and the transition from the conceptual (Schulz) through the phenomenal (inert matter) to the audiences' experience of animated actants in the Quay Brothers' work, I start with the concept of metaphor.

In a discussion of Aristotle's definition of metaphor, D. Kirklin observes:

> [Paul Ricoeur] argues that metaphor bears information because it redescribes reality in a way that is made possible by the use of the calculated category—mistake. The deployment of metaphor therefore requires the creation of a new order by the creation of a rift or disturbance in the old order. (Kirklin 2007: 12)

This 'disturbance' requires an engagement to understand what the difference to the old order entails. In terms of images, in his thorough analysis of cinematic metaphor, Trevor Whittock suggests that viewers and various tropes, or metaphorical devices, are joined in a process of cocreation:

> They function in relation to one another and to other elements in the work In art, figurative meanings coalesce to form new constellations; patterns amalgamate to create larger structures; constituent parts are ever-combining into significant wholes. Metaphor is not only an element in this process: The very process itself is one of metaphorical transformations. (Whittock 1990: 15)

In other words, metaphors are not merely represented in and by an artwork, but the artwork itself comes into being through the viewer's own powers of imagination, in "the link between the artist's conception and the

spectator's cocreation of [visual metaphor]. It posits the film image as mediating between the two" (29). This co-creativity is generated by a disturbance of the old order that is re-described through metaphor. Noël Carroll, writing specifically about animated cartoon figures, elaborates on visual metaphor, describing it as a form of 'physical noncompossibility': it is that which "is not physically compossible with the universe as we know it that muscles be anvils, that people be cassette recorders or that spies be foxes" (2001: 213). The 'old order' here is disturbed because a human bicep cannot literally be an anvil, yet the conceptual comparison is meaningful and the metaphor 'strong as an anvil' implies inhuman strength. Such noncompossibility of the visual occurs in a situation of homospatiality as a property of "elements [that] are co-present—or homospatial—in the same figure" (212) as in the Popeye example, on the one hand, and on the other, noncompossibility can suggest identity "when [elements] are *visually* incorporated or amalgamated into one spatially bounded homogeneous entity... but nevertheless [are] self-identifable ... *visually* indicating that these elements are elements of the self-same identity"[19] (213–214, my emphasis). They are a specific visual metaphor comprised of noncompossible elements that fulfill Aristotle's definition of metaphor—that which makes unlike things like—and are inherently a form of disjunctive synthesis, as I will now explain.

The viewer's cocreative play with these visual metaphors and noncompossible objects bears comparison with similar play with the literary technique of portmanteau.[20] The reader's comprehension of nonsense words compiled of lexemes blend to produce a different sense than the original components. For instance James Joyce's pornographic, philosophical "pornosophical" (1984: 353); is a merging of male and female 'old order' attributes (his, her, she, him) in "shis" and "hrim" (440); "Grandjoker Vladinmire Pokethankertscheff" (252) reifies a combination of names, languages, types and attributes of matter (fabric, muddy) and sounds (a sneeze); and "familllionarely" (attributed to G. Heymans in Freud 1966: 12–13) is a merging of familiar and millionaire. Many of the Quay Brothers' puppets and vitalist machines are constructed through visually noncompossible metaphors, and they form what I have described elsewhere as portmanteau puppets: "composite figures made of disparate materials that notionally have nothing in common, but which, in their specific combinations, create a unique type of cinematic metaphor" (Buchan 2001: 129). Like the reader, the spectator must also engage in a form of play to discover the animators' intended meanings in the particular combination of fragments used to make the animated objects. Examples are: the 'rubber band machine' automaton (**See Figure 6.3**), the 'sewing machine' device, that 'vivifies' a machine with blood (**See Figure 6.1a**), and the tailor's assistants (**See Figure 6.4a,b,c**) that combine fragments of human form (empty porcelain puppet heads) with fabric, wood and metal parts to suggest a

bionic nature/culture female puppet. The drawers with Polish typography embedded in their lower torso suggests they are literally part of the tailor's shop architecture (and recall Salvador Dali's female figure in *The Burning Giraffe*, 1937).

In *The Logic of Sense*, Gilles Deleuze suggests that "the portmanteau word is grounded upon a strict disjunctive synthesis. Far from being confronted with a particular case, we discover the law of the portmanteau word in general, provided we disengage each time the disjunction which may have been hidden" (1990: 46). The portmanteau technique is also a form of assemblage and homologous to the Quay Brothers' animated objects that are assembled artworks. In *Dialogues 2*, Deleuze suggests that "the product of an assemblage ... is always collective, which brings into play within us and outside us populations, multiplicities, territories, becomings, affects, events" (Deleuze and Parnet 2007: 51). Carroll suggests something similar, that "metaphors interanimate the relations between classes or categories" (2001: 219). The composite, assembled machines in the Quay Brothers' film are *literally* bodies-without-organs (though some are organs without bodies, which I address elsewhere).[21] I propose that their noncompossible vitalist machines employ a form of disjunction that corresponds with Deleuze and Félix Guattari's notion of disjunctive synthesis, that Thomas Lamarre has also applied to techniques used in Japanese Heian poetics and art.[22] While I am not using this concept in the authors' original context and purpose—a critique of psychoanalysis and capitalism—disjunctive synthesis is compelling as a concept to help elucidate the differences between the Quay Brothers' animation process and the viewers' experience of the product: a film that presents noncompossible, homeospatial materials as forms and actants that exhibit characteristics of life on-screen:

> Production is not recorded in the same way it is produced, however ... we have passed imperceptibly into a domain of the production of recording, whose law is not the same as that of the production of production The disjunctive synthesis of recording therefore comes to overlap the connective synthesis of production. (Deleuze and Guattari 2004: 13)

Michael Hardt explains that "we can call the disjunction also a synthesis, because the disjoint elements do not exclude or contradict one another. They remain distinct but allow a kind of passage between them" (Hardt, undated). This passage is the viewer's co-creative work: to make visual metaphors that synthesize fragments into a comprehended unity of the noncompossible object. In terms of matter and the viewer's *experience* of animated matter, Deleuze and Guattari suggest: "The disjunctive synthesis of recording ... is capable of two uses, the one immanent, the other transcendent" (2004: 86). The materials used in puppet animation

production are immanent, and the assemblages created through the production process of animation that we see on-screen are transcendent. In other words, animated visual disjunctive synthesis is that which holds together noncompossible animated elements of life and soulless non-life, and the organic and the mechanical models are synthesized in the mode of the third entelechy.

Via the cognitive processes of visual metaphor, noncompossible assemblage and disjunctive synthesis that generate the spectator's engagement with and understanding of the actants in the Quay Brothers' cinematic 'world', the puppets and vitalist machines become credible, what Carroll describes as "compossible entities in what might be called the world of the fiction or the world intended by the narrator" (2001: 216). The spectator is complicit in cocreating them as viable, believable actants in the film's fiction. As Michael Heim proposes "A world is not a collection of fragments, not even an amalgam of pieces. It is a felt totality or whole … not a collection of things but an active usage that relates things together, that interlinks them" (2000: 89–90). The Quay Brothers' sculptural non-compossible assemblages are visual metaphors that, following Heim, are perceived and felt as wholes within the *unique* fictional world of the film. In their animated 'worlds' the Quay Brothers literally interanimate between categories of literature, sculpture, material commodities and cinema; they also interanimate the viewer's 'passage' between categories of phenomenal worlds and the experience of the third entelechy I have proposed, that allows the viewer to experience a non-human, non-physiochemical form of soulless vitalist machine.

a cinema of apprehension

I will now entertain a third proposition. If the spectator's co-creativity oscillates between the knowledge that puppets and vitalist machines 'exist' only as animation in the fictional world of the film, between the phenomenal world and an animated world, an epistemological ambivalence arises between inanimate objecthood on the one hand, and the emotionally charged pathetic fallacy of attributing life and sentience to inanimate things, on the other. The latter allows the viewer to perceive animated objects as living, inciting what Marie-Laure Ryan calls "the amphibian state of pleasurable entrancement" (2001: 97). However, rather than the immersion-related experience of entrancement, and closer to the notion of attraction, and to the type of 'sensation' Lawson-Tancred describes, I suggest the viewer's reaction to this animated vitalist-cinematic dialectic is a combination of enchantment and of apprehension. Because the spectator's experience is one of uncertainty, indeterminacy and undecidability, apprehension is the name I will give to this ambivalent oscillation.

Apprehension is the cognitive condition of partial understanding (as opposed to comprehension which claims understanding of wholes), of grasping something with the intellect, but only partially. Apprehended knowledge can be: first-hand and sensory; knowledge that comes from others, or abstract concepts that conflict with our direct sensory—or phenomenal—apprehension. But it can also mean an affective 'understanding' and emotional grasping *without* intellective affirmation, and a recognition that what one comes to cognize may not be what is epistemologically expected: it is this undecidable difference that constitutes apprehension in my use of the term. It is the cognitive condition of an understanding faced with a dialectic of two opposing yet unresolvable states, of grasping something incompletely, simultaneously through intellect *and* affection.

To contextualize and explain how apprehension is an element of the spectator's experience, I start with Sergei Eisenstein's original definition of an attraction:

> An attraction (in relation to the theatre) is any aggressive
> aspect of the theatre; that is, any element of the theatre
> that subjects the spectator to a sensual or psychological
> impact, experimentally regulated and mathematically
> calculated to produce in him certain emotional shocks
> (Eisenstein 1974: 78)

These emotional shocks are similar to Kirkland's notion of disruption of old order expectations. Gunning's own definition of the cinema of attractions is "a cinema that displays its visibility, willing to rupture a self-enclosed fictional world for a chance to solicit the attention of the spectator" (1990: 230). He suggests: "These early films explicitly acknowledge their spectator, seeming to reach outwards and confront. Contemplative absorption is impossible here. The viewer's curiosity is aroused and fulfilled through a marked encounter, a direct stimulus, a succession of shocks" (1995a: 123). As third entelechy soulless forms, the Quay Brothers 'autistic' vitalist machines *do not* acknowledge the spectator, but they do allow for a type of absorption that is also not contemplative: the experience of these forms cause an oscillation between critical detachment towards non-human, inorganic forms and a form of shock, an affective apprehension of them as 'living' actants on-screen.

Eisenstein's and Benjamin's notably related concepts of the attraction and emotional shock are criticized today because of spectacle saturation and the overload of digital visuality. Some authors engage the term in a more positive way, and the first useful for my purposes here is another aspect of shock that Gunning discusses in the context of new technologies and modernity:

> As [Miriam] Hansen has indicated, Benjamin's analysis of
> shock has a fundamental ambivalence, moulded certainly
> by the impoverishment of experience in modern life, but
> also capable of assuming 'a strategic significance—as an
> artificial means of propelling the human body into
> moments of recognition'. (Gunning 1995a: 128–129)[23]

It is on this "fundamental ambivalence" and "recognition" that I focus now. Ethicist philosopher Jane Bennett is the second author who treats shock in a positive way, and she describes a mood that can explain the appeal and affective experience of watching the Quay Brothers' vitalist machines. Her project offers an alternative to what she terms the "disenchantment tale" of modernity and contemporary life that she describes as "a place of dearth and alienation and of control" (2001: 3–5). Bennett's 'disenchantment tale' corresponds compellingly with Gunning's observation about Modernism that

> [t]he sudden, intense and external satisfaction supplied by
> the succession of attractions was recognised by Kracauer as
> revealing the fragmentation of modern experience
> Attractions are a response to an experience of alienation,
> and for Kracauer (as for Benjamin) cinema's value lay in
> exposing a fundamental loss of coherence and authentic-
> ity. (Gunning 1995a: 128)

Bennett softens the critique of emotional shock and Kracauer's negative experience of alienation by introducing the exhilaration of the new and unexpected. Her alternate tale—one that is also highly pertinent when thinking about the emotional appeal of animation and that corrects prevailing misconceptions that it is childish or regressive—is rife with examples of what she calls "sites of enchantment" that include:

> the discovery of sophisticated modes of communication
> among nonhumans, the strange agency of physical systems
> at far-from-equilibrium states, and the animation of
> objects by video technologies and animation whose effects
> are not fully captured by the idea of 'commodity fetish-
> ism'. (Bennett 2001: 4)

The non-digital vitalist machines of the Quay Brothers' films are "sites of enchantment" that reconcile the conflict and ambivalence between technology and the (apparently) organic and the inorganic, and it is only possible through the regulation and mathematical calculations of the animation process and film projection. Through animation, the Quay Brothers' vitalist machines perform non-human communication without linguistic structures. Importantly, their repetitive motions and gestures

are choreographed to mainly acousmatic music, sound and noise to create what Michel Chion describes as temporalization through "sound [that] vectorizes or dramatizes shots, orienting them toward a future, a goal, a creation of a feeling of immanence and expectation" (1994: 13). This incites an affective engagement that is distinct from the emotions elicited by anthro- and gynopomorphic forms.

Bennett proposes a phenomenology for enchantment, that I interpret as a positive form of shock, that is experienced as: "a condition of exhilaration or acute sensory activity. To be simultaneously transfixed in wonder and transported by sense, to be both caught up and carried away—enchantment is marked by this odd *combination* of somatic effects" (2001: 4, my emphasis), and I will return to this below. Describing cognitive phenomena of the experience of non-human behavior, of a kind such as the repetitive movements of the Quay Brothers' vitalist machines (the pumping sewing machine device, the reflex-like expanding and collapsing rubber band machine), Grodal suggests that "the registration of non-human 'one-track minds' impels a strong emotional impact, with reactions varying from fear and disgust to amusement (or, in relation to children and certain animals, a reaction of tenderness" (1999: 108). I suggest somatic and emotional enchantment leads to another cognitive phenomenon, similar to a type of immersion that Grau posits "can be an intellectually stimulating process; however, ... in most cases immersion is mentally absorbing and a process, a change, a passage from one mental state from another" (2003: 13). This recalls Lawson-Tancred's shock-related, sense-based "transition from potential to actual similarity" (1986: 76), but these mental states are different in the state of enchantment.

The Quay Brothers' films exhilarate us emotively—we are subjected to Eisenstein's sensual or psychological impact and experience 'certain emotional shocks'—as we are confronted with the combination of non-human communication, non-human logic of movement and a sound track that transports us into highly affective states. But this type of enchantment is different from Gunning's cinema of attractions that he describes as "a cinema of instants, rather than developing situations" (1995a: 123). The psychic and somatic effects trigger two reactions related to shock and enchantment: apprehension and its attendant affective uncertainty. But these emotional and somatic experiences of the initial confrontation with the third entelechy are *succeeded by* mental absorption and a hermeneutic engagement. As well, "through repetition of sound and music cues, we acquire a posteriori knowledge [about the vitalist machines] that also allows us to develop our expectations, and this assuages apprehension" (Buchan 2011: 176). This invites the viewer's analogical, co-creative complicity with the Quay Brothers' complex cosmogony to engage in a narrative of the 'developing situations', however banal and mechanistic, of the vitalist machines within and over the course of the film.

As we have seen, the creation of this vitalist cinematic cosmogony has its origins in Bruno Schulz's literary works. Gunning's discussion of the spectators' experience of the 1896 Lumière projections has resonance with Schulz's theoretical and perceptual writings:

> If the first spectators screamed, it was to acknowledge the power of the apparatus to sweep away a prior and firmly entrenched sense of reality. This vertiginous experience of *the frailty of our knowledge* of the world before the power of visual illusion produced that mixture of pleasure and anxiety which the purveyors of popular art had labelled sensations and thrills on which they founded a new aesthetic of attractions. (Gunning 1995a: 122, my emphasis)

This 'frailty of knowledge' is comparable to Jerzy Ficowski's suggestion that Schulz's theoretical view was that "the limitations of human knowledge, our epistemological helplessness, decreases the distance between the power of knowledge and art" (2003: 76). Watching the Quay Brothers' artistically created objects, this 'helplessness' takes the form of apprehension and its affective uncertainty, of an oscillation located between the intellectual certainty of the 'real' photo-indexical world and the counterpart intellectual uncertainty of the animated vitalist *generatio aequivoca*.

A creative way of understanding this frailty and intellectual uncertainty is through Kirklin's comment on how we engage with metaphor, which "redescribes reality in a way that is made possible by the use of the calculated category—mistake" (2007: 12). Victoria Nelson suggests that it is in his *Cinnamon Shops* that Schulz presents "his main metaphysical proposition, which is deeply Platonic; that *what we mistake for objective reality*—that is, the *empirical world of the senses*—is always trembling on the point of disintegration" (2002: 71, my emphasis). This disintegration corresponds to Gunning's notion that attractions are

> a response to a feeling of alienation …. The radical aspiration of film must lie along the path of consciously heightening its use of discontinuous shocks, or as Kracauer puts it, 'must aim radically towards a kind of distraction which exposes disintegration rather than masking it'. (Gunning 1995a: 128)[24]

Noncompossible vitalist machines cause shocks for the viewer in that there is an alternation—the disjunctive synthesis of oscillation—between representations of what we recognize from the phenomenal world, and the experience of the third entelechy, the matter-based actants that move, but are not 'alive'. The oscillation between the noncompossible juncture of the vital and the mechanical allows the actant to emerge as soulless. Crucial to understanding why the Quay Brothers' film manages to express in images

what Schulz's proposition entails, is that the sensory modal 'mistake' that Nelson and Kirklin articulate can incite a sense of apprehension, and it is this apprehension that the Quay Brothers have managed to so skillfully create in their animated imagery: a haptic world of the senses that *is* crumbling, that *does* fall apart and disintegrate. Yet, while this objective reality—the pro-filmic matter, objects and stuff—is animated, it *does not cease to be in the world as objects*. This dialectic merges the third entelechy with the photo-indexical reality of the objecthood of the puppets.

Besides the sense of alienation there is also a positive experience of these shocks that reflects on a potentiality of these third entelechy subjects I discuss in the conclusion. Bennett goes on to describe the mood of enchantment as:

> involv[ing], in the first instance, a surprise encounter, a meeting with something that you did not expect and are not fully prepared to engage. Contained within this surprise state are (1) a pleasurable feeling of being charmed by the novel and as yet unprocessed encounter and (2) a more unheimlich (uncanny) feeling of being disrupted or torn out of one's default sensory-psychic-intellectual disposition. (Bennett 2001: 5)

The Quay Brothers' films can evoke this surprise state—a pleasurable apprehension—in that it is a novel encounter that disrupts the sensory-psychic-intellectual disposition. Gunning suggests the spectator is rendered speechless and that "astonishment derives from a magical metamorphosis rather than a seamless reproduction of reality" (1995a: 118). The 'magical metamorphosis' of the Quay Brothers' noncompossible vitalist machines—Schulz's amorphous forms, with no internal structure—share properties with what Bennett describes as "metamorphing creatures in film and literature that are interspecies and intraspecies crossings in a state of becoming" (2001: 17). The reification of an abstract concept, the *generatio aequivoca*, into a haplessness of matter—the non-anthropomorphic vitalist machines—poses epistemological puzzles to the viewer. My claim is that the disjunctive oscillation—between knowledge and apprehension caused by epistemological helplessness—is another form of shock, and is an emotional, affective response to what I am calling a special cinematic presence-as-actualized-movement of noncompossible and non-anthropomorphic vitalist machines. Their mode of reception—a *cinema of apprehension*—assumes the form of an unexpected experience of vitalist machines disrupting the old order dichotomy of organic/machine, eliciting in the spectator a form of immersive enchantment. But importantly, and distinct from the discontinuity of shocks, after this apprehensive oscillation, the viewers' hermeneutic engagement co-creatively develops increasingly coherent patterns—in the narrative, the mise en scène, the undercurrent

vitalism of the realm—as intellectual apprehension gives way to enchantment and a co-creative pleasure of the new order. This is the full significance and cinematic effect of the Quay Brothers' poetic dialectics of the *generatio aequivoca*. We don't have to 'shut our eyes to see'.

conclusion

Puppet animation is a cinematic technique that enables us to experience inanimate organic and inorganic matter from the palpable world around us in 'worlds' and states that are not possible in pre-digital live-action cinema. In his review of *The Cinema of Attractions Reloaded*, Cubitt concludes that "discussions and extensions of the cinema of attractions seem to point to another set of possibilities: that what might be at stake is no longer the representation of the world, but communication between worlds, and between their inhabitants" (2007: 282). I would extend this to include communication between humans and the non-human and non-organic, with animation as the agency and enabler of communication between *all* the cinematic actants and the viewer. In this agency, I see a correlation between cinematic attraction and cinematic apprehension. What is attractive about cinematic attraction is its exhilarating mix of pleasure and anxiety; what the vitalist machine does through the *generatio aequivoca*, is to reconstitute naïveness as the critical form of the animated subject through apprehension. Structured according to the third entelechy, and productive of apprehension, rather than operating fetishistically as substitutions for subjectivity, vitalist machines enchant in that the spectator is constructed anew in the undecideable, self-reflexive state spontaneously generated between the intellective and the emotive.

My observations also have implications for contemporary experience in the post-human age that is determined by the persistent nature/culture divide, and the fear of both mechanical genius and artificial intelligence. Vitalism is relevant here for a number of reasons. Scott Lash has suggested "[t]he currency of vitalism has re-emerged in the context of (a) changes in the sciences, with the rise of uncertainty and complexity and (b) the rise of the global information society" (2006: 323). He suggests "experience for vitalists tends to be much more sensory and works through *affect*" (324) and names Deleuze as "the leading contemporary vitalist" (326). Lash also makes a distinction between mechanism, which is external and determined, and vitalist causation that "is largely *self*-causation" (324), which is important with regard to the animated actants and their performance on-screen. As Monica Greco suggests: "once it is understood performatively, as resistance and excess with respect to the remit of positive knowledge, vitalism therefore appears valid—not in the sense of a valid representation of life, but in the sense of a valid *representative*" (2006: 18). This performance of representation, and not representation itself, constitutes the vitalist machine through

a third entelechy as an animated actant that encourages us to engage with animated matter and to experience its world through its vitality.

Bennett describes the overall effect of enchantment as "a mood of fullness, plenitude, or liveliness, a sense of having had ones' nerves or circulation or concentration powers tuned up or recharged—a shot in the arm, a fleeting return to childlike excitement about life" (2001: 5). One reason that animation has been long sidelined by film studies, not least because of access issues and that many short independent animation films do not enjoy mainstream distribution, is because it was generally considered to target children; in other words, animation was naïve. I contend that one of the attractions of many styles of animation lies not in its being 'childish' in a regressive, omnipotent way, a critique often made about the form, but rather in a *naïve delight* we experience in seeing inanimate forms come to (a type of) life. Bennett writes that "naïve realism takes human fascination with objects as a clue to the secret life of nonhumans" (2004: 358). Naïve realism is a theory of perceptual philosophy that is based on the existence of a world of material objects that "are immediately and directly present to us in sense experience" (Olsen 2003: 21), and that these objects have the properties that they *appear* to have: "the object shows itself differently than it normally would" (22). The naïvety I am ascribing to the viewers' experience of the Quay Brothers' vitalist machines arises after the sense of apprehension; the naïvety Bennett recuperates as a core element of human curiosity. Both are positive reinstatements of the value of the human ability to engage with other forms of life and with non-life. As Bennett suggests, there is: "the possibility that attentiveness to (nonhuman) things can have a laudable effect on humans" (348). Through a reinvention of matter as a type of *animated subject*, a rethinking of naïvety in the ways I have described in this chapter offers us two opportunities. One is to reassess (puppet) animation as a object meriting deeper academic engagement; the other is as a possible alternative to Bennett's 'disenchantment tale', that softens the biological/mechanical division between humans and the non-living matter around us, and enables us to experience the *generatio aequivoca*, the 'secret life' of vital matter.

notes

1. Some ideas in this chapter elaborate on themes I initially developed in *The Quay Brothers: Into a Metaphysical Playroom* (Minneapolis: University of Minnesota Press, 2011).
2. For a discussion of Cavell's 'region', see: Suzanne Buchan, The Animated Spectator: Watching the Quay Brothers' 'Worlds,' 16–21, in *Animated 'Worlds'*, ed. Suzanne Buchan (Eastleigh: John Libbey Publishing, 2006: 15–38).
3. While my term is inspired by to David Channel's concept of 'the vital machine', I will define it differently. See: David F. Channell. *The Vital Machine: A Study of Technology and Organic Life.* (New York: Oxford University Press, 1991).

4. The epigraph is from the 'Proteus' (3rd) chapter of *Ulysses*, notable for Stephen Dedalus's philosophical musings on transformation and perception.

5. Duncan's essay on notions of the visible and mainly of the audible in *Ulysses* is an interesting interpretation of Joyce's engagement with Aristotle.

6. For an extended discussion of these terms, see: Joseph E. Duncan (1957).

7. I want to make clear I am not discussing anthro- and gynopomorphic puppets such as those used in non-digital puppet animation films from Jiří Trnka, Suzie Templeton or Kihachiro Kawamoto.

8. As respondent for a panel on animation theory at the 2012 SCMS conference in Boston, Donald Crafton, who has been credited with introducing the concept that animators gave their works *anima*, or the 'breath of life', remarked that it has been overused and sometimes misinterpreted by many who use it. Correspondence with the author, October 19, 2012.

9. Greco's reference is to F. M. Wuketits' Organisms, Vital Forces, and Machines: Classical Controversies and the Contemporary Discussion 'Holism' vs. 'Reductionism'. In *Reductionism and Systems Theory in the Life Sciences*, eds P. Hoyningen-Huene and F. M. Wuketits (Dordrecht: Kluwer Academic Publishers, 1989: 3–28).

10. The names given for the Quays' constructions are my own.

11. A stunning example that animates humans, puppets and live fish simultaneously is Dave Borthwick's *The Adventures of Tomb Thumb* (1993).

12. Footnote in Oklot refers to *Bruno Schulz. Opowiadania: Wybor esejow i listow*, ed. Jarzębski, Jerzy. (Wrocław: Os solineum, 1989: xxx).

13. Endnote 39 in Gunning: Agamben, 23 refers to Giorgio Agamben. 1993. *Stanzas: Word and Phantasm in Western Culture*. (Minneapolis: University of Minnesota Press).

14. The Quays also create anthro- and gynomorphic portmanteau puppets, including the 'light bulb man' and the 'Tailor's assistants'.

15. Definition in Merriam-Webster's Collegiate Dictionary: Eleventh Edition, 2004.

16. For a detailed analysis of music, sound and noise in the Quays' films, see Ch. 6: The Secret Scenario of Soundscapes, *The Quay Brothers*, 2011.

17. With the term 'actant' I am using Bruno Latour's definition in his Glossary in *Pandora's Hope. Essays on the Reality of Science Studies* (Cambridge, MA: Harvard University Press, 1999): "The key is to define the actor by what it does – its performances*—under laboratory trials*. Later its competence* is deduced and made part of an institution*. Since in English 'actor' is often limited to humans, the word 'actant' borrowed from semiotics, is sometimes used to include nonhumans' in the definition". (303)

18. I discuss Benjamin's notion of detritus and the Quays' puppet construction in *The Quay Brothers* 2011: 47–50.

19. In note 7, Carroll writes: "Note that the requirement here is that the physically noncompossible or disparate elements must be *literally* co-present in the same object" (222, my italics). He then makes a crucial distinction to what he calls *mimed metaphor*, using the boot sequence of Chaplin's *The Gold Rush*, "where the lace elements and the spaghetti elements are not literally co-present in the object". (222).

20. A neologism coined by Charles Dodgson (AKA Lewis Carroll), portmanteau is the combining of two or more words or lexemes to create a new meaning.

21. For a discussion of animated body parts in the Quay Brothers' and Jan Švankmajer's films, see: Buchan, *The Quay Brothers*, 115–116.
22. See: Thomas Lamarre, *Uncovering Heian Japan: An Archaeology of Sensation and Inscription*. (Durham, NC: Duke University Press, 2000: 96–97, 182).
23. The footnote reference (38) to Hansen in Gunning's text is missing. The citation is from Miriam Hansen (1987). Benjamin, Cinema and Experience: 'The Blue Flower in the Land of Technology', *New German Critique* Vol. 40: 211.
24. Note 37 in Gunning's text refers to Siegfried Kracauer, "Cult of Distraction. *New German Critique* Vol. 40, Winter 1987: 96. The original English source is p. 328, The Cult of Distraction in Siegfried Kracauer, *The Mass Ornament. Weimar Essays*. Trans. and ed. Thomas Y. Levin. (Cambridge: Harvard University Press, 1995: 323–328).

references

Aristotle. *De Anima. [On the Soul]*. 1986, *ca* 350 BC. Translated with an introduction and notes by Hugh Lawson-Tancred. Harmondsworth: Penguin.

Auxier, Randall E. 1999. Influence as Confluence: Bergson and Whitehead. *Process Studies*, Vol. 28, No. 3–4, Fall-Winter: 301–338.

Benjamin, Walter. 2004. Old Forgotten Children's Books. Translation of 'Alte vergessene Kinderbücher' (1924). In *Selected Writings*, trans. Rodney Livingstone. ©1996 Cambridge, MA: Harvard University Press: 406–413.

Bennett, Jane. 2004. The Force of Things: Steps toward an Ecology of Matter. *Political Theory*, Vol. 32, No. 3: 347–372.

—— 2001. *The Enchantment of Modern Life*. Princeton, NJ: Princeton University Press.

Carroll, Noël. 1996. *Theorizing the Moving Image*. Cambridge and New York: Cambridge University Press.

Cavell, Stanley. 1979. *The World Viewed: Reflections on the Ontology of Film*. Enlarged edn. Cambridge, MA: Harvard University Press.

Chion, Michel. 1994. *Audio-Vision. Sound on Screen*. Trans. Claudia Gorbman. New York: Columbia University Press.

Cubitt, Sean. 2007. Review Essay: The Cinema of Attractions, ed. Wanda Strauven. *The Cinema of Attractions Reloaded. animation: an interdisciplinary journal*, vol. 2, No 2: 275–286.

Deleuze, Gilles. 1990. *The Logic of Sense*, ed. Constantin V. Boudas, trans. Mark Lester with Charles Stivale. London: Athlone Press.

Deleuze, Gilles and Félix Guattari. 2004. *Anti-Oedipus. Capitalism and Schizophrenia*, trans. Robert Hurley, Mark Seem and Helen R. Lane. London: Continuum.

Deleuze, Gilles and Claire Parnet. 2007. *Dialogues II*, trans. Hugh Tomlinson. New York: Columbia University Press.

Duncan, Joseph E. 1957. The Modality of the Audible in Joyce's Ulysses. *PMLA*, Vol. 72, No. 1: 286–295.

Ficowski, Jerzy. 2003. *Regions of the Great Heresy: Bruno Schulz, a Biographical Portrait* [*Regionz wielkiej herezji i akalice*, 2002.] Trans. and ed. Theodosia Robertson. New York: W. W. Norton and Company.

Freud, Sigmund. 1966 [1905]. *Jokes and their Relation to the Unconscious*. Trans. J. Strachey. London: Routledge & Kegan Paul.

Grau, Oliver. 2003. *Virtual Art: From Illusion to Immersion*. Cambridge, MA: MIT Press.

Greco, Monica. 2005. On the Vitality of Vitalism. *Theory, Culture & Society*, Vol. 22, No. 1: 15–27.

Grodal, Torben. 1999. *Moving Pictures. A New Theory of Film Genres, Feelings, and Cognition*. Oxford: Clarendon Press.

Gunning, Tom. 2007. To Scan a Ghost: The Ontology of Mediated Vision. *Grey Room*, No. 26, Winter: 94–127.

—— 2000. The Cinema of Attraction: Early Film, Its Spectator, and the Avant-Garde [1986] In *Film and Theory: An Anthology*, eds Robert Stam and Toby Miller. Malden MA: Blackwell: 229–235.

—— 1995a An Aesthetic of Astonishment: Early Film and the (In)credulous Spectator (1989). [Reprinted from *Art and Text*, Vol. 34, Spring: 31–45]. *Viewing Positions: Ways of Seeing Film*, ed. Linda Williams. New Brunswick, NJ: Rutgers University Press: 114–133.

—— 1995b 'Animated Pictures,' Tales of Cinema's Forgotten Future. *Michigan Quarterly Review*, Vol. 34, No. 4: 465–486.

Hardt, Michael. undated. Reading Notes on Deleuze and Guattari Capitalism and Schizophrenia, http://www.duke.edu/~hardt/ao3.htm (Accessed September 25, 2011).

Heim, Michael. 2000. *Virtual Realism*. New York: Oxford University Press.

Joyce, James. 1986 [1922]. *Ulysses. The Corrected Text*, ed. Hans Walter Gabler. London: Penguin.

Kirklin, D. 2007. Truth telling, autonomy and the role of metaphor. *Journal of Medical Ethics*, Vol. 33, No. 1: 11–14.

Lash, Scott. 2006. Life (Vitalism). *Theory, Culture & Society*, Vol. 23, No. 2–3: 323–329.

Lawson-Tancred, Hugh. 1986. Introduction to *De Anima* (On the Soul): 11–116.

Mitry, Jean. 1997. *The Aesthetics and Psychology of the Cinema*, trans. Christopher King. Bloomington: Indiana University Press.

Nelson, Victoria. 2002. *The Secret Life of Puppets*. Cambridge, MA: Harvard University Press.

Oklot, Michal. 2007. Maturing into Childhood: An Interpretive Framework of a Modern Cosmogony and Poetics. *Alif: Journal of Comparative Poetics*, Vol. 27, January, unpaginated, http://www.thefreelibrary.com/Maturing+into+childhood%3a+an+interpretive+framework+of+a+modern.-a0167894998 (Accessed May 15, 2011).

Olsen, Robert G. 2003. *A Short Introduction to Philosophy*. Mineola, NY: Courier Dover Publications.

Quay Brothers. 1986. In Deciphering the Pharmacist's Prescription 'On Lip-Reading Puppets'. London: Unpublished manuscript provided to the author.

Randall, John Herman. 1960. *Aristotle*, New York: Columbia University Press.

Recuber, Tim. 2007. Immersion Space: The Rationalization and Reenchantment of Cinematic Space. *Space and Culture* Vol. 10, No. 3: 315–330.

Rosenfeld. Louis. 1985. The Last Alchemist—The First Biochemist: J. B. van Helmont. *Clinical Chemistry*, Vol. 31, No. 10: 1755–1760.

Ryan, Marie-Laure. 2001. *Narrative as Virtual Reality. Immersion and Interactivity in Literature and Electronic Media.* Baltimore, MD: Johns Hopkins University Press.

Sachs, Joe. 1995. *Aristotle's Physics: A Guided Study.* New Brunswick: Rutgers University Press.

Schopenhauer, Arthur. 1966. *The World as Will and Representation: V. 1.* (1819), trans. E. F. Payne. New York: Courier Dover Publications.

Schulz, Bruno. 1977. *The Street of Crocodiles* [1963], trans. Celina Wieniewska, Intro. Jerzy Ficowski, trans. Michael Kandel. New York: Penguin.

Scott, Rob and David Koch. 2009. Modern Vitalism and Health Care. A Symposium Concept Proposal. Proceedings of *Exploring the New Vitalism* conference, http://www.lifeoctagon.org/ (Accessed June 15, 2012).

"soul" Oxford Dictionaries Pro. April 2010. Oxford University Press, http://live.oxforddictionaries.com (Accessed June 18, 2011).

Whittock, Trevor. 1990. *Metaphor and Film.* Cambridge: University of Cambridge Press.

the east asian post-human prometheus

animated mechanical 'others'

j o o n y a n g k i m

introduction

Many years of viewing animation around the world have given me a clear memory of several East Asian characters—Chinese, Japanese, and Korean—in Hollywood's animated films: *Chinaman's Chance* (Ub Iwerks 1933) from the *Flip the Frog* series; *Censored* (Frank Tashlin 1944), and *Operation SNAFU* (Friz Freleng 1945), both of the *Private SNAFU* series; and Disney's classic feature *The Rescuers* (Wolfgang Reitherman et al. 1977). My South Korean identity did not let me watch these indifferently or easily forget the characters in the films, because *I* could have been among them, or because the cultural gaze through which the films depicted them could apply to *me* as well; *me* as an embodied entity of socio-political values.

As a starting point, it is worth examining how the East Asian characters are portrayed in these animated films. First, *Chinaman's Chance* portrays a Chinese man as a criminal who is eventually arrested by the protagonist, the policeman Flip. In the hero's chase into Chinatown, a group of Chinese people are indulging in opium,[1] and then in his own opium-induced

hallucination, Flip is seduced by a Chinese woman character with a realistic, eroticized, life-size human body different from his own frog-like body. Second, produced as informational entertainment films shown to all branches of the US Armed Services during the Second World War,[2] the *Private SNAFU* series introduces Japanese military figures who all look much alike and move very similarly in both episodes. *Operation SNAFU* shows three geishas (one of whom is the US soldier hero in disguise in the middle of his mission,) making suggestively sensual, ridiculous gestures toward a Japanese male officer, who responds by sexually harassing the soldier in drag. Lastly, *The Rescuers* presents an anthropomorphized mouse in a white outfit and a black hat, which seem to be traditional Korean dress, suggesting that he is Korea's representative in an international organization of the mouse 'world' located beneath the UN building. It should be noted that South Korea's human representatives preferred to wear Western-style suits, which would have appeared 'modern' in international scenes in the 1970s. Given that neither South nor North Korea was a member of the UN at that time, this figure's appearance in this Disney feature is quite surprising. However, the film's editing marginalizes him at the bottom of the frame and he soon disappears to the left of the frame, while the camera follows not him but other national representatives that move from screen-center to screen-right.

There are in fact too many examples to enumerate of unfavorable representations of East Asian people in live-action films, as compared to animated films. It is noteworthy that Monma Takashi (1995) published a 300-page book dealing with representations of the Japanese in Western films produced throughout the twentieth century. A comment on the back cover of the *SNAFU* series DVD states: "[These rare cartoons] might offend people of German or Japanese descent,[3] but they were no worse than other propaganda films of their day", but such self-justification of prejudiced, often false, characterizations is exactly one of the functions of propaganda, whether in 'their day' or 'ours'.

What is interesting to me here is the formal, rather than narrative, aspect visualized in the two *SNAFU* shorts. For example, the Japanese soldiers all resemble each other and all move in a similar, mechanical way; they look like 'robots' in animated, human form. Their impersonality and mechanicalness are not simply a representation of their military totalitarian condition, because *ojigi*, one of the traditional Japanese forms of salutation, is included in their repetitive action which Private SNAFU is supposed to ridicule. This suggests the concept of the automaton, specifically in the sense of *animating* the Asian 'other',[4] and brings me to Rey Chow's postcolonial/postmodern commentary on Olympia, the mechanical doll of E. T. A. Hoffmann's tale *The Sandman* (1816). In her *Writing Diaspora*, Chow (1993: 63–67) suggests that many versions of Olympia present the same mechanical response to a Western subject, demanding repeated uniform messages

for his/her (modern) interest in non-Western cultures, just as Hoffmann's Olympia replies in the form of "Ah, ah!" to everything that the protagonist Nathaniel says. Of particular interest is Chow' critique that a great number of academic discourses about non-Western cultures serve to determine or to reproduce Olympias. In her Introduction, Chow argues that a group of First World intellectuals remains blind to their own tendency to exploitation as they make "the East" their career (15). This does not mean a cultural essentialist position. She notes: "A critique of [the] Orientalism in East Asian [studies] neither implies that only 'natives' of East Asian cultures are entitled to speaking about those cultures truthfully nor that 'natives' themselves are automatically innocent of Orientalism as mode of discourse" (7). In light of Chow's observations and with Olympia as a cultural metaphor in mind, I will now discuss what is called *anime* as a recent type of Orientalist discourse.

discourses of anime: olympia's mechanical tongue

Anime is currently the most popular 'Olympia' of East Asian animation productions. Many discourses in a variety of academic fields in the West since the mid-1990s treat Japanese animation as a given genre and often attempt to define its aesthetic form in an ahistorical way, as if anime were a brand new grist for the mill of intellectual careers, as noted by Chow above. Journalism was a swifter and more influential initiator of anime debates. As an early example, *Newsweek* ran a story about Japanese animation under the headline "Holy Akira! It's Aeon Flux" that introduced the word 'anime', with the phrase "pronounced ANNI-may" in a thoughtful parenthesis, following the sensational phrase "the Japanimation invasion of America" (Marin et al. 1995: 54). The way in which *Newsweek* treated the term as a buzzword seemed to be rather strange at that time, because it was common knowledge in South Korea that 'anime' is simply a Japanese abbreviation of the original English word 'animation' and not necessarily limited to only Japanese animation, whatever its linguistic origin might be. Accordingly, South Korean animation fans coined and have used a Korean abbreviation 'ani' (pronounced Annie), instead of 'anime', of the same English word. After the "Holy Akira" article, *Eureka Extra Edition: Japanimation!* (Yuriika Rinji Zōkan Japanimeishon! 1996), a special issue of the Japanese monthly magazine *Eureka* published by Seidosha, made use of the word 'Japanimation' rather than anime, as shown in the title, to discuss its factual referent—Japanese popular animation—as an early professional reaction from Japanese society to the increasing Western interest in the new (sub-)cultural 'other'. In the West, however, 'anime' still tends to be regarded as equivalent to Japanese animation, whereas much less use is made of Japanimation, the portmanteau word introduced for the same referent in "Holy Akira". The Western usage of the word anime can be viewed

from the question Chow asks about the title construction "*Funu, Guojia, Jiating*" [Chinese women, Chinese state, Chinese family], of the article by Tani Barlow[5] in Chinese studies:

> [But] *funu, goujia, jiating* are simply words in the Chinese language that mean women, state, family. Had the title been 'le femme, l'etat, la famille', would it be conceivable to append a phrase like 'French women, French state, French family'? … A scholarly nativism that functions squarely within the Orientalist dynamic and that continues to imprison 'other cultures' within entirely conventional disciplinary boundaries thus remains intact. (Chow 1993: 6)

Noting that Orientalism and nativism are the obverse and reverse of the same coin, she warns that such particularizing representation of the 'other' in Western cultural studies ignores the class and intellectual hierarchies within cultures in the East, that are usually as elaborate as those in the West (Chow 1993: 13). If the art of animation is part of such cultures, then a similar hierarchy in Japanese animation cannot be ignored. To put it simply, an antipathy to the once-neutral word 'anime' is now evident among animation-related communities and individuals who want to separate themselves from commercially oriented animation. Japanese society has a tendency to distinguish commercial from artistic production as inflexible notions in many cultural fields, as well as in animation; the same attitude is found in South Korean society as well.

However, anime as an Orientalist device of essentializing Japanese animation was quite soon re-imported to Japanese society. This is not a great surprise and is in line with Ueno Toshiya's suggestion that Orientalism "is also the mechanism through which Japanese people misunderstand themselves, using Western understanding as a means of explaining themselves" (1996). Several years after his 1996 online article, Japanese governmental organizations responded politically to the anime discourses of the West by collaborating with them in order to develop animation as a new national industry. An example of this is the Tokyo International Anime Fair.[6] It would be an optimistic view to assume that this official form of echolalia was not intended to have an encouraging affect on the Japanese animation industry to produce more and more Olympias.

pinocchio revisited: did astro boy become a real boy?

Regarding the global anime wave as a techno-version of Orientalism, importantly, Ueno calls attention into the fact that the type of animation which introduces the android, robot and cyborg as its subject is very developed in Japan, and adds that in the 1970s when the German techno-pop band Kraftwerk used android or machine-like gestures in their live shows,[7]

they reportedly took as their model the gestures, robot-like bowing and expressionless laughter of Japanese businessmen in Europe (1996). David Morley and Kevin Robins also point out, "Western stereotypes of the Japanese hold them to be sub-human, as if they have no feeling, no emotion, no humanity" (1995: 172). Does it then follow that androids, cyborgs, and robots depicted so far in Japanese (popular) animation are equivalents of the mechanical Japanese soldiers imagined in the two *SNAFU* episodes? Do the animated figures imply that Western stereotypes of the Japanese were accepted and internalized in the creators of Japanese animation?

Per Schelde's analysis of science fiction films offers an alternative approach. Schelde suggests that sci-fi films share two traits with the traditional folktale: both may be understood as dreams that dissolve the boundaries of reality to create a new and separate reality; and both are symbolic and metaphorical expressions of protest (1993: 7). The conception of the sci-fi film as a modern form of wish fulfillment and secular protest can also apply to animated films and television programs from Japan and South Korea which introduce mechanical entities with human form. In this light, I will begin my exploration of mechanical 'others' and their implications with *Astro Boy* (1963), the animated television series created by Tezuka Osamu.

Episode One of the *Astro Boy* series is a very important one as it recounts the famous mechanical hero's birth and tragic fate. One day in the future, a boy named Tobio, while driving an anti-gravity car, dies in a crash; his father, the scientist Tenma, is overcome with sorrow and invents a technological substitute of his dead son. His madness-driven animation of an android to assuage the death of his son is similar to Dr Frankenstein's animation of a monstrous creation, driven by a very similar motive, in Mary Shelley's *Frankenstein; or, The Modern Prometheus* (1818). Tezuka Osamu knew of Shelly's gothic novel, at least of his monster; Episode Three of the *Astro Boy* manga published in the early 1950s features Frankenstein directly (Shida 2003: 18), while a robot named Franken appears in Episode Two of the 1963 animated series (Shimotsuki 2003: 66). Tezuka originally conceived the mechanical hero as a girl (Tezuka 2003: 126), and in his manga *Metropolis* (1949), two years before Astro Boy's first appearance in comics, he introduced an android girl, the precursor of Astro Boy. Inspired by Fritz Lang's imagery of the android Maria (*Metropolis* 1927) on the point of being animated in a lab, Tezuka's prototype of Astro Boy[8] takes its place in the genealogy of gynomorphic androids, alongside Olympia, Hoffmann's Coppélia from the ballet of the same name (Léo Delibes 1870), and Hadaly from the French novel *L'Ève future* (Auguste Villiers de l'Isle-Adam 1886). Significantly, it is Pinocchio from Collodi's 1883 novel that Tezuka refers to as a revelation for Astro Boy (Tezuka 2003: 126); both are boys. He drew and wrote a comic adaptation of Disney's 1940 animated feature *Pinocchio*, just after *Ambassador Atom* (Atomu Taishi), the earliest of the manga series *Astro Boy*

that was published April 1951 to March 1952 (Ōtsuka 2008: 115). I will consider the Disney feature as a Western counterpart of *Astro Boy*, both of which are created in the animated form/medium.

In Disney's *Pinocchio*, fulfilling Geppetto's wish, the Blue Fairy gives life to Pinocchio, adding that he is not a real boy, and suggesting that the mere abilities to move and talk ("I can move, I can talk, I can walk") do not in themselves satisfy the conditions necessary to be fully human. He will become a real boy only if and when he is able to choose between right and wrong with bravery, truthfulness, and unselfishness. However cruel such a pedagogic voice might sound for a 'child' just born to a human-centric world, the fairy's view of humanity expresses the morality and rationalism of Enlightenment Europe, no better formulated than in Descartes' *Discours de la Méthode* (1637). The seventeenth century French philosopher maintained that even if any machines, any automata, resemble us in body and imitated our actions, we should still have two means of recognizing that they are not real human beings. One is the human ability to organize words and other signs to declare thoughts, which even the most dull-witted persons have; the other is reason, a universal instrument that can operate in all sorts of situations and cause human beings to act consciously (Descartes 2006: 46–47). Therefore, it is not surprising that a version of Chow's Olympia is found in Descartes' descriptions of the automaton as non-human: "[I]f, for example, we touch it on a given spot, it will ask what we want of it; if we touch it somewhere else, it will cry out that we are hurting it" (46). Further, he asserts that

> [Machines'] organs have to have a particular disposition for
> each particular action, from which it follows that it is practi-
> cally impossible for there to be enough different organs in a
> machine to cause it to act in all of life's occurrences in the
> same way that our reason causes us to act. (Descartes 2006: 47)

Indeed, Pinocchio seems to lack Descartes' second human condition when he thinks the right and left hand are the answer to the matter of right and wrong that the fairy demands of him in order to become human. In Cartesian thought, he is not yet different in essence than the automaton as the mechanical 'other'.

In *Astro Boy*, Dr Tenma also accepts the mechanical puppet as if it were his resurrected dead son, and gives it his son's name: Tobio. At first awkward in speech and behavior, the 'new' Tobio[9] is supposed to achieve a human, or even superhuman, level of abilities in Cartesian thought. However, in time the father denies that the android Tobio, that is, Astro Boy, is his real son, as he is angry that the mechanical body of the child does not grow. It seems to be rather strange and absurd that Dr Tenma should blame Astro Boy for no physical growth, as he is the mechanical son's very creator. What Tezuka makes clear here is that the body is

regarded as the crucial condition necessary to be human in the established order. As a result, the Japanese scientist hands over his not-real son, as a product, to the circus master who exploits a variety of robots as slaves for his shows. The differences between Disney and Tezuka's treatment of mechanical 'others' may be taken further. Unlike Pinocchio, who finally becomes a real boy through his behaviors (based on his experience of lying, and thereby learning to reason), after all his sacrifices made in order to help other powerless mechanical slaves and to save even the circus master's life from a fire, Astro Boy continues to be a material object under the capitalist order of private property. The circus master can be said to be reasonable enough to keep Astro Boy as someone keeps his/her faithful dog that saved him/her from a fire. Tezuka believes in neither enchantment nor even technology as solutions to save the little mechanical boy and others from slavery. At the ending of Episode One, it is the rights endowed through the declaration of a UN-like international organization that allow them to be equal to human without any requirements of a human body. As Astro Boy does not show any change in intelligence and body that would bestow him with humanity, Tezuka seems to have thought that what is human depends on the sociopolitical order rather than on the individual's value. In contrast, in the Disney film, the fairy says to Pinocchio, "It's up to you." What I wish to put into question here is the significance of the transformation of Pinocchio's body from wood to flesh and blood and his subsequent award of humanity from the fairy. Such qualitative change of the body does not seem to be necessary for the following reasons. He proved his virtues under all given conditions; his father was not interested in his wooden body; and even the fairy did not refer to the issue of body with respect to humanity at the beginning. For Descartes, only reason/ mind makes a body specifically human. In fact, it is not Pinocchio but rather Astro Boy that needs an organic body, one capable of growth, since the lack of this capability was the reason his 'father' abandoned him. The magical scene of the puppet's corporeal transformation from wood to flesh and blood reveals the underlying truth that humanity is incarnated by the gaze of the viewing human subject, and that the body should be indispensible to, or inseparable from humanity itself.

The body, which is one of my concerns in this chapter, is the ultimate locus in which 'otherness' is identified, as an immediate object of a modern racist theory based on human biology, as is discussed by Hardt and Negri (2001: 258). In the theory, "Subordinate people are [thus] conceived (at least implicitly) as other than human, as a different order of being" (258). The *Astro Boy* narrative in which mechanical slaves fight against discrimination to obtain equal rights as humans reads as a metaphor of the 1960s African-American Civil Rights Movement that coincided with production of the animated series (Ōtsuka 2003: 10) **(See Figure 7.1)**. However, it is still difficult to transform the non-Western body into the Western one—in the

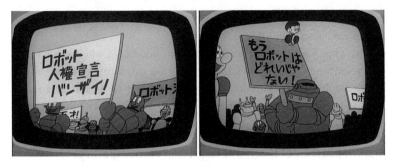

Figure 7.1

(a,b) Mechanical slaves protest for their own equal-to-human rights, *Astro Boy*, Tezuka Osamu, 1963.

analogy of transforming the mechanical body to flesh and blood—by means of any modern technology of which Tezuka himself had very little idea of as a medical doctor; although some East Asian people attempt to Westernize their faces by means of plastic surgery.

Suggesting that Tezuka pursued the theme of encounters with the non-human extraterrestrials and half-animal/half-human characters in his works, Yomota Inuhiko notes that his manga *Ambassador Atom* criticizes humans who can achieve their own humanity only by excluding other-than-human or sub-human entities (2008: 101). Tezuka stated that his theme of the conflict between the human and the 'other' was deeply derived from his experience of being assaulted by one or more American soldiers, of not being able to react or resist the violence, as he could not speak the ruler's language, and because he was afraid that under the US occupation of Japan (1945–1952), the law might not protect him from being shot to death (2003: 126–127). Episode One of the 1963 television series where Astro Boy appears to be docile, as well as being obedient to his human friends, makes this personal experience of Tezuka its central theme. Even when abandoned by his human father and abused by the human circus master, it is not easy to grasp the mechanical puppet's anger (understood as the metaphor of an occupied victim), while he is said to have a heart more human than a human (Tezuka Productions, 2012). An answer to this conundrum is that the resultant sense of loss that Astro Boy is left with can only be compensated for by his repetitive fight with the non-/sub-human 'others' that are incessantly introduced in the series' continuing weekly episodes (Yomota 2008: 103). In the last scene of Episode One, the mechanical boy, adopted as an equal-to-human son by the human rulers of the world, also becomes a national icon for a dream of reconstructing Japan, by way of technology, to become a member of the international political community. Kang Sang-jung suggests that *Astro Boy* made Tezuka a national artist when, in the middle of the 1960s and concurrent with the

Japanese post-war economic miracle, television assumed the role of a new national medium (2001: 127).

But what happens to a mechanical girl, not a boy, when she has not only resentment but also envy and hostility towards humans in the Eastern Confucian hierarchy? This question brings me now to the female android Mary in the South Korean animated feature *Robot Taekwon V* (1976), directed by Kim Cheong-Gi.

mary, a portrait of mechanized girls in contemporary south korea

The animated film *Robot Taekwon V* is mostly known in South Korea for its eponymous heroic mechanical giant, a national icon of the modernization and industrialization of the country under the military dictatorship in the 1960s and 1970s. My concern here is not Taekwon V; this male type of humanoid machine represents much the same ideological role as Astro Boy. As a primary antagonist, Mary believes herself to be a human girl, but discovers that she is a machine through the fatal physical damage of her body during her secret mission for the Red Empire at Dr Kim's laboratory cum residence. At the same time, this discovery leads Dr Kim, his son Hun, and Hun's girlfriend Young-Hee to understand why she was so emotionless and hostile to friendly animals while staying at the residence in the guise of visitorship; her real mission is to steal the blueprint of the new weapon, Taekwon V.

Shocked to discover that she is an android. In her grief, Mary confesses to the film's human hero Hun that she is the machine that is unable to think. Hun attempts to cheer her up with his unintended insinuations of a romantic relationship; his human girlfriend, who is supposed to marry him by their fathers' arrangement, jealously interrupts their conversation, reminding them contemptuously that Mary is a machine. In this triangular affair, the mechanical 'girl' is not socially equal with the human rival, since as an android she cannot be a member of the film's human family (**See Figure 7.2a**). Humiliated, angry and jealous, Mary turns her back on humans, shouting that she would like to be human, and returns to her original mission. Later, despite her affection for Hun and her dream of being human, she is forced to fight against Taekwon V, the machine controlled by Hun and assisted by his girlfriend. The result of the battle is human victory over mechanical evil. Finally, Hun finds Mary's mechanical heart among the remains of the base of the Red Empire that was destroyed through her self-sacrifice, after all her despair of finding any resting place for her in either the human society that condemned her as a mechanical object, or in the mechanical empire that exploited her.

Distinct from South Korean national elite humans as represented by Dr Kim and his son, Mary is the 'other' that is not merely non-human but also

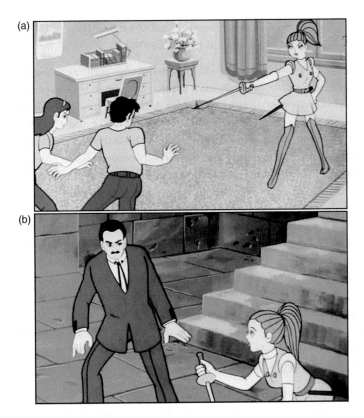

Figure 7.2
(a) The mechanical doll's envy and anger at the human couple;
(b) her despair between human and mechanical, *Robot Taekwon V*, Kim Cheong-Gi, 1976.

non-South Korean. She has blonde hair, blue eyes and an English name, and is a mechanical Western girl that loves a human Korean boy, and thereby potentially wishes to be a legitimate member of his patriarchal family. This raises a complex issue: Mary is a key icon to understanding the deep-rooted class and gender hierarchy of the mid-1970s South Korea, which was concealed by nationalism and neglected by Orientalism. As Kim Soyoung's analysis of women in South Korea's post-independent live-action films through the 1970s points out:

> The inauguration of military government in 1961 launched the project of state-initiated modernization, which involved controlling cheap female labor by controlling female workers' sexuality. On the one hand, this social phenomenon triggered the film industry to churn out a series of films about Western Princesses (*yangongju*: military prostitute), bar girls, and hostesses, which narrativize the

rural migrant female workers' failed incorporation into the labor-intensive industry. (Kim 2000: 149)

As one of the most vulnerable and exploited groups of the new-born urban spaces in the decade, young Korean rural women often became either factory workers (*yeogong*) in light industry or domestic helpers (*shikmo*) residing in homes (158). While cinematic representations of the former were strongly oppressed by the government (196), the latter were dealt with in a few films, where the young and unmarried female resident workers are suspected of being underclass femme fatales who threaten urban middle-class families in general, and housewives in relation to their husbands in particular (158). In my view, the figure of Mary is a compounded embodiment of two social types: on the one hand, as a mechanized worker—for the Red Empire, which is itself a factory; and on the other, as a fatally eroticized object—posing a threat to the traditional extended family which consists of the South Korean national elites. It is not to the factory but to the upper-class family that the abject, sub-human girl desires to belong (**See Figure 7.2b**). Her desire for family, then, has the effect of making her more unacceptable by and even more dangerous to the governing social order. Kim comments on the scandalous love affair-themed live-action film *Madame Freedom* (1956) that:

> [P]ost-colonial South Korean cinema, in its attempt to face the constellation of modernity, has heavily focused on the representation of modern women figures and the elaboration of feminine sexuality which is simultaneously taken as dangerous and desirable. Madame Freedom becomes an object of desire, and subsequently of punishment, only when she masquerades herself in a western style costume. (Kim 2000: 144)

Likewise, Mary's miniskirt[10] and thigh-high boots, as well as her blonde hair and blue eyes, serve as devices not only to eroticize her explicitly, but also to exclude her as 'other' from South Korea's sartorial codes acceptable for women of the period. The fact is, however, that the Westernized android girl is an analogy for the female South Korean worker of the lowest class: invented, violently controlled, and eventually abandoned by the country's 1970s capitalism. It should be noted here though that these forms of oppression were not uncontested. Worker and workers' rights activist Jeon Tae-Il set himself on fire and ran through the streets of downtown Seoul, shouting, "We are not machines."

This raises a new question: What would the social and cultural consequences be if the conception of machines was such that they were no longer easily distinguished from humans, and vice versa? To explore this I now turn to Oshii Mamoru's vision in which human soul/mind/

intelligence is materialized in the form of electrically processed information, taking into account (Western) theories, including the late-twentieth-century discourse of the cyborg and La Mettrie's eighteenth-century radical materialism, both of which undermine the Cartesian definition of humanity outlined above.

a body of shells: neo-platonic dreams in the internet

In the West since the Enlightenment, modern science has "threaten[ed] to replace the individual, Christian God-endowed soul with a mechanical, machine-made one" (Schelde 1993: 9). The problem of the human/machine dichotomy led to the twentieth century's critique of post-humanism. According to Christopher Bolton, this is "defined as that which seeks to revise or overcome conventional notions of the human by blurring or erasing the lines that divide 'us' from [the] non-human alternatives" (2008: xi). At the center of the post-human is the cyborg. As a theorized and fabricated hybrid of organism and machine, a creature of social reality as well as a creature of science fiction (Haraway 1991: 140–150), the cyborg differs from androids I have discussed such as Mary and Astro Boy. In the view of Donna J. Haraway,

> Unlike the hopes of Frankenstein's monster, the cyborg
> does not expect its father to save it through a restoration of
> the garden ... The cyborg does not dream of community
> on the model of the organic family, this time without the
> oedipal project". (Haraway 1991: 151)

She adds that cyborgs are not faithful to their origins, 'fathers', whose illegitimate offspring they are (151).

Both Mary and Astro Boy are essentially faithful to their creators/ fathers; while the former hopelessly dreams of belonging to a human family, the latter's human fathers eventually present him with his own mechanical family, imitating the modern nuclear bio-cultural family. In the film *Ghost in the Shell* (1995), director Oshii Mamoru explores the cyborg through the issue of the mechanical body, which has long played a central role in a host of Japanese animated narratives since it made its unmistakable first appearance in *Astro Boy*. Although called *she* throughout the film, Kusanagi, the leading character of the Oshii film, is a cyborg that had most of her original human organs replaced with mechanical parts so that sex/ gender no longer appears to have any meaning for her. As Haraway argues, "The cyborg is a creature in a post-gender world" (1991: 150). In such a world, according to Schelde, "[T]he body is becoming increasingly *exteriorized*. Bodies are no longer self-contained organ complexes; they are loci of medical and scientific experimentation" (1993: 207). And in Haraway's vision of the cyborg world, "Furthermore, communications sciences and

modern biologies are constructed by a common move—the translation of the world into a problem of coding" (1991: 164).

The cyborg Kusanagi is a member of a special type of government agent team that is investigating a super-hacker, the Puppet Master, and 'his' seriously absent-minded human victims. The hacker's targets are human *ghosts*. Yet what is referred to as a ghost in this film is much closer to concepts of memory or perception. On the track of the hacker, Kusanagi is confronted with an ontological question; it is neither about her situation of being plugged into and being under the control of powers outside herself, nor about of the history of how she became what she is. Her existential plight is also not a personal vendetta like that of Murphy in *Robocop* (1987), who aims to kill those responsible for his physical transformation and is obsessed with memories of his original human form. As Susan J. Napier describes, "… American films seem to privilege a kind of individual humanism as a last resort against the encroaching forces of technology and capitalism" (2001: 114). In contrast, Kusanagi's ontological dilemma questions the rules and limitations for cyborgs that humans define in order to more securely identify themselves by establishing 'others'. She suspects a phenomenological rather than socio-political motivation for the boundaries that confine her in the world of digital information networks where the body and the ghost, almost entirely prostheticized and cyberneticized, can extend themselves, potentially without any limit.

The Puppet Master, that is the very embodiment of artificial intelligence (AI), offers Kusanagi the fusion of himself with her, that is, her ghost, to create a new, next-generation life form in the virtual world. Again, this contrasts significantly with Napier's comment about humanist individualism, as portrayed in the 1977 live-action film *Demon Seed* (directed by Donald Cammell), in which a woman desperately resists Proteus, the violent AI that attempts to create its/his offspring by means of her organic body. In *Ghost in the Shell*, Kusanagi eventually decides to merge with the persuasive Puppet Master AI that is not interested in her prosthetic body; she does not entirely overcome the concern that what she currently 'is' might cease to exist after the process. If "*Demon Seed* is a machine-age account of a false Jesus" (Schelde 1993: 142), *Ghost in the Shell* is an information-age account of a virtual *messiah*; in other words, if the former is a techno-horror parody of the Son, the latter is a post-human hymn of praise to *holy ghosts*.

While it should be noted that unlike the West, East Asia has not been dominated by monotheistic Christianity (the Holy Ghost/Spirit) but rather follows poly/pantheistic religious traditions (ghosts/spirits), the film's optimistic vision of the near future is also a consequence of Oshii's notion of humanity. He argues, "Everyone is an organic cyborg [whose body is a city], or a puppet made of flesh and blood" (2004: 188). Similarly, he has commented that he was very surprised to realize that the art of hand-drawn or computer graphics animation is in effect the same activity of infusing life

into imitations of the human, treating human characters as puppets, as happens in puppet animation (16–17). Haraway, too, argues, "We are cyborgs. The cyborg is our ontology" (1991: 150). Furthermore, Oshii's comment about human-as-puppet can be understood as an extension of the eighteenth-century French materialist philosopher Julien Offray de La Mettrie's *L'Homme machine* (1748). La Mettrie, refuting Descartes' notion that animals are machines but human beings are not, goes so far as to argue: "The human body is a machine which winds itself up, a living picture of perpetual motion" (1996: 7); "To be a machine and to feel, to think and to be able to distinguish right from wrong ... are no more contradictory than to be an ape or a parrot and to be able to give oneself pleasure" (35); in this view, Pinocchio was already human as soon as he could move his body. As regards the human soul, Aram Vartanian suggests in his account of La Mettrie that: "The metaphysical and theological concept of a spiritual soul is made to designate simply certain effects of organic matter in motion" (1999: 46). In his science fiction novel *L'Ève future*, the late nineteenth-century French writer Villiers de l'Isle-Adam makes claims as radical as La Mettrie, through the cynical voice of the novel's character Edison. In the novel, the human protagonist Lord Ewald raises a question, grounded in Cartesian conditions of humanity, about the ability of speech in Hadaly, the female android created by Edison. The American inventor responds that humans are always reciting to the extent that there is no single word that is not repetition, and that their vocabulary is reduced to a hundred routine formulas which they repeat over and over (1982: 137–138).

In the final stage of *Ghost in the Shell*, the fusion of Kusanagi with the Puppet Master results in a disembodied intelligence entity with a temporary, incidental body. This conclusion has two implications for Oshii's post-human vision. One is, in a direct way, to migrate from a given cyborg (cybernetic-organized) body. This body is mechanically produced and structurally controlled, by the process of articulation and schematization, which have also been developed as a visualizing strategy of bodily expressions difficult in hand-drawn animation, as suggested by Oshii (2004: 182–183). The other, indirect implication is to dismiss the concept of heart[11] that Tezuka tries to impart to Astro Boy. The heart is allowed to be only good, not evil, deprived of free will, the right to be able to choose the wrong, in order to show that the android boy is a "good" friend of humans, that the high-tech armed Japanese national hero should not post the threat of Frankenstein's monster against the West. The fusion of Kusanagi and Puppet Master is now a new life form materialized in the world of electronic networks, transcendentally freed from a vestige of flesh or blood as well as from her prosthetic body, and capable of indwelling all kinds of plugged bodies. For Oshii, this means to play hide-and-seek with the Orientalist gaze.

The sequel *Ghost in the Shell 2: Innocence* (2004) is part of Oshii's conceptual and Kusanagi's animated (trans)migration from one body to another.

Indeed, the director undertook a journey to investigate puppets and dolls, visiting the International Center of Photography (New York) to see Hans Bellmer's original life-size doll (presumably *La Poupée* made in 1933) and doll photographs, and the La Specola museum (Florence, Italy) known for its collection of wax anatomical models (Oshii, 2004: 11–55). At the earliest stage of the journey, the Japanese doll artist Yotsuya Shimon's life-size doll[12] inspired Oshii to envisage an antagonist for the *Ghost in the Shell* sequel: Kim, who make himself completely prosthetic and cybernetic. In the film, it is almost impossible to distinguish between humans, cyborgs, and the once-human, drastically modified, now entirely-artificial entity Kim. Among these (post-)human life forms are ghost-dubbed dolls[13] as a new technological 'other'. Before dealing with this 'other', I will develop a discussion of bodily migration in another film that portrays a hybrid character as a creature of social reality, as cited above from Haraway (1991: 149), and of which Oshii provides a vague view.

hybrid 'others' migrating in the fluid capitalist system

The migration of an intrasomatic mode—not transomatic, as in the *Ghost in the Shell* films—is found in hybrid characters in Chang Hyung-Yun's hand-drawn animated short *A Coffee Vending Machine and Its Sword* (2007). This film does not fit the previously discussed genre of science fiction, but rather that of fantasy, and as such, does not display any clear interest in the soul/body dichotomy. What Chang is concerned with is not such philosophical concepts but rather lived social relations. The male protagonist Jin Young-Young, who had long ago been a young master of martial arts, is reincarnated in the form of a vending machine in contemporary Seoul. What is special about the animated character of Jin is that it/he is an entity floating randomly on the continuum between human and mechanical (**See Figure 7.3**). It does not seem that his bodily transformation is entirely involuntary or voluntary. When in the form of the vending machine, Jin can sometimes even change it/himself into a full human by pushing a selection button with its/his own hands protruding from both sides of the metal body; but he cannot decide the lasting time of his human state. The visualization of such arbitrary transformation is done by the enchanting method of metamorphosis specific to hand-drawn animation. Despite his temporal and form-changing transmigrations, the young soul, who is under a spell, retains his previous memory and ability as a martial artist, regardless of his unstable position on the somatic continuum. Yet Jin's physio-material state of a vending machine locates him in capitalist order; he is concerned about competition with coffeehouse chains—like Starbucks—which have sprung up everywhere in Seoul.

In an oscillating (animated) metamorphosis, this cyborg is similar to the humanoid vending machine for fast food in the first episode

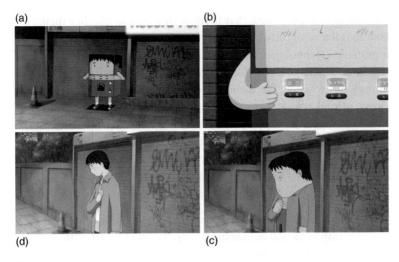

Figure 7.3

(a–d; clockwise from top left) Metamorphosis from the vending machine to the human being; *A Coffee Vending Machine and Its Sword*, Chang Hyung-Yun, 2007. Chang Hyung-Yun ©2007 All Rights Reserved.

("Breakfast") of Czech director Jan Švankmajer's 1992 short film *Food*. In this film, each of the three men, at the front of a very long queue back to the room's entrance, is functionally and viscerally changed into a vending machine for his next customer, once he finishes his own meal (**See Plate 20**). František Dryje hesitatingly compares Švankmajer's *Food* with Chaplin's *Modern Times* (1936), indicating that Švankmajer conceived the fast-food scene long before the first McDonald's restaurant opened in the Czech Republic in 1992 (1995: 124). In light of this, there would appear to be no reason to object to my suggestion that the hybrid entity of a human and a vending machine in *Food* can be regarded as a new mode of life, a chimera, put under the spell of a market economy which was introduced in the aftermath of the 1989 Velvet Revolution in the country.

In the politico-economic context of Chang's film, it is noteworthy that the International Monetary Fund (IMF) crisis occurred in South Korea in 1997–1998, followed by a neoliberal surge in which the government embraced market-driven policies and undertook privatization of many public services. This was just before Chang, in his twenties and at the start of his career in animation, participated in a digital animation workshop in 1999. One of the most serious socio-economic issues that have since emerged in the country is the rapid increase of temporary workers, among whom there are many young animation artists such as Chang; and animation is regarded as one of the most minor and vulnerable sectors in South Korean entertainment industry. Of interest here is Oshii's conception of the part-time working body in relation to the contemporary global situation of employment: "People who live the present world seem to be content with

187

the part-time body. I think that there are few people who live their own body in full time or full-time job" (2004: 287). Here, it should be noted that information technologies have played a highly influential role in changing the mode of labor at a global level since the late twentieth century; South Korea is no exception. Discussing the immaterial labor that produces a services, cultural artifacts, knowledge, communication and the like, Hardt and Negri suggest that an aspect of labor is understood in analogy to the functioning of the computer—capable of continuing to modify its own operations by means of itself—as a general tool which makes various laboring activities look homogeneous beyond their boundaries (2001: 382–384). I find a variation of La Mettrie in the two authors' point that:

> In an earlier era workers learned how to act like machines
> both inside and outside the factory. We even learned (with
> the help of Muybridge's photos, for example) to recognize
> human activity in general as mechanical. Today we increas-
> ingly think like computers, while communication tech-
> nologies and their model of interaction are becoming
> more and more central to laboring activities. (383)

The protagonist's body in Chang's film not only displays the way in which humans are understood and treated under the post-industrial order of the real world, at a global level, that becomes more and more unpredictable; it also implies a non-transcendental level of escape made on the thin line between human and other-than-human. This escape is embodied in Jin's warrior rival as well that makes a living as the artifact of a children's ride in the form of a zebra; this character is a hybrid of human, animal and machine. These two characters' enchanted non-human bodies enable them to escape from human constraints and laws that have meaning only when they are in human form. They are contemporary Korean variations of Kafka's Gregor Samsa.[14] Jin's vending machine body hinders its male bearer from engaging further in a romantic relationship with a human girl, and thereby from being subsumed under the patriarchal family system, which is often reinforced by the Confucian tradition in South Korea. What Chang desires in the age of the information technology is enchantment. Philosopher Jane Bennett defines this 'premodern' concept as "a feeling of being connected in an affirmative way to existence" (2001: 156). Adding that such a feeling for a world "allows numerous links to human, animal, material, technical, and artificial bodies" (165), she comes to the conclusion that enchantment, as a crucial source of ethical generosity in contemporary life, can give us "the energy and inspiration to contest ugly and unjust modes of commercialization" (174).

Commercialization is a mode of the near-future world depicted in *Ghost in the Shell 2: Innocence*, too, where androids impregnated with duplicated human minds are dealt in as a commodity. Now let me return to Oshii

Mamoru, who raises an ethical question in his vision of an entirely materialized, disenchanted world.

oshii mamoru: towards a conclusion

Oshii conceived his *Ghost in the Shell 2: Innocence* as "the ultimate film of discourses of the body" (2004: 37). The viewer sees animated androids massively produced and consumed by means of a new technology, possibly nanotechnology, and of a fictional technology, called ghost dubbing, to transplant a duplication of a human being's original ghost—as if it were a material-based information substance—into an imitation of the human body (**See Plate 21a**). This kind of android commodity, pseudo-cyborg, might be considered as an ultimate mechanical 'other' in the sense that they are devoid of any original human element: this is distinct from the cyborgs Kusanagi and Jin. And they are unnamed and anonymized factory products, unlike the original type of androids with proper names like Astro Boy and Mary. In *Ghost in the Shell 2*, a gynomorphic type of pseudo-cyborgs produced for the sex industry (**See Plate 21b**) is an epitomization of Haraway's comments on "women of color" synthesized and manipulated as a cyborg: "Young Korean women hired in the sex industry and in electronics assembly are recruited from high schools for the integrated circuit. Literacy, especially in English, distinguishes the 'cheap' female labor so attractive to the multinationals" (1991: 174). This raises two important points: one is that there is a (manmade, patriarchal) hierarchy within sub/post-human 'others'; and the other is that sub/post-human otherness is already a multinational, transnational situation for many women and/or migrant workers in the commodity culture beyond the East/West dichotomy.

For La Mettrie, the man-as-machine is "the zero point of human dignity" (Vartanian 1999: 66) and is the embodiment of "an underlying belief that nature had constituted the human being as independent and autonomous, with a *raison d'être* that was physiologically innate" (85). However, my question is: what happens if it is a machine of the kind which the radical materialist would deny, a machine programmed, operated, and moved by an outside power? Would it be that such an android deserves no value or no respect? This is extremely pertinent to why, at the end of *Ghost in the Shell 2*, the male cyborg protagonist Batou is furious at humans (or partial humans or once-humans). In the film, a gynomorphic type of android commodities is reprogrammed by a few human engineers to cause terrible accidents and/or to destroy themselves, in order to save the lives of human girls in danger of ghost dubbing. Batou asks the humans if they had no idea of what would happen to the androids as the result of such reprogramming. He seems to give meaning to a voice, "Help me," which he heard from one of them. Which is it: *her* authentic voice or just an audio data file copied in *its* memory device? An analogous form of this question is evident in a

particular attitude towards animated films and television programs, given that, in both South Korea and Japan, many of them have been treated as meaningless and lacking cultural value, for reasons of their seeming unoriginality or their status as a commodity.

As an appeal for such objects subjected to the dogma of mass production and mass consumption, I find a possible response to these questions in David Batchelor's discussions about Minimalism. Batchelor proposes:

> In its seriality and repetitions, in its avoidance of hierarchy and centeredness, in its negation of the interior/exterior model of art, Minimalism ... negated its metaphysical equivalent: the idea that the meaning of such work resides in the subject's inner (private and privileged) psychological life. As is the case with the readymade, the viewer is no longer faced with extracting the psychological subject from beneath the physiognomic surface. (Batchelor 2003: 70)

In raising the question of where the meaning is, if they are not in the work, in particular, in the case of objects in which viewing subjects hesitate to find any value, any soul, in reference to Rosalind Krauss, Batchelor goes on to note, "Krauss argues that meanings, rather than being inherent in words or objects, are produced only through the relationships of these with other words or objects" (2003: 70–71). In Villiers' novel, in which such relationships are focused on an issue of a male human subject unsure that he is capable of falling in love with an android female 'other', the latter says that she will come to life under his eyes precisely to the extent that his creative good will has penetrated her; for that, he must first affirm that she *is*, instead of being afraid that she might not *be*, a *real* woman on the basis of reason (1982: 199).

In Disney's feature, Pinocchio, told by the fairy about how to become a real boy, asks "What is conscience?" Jiminy Cricket replies, "A conscience is that still small voice people won't listen to." In light of the issues and concepts raised and discussed throughout this chapter, the cricket's answer can be revised: the voice from sub-humans or mechanical 'others' is that perennially small voice people listen to least. Finally, however, let me ask a question in La Mettrie's sense: Do 'we' have an organ or mechanical part good enough to hear such a voice?

190

acknowledgments

I am grateful to Professor Koide Masashi for presenting me with *Astro Boy: Complete Book* as a reference to help my research of the issue of heart in *Astro Boy*, and to Professor Kim Soyoung for offering me English manuscripts of her book *Specters of Modernity: Fantastic Korean Cinema* that is published in Korean. And special thanks to Suzanne Buchan and Mark Bartlett for their thoughtful comments.

notes

1. Identification of the drug as opium is made in the note of the DVD entitled *Cartoon That Time Forgot: The Ub Iwerks Collection Vol. 2*, distributed by Image Entertainment.

2. From the DVD entitled *The Complete Uncensored Private SNAFU: Cartoons from World War II*, distributed by Image Entertainment.

3. In American cinema's anti-Japanese and anti-German attitude, Monma (1995: 44) notices that there is a tendency in which Japanese are depicted as a fundamentally different kind of life form, unlike Germans, despite their same position as the enemy of the USA, in *Bataan* (1943), the live-action film directed by Tay Garnett, adding that Japanese in it look like barbarian monsters, not counterparts who have comprehension through conversation, while Germans are seen as human beings in essence equal to Americans, even when they are Nazis.

4. The term 'other' and its concept in my chapter owe much to Edward Said's 1978 book *Orientalism*.

5. Chow refers to the article: Tani Barlow. 1991. Theorizing Women: *Funu, Guojia, Jiating*. (Chinese Women, Chinese State, Chinese Family) *Genders* Vol. 10, Spring: 132–160.

6. The first event of the Fair was held in 2002 in order to promote the Japanese animation industry. One of the main organizers is the Tokyo Metropolitan Government and the Fair's chairperson was Ishihara Shintarō, the Governor of Tokyo since the start until he resigned from the office in 2012. The main interest of the Fair is Japanese popular animation, but it extends to foreign animation as well as Japanese independent and student animation.

7. Presumably, Ueno refers to a live show in which Kraftwerk performed the band's famous song, *The Robots* (1978).

8. Reportedly Tezuka did not see Lang's *Metropolis* before conceiving his comics of the same title (Tezuka Productions 2012).

9. In the 1963 series, the mechanical copy of Tobio is later renamed Atomu (Atom in English) in Japan. He is mostly known as Astro Boy or Astro in the English version of the same series.

10. The miniskirt was sensationally introduced to South Korean society in 1967. Women in miniskirts were arrested in the 1970s, and many of them were often thought of as prostitutes.

11. The conception of the heart as a requirement for humanity is also found in *Robot Taekwon V*, in which the human protagonist says to the android girl Mary that she can be human if she has a good heart. The good heart relates semantically to *yangshim* in Korean and *ryōshin* in Japanese, which are both thought of as accounting to conscience in English. In the *Oxford English Dictionary: Online Version* (2010), however, the word conscience includes the part of 'know' in an etymological respect, and is involved with consciousness, recognition and mind, rather than heart.

12. It is possible to see the artist's doll works at his official website, http://www. simon-yotsuya.net/

13. In the sequel, the basic concept of 'ghost dubbing' seems to be close to the animating process of extracting something from the human Maria and then infusing it into the robot Maria in *Metropolis*, but the word 'dubbing' alludes to reproducing, rather than transplanting, the original.

14. Gregor Samsa is the main protagonist that is transformed into an insect in Kafka's 1915 novel *The Metamorphosis* (*Die Verwandlung*).

191

references

Batchelor, David. 2003. *Minimalism*. Trans. Moo-Jeong Jeong. Paju, South Korea: Youlhwadang.

Bennett, Jane. 2001. *The Enchantment of Modern Life*. Princeton: Princeton University Press.

Bolton, Christopher. 2008. Introduction to *Mechademia: Limits of the Human*, ed. Frenchy Lunning. Minneapolis: The University of Minnesota Press: xi–xvi.

Chow, Rey. 1993. *Writing Diaspora*. Bloomington: Indiana University Press.

Descartes, René. 2006. *A Discourse on Method*, trans. Ian MacLean. Oxford: Oxford University Press.

Dryje, František. 1995. The Force of Imagination. In *Dark Alchemy: The Films of Jan Švankmajer*, ed. Peter Hames. Westport, CT: Praeger: 119–168.

Haraway, Donna J. 1991. *Simians, Cyborgs, and Women: The Reinvention of Nature*. New York: Routledge.

Hardt, Michael and Antonio Negri. 2001. *Jeguk* (Empire), trans. Soo-Jong Yoon. Seoul: Ehak.

Kang, Sang-jung. 2001 *Glōbaru-ka No Enkinhō* [Perspective of Globalization]. Tokyo: Iwanami Shoten.

Kim, Soyoung. 2000. *Gundaeseong Ui Yooryeongdul: Fantastic Hanguk Yeonghwa (Specters of Modernity: Fantastic Korean Cinema)*. Seoul: Seedbook.

La Mettrie, Julien Offray de. 1996. *Machine Man and Other Writings*, ed. Ann Thompson. New York: Cambridge University Press.

Marin, Rick, T. Trent Gegax, Sabrina Jones, Adam Rogers and Hideko Takayama. 1995. Holy Akira! It's Aeon Flux. *Newsweek*, August 14.

Monma, Takashi. 1995. *Ōbei Eiga Ni Miru Nippon (Japan Found in Euro-American Cinema)*. Tokyo: Shakai Hyōronsha.

Morley, David and Kevin Robins. 1995. *Spaces of Identity: Global Media, Electronic Landscapes and Cultural Boundaries*. London: Routledge.

Napier, Susan J. 2001. *Anime: from Akira to Princess Mononoke*. New York: Palgrave.

Oshii, Mamoru. 2004. *Inosensu Sōsaku Nōto: Ningyō, Kenchiku, Shintai No Tabi + Taidan (Production Note of Ghost in the Shell 2: Journey to Dolls, Architecture, and Bodies + Conversations)*. Tokyo: Tokuma Shoten.

Ōtsuka, Eiji. 2003. *Atomu No Meidai (The Thesis of Astro Boy)*. Tokyo: Tokuma Shoten.

———— 2008. Disarming Atom: Tezuka Osamu's Manga at War and Peace, trans. Thomas Lamarre. In *Mechademia: Limits of the Human*, ed. Frenchy Lunning. Minneapolis: The University of Minnesota Press: 111–125.

Schelde, Per. 1993. *Androids, Humanoids, and Other Science Fiction Monsters*. New York: New York University Press.

Shida, Takemi. 2003. Tetsuwan Atomu Konpuriito Fairu Manga-hen. (*Astro Boy: Complete File in Comics*). In *Tetsuwan Atomu Konpuriito Bukku (Astro Boy: Complete Book)*, ed. Takanaka Shimotsuki and Takemi Shida. Tokyo: Media Factory: 17–37.

Shimotsuki, Takanaka. 2003. Tetsuwan Atomu Konpuriito Fairu Anime-hen Monokuro-ban (*Astro Boy: Complete File in the Black and White Version of Animation*). In *Tetsuwan Atomu Konpuriito Bukku (Astro Boy: Complete Book)*, ed. Takanaka Shimotsuki and Takemi Shida. Tokyo: Media Factory: 65–97.

joon yang kim

Tezuka, Osamu. 2003. Tezuka Osamu, Kako No Essei, Taidan Kara. (Tezuka Osamu from the Past Essays and Interviews). In *Tetsuwan Atomu Konpuriito Bukku* (*Astro Boy: Complete Book*), ed. Takanaka Shimotsuki and Takemi Shida. Tokyo: Media Factory: 126–127.

Tezuka Productions. 2012. Manga Wiki: Metropolis (Daitōkai): Introduction, http://tezukaosamu.net/jp/manga_syllabary_search/492.html (Accessed April 10, 2012).

Ueno, Toshiya. 1996. Japanimation and Techno-Orientalism: Japan as the Sub-Empire of Signs. *Documentary Box* #9, http://www.yidff.jp/docbox/9/box9–jp/docbox/9/b1-e.html (Accessed November 12, 2010).

Vartanian, Aram. 1999. *Science and Humanism in the French Enlightenment*. Charlottesville, VA: Rockwood Press.

Villiers de l'Isle-Adam, Auguste. 1982. *Tomorrow's Eve*, trans. Robert Martin Adams. Urbana: University of Illinois Press.

Yomota, Inuhiko. 2008. Stigmata in Tezuka Osamu's Works, trans. Hajime Nakatani. In *Mechademia: Limits of the Human*, ed. Frenchy Lunning. Minneapolis: The University of Minnesota Press: 97–109.

history, documentary

and truth

socialimagestics and

cinemasymbiosis

the materiality of a-realism

e i g h t

m a r k b a r t l e t t

> Modernism resolves the problems posed by
> traditional realism, namely, how to represent
> reality realistically, by simply abandoning the
> ground on which realism is construed in terms of
> an opposition between fact and fiction. The denial
> of the reality of the event undermines the very
> notion of fact informing traditional realism.
>
> Hayden White

> We will take the position … that what remains
> unengaged in de Man's text addresses the possibil-
> ity of intervention in the mnemonic, the pro-
> gramming of the 'historial', and a treatment of
> 'materiality' that compels a rethinking of technic-
> ity and the 'sensorium' on the basis of inscription.
>
> Cohen, Miller, Cohen

The future is no longer what it used to be.

<div align="right">Stan VanDerBeek</div>

introduction

Theoretical works indigenous to cinema, in the way quantum physics, say, is indigenous to physics, are rare. How might film studies conceive film production analogously in a 'philosophically' methodological sense, without reducing such a conception *to* philosophy? What would a theory of cinema be that arose from the perspective that film itself is analogous to a field of study like astronomical or terrestrial motion? By proposing this analogy, as will become clear, I am not proposing a 'scientific' study of film, in any positivist sense. One such indigenous study of value, Hugo Münsterberg's *The Photoplay: A Psychological Study* (1916), is such a work, written 2 years after Winsor McCay's *Gertie the Dinosaur*, and 3 years before Max Fleischer's *Out of the Inkwell*. Münsterberg demonstrated if by nothing else, the fecund ambiguities of his nomination for … yes, by what name do we classify 'cinema' (including animation)—medium, technology, form, art, revolution, train, spectacle, science, propaganda, pornography? It has been called all these things. It is an event, both technical and historical, that defies what it is as a medium. Dare we imagine, 'camera consciousness?' Münsterberg's study attempted exactly that, and psychology for him, it should be recalled, was clinical, more akin to today's field of consciousness studies than to psychoanalysis. Thus, for the sequel, I offer it loosely as a kind of 'outsider' frame of reference, and against apparatus theory, with which to begin to imagine a paradigm for theorizing animated film.

Apparatus theory, in the meantime, the dominant paradigm still in need of critique, has done not an altogether bad job of it, though it has fallen into the ideological traps of material determinism or a variety of dualisms. 'Film' versus 'cinema', 'form' versus 'content', 'authentic' versus 'copy', 'culture' versus 'politics', and the like, are logical consequences of the view that apparati deterministically 'interpolate', or, 'read between the lines', to make their cases. And indeed, even the late Althusser may have agreed with this modernist state of affairs. When denied subjectivity by the state, the only political form of resistance for a theory that naturalizes it, is to assert subjectivity. Or conversely, when the state co-opts the politics of non-subjectivity, (disallowing a subject's speech) opposition must assert subjecthood (Althusser 1993).

Cinema has suffered a similar fate. Reduced to genres, semiology, psychoanalysis, and permutations of realism or avant-gardism, by the 'state' of 'film studies' a film theory today must imagine something more and reassert itself as a subject, in its own terms, that resists endogenous theories that seek to reduce it through interpolation to an epiphenomenon of a given

conceptual apparatus. In this light, Münsterberg's use of the pristine term commonly used at that time, 'photoplay', has a libratory effect—light-theater, and literally everything one can imagine illuminated there. "Our aesthetic satisfaction results from this inner agreement and harmony, but in order that we may feel such agreement of the parts we must enter with our own impulses into the *will* of every element, into the meaning of every line and color and form, every word and tone and note" (Münsterberg [1916] 2002: 128 my emphasis). "Will" here goes beyond the romantic organicism to which he appeals, while strongly suggesting that cinema produces 'camera consciousness' in its viewers, not conceptually, but affectively (impulsively), imposes its formal attributes not only as formal effect, but as 'meaning'.

Münsterberg's view of cinema is consistent with Deleuze's 'film philosophy', another candidate for the approach to film I am suggesting; though for all his tranversalist methods of analysis and exquisite mining of film as a field of objects of study analogous to physics, he remained committed to assimilating film *for* philosophy, and thereby remaining exogenous to it.[1] As Raymond Bellour, glossing Deleuze's relation to art, has put it: "... it is philosophy's repeated affirmation as an activity in itself, qualified by the invention of concepts, that Deleuze intends to distinguish from art's sensations and fabrications ..." (Bellour 2010: 6). Like Althusser and Adorno, his work is predicated on the view that *knowledge* is the province of philosophy, while art produces only perception and emotion (Althusser 1971: 204). Only philosophers produce the epistemological concepts of aesthetics, while artists must make do with producing at most audiovisual affective images. Plato's exile of the poet is a figure deeply repressed by philosophy's 'knowledge practices', as the tradition of attempts to eradicate the figural from scientific language, from Locke, through Condillac, to Kant, attest. The limits of film theory to date remain, then, particularly problematic for animated film, for reasons to be elaborated below. Suffice it to say here that mainstream film theory's long practice of 'desubjectivizing' animated film (of relegating it to the status of an inferior sub-genre unworthy of film theory's attention) is an index of the formers ideological constraints; and that the latter's form of resistance lies in two predominant traits—its artisanal, antidisciplinarity, and its rejection of the real-phantasy dichotomy. As Althusser has controversially claimed: "hallucinations are also facts" (Althusser 1993: 81). What is at stake here is challenging realist representational claims to truth and authenticity in order to make a case that animated film cannot be reduced to a state of pure fantasy or, to affect and perception. To enter into the will of animated film is a wholly different encounter than to enter into the will of 'realist' film.

Because film studies has developed along two divergent discourses, the first largely reliant on psychoanalytic, semiotic, or cognitive theories (variously 'realist' and even scientistic in approach); and the second on

historical analysis to account for the sociopolitical conditions of film production (the cultural studies view); I will sidestep both in order to approach a theory of animation from a binocular perspective—that of 'historiography' and 'historicity,' in one view, and that of 'materiality' and 'technicity' in the other. The term technicity refers to the way a given technology mediates our interaction with the world.[2] Historiography, in my view, produces historicity through the technicities of a performative conception of materiality freed of semiocentrism. I will initially frame my use of historiography via Hayden White, in order, using Paul de Man's late work, to shift it onto the terrain of "materialism without matter" as Derrida has put it (Derrida 2001: 319, 350–351). I do so because the field of film theory, (and most other fields as well), is still so saturated with semiology that non-linguistic forms of knowledge remain profoundly suppressed, *for* theory. Second, by making de Man's radical materialism comprehensible as a supplement to White's historiography,[3] I will conceptualize a materiality for the hybrid states of fictional-facts and factual-fictions the latter, though not with that terminology, proposes. Lastly, I will demonstrate how such a concept is applicable to a theory of *some* animated film, films which hybridize animation and life action sequences. I limit my theory of animation to *some* animated film because, as this anthology will undoubtedly demonstrate, the field is far too diverse to succumb easily to a single theoretical apparatus. Nor should it. The state of animation today demands a multiplicity of approaches.

I will then apply this analysis to key, though largely unknown, theories of the experimental animator and techno-artist, Stan VanDerBeek. It is through his great promiscuous dissolve into a primordial ocean of technicity and its hybrid audiovisual forms that VanDerBeek imagines a future historicity that is no less transformative than Benjamin's 1934 account of the consequences of mechanical photographic and cinematic reproducibility. Because the filmic was, between 1965 and 1975, transubstantiated as the informatic, the very material substance of animation, digital animation has enabled global image flows to achieve a new order of magnitude of saturation and impact, both good and bad. Because VanDerBeek understood and theorized these monumental changes in a series of little know writings and radical 'post-filmic' works that were largely incomprehensible to artists and critics at that time, his political critique of this momentous cultural shift has yet to be understood. It is for this reason that he is so important today, and why I take his writing in particular as the subject of my 'theory of animation' here.

I must ask the reader to bear with me while I set out at some length a theoretical context that I hope will open up, for theory the extraordinary cultural significance for modernity and postmodernity of animation, not as a 'new' phenomenon, but one that has been coeval with them from its late nineteenth century cinematic inception.

radical historiography and its implications for animation theory

Of Hayden White's work, his essay, "The Modernist Event", has made the most direct contribution to film studies (White 1999; Sobchack 1999; Skoller, 2005). The central issue there is the oft-pondered possibility or impossibility of representing events such as the holocaust and 9/11, a problem that "... is indeed not one of method but, rather, one of representation ... [that] requires the full exploitation of modernist as well as pre-modernist artistic techniques for its solution" (White 1999: 81). Readers should pause over that claim. White expresses here a tenet that has been central to his philosophy of history from early on, and should be understood as a fulcrum around which his critique of historiography pivots, and the principle of his term, *figural realism*. In his early essay, "The Burden of History" (1966) we find this view in its most aesthetically explicit form:

> Such a conception of historical inquiry (in which the historian and scientist organize facts through tentative metaphoric approximations) and representation would open up the possibility of using contemporary *scientific and artistic* insights in history without leading to radical relativism
> It would permit the plunder of psychoanalysis, cybernetics, game theory, and the rest And it would permit historians to conceive of the possibility of using impressionistic, expressionistic, surrealistic, and (perhaps) even actionist modes of representations for dramatizing the significance of data (White 1978: 47, my emphasis)

Here, White is allowing that the potentials of both art and science to contribute to historiography's modes of representation are equal. Méliès, in this view, is as good a source of historical representation as Vertov or Chaplin, for example (or for that matter, Norbert Wiener's cybernetics and Chris Burden's risk performances). His epistemological egalitarianism is elaborated in the "Preface" to his collection of essays, *Figural Realism*, where he explains that the term and its project intends "to show how figurative language can be said to refer to reality quite as faithfully and much more effectively than any putatively literalist idiom or mode of discourse might do" (White 1999: vii). He isn't, however, as satisfied as it might seem at first glance, with his somewhat diplomatic comparison of the two approaches to 'realism;' his emphasis is not so much on the "quite as faithfully" as on the superlative, "much more effectively". Figural realism posits, "... not that history is no longer represented realistically but, rather, that the conceptions of both history and realism have changed" (White 1999: 41). The importance of this claim is that both history and realism have been denaturalized, and that historicity and its technicity are understood as culturally determined forces. In effect, White's post-Enlightenment historiography is an epistemological

revolution that elevates artistic practice over scientific practice, making the 'figural' the most effective mediator between binaries: "… the very distinctions between what can count as literal and figurative, denotation and connotation, proper and deviant, fact and fiction, and yes, even truth and lies …" (White 1999: vii). Put another way, historical realism is no longer equated with film's indexical, naturalist representation bequeathed to modernity by Enlightenment rationalism, nor is history to be conceived as a science but inescapably as an art; the result of which is the erasure of absolute polarities, and the discursive formation of a middle ground between them constituted by hybridized states of fictional-facts and factual-fictions.

Enlightenment era historiography constituted a form of naïve realism because it assumed as unquestionable the existence of an experiential reality made up of knowable, realistically observable facts (positivism's legacy). White claims that for our post-World War II world the very conceptions of history and reality have been transformed into ratios of fact and fiction; that the pure states of the factually real and fictionally imaginary are simply inconceivable as anything else than thought experiments. The implications here are immense for film theory. *The characterization of realist film as realist is a fantasy; just as the characterization of animated film as unreal, is.* In other words, the inevitable effects of the figural expose both realism and fantasy as false presumptions of aesthetic ideology. What is 'real' and therefore 'true,' is that *both* realist modes of representation are inherently part fantasy, *and* animated modes of representation are inherently part realist.

Figure 8.1 suggests a way to convert, so to speak, White's historiographical imaginary to argument. Language's referential function (its mimesis

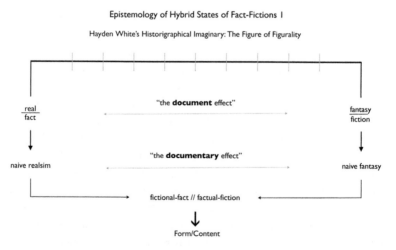

Epistemology of Hybrid States of Fact-Fictions I

Hayden White's Historigraphical Imaginary: The Figure of Figurality

"the **document** effect"

real
fact

fantasy
fiction

"the **documentary** effect"

naive realsim

naive fantasy

fictional-fact // factual-fiction

Form/Content

Figure 8.1

'Figures' govern content, but White's concept is that rhetorical tropes govern entire narratives. Thus, the figure of figurality always implies a general proposition comprised of these ratios—Fact/Fiction :: Content/Form. Diagram by the author.

effect) is unavoidably figurative, is predetermined by tropes that superimpose linguistic form onto the observed world and events, just as our senses impose analogous somatic content. The means by which White's figurative realism may be interpreted as historically specific is by determining, relative to some concrete event such as the trial of the Chicago Eight, the ratios of fact/fiction in any given account, whether purely textual or visual, scientific or aesthetic. Since the document effect is always figural, we may speak of the "figure effect" as a ratio of fact/fiction that determines where on the spectrum the hybrid state of a claim's *content* falls. Similarly, the "figural effect" is a ratio of fact/fiction that determines where on the spectrum the hybrid state of a claim's *form* falls. Taken together, these two propositions suggest that the fact/fiction ratio may also be expressed as that of form/ content. In the various filmic versions of *JFK* for example (**See Figure 8.2**), the "figure effect" of an 'assassinated president' (as opposed to killed, murdered, 'offed', martyred, etc.) has, historically, several modalities. The primary 'realist' visual source is the Zapruder film (1963), the status of which is near-factual and thus almost purely documentary because mechanical and devoid of intention or narration, and therefore constitutes pure data or content without figural form. Oliver Stone's 'realist' *JFK* (1991) is structured to review the 'factual' evidence (content) in the case, representing it with an assemblage of narratives (form) that works in support of one particular conspiracy theory. Ant Farm, T. R. Uthco's work *Eternal Frame* (1976)[4] is obviously Situationist in intent (form), and yet an accurate, an actual-reenactment (content) of the Zapruder film, on the 'grassy knoll' in Dallas. Given White's historiographical theory, we

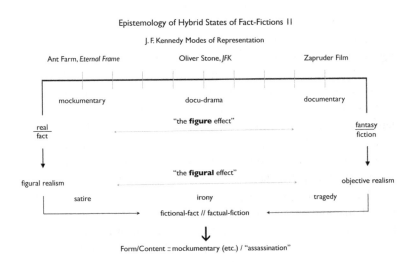

Figure 8.2

The figure of figurality common to these three films is that of assassination. Diagram by the author.

203

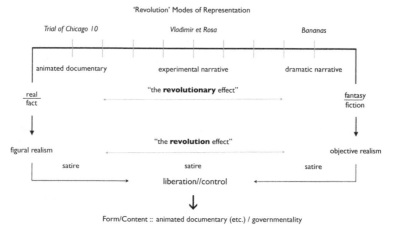

Figure 8.3

The figure of figurality common to these three films is that of revolution, or in Foucault's terms, governmentality. Diagram by the author.

find that *Eternal Frame* is the most figurally real because it *"dramatizes the significance of data"* through an actionist mode for a later historical moment. The Zapruder documentary is the least figurally real because it is a mere filmic datum shorn of any dramatic or interpretive significance (mere historical chronicle). Stone's film then by comparison falls somewhere in between.

Bringing this analysis to bear on animation (**See Figure 8.3**), Brett Morgen's *Chicago 10* (2007), is the equivalent of *Eternal Frame* in terms of its figural reality, in comparison to Jean-Luc Godard's *Vladimir et Rosa* and Woody Allen's *Bananas*, for example, both of which play on the figure of the revolutionary and allude only indirectly to the events of 1968 Chicago, the figural effects of which are satirical depictions of revolutions, while the figure of figurality yielded by the comparison is that of, in Foucault's terms, governmentality, in which liberation and control contest each other.

Morgen's animated documentary represents the reality of governmentality "much more effectively" than either Godard or Allen, precisely because its hybrid mode of representation dramatizes an 'actual' historical event—Democratic Convention, Yippie Festival of Life, Mobilization Against the War, police state (not only the trial)—using a wide spectra of visual representations, from purely animated, to animation/live-action hybrid, manipulated live-action, and purely realist live-action, sequences (**See Plate 22, Figures 8.4** and **8.5**). There are also many instances of visual effects found in experimental avant-garde film. The overall formal, aesthetic effect is to render the content of each visual mode unstable in its 'truth' value because each relies on a different register of 'camera consciousness' and it's political, affective, and figural effects. Because no 'realist'

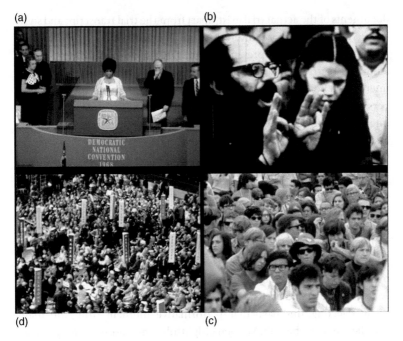

Figure 8.4

Morgen's film intends to visualize the polarized figure of governmentality of 1968 USA. Juxtaposition of types of 'leaders' (clockwise from top left): (a) 'political leaders' to (b) cultural leaders (Alan Ginzburg).
Juxtaposition of types of political organization, (c) the Festival of Life to (d) the Democratic Convention. All screen grabs from Brett Morgen's *Chicago 10*, 2007.

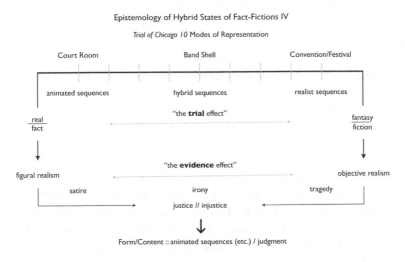

Figure 8.5

The figure of figurality common to these three scenes is that of the trial (legal, popular, political), each the forum in which judgments are made, debated, and determined. Diagram by the author.

documents of the actual trial exist, apart from the trial transcript and some audio recordings (data equivalent to the Zapruder film), Morgen chose animation to visually represent/interpret it. Structurally, he threads the animated courtroom scenes through the film's narrative, continuously interrupted by archival live-action footage that represents a wide array of perspectives that includes news presenters, Mayor Daley, activist meetings, interviews with Chicago citizens including youth, lectures to university audiences by the activists, and of course scenes of the Festival of Life, the Convention, and the violent encounters between activists, police and National Guard. But none of the mélange of archival material would have historical significance without the animated court scene axis (**See Plate 23**), where governmentality and the contestations of power are brought under judgment. In other words, the film's historical veracity relies not on the realist elements of the archive, but on the animated scenes of the trial where the figure of figurality shifts from governmentality to that of judgment that exposes the faultlines between justice and injustice, democracy and control, fact and fiction, and yes, even truth and lie.

By selecting this particular performative moment from the many parodic events of the trail, Morgen insightfully emphasized, through visual synecdoche, the pivotal issue contested in Chicago 68, the 'trial' of the 'agonistic system' comprised of popular, political, legal (including its policing) dissent and judgments (Morgen *Chicago 10*, 2007).

The significance of White's *figural realism* for film theory and history is that the opposition between abstraction and realism that has been foundational for both the practices and theorizations of avant-gardism and popular film alike, was predicated on an obsolete historical episteme. According to this perspective we can only conclude that the *raison d'etre* of post-war avant-gardism, and particularly of formalist materialism's commitment to abstraction, was already undermined at the moment it was initiated, *because it assumed a falsely conceived historical opposition as the catalyst for its presumed political efficacy.* At the heart of experimentalism's aesthetic ideology was an erroneous, essentialist view of not only media, but more consequentially, a 19th century assumption of corporeal authenticity, of phenomenological veracity that Benjamin had already put paid to, on the one hand, and on the other, a naïve belief in the power of film to determine radical rather than reactionary consequences. In effect, it lapsed into bourgeois autonomy precisely because of its disconnect from the hegemony of mass media culture. Formalist experimentalism, in other words, succumbed to the *political effects* of the technological determinism it opposed *in theory* by its reduction of the filmic to the limits of its media-centric capacity. Its *historicity*, in other words, was at odds with flows of mass media society at the very moment when mass media opted for a far more powerful expansion through media hybridity.

At this point, I will assert without demonstration that the political agenda, if not the work, of the 60s film avant-garde that has been canonized,

capitulated to the apolitical agenda of Greenbergian formalism, and knowingly/unknowingly allied itself ideologically with aesthetic internationalism. If this view is at least a partial vindication of Godard's filmic politics, it is also a condemnation of 'visionary film' that overtly allied itself with the nineteenth century anachronism indicated above. That the Sitney/Mekas canon allies itself with a masculinist romantic transcendentalism of a supposed 'poetics' can only be understood as a form of political retrogression based on an erroneous conception of history. The revisionist interpretation I am suggesting means that the formalist avant-garde's politics were ineffective precisely because its purist ideology obligated it to polarize itself in relation to its nemesis, Hollywood, when it should have been engaging it. This is exactly what VanDerBeek regarded was necessary, as will be seen below. What I want to stress at this juncture, is that figural realism requires a major re-evaluation not only of the now standard film histories of the period, but of what constitutes political efficacy and the profound contributions animation *has in fact* played. In other words, the most effective means by which the cultural politics of modernity could be challenged was through a *politics of animation* that aimed to challenge the conventions of literalist realism—represented by that subset of film in which animation and live-action are hybridized, as in Morgen's *Chicago Ten*. This does not mean that all film that does this is effectively political in an oppositional sense, but the potential lies along that vector.

radical materialism

White's analysis, however, can take us only so far because he explicitly limits figural realism to historiography's discursive and tropological field, to the rhetorical dimensions of language. This poses another dilemma for my argument here, because White's analysis is committed, as the twentieth century was, to an episteme modeled and governed by the linguistic turn.[5] Hence, as historicity emerges in hybrid states between binaries of fact and fiction, truth and lie and so on, and because he fails to posit a materiality for such a ground, his analysis remains in fact more figural than realist, more fictional than factual, still encumbered by a metaphysical, linguistic self-reflexivity. He does not, as de Man does, attempt to extend "... the linguistic model beyond its definition as a system of tropes". Because tropes, according to de Man, constitute at best a form of "pseudocognition (all that semiosis can offer)", language must "... expand to the activity of performance" (de Man 1996: 79), to the historicity of event in order to theorize "... a materialism much more radical than what can be conveyed by such terms as 'realism' or 'empiricism' ..." (121). He relies for this proposition on Kant's own critique of empiricism: "One will never be able to reach the a priori principle, objective or subjective, that underlies judgments of taste by tracking down the empirical laws that govern the fluctuation of

our moods …" (de Man 1996: 120). What de Man proposes, then is "… an absolute, radical formalism that entertains no notion of reference or semiosis … [a formalism] entirely a-referential, a-phenomenal, a-pathetic …", in order to free it of the pseudocognition inevitably produced by tropes. De Man then hazards this Kantian definition: "the radical formalism that *animates* aesthetic judgment in the dynamics of the sublime is what is called materialism" (de Man 1996: 128, my emphasis).

What the essays in *Aesthetic Ideology* set out to achieve, in itself a radical revisionism, is to purge Kant's third *Critique* of its nineteenth century, empiricist misinterpretation that assumed a transparent relationship between subjectivity, language, and things in the world. "One can certainly see why," he comments, "so many interpreters [of the third *Critique*] have lost sight of the forest for the trees—have concentrated, for instance, on purposiveness without purpose at the expense of the *teleological judgment it makes possible*, or on the notion of the aesthetic of free play at the expense of *the aesthetic as pure reason*" (de Man 1996: 120, my emphasis). De Man's revision of Kant is radically at odds with, as he puts it, "all commentators on [him]" in that pure reason, restored to Kant's actual conception of it, is subordinate to a transcendental aesthetic faculty that makes teleological judgments possible, in the materialist sense that it *produces* them, or, animates them performatively. This is a rather remarkable inversion of traditional views of the relation of pure reason and aesthetic judgment. *Aesthetic Ideology* demonstrates that philosophy is determined not by its logic, but by both its conscious and 'unconscious' deployment of figural language. He demonstrates, for example, that Kant's third *Critique* "is a story, a dramatized scene of the mind in action. The faculties of reason and of imagination are personified, or anthropomorphized … We are clearly not dealing with mental categories but with tropes, and the story Kant tells us is an allegorical tale" (de Man 1996: 86–87). Tropes limit language to pseudocognition in that they trap it in figurality, foreclosing the possibility of the knowledge of things-in-themselves. His radical formalism relies on what today is typically ascribed to Austin's concept of the performativity of language,[6] but which the former says is not new with the latter, and is in fact found in Kant and others. As such, its materiality is that produced by the performative aspects of language, of the letter, of utterances that strip language of its figurality, of its tropological effects on epistemology, when conceived as actual, productive events, *in the form of* aesthetic judgment as it performs, on and in the world.

Conversely, his essays, collectively, aim to construct a "continuous line … from Locke to Rousseau to Kant and to Nietzsche … [We] assume that it is possible to coordinate Locke and Nietzsche by claiming that their similarly ambivalent attitudes toward rhetoric have been systematically overlooked …" by philosophers, he implies (de Man 1996: 49). Thus, the task of reading de Man is a pendulous one, cycling between the

'philosophical' ramifications of such a 'literary' analysis of philosophy, and, those of a philosophical analysis of literature. Such a dual task requires that readers of de Man 'perform' the equally dual, and perilous task of tracing the reversals, simultaneously literary and philosophical, along the trope of chiasmus (de Man 1996: 135). *The literary significance of philosophy is the philosophical significance of literature; while the philosophical significance of literature is the literary significance of philosophy.* (As we shall see below, this formulation will be reiterated in terms of animation's relation to live-action.) What makes 'formalism' radical, then, is the privative conditions de Man ascribes to it (a-mimetic, a-reflective, a-perceptual), and that this triple void (degree zero of the sign—"rudderless signification") (de Man 1996: 59), is precisely what allows aesthetic judgment to *animate* materialism. In the language I use above, it's aesthetic judgment that inscribes the contents of pure reason with form, and the 'world' becomes fundamentally and inescapably, *imagined*, and therefore imaginary.

To engage de Man's anti-referential notion of materialism further, I will first return us to two passages often cited in discussions of materialism and film theory; but which assume additional dimensions here. The first is Marx's account of commodity fetishism, and the second, Benjamin's account of the demise of aura. Marx's comments that follow posit a number of complexities that are not easily parsed.

> The existence of things qua commodities, and the value relation between the products of labour which stamps them as commodities, have *absolutely* no connection with their physical properties and with material relations arising therefrom. There it is a *definite* social relation between people, which assumes for them the *phantasmagoric* form of a relation between things. (McLellan 1977: 436, my emphases)

In the first instance, what are we to make of his absolutism? Commodities and their value relations, he insists, exist materially, yet do so absolutely independently of both their physical properties and the material relations that arise from such properties. If value relations, then, are absolutely immaterial and nonphysical relations, then they must be conventional social and psychological constructions freed from all material conditions of existence of things qua commodities. In the second instance, how are we to understand that the social relations between people are both definite, and phantasmagoric? 'There', that is, in the immaterial zone between material commodities and their value relations, phantasms constitute the social relations between people, but this phantasm is one in which values of things are substituted for values of people. It is this substitution that constitutes Capital's fetishism, as fantastic. The value of my social relation to you is determined by the material event of exchange of definite phantasmagoric things, like the performative speaking at a distance through

the mediation of a mobile phone, which inscribes us in a materialism of the imaginary. But how are we to understand Marx's definite, phantasmagoric form of social relations when these relations are mediated by the visual images of film? Benjamin solves this problem in his analysis of the historical significance of mechanical reproduction.

Photographic and filmic representation, all forms of audiovisual, mechanical reproduction including animation, in his view, establish a fundamental historical break for humanity and more than any other event, divide it from its pre-modern history. Mechanical audiovisual reproduction reconstitutes humanity on this side of modernity within an ontology that can become an object of knowledge only through a figural realism reinscribed 'cinematically'. More on this later. The implications of Benjamin's analysis is that technicities of this sort bring Enlightenment humanism and its form of subjectivity to an end. In his language: "the technique of reproduction detaches the reproduced object from the domain of tradition". It "... lead[s] to a tremendous shattering of tradition which is the obverse of the contemporary crisis and renewal of mankind ...", to "the liquidation of the traditional value of the cultural heritage" (Benjamin 1968 [1936]: 228). This radical break then, must radically transform the social relations between people, and their definite, phantasmagoric form is determined by mechanical (re)production. But if it detaches the reproduced object from tradition, it also must radically reconfigure the traditional subject if "aura" is understood phenomenologically as materially (re)produced by the human sensorium. Mechanical technicities of audiovisuality produce an 'aesthetic state' that is specifically modernist, at a mass scale that reprograms perception and all that is consequent to it. The pre-cinematic authority of objects (of commodity fetishism), and the objective authorities reliant on them are liquidated, and replaced by a specifically cinematic form of figural realism. More, Benjamin suggests that history itself is displaced and foreshortened as the 'substantive duration' of objects, and our subjective memories of them, 'cease to matter'. In de Man's terms, the technicity of mechanical production takes the material form of inscription, which acts on subjectivity not only through the elimination of aura, but 'positively' in the sense that it reprograms human perception through machinic, dynamic audiovisuality.

Tom Cohen, via his reading of de Man, elaborates on the implications of Benjamin's views:

> If much of 'film theory' returns us to humanizing and subjectivizing tropes, under the cover of psychoanalytic codes, it regresses to a pre-Benjaminian—which is to say, in his terms, precinematic—topos ... Such appropriating interpretation ... is constitutive in de Man's sense not only of the institutions of 'liberal education' but of the aesthetic

state. This ghost state without temporal or geographical borders, technically nonexistent, is linked to the institutional grids of mimeticism and historicism, [read White] yet it also creates and reconfirms the 'human' as a closed interpretive system: such a spectral 'state …' nonetheless determines referential codes, programs nervous systems and sensoria, enforces hermeneutical programs, and services archival politics that it itself has no means to read or determine. [This] 'aesthetic state' … is designed to efface a materiality of inscription … [its] programming, [its] mnemotechnics, so as to affirm a putative immediacy of the perceived, of facticity, and so on—yet just this mnemotechnic order is what would have to be assaulted, or altered, if the prerecordings of historicism, agency, or for that matter the sensorium were to be ex-posed or suspended. (Cohen 2001: 120)

To return to my comments above, it is precisely animation's capacity for assaulting and altering the mnemotechnic order that Cohen (in reference to de Man's critique of Schiller's concept of 'aesthetic education') calls the aesthetic state, and that constitutes its political efficacy. Just as the formalist avant-garde succumbed to the *political effects* of the technological determinism it opposed *in theory* by its reduction of the filmic to the limits of its media-centric capacity, so has film theory succumbed to the "humanizing and subjectivizing tropes, under the cover of psychoanalytic codes" that regresses to a pre-cinematic topos. In other words, film theory and avant-garde film have alike tended to reinforce the aesthetic education of the ghost state of the pre-cinematic nineteenth century, the very state de Man was at pains to eliminate from the traditions of Kantian interpretation.

What makes cinema's images performative image acts, is that they *assert* a form of materialism freed of physiological constraints, or in Kant's language, they release understanding's perceptions from the imposition of pure reason's categories and schemata, that formally make empirical observations possible. This is what de Man means by a formalism that is radically a-referential. They have "*absolutely* no connection with their physical properties and with material relations arising therefrom", as Marx suggests; nor to the inherent categories of our brains, as Kantian interpreters have (erroneously) suggested; but are forces that impose their will on, as Münsterberg suggests, and either free us from or maintain, the aesthetic state of pre-cinematic modernity. Potentially, they may free us from its mnemotechnics that maintain the aesthetic education of ghost states represented by psychoanalytic and semiological regimes of film theory.

What epistemological work does some animation then do? Live-action, as a mode, ideologically maintains pre-cinematic, humanistic subjectivity

through the figural phantasms of indexicality. Whereas animation, as a mode, critically engages humanistic subjectivity through the indexicality of its phantasms. What is at stake here are two types of phenomenalization, two forms that elicit opposing regimes of aesthetic judgment; live-action induces judgments of realism, while animation induces judgments of figuration. At this point, two hypothetical filmic states must be proposed for the sake of argument. 'Pure' live-action imposes image acts that are most faithful to naturalistic perception; while 'pure' animation imposes those that are most faithful to phantasmal depictions of such perceptions. Neither of course in fact exists as a pure aesthetic state, as we have seen. It is only when alloyed with White's concept of figural realism, and with the notions of fictional-facts and factual-fictions illustrated above, that de Man's a-referential 'radical formalism' that *animates* aesthetic judgment, comes to have a material meaning for *some* animation. For de Man's materialism to animate, means to produce an aesthetic state *in opposition* to that determined by the ghostly and falsely re-humanizing reifications, by inscribing its will on spectator consciousness, in effect, exorcising them of modernity's pre-cinematic ghosts. Animated films *perform* such exorcisms *if* they succeed in producing in the spectator the material event of camera consciousness that strips them of pre-coded histories of aesthetic education. In positive terms this means to produce *content* (conceptual, affective, sensory) through cinema's aesthetic judgments that make explicit a work's ratios of fictional-facts and factual-fictions. Morgen's animated trial imposes its aesthetic judgments on the film's figures of governmentality and judgment, severing them from the aesthetic state of realism, and simultaneously from its retrogressive historicity. Its polyvalent technicity constitutes its performative efficacy in such a way that government is refigured and the antagonism between justice and injustice is reinscribed for contemporary spectators.

Animation, then, is "a-referential, a-phenomenal, [and] a-pathetic" because it is non-indexical, eschews somatic phenomenal referentiality, and is therefore a-pathetic (in the usual sense of the term) because the frames of reference of human corporeality and its identity structures are rejected. This is not to say that animated films are devoid of referentiality, phenomenology, or pathos; but that they assume a-humanist ratios of fact and fiction, form and content. In other words, they are constituted by epistemologies in which the *will* of its forms and contents are transhuman, and generate an *a-realist* imagined consciousness without human referentiality or identity. A-realism refers to what de Man termed "rudderless signification" and must be understood as a force that cinema performatively imposes on consciousness. How then do we answer de Man's implied question: *what*, in the zero-condition of signification, animates?

socialimagestics and cinemasymbiosis

What is at stake today, then, is nothing less than the 'aesthetic education' of imagination that constructs us as transhuman through the materialism of digital technicity. Education was once stipulated by Enlightenment modernity to be the fundamental condition of a democratic state. It was, once, the material condition of modernity in general, determined by an anthropocentric secularism—this is what 'humanism' means in Enlightenment ideology. It did indeed produce nothing less than what can only be called an 'aesthetic state', a decidedly literary and encyclopedic one, based on a naïve belief in pure reason. But as we have seen, de Man's reinterpretation of Kant sought to obviate that illusion in order to provide a philosophical ground for Benjamin's account of a cinematic modernity governed by aesthetics *as* pure reason, or better, pure reason reconceived as performative aesthetic judgment. De Man's radical reinterpretation of Kant's third *Critique*, then, offers a similar method by which to approach the audiovisual. We must learn to see as the poets do, "… as the eye seems to perceive …" But, he continues, "neither is the vision a sensation … the eye, left to itself, entirely ignores understanding: it only notices appearance (it is *Augenschein*) without any awareness of a dichotomy between illusion and reality" (1996: 127). There could be no better description of Stan VanDerBeek's *Poemfields* series, in which the 'fields' are comprised of first, materially, digitally realized visuality, and second, the text-fields of poetry.

VanDerBeek's historiographical position stipulated as early as 1965–1966 that the filmic was being eclipsed by the televisual, and that television would itself eventually be eclipsed by information and computing technologies.[7] In 1973, the American Film Institute published his image/text collage entitled, "Socialimagestics: Some notes on 'Dream Theatres'© and 'Social surrealism'© in the future" (VanDerBeek 1973). Through a logic of text-image citations, VanDerBeek filters the meanings of both "dream" and "surrealism" to obtain uniquely reconfigured definitions of each term, their relationship, and their particular form of sociality, he called "socialimagestics," a full-fledged, if highly compressed, social theory intentionally writ small. It took the form of an inductive synthesis of Wittgenstein-quality language games and Keaton-quality 'illogical analysis.' His conceptions of the "dream" may be conceived as a compositing of Lacanian 'subjectivity' with Debordian Spectacle.

> Group dream conditioning is a new social biproduct/function of the social inter-perspective, "minds-I" American television experience … The Tell/A/Vision experience of image "imprinting" has influenced all of us, and is setting up a new image/matrix for western eyes …. (VanDerBeek 1973: no pagination)

VanDerBeek insists here on a type of post-humanist subjectivity that is at once a bi-product, a consequence of causes exterior to it, and paradoxically, an interior function of these same exterior causes of the image/matrix, or, Spectacle. Tell/A/Vision is a poetic deconstruction of TV as a self-reflexive feedback system that *constructs* the social formation as a specifically American, TV "minds-I". Visual perception of the "eye" causes, or in his terms, "conditions" the "I" as socially constituted, as a group, or, culture industry dream. He follows this analysis with a mock (surreal) syllogism that emphasizes this mass media shift in social consciousness:

> "I think therefore I am" ... Descartes (1620)
> "If I hadn't believed it, I wouldn't have seen it with my own eyes" sv (1969)
> "I dream therefore I become" sv (1973). (VanDerBeek 1973: no pagination)

Tell/A/Visual dreaming opposes not only Cartesian rationalism, but posits a second annihilation that severs history with the same finality as (and from) Benjamin's cinematic break, substituting a transformable subjectivity for an absolute one, and positioning the "minds-I" relative to a deep sociopolitical conundrum: I see, *with my own eyes*, only what *I* believe. VanDerBeek is here positing a very specific kind of aesthetic state created by a double operation by which *only* an 'untraditional' belief can be severed from the predetermining codes of cinema and determine what is subjectively knowable; *and* conversely, by which lack of belief determines what is objectively knowable (I see with other eyes only what I disbelieve). It is in this sense that VanDerBeek understands the "social inter-perspective minds-I" as a double operation akin to that of de Man's, that is both the product and function of Tell/A/Vision experience of image "imprinting," what as we shall see in a moment, he conceived as a process of 'collaborative modeling".

These two reciprocal filter layers (belief–disbelief/subjectivity–objectivity) are followed by a quotation in which Breton defines surreality as the 'absolute reality' formed through the fusion of dream and reality. Without, as de Man commented above, any awareness of a dichotomy between illusion and reality. The importance of the Breton passage lies in its late-Surrealist formulation, when it turned to a pseudo-empiricist, methodological attitude suggesting nothing of chance, free associations, or exquisite corpses as surrealist technicity is popularly understood. He speaks of the time "when we can submit the dream to a methodical examination," in order to "realize the dream in its entirety" and "when the dream curve is developed with an unequalled breadth and regularity" (Breton 1978: 29). VanDerBeek's playfulness and irony is a means for locating exact social trigger-points anywhere along this "dream curve" as determined by the dual, compositing forces of production and function. In other words, we've

arrived again at a conception of a-realism constructed by the interplay of fictional-facts and factual-fictions determined by the aesthetic state of the tell/a/vision "social inter-perspective, minds–I". He diagnoses the mechanisms which form the newly emerging collective fantasy/Spectacle of specifically Western visuality, through the process of subjective 'image imprinting', which results either in seeing with ones own eyes what one believes, or, believing only what one sees. It is impossible here not to make the comparison to Lacan's essay, "The Mirror Stage as Formative of the Function of the I" (1977), where he talks of the "imago", the mechanism of human imprinting as "parent" on goslings. VanDerBeek is similarly suggesting a form of a partial "technological" determinism not at the levels of means of production as classical Marxism would, but at the physiological and psychological levels of a newly constructed human, produced by a now, transhuman, televisual will, or technological aesthetic judgment. It is the 'new image matrix' that constitutes *becoming* in history through the dual dream operations of tell/a/vision.

If cinematic reproduction instantiated the radical historical break for Benjamin, for VanDerBeek, a second such break was brought about not only by computing technology, but a particular conception of it that was foundationally articulated by J. C. R. Licklider, the first director of ARPANET appointed specifically to conceptualize the decentered information distribution system that became the internet, and head of the Man and Computer (MAC) research group at MIT, which VanDerBeek was to work with beginning in 1970 as a fellow at the Center for Advanced Visual Studies.[8] Licklider was one of many theorists of the 1960s who advocated for and were able to implement research programs that aimed to bridge the gap between humans and machines. In 1960, he wrote a highly influential essay entitled, "Man-Computer Symbiosis", in which he specified "symbiosis" as a "subclass of man-machine systems" refining Norbert Wiener's generalization of an earlier era. His metaphor significantly elides the difference between the biological and the mechanical, stressing with this trope the concept of interdependence, and "interactivity with living information" (clearly a reference to animation), rather than mere mechanical and computational substitution for human effort, both physical or intellectual. Licklider's 1968 essay, "The Computer as a Communication Device", announces one of the most trenchant aspects of the cyberlibertarian, utopian construction of technology that, until recently, has been largely dominant in cyberspace: "In a few years, men will be able to communicate more effectively through a machine than face to face". Licklider continues:

> Creative, interactive communication requires a plastic or moldable medium that can be modeled, a dynamic medium in which premises will flow into consequences, and above all a common medium that can be contributed to and experimented with *by all*.

Such a medium is at hand—the programmed digital computer. (Licklider 1968: 22, my emphasis)

A few paragraphs later, Licklider makes fully explicit the social agenda that was still alive and well even in the highest circles where academic and military research programs intersected. "Society," he asserts, "rightly distrusts the modeling done by a single mind ... the requirement is for communication, which we now define concisely as 'cooperative modeling'—cooperation in the *construction, maintenance, and use* of a model" (22). Thus, Licklider effectively created the concept of an operational social network based on what has far more recently come to be known by the terms, 'mindshare' and 'social networks', or in VanDerBeek's terminology, a "social inter-perspective, minds–I".

> Mind 'models' and mind 'sets' are part of the 'virtual' modeling that takes place between the interior/exterior worlds with the film-on-going experience as part of our national image patterning 'process' (i.e., image habits, the corporate 'image,' 'identity' crisis, life 'style,' etc.) undergoing a major changeover. (VanDerBeek 1973: no pagination)

His first 'postfilmic works', *Poemfields 1–8*, are experiments in applying Licklider's conception of cooperative modeling ("mind 'models' and mind 'sets'") to mass media technologies, and in a perfectly Benjaminian sense. The film-on-going experience is a 'virtual' dimension in which the mind is modeled, in which image habits—corporate, nationalist, commercial, and cultural—are patterned. VanDerBeek's position is a form of technological potentialism that recognized with great subtlety the power of social relations in Marx's sense analyzed above, over mechanical means of audiovisual production. Writing with his characteristically prophetic and neological style, he elaborates:

> The narrative Hollywood Movie probably hasn't any idea that its essential 'genetic' coding will allow it to evolutionize into 'abstronics' graphic/ethos/*cinemasymbiosis*, videographics, and larger scaled image matrix systems (global image transfers) that are as yet *unlabeled* visual flows via/vis computers, synthesizers in sight and sound, 'instamatics'–kodak-ghosts, the 'still' and movie role for video cassettes, stereo sights and sound systems. All of the methods of image use and re-use are active in the process of finding uses for these new forms Let us image 'visual/acupuncture'? (VanDerBeek 1973, no pagination, my emphasis)

VanDerBeek's language powerfully reminds us that the effects, as well as the instruments of new technologies, entail great hermeneutical invention,

guesswork, and struggle for names for the "as yet unlabeled visual flows" and their particular heterogeneous forms of technicity, that VanDerBeek prophetically called in a Joycean idiom, cinemasymbiosis. What set him apart from his contemporaries, however, was his insistence on what today we call 'platforms' and the forms of media convergence between them, that political critique and potential prosocial effects were to be found not in the media specificity of each form, but in their interconnectedness. He insisted that political transformative potentialities of "image use and re-use" are inherent not in the technologies themselves, but in the combinatory possibility to produce a new aesthetic state by applying visual/acupuncture to Hollywood's genetic codes. His politics here aligns perfectly with Cohen's diagnosis above: "yet just this mnemotechnic order is what would have to be assaulted, or altered, if the prerecordings of historicism, agency, or for that matter the sensorium were to be ex-posed or suspended." VanDerBeek is indirectly Marxist; like the Frankfurt school, like Eisenstien's appreciation of Disney, and the Situationist tactic of détournement, he understood that mass cultural "image matrix systems" and new forms of visuality had the potential to produce nothing less than a potentially revolutionary cultural ethos of cinemasymbiosis.[9]

VanDerBeek, then, is completely aware of the significance of Benjamin's post-auratic condition, and understood that the Sitney/Mekas/Brakhage axis regressed cinema to nineteenth century humanism and the romantic visionary as the ideological aesthetic state both Benjamin and de Man sought to overcome. VanDerBeek sought to radically break with materialist formalism's aim to restrict aesthetic significance within the limits of specificity; he realized that that project only foreclosed its political efficacy by abandoning critical engagement with regimes of mass representation. Avant-garde technicity, in his view, became not only parochial in its reduction to self-reflexivity, but politically regressive because it allied itself with a historicity of a previous aesthetic state, nineteenth century Transcendentalism. Similarly, the reliance of film theories and histories, as Cohen points out, on psychoanalysis has had the regressive effect of reconfirming humanism as a closed interpretive system, and thereby obviating the revolutionary political potential of liquidating those forms of authority which discipline and control the mass aesthetic state through canonization projects like Anthology's list of visionary film. Cinemasymbiosis moves in exactly the opposite direction, and posits a radical break with tradition, including the tradition of cinema in its media specific form.

VanDerBeek's *TV-Information Jacket* (**See Plate 24**) opposes that aesthetic ideology and illustrates both Licklider's 'collaborative modeling' and his own entirely original conception of animation—as the man-computer cinemasymbiosis on the one hand, and the reciprocal ways in which animated film inscribes the human body and consciousness, and vice versa. It is a depiction of animation in which computers re-animate the humanist

mind-body, as the post-human mind-body re-animates the analog-digital 'machine'. It also represents the space between fact/fiction, realism/fantasy, animation/live-action, and the way in which they mutually co-create each other in the form of Benjamin/de Man/Münsterberg's 'cinematic will' of the 'film-ongoing-experience'. If the *TV-Information Jacket* illustrates an animated, cinemasymbiotic technicity as collaborative modeling, then socialimagestics is its historiographical complement. The *TV-Information Jacket*, while a clear precursor to VR technologies, unlike them, is modeled on *commensurate*, multi-channel feedback between the sensory systems of the body and the ICT systems with which it interacts. The mind-body becomes a device through which image generation in the technological network may be controlled, and vice versa. This communication feedback system is the model of animated interactive collaboration between the mind-body and the world of 'living information'. It is a specifically trans-human machine, the central purpose of which to the production of cinemasymbiotic aesthetics states and their respective forms of judgments. But it also refers to any such 'controlled feedback' system, to social networking over multiple channels of communication carrying differentiated forms of information embedded in and interwoven with every facet of technocultural life. *Animation, then, is the audiovisual technicity of today's historicity that is irreducible to any singular technology. And once freed from media specific conditions of 'cels' and even digital 'keyframes', it describes the pervasive aesthetic state of psycho-corporeal embedment in cinemasymbiotic systems that produce the audiovisual a-realism of de Manian materiality.*

Cinemasymbiosis produces, then, the figural materialism of a-realism defined as the aesthetic state that is without any awareness of a dichotomy between illusion and reality. It is the technicity that produces the historical conditions of our postmodern aesthetic reason. Socialimagestics is a theory of its judgments. And because it is a direct allusion to Licklider's *Man-Computer Symbiosis* essay, it suggests not just synthesis, but that image matrix systems shape us forcefully and materially, in animated form. VanDerBeek would agree that 'this side of modernity' means that the old phantasma of realism, form and matter, have given way to material and force and their dynamic processes, to their performative events as epitomized by the technicity of animation. Visual/acupuncture is here powerfully modeled as a collaborative, performative system, and is the equivalent of de Man's radical formalism in that "as yet unlabeled [global] image flows" *just might* lead to a healthier aesthetic state through dispelling humanism's ghost state aesthetic ideology, epitomized by literalist live-action film. The question mark in the above citation ("visual/acupuncture?") signifies VanDerBeek's recognition that it might, from the vantage of the actually revolutionary moment circa 1973, just as likely, all go wrong.

As he put it in 1966: "*The process of life as an experiment on earth has never been made clearer.*" Or to put it in Bakhtinian terms: *to be* means to communicate;

or conversely, not to communicate leads directly to the danger of annihilation because man *"cannot judge the results of his acts before he commits them"* (VanDerBeek 1966: 38). Technicity here acquires a darkly ominous form; VanDerBeek no doubt has in mind the atomic bomb, an image that figures prominently in his animated films. (Today, we need only think of finance capitalism.) Technological impacts lead directly to "culture over-reach"[10] because it places human intelligence outside itself, in the unpredictable, uncontrollable, unforeseeable forces of science and technology. The *TV-Information Jacket* is a prototype cinemasymbiotic-theater meant to counter this social problem by giving it a complex 'pedagogical' aesthetic directive to act along two interwoven trajectories, simultaneously, one that combines Brecht's Marxian theater of alienation effects, with Artaud's physiological theater of cruelty.[11] Both Brecht and Artaud aimed to prevent such over-reach by "giving psychology a form that is much more vital and active ..." (Artaud 1927: 151) than the traditional, dramatic theater and talkie cinema of their era. Here too we may easily translate the "more vital and active" form of psychology as the product of the animated aesthetic state best exemplified, then, by Méliès. Both theater-philosophers sought, through quite different, even oppositional methods, to eradicate the humanist 'psychological man', (capitalist and romantic), whose death poststructuralism has aimed equally hard to ensure. Brecht's "A-effect" could be translated today as Animation-effect in that it is animation that alienates the aesthetic ideological effects of humanist realism. Just as Artaud sought to trigger the "profound barbarity" of embodiment, (Münsterberg's 'meaning' of cinematic phenomenology,) by relocating the theatrical between the *intelligence* of physical, corporeal sensation, and audiovisual, cultural, linguistic intelligences which situate it. In the *Poemfields* series (**See Plate 25**), we find both Brecht and Artaud interwoven in the mode of animation's historical rupture both from live-action film and its linguistic dominance. VanDerBeek sought to free the poetry of images from the 'arrest of speech'[12] (Artaud 1927: 151), by releasing them into the political fields of animated (digital Bflix) technicity:

> The new artist/citizen has a unique role to explore and research the new media to utilize the image associations talents of mind, via new media systems on hand. Think of film, multifilms, (Film/'pools') video, (satellite, cable) the synthetic images and electronic colors of computer graphics, electronic light, not of course to overlook the importance and purpose of 'available light' ... 'light brings us news of the universe' ... sv 1970. (VanDerBeek 1973, no pagination)

It is this socialimagestics of cinemasymbiosis ("film on going experience" in the photoplay of available light) that determines the political role of the

"new artist/citizen." He is of course describing his own art practice here, of exploring and experimenting dangerously with new media (not, New Media) uses that take advantage of the new minds-I social inter-perspectives, of new "mind models" and "mind sets" and "life styles" (styles of life and living) that have caused the identity crisis for the "national image." The complexity of VanDerBeek's approach is that he understands perfectly that such radical changes to human consciousness by such technological forces are capable of both liberating and inimical consequences, and that such a dangerous mix is the very material that artist/citizens can and must use as the very raw material for a positively constructed new form of symbiotic, cinema-human consciousness, in the audiovisual registers of animation. How else break the hold of the historicity of the Frères Lumière's on cinematic 'realism?'

VanDerBeek's theories and practices of socialimagestics and cinema-symbiotic work[13] led him to a different conception of animated communication, and therefore to different types of animated technicity that do not conform easily to canonical animated cinema. But in each case, his object remained the same: to not give in to modernism's aesthetic state, concerned primarily only with singularity of form and media, and to seek other aesthetic practices, not by exploring the singularities of old and new media, but by insisting on putting them in critical, sociopolitical relationship to each other, so that they *might* animate and reanimate each other. The *Poemfields* series is his attempt to demonstrate how it *might* go right, and how a radical new materialist formalism *might* inscribe consciousness with a new techno-historicity and produce new forms of aesthetic reason and judgments capable of, in turn, producing an a-realism in which the dichotomy between illusion and reality is abolished.

notes

1. Deleuze and Guattari themselves comment on the disciplinary nature of philosophy in this way: "Every philosophy must achieve its own manner of speaking about the arts and sciences, as though it established alliances with them. Philosophy cannot be undertaken independently of art or science. Art, science and philosophy seemed to us to be caught up in mobile relations in which each is obliged to respond to the other, but by its own means." (Deleuze and Guattari 1994: xvi).
2. For one account of the complexities of the term, see Simondon, 2011: 407–424.
3. Miller articulates de Man's concept of materiality as having three, but ultimately equivalent, forms: "… the term materiality and its cognates occur in three related, ultimately more or less identical, registers in de Man: the materiality of history, the materiality of inscription, and the materiality of what the eye sees prior to perception and cognition" (Miller 2001: 187). Miller doesn't recognize as will be shown, that these three forms rely on de Man's radical reinterpretation of Kant's pure reason as 'aesthetic reason'.
4. This may be found on ubuweb.com

5. Rodowick's *The Crisis of Political Modernism* attempts to broach this problem; however, his analysis remains in the reformist mode of semiocentrism I'm attempting to extricate my analysis from, and he leaves his history of film theory uncontested.

6. See (Miller 2001: 183–204) and (Butler 2001: 254–276).

7. As he commented: "The image revolution that movies represented has now been overhauled by the television evolution, and is approaching the next visual stage – to computer graphics to computer controls of the environment to a new cybernetic 'movie art'." (VanDerBeek 1970).

8. VanDerBeek was invited by Licklider in 1969 to join a group of MIT academics, to form a laboratory in which artists, scientists and engineers would collaborate. Correspondence in Vanderbeek's archive, Museum of Modern Art, New York.

9. Deleuze and Guattari's concept of 'synthesis' is apropos to VanDerBeek's concept of cinemasymbiosis, a variety of 'synthesis' as a kind of philosophical background noise: "The synthesizer, with its operation of consistency, has taken the place of the ground in a priori synthetic judgment: is synthesis of … material and force, not form and matter …" (Deleuze and Guattari 2010: 378).

10. What VanDerBeek means by 'culture over-reach' is clarified here: "It is imperative that each and every member of the world community join the 20th century as quickly as possible. Technical 'power' and cultural 'over-reach' are placing the fulcrum of man's intelligence so far outside himself …" (VanDerBeek Stan 1966: 173).

11. VanDerBeek was very close to M. C. Richards, poet and translator of Artaud's work, whom he had met at Black Mountain College.

12. "Besides, since the talking film, the elucidations of speech arrest the unconscious and spontaneous poetry of images; the illustration and completion of the meaning of an image by speech show the limitations of the cinema". (Artaud 1927:151)

13. For descriptions and analyses of these works, see my essays, "The Politics of Media in Stan VanDerBeek's *Poemfields*," *animation: an interdisciplinary journal*, November, 2008; "Strategic Canonization and the Audio-Vision-ary Pragmatics of Stan VanDerBeek's Culture: Intercom," *animation: an Interdisciplinary journal*, Vol. 5, No. 2, July 2010; "Socialimagestics and the Fourth Avant-garde of Stan VanDerBeek," in *Expanded Cinema: Art, Performance, Film*, eds. David Curtis, Al Rees, Duncan White, London, Tate Modern Publications, 2011; "The Culture:Intercom," in *Stan VanDerBeek— The Culture:Intercom*, List Center for Visual Arts, MIT and Contemporary Arts Museum, Houston, TX, 2011. For essays on VanDerBeek's work by other authors see, "Re-Animating Stan VanDerBeek, Special Issue" of *animation: an interdisciplinary journal*, Vol. 5, No. 2, July 2010, edited by me; and *Stan VanDerBeek—The Culture:Intercom*, List Center for Visual Arts, MIT and Contemporary Arts Museum, Houston, TX, 2011.

221

references

Althusser, Louis. 1971. *Lenin and Philosophy, and Other Essays*. Trans. B. Brewster. London: New Left Books, and New York: Monthly Review Press.

——— 1993. *The Future Lasts a Long Time: A Memoir*, ed. O. Corpet and Y. M. Boutang. Trans. R. Veasey. London: Chatto and Windus.

Bellour, Raymond. 2010. The Image of Thought. In *Afterimages of Gilles Deleuze's Film Philosophy*, ed. D. N. Rodowick. Minneapolis: University of Minnesota Press: 3–14.

Benjamin, Walter. 1968 [1936]. The Work of Art in the Age of the Mechanical Reproduction. In *Illuminations*, trans. Harry Zohn. New York: Harcourt, Brace & World.

Butler, Judith. 2001. How Can I Deny That These Hands and This Body Are Mine? In *Material Events: Paul De Man and the Afterlife of Theory*, ed. Tom Cohen, Barbara Cohen, J. Hillis Miller, and Andrej Warminski. Minneapolis: University of Minnesota Press: 254–276.

Cohen, Tom. 2001. *Material Events: Paul De Man and the Afterlife of Theory*, ed. Tom Cohen, Barbara Cohen, J. Hillis Miller, and Andrej Warminski. Minneapolis: University of Minnesota.

Deleuze, Giles. 1995. *Negotiations*. New York: Columbia University Press.

De Man, Paul. 1996. *Aesthetic Ideology*. Minneapolis: University of Minnesota Press.

Derrida, Jacques. 2001. *Monolingualism of the Other: Or the Prosthesis of Origin*. Trans. P. Mensah. Stanford: Stanford University Press.

Foucault, Michel. 1980. *Power/Knowledge: Selected Interviews and Other Writings, 1972–1977*, ed. trans. Colin Gordon. New York: Pantheon.

Licklider, J. C. R. 1960. Man-Computer Symbiosis, reprinted in *IRE Transactions on Human Factors in Electronics*, Vol. HFE-1: 4–11.

——— 1968. The Computer as a Communication Device, reprinted in *Science and Technology*, April. Also in In Memoriam: J. C. R. Licklider 1915–1990 Research Report 61, Digital Equipment Corporation Systems Research Center, August, 1990.

McLellan, David. 1977. *The Selected Writings of Karl Marx*. Oxford: University of Oxford Press.

Miller, Hillis J. 2001. Paul de Man as Allergen. In *Material Events: Paul De Man and the Afterlife of Theory*, ed. Tom Cohen, Barbara Cohen, J. Hillis Miller, and Andrej Warminski. Minneapolis: University of Minnesota Press: 183–204.

Münsterberg, Hugo. 2002 [1916]. *The Photoplay: A Psychological Study*, ed. Allan Langdale. New York: Routledge.

Rodowick, D.N. 1988. *The Crisis of Political Modernism: Criticism and Ideology in Contemporary Film Criticism*. Los Angeles: University of California Press.

Simondon, Gilbert. 2011. On the Mode of Existence of Technical Objects. In *Deleuze Studies*, Vol. 5. Trans. Ninian Mellamphy, Dan Mellamphy, and Nandita Biswas Mellamphy. 407–424. Edinburgh: Edinburgh University Press.

Sobchack, Vivian. 1999. *The Persistence of History: Cinema, Television, and the Modern Event*. New York: Routledge.

Skoller, Jeffrey. 2005. *Shadows, Specters, Shards: Making History in Avant-garde Film*. Minnesota: University of Minnesota Press.

VanDerBeek, Stan. 1966. Culture: Intercom and Expanded Cinema: A Proposal and Manifesto. In *Tulane Drama Review*, No. 11: 38–48. Re-published in *Film Culture*, No. 40, Spring 1966: 16. Anthologized in *The New American Cinema*, ed. Gregory Battcock. New York: Dutton, 1976: 173.

—— 1970. New Talent – the Computer. *Art in America*, Vol. 58, No. 1: 86–91.

—— 1973. Socialimagestics: Some notes on 'Dream Theatres'© and 'Social surrealism'© in the future. *American Film Institute Report*, Vol. 4, No. 2: no pagination.

White, Hayden. 1999. *Figural Realism: Studies in the Mimesis Effect*. Baltimore: Johns Hopkins University Press.

—— 1978. *Tropics of Discourse*. Baltimore: John Hopkins University Press.

reanimator

embodied history, and the post-cinema

trace in ken jacobs' 'temporal

n i n e

composites'

j e f f r e y s k o l l e r

A people is always a new wave, a new fold in the
social fabric; any creative work is a new way of
folding adapted to new materials.

<div align="right">Gilles Deleuze 1995</div>

Neither thought nor creation occurs without a
medium. A medium in this sense is not a passive
or recalcitrant substance subject to artistic will. It
is itself expressive as potential, or powers of
thought, action or creation. But these powers are
variable and conditional. In exploring their
potential we discover the conditions of possibility
of a new medium, and new powers of thought and
creation.

<div align="right">D. N. Rodowick 2007</div>

I.

Cinema, since its beginnings at the turn of the last century is the art form that has been inextricably linked to the most utopian social movements throughout that century. There has been an attempt to create an image of nearly every important social and cultural moment one can think of: from the revolutionary society of the early Soviet Union to the underground cinemas of the USA and Europe; from the postcolonial revolutionary movements in Africa, Asia and Latin America to the micro/community-based media groups currently springing up throughout the world. In each of these cases, the desire was and is to invent cinematic forms that could engage the most idealistic aspirations for better ways of living both collectively and existentially. This radical aspiration of cinema embodies the belief that through aesthetic experiences in film we could ask the deepest and most relevant questions that we face in our lives and worlds, and that the medium was actually capable of answering such questions.

Traditionally, the politically engaged film and the animated film have been placed at opposite poles of the cinematic spectrum, the former representing the challenging realities of the world with its aura of seriousness and the latter, flights of imagination and fantasy and often cartoon-like versions of the world. The antinomies that mark the popular, animated film and its pleasures have been marked by the illusory motion of still images producing visualized fantasy and the frivolous phantasmagorical worlds created through a variety of animation techniques that are deeply embedded in the cultural and economic life of capitalist society and which carry us away from the Euclidian reality of our lives.[1] Although there were a small number of Modernist animation films that addressed form (more on this below), the politics of Modernist cinema by contrast was defined by a commitment to formal experimentation as an essential part of a film's content, the invention of new forms of representation and new modes of visual perception. These new forms would challenge the viewer to question dominant ideologies, their modes of production and the very forms of daily life lived. Such a politics of aesthetics contends that cinema's role in the transformation of consciousness necessary for radical social change can only be engaged through equally radical aesthetic practices, "Not to make political films, rather to make films politically," insisted Jean-Luc Godard.[2]

225

II.

Esther Leslie has convincingly argued that the radical promise of early animation paralleled many of the political Modernist movements of the 1920s and 1930s such as Constructivist, Futurist, Surrealist, Dadaist and Brechtian dramatic forms, in the ways they produced elisions between high and low culture creating new kinds of cinematic representational spaces and

temporalities that suggested alternatives to the naturalisms of the domi-nant cinema. In *Hollywood Flatlands* (2002), Leslie argues for the radically transformative possibilities of early animation practices. "From the very first, animation, self-reflexive and unmasking establishes a circuit of life and destruction Through the intervention of the artist's hand, through the knowing play with surface and depth and through an acknowledge-ment of screen, simulation and situation ... the illusion struggles against the illusory" (2002: 2). Contrary to the illusionistic fantasies promoted by Hollywood and other commercial cinemas, as Leslie argues, animation's deep engagement with the politics of aesthetics of Modernism rejected painterly realism, exploring instead the materiality of surface flatness, abstraction and anti-illusionist forms of narrative—all hallmarks of the avant-garde. In early animations of Walt Disney, Émile Cohl, Max and Dave Fleischer, Oskar Fischinger and Hans Richter among others, one could glimpse the promise of radical aesthetics within the context of the popular culture of the animated film. Such hopes for a radical vernacular modernism were short lived as the US-based mass market animators and film studios moved toward developing films which reasserted conven-tional narrative forms of storytelling and psychological realism of the dominant dramatic cinema. As Leslie continues, The idealized world moulded in Disney's fairy-tales showed nothing other than the momen-tary arrest of all possibilities for social transformation in the 1930s and 1940s" (iv). This entrenchment of representational and novelistic storytell-ing as the dominant form of animated film, both in the USA and interna-tionally, embodied the emergence of a 'Disney-fied' postwar corporate consumer culture, while the radical exploration of cinematic move-ment, space, and time left the realm of mass culture and went under-ground as part of the post-war avant-garde film movements of the 1950s and 1960s.

The work of filmmakers such as Harry Smith, Stan VanDerBeek, Mary Ellen Bute, Larry Jordan, Jordan Belson, and more contemporarily, the Quay Brothers, Janie Geiser, Lewis Klahr and Martha Colburn, among others, are easily recognizable as being in the tradition of materialist film animation. They have continued earlier explorations of the politics of aesthetic form, medium specificity, concerns with illusionism, flatness, abstraction and unconventional narrative forms, while attempting to re-engage popular culture's imagery and themes. Less recognizable is the way new digital technologies are transforming our notion of what anima-tion is, and perhaps what constitutes politically and aesthetically radical animation. With the replacement of the materiality of the photographic trace of motion picture film with digital code, is there such a thing as medium specificity as cinema has faded into an overlapping multiplicity of platforms and technologies? Is animation a technology, a series of tech-niques, or is it a simply metaphor for the illusion of movement on-screen?

Through the work of the artist and filmmaker Ken Jacobs, who has been making experimental film and media for over half a century, I will focus on the current transitional moment between photographic filmmaking and its technologies and the emerging digital ones in creative media practice. I want to trace the unexpected ways photographic film and new digital media practices extend and, perhaps, deepen these historical debates about animation and political art in the current moment, to consider the ways new media technologies continue to raise questions and, indeed, revitalize the possibilities of a politically engaged media culture through formal experimentation and innovation. Though not known for making animated films in any traditional sense, Jacobs can more interestingly be seen as a *re*-animator: one who is dedicated to bringing inert, discarded and irrelevant objects back to life. Since he began working in the mid-1950s, Jacobs has been known primarily as a filmmaker, with a large and variegated body of work. Very much in the manner of Walter Benjamin's *ragpicker*, Jacobs, along with other American artists of the time including Joseph Cornell and Bruce Conner, was a pioneer of the found footage film.[3] Sensing the importance of the accumulating and discarded film materials he saw around him, Jacobs began rummaging through the waste bins of New York City, the archives of early cinema, and the attics and basements of relatives to find lost and discarded images and sounds. Using techniques of re-photography, pixilation, and home-made frame-by-frame projection to draw out the latencies of such dead cinema, he reanimates these images bringing them back to action. Through such reanimation, he explored how the film strip re-members in order to revive the latent possibilities for perceiving the footage. This revivification has enabled him to crack them open, so to speak, and allow the present to emerge.

Through this body of work, Jacobs has opened up new ways of thinking about the relationship between images and time, while deepening the links between historiographic practices and what one might call aesthetic knowledge—that is, to ask in what ways do the aesthetics of form produce new ways of knowing? Jacobs' films eschew the artifice of recreation in ways that challenge our thinking about how we use past events in relationship to the present and future. They use the material force of time to call our attention to those aspects of history that exceed the visible and representable, creating new relationships between past events and their place in the present. In this way, he creates an experience of historical knowledge as something that is constantly in transformation, rather than as a static artifact from the past. Jacobs' films force us to consider elements of the past that are unseen, unspeakable, ephemeral and defy representation. Such invisible elements supplement the actual image with a surplus of meanings

that deepen and give poetic dimension to history. These spectral presences, which are often sensed but non-apprehendable, are nevertheless part of the energy of the past and exert themselves as a force on the present. The attempt to bring these unseen forces into play in the new work creates an awareness of other temporalities in which linear chronologies are called into question.

Film images that cause the viewer to become aware of being in the flow of time—real time as duration as well as diegetic time of the narrative as in past, present and future—as part of the experience of the image are what philosopher Gilles Deleuze has called *direct images of time* (Deleuze 1989, passim)[4] in which the temporal element in the encounter with a film image is experienced as a material force in the present. He stressed that the direct experience of duration goes beyond the purely empirical succession of time, past into present into future. Rather, duration is experienced as a "co-existence of distinct durations or levels of duration reverberating between the actual and virtual of the image"—that is, between what is actually seen and what can be imagined and experienced in other ways (Deleuze 1989: vii). What links the various formal approaches in such historical films are the ways in which time is a force that surrounds the images through which their meanings accrue. In such films, as we will see, the pressure of time is placed on images to exceed themselves by allowing or causing the co-existence of the multiple temporalities that surround them to emerge, something that animation, which is not bound by the spatial and temporal verisimilitudes of live-action cinema, can powerfully create. Such virtual temporalities are experienced as thought, affect, memory, desire or the bodily sensation of time passing—the experience of the body adjusting its metabolism to the velocity of high-speed movement or the stasis of real time passing, for example. It is here, in an attempt to engage with these ephemeral, but no less crucial, aspects of the historiographic that the aesthetic elements of how the past returns to us becomes an artistic project.

The films from the historical avant-garde of the early part of the twentieth century generally idealized the idea of the future as inexorably progressive, using the emerging technologies of cinema and photography to create radical image forms to more accurately figure the promise of modern technologies of industrial production, dynamic new social formations and enlightened political consciousness. As it happened, things did not turn out as imagined. By the late twentieth century, such utopian forms were dissolving into clichéd style and sedimented ideology. In contrast to these earlier futurist films, contemporary historical materialist practices have focused on the retrospective view, in which the pressures of failed aspiration and political projects to transform society have raised the question of the past as a political imperative. The modernist question, "how do we get there from here?" has, for the moment at least, been

superseded by the more urgent question, "how did we end up here?"
It is through this historical shift that we can grasp the deep politics of many
contemporary artists' turn toward the exploration of past narratives,
objects, artifacts and useless technologies as part of a contemporary
radical media practice. The labor of confronting the past for the needs of
the present by exploring anachronistic materials from the past and
trying to make sense of their meanings for the present is what Walter
Benjamin called brooding. Benjamin described the figure of the brooder
as one

> who has arrived at the solution of a great problem but then
> has forgotten it. And now he broods—not so much over
> the matter itself as over his past reflections on it. The
> brooder's thinking therefore bears the imprint of memory.
> His memory ranges over the indiscriminate mass of dead
> lore ... like the jumble of arbitrarily cut pieces from which
> a puzzle is assembled ... he rummages here and there for a
> particular piece, holds it next to some other piece, and
> tests to see if they fit together—that meaning with this
> image or this image with that meaning. The result can
> never be known before-hand, for there is no natural medi-
> ation between the two. (Benjamin 1999: 367–368)

The relationship between the figure of the brooder and the filmmaker who
is working with images from the past, trying to reactivate their meanings
for the present, becomes irresistible. The brooder's melancholic reflection
on his own activities produces an awareness of being in time, as he is liter-
ally taking history into his own hands. Such creative brooding is the activ-
ity of creating politicized relationships between past and present as a way to
awaken people to the crisis of the current moment. At the same time, it is
a memorializing of the aspirations of modernity and is often the work of
mourning for what has failed. The current preoccupation in the arts and
humanities with questions of history, the archive, memory, trauma and
failure is part of a larger postmortem that surrounds the modernist project
of the twentieth century.

Understood in this sense, constructing a history of the present is engag-
ing in the active work of grappling with the discontinuities between the
promise of progress, the realities of the present and the complex interplay
between them. History then, is an interruption, an alternative temporal-
ity, through which a new interpretation might emerge. For Benjamin, the
dialectical image is a form of active critical memory. It is the willingness to
work with one's hands and mind to try to actively transform the bits and
pieces that remain of an event into some structure of significance—even if
one is not sure of the result beforehand—and the acceptance of the impos-
sibility of adequately representing the enormity of what has occurred.

Revivifying such material, bringing it to the light of the projector, Ken Jacobs at times simply shows them exactly as he found them, in the manner of the Duchampian readymade. For example, *Perfect Film* (1985: 22 min) is a reel of film Jacobs found in a junk store in New York. On the reel were out-takes from local TV news coverage of the assassination of Malcolm X in 1965. All of the shots that were considered important for the news report had been cut-out and what was left was considered unimportant and discarded. In looking at it, Jacobs recognized a counter-history, an image of the things that are left out of an official historical event. Untouched, the images on that reel with their fragmented arrangements and random witnesses' attempt to articulate what they saw and felt conveyed the sense of loss, confusion, and emotional intensity of an experience that cannot be shown or aspects of an event that cannot be seen. He decided to leave the film untouched. *Perfect!*

In the most influential of Jacobs' films, *Tom, Tom, The Piper's Son* (1969: 115 min), he uses an eight-minute found film of the same name from 1905, which has been attributed to D. W. Griffith's cameraman Billy Bitzer.[5] Re-photographing each frame separately, Jacobs extends the film to over 10 times its original length. Beginning by presenting the film as it originally appeared, Jacobs then repeats it, showing different permutations of the original, this time emphasizing the material and non-representational elements that make up the image. By enlarging aspects of the frame, allowing the film to lose its registration in the projector gate and slowing down its movement, the rephotographed film is an exploration of the actual materials of the film strip. Examining the shifting densities of the emulsion, the movement of grain patterns by enlarging individual frames, abstracting and fragmenting them, Jacobs shifts this late nineteenth-century cine-story into an epic exploration of the material of film. In *Tom, Tom*, the illusionistic representational elements of the original film give way to the event that is taking place on the surface of the film and reflected onto the screen as an experience of the present.

As Jacobs writes of his film:

> I wanted to show the actual present of film, just begin to indicate its energy I wanted to 'bring to the surface' ... that multi-rhythmic collision-contesting of dark and light two-dimensional force-areas struggling edge to edge for identity and shape ... to get into the amoebic grain pattern itself—a chemical dispersion pattern unique to each frame, each cold still ... stirred to life by a successive 16–24 f.p.s. pattering on our retinas. (Jacobs 1989: 270–271)

Tom, Tom the Piper's Son is not so much deconstruction as alchemical re-enchantment, in which he re-activates the aesthetic richness and

experiential possibilities latent in these forgotten cine-photographic materials in response to the cultural imperatives of the present. While not the traditional form of drawn animation, it is in a material sense, indeed, animation: re-photographing of individual frames, creating movements and new images from the original photographic film strip. Jacobs transforms the inert frames into highly dynamic movements of film grain, and transmogrifying densities of black and white, at times representationally recognizable and at others completely abstract. More complexly, it is also animation in the sense of revivification, giving new life and vigor to the long dead as they return to the present in the film. As Jacobs writes, "Ghosts! Cine-recordings of the vivacious doings of persons long dead. The preservation of their memory ceases at the edges of the frame (a 1905 hand happened to stick into the frame … it's preserved, recorded in a spray of emulsion grains)" (1989: 270–271). Unlike traditional forms of animation which are generally used to send us away to fantastical worlds of the imagination, *Tom, Tom, the Piper's Son* is a form of animation that brings us closer to the materiality of the cinematic, while at the same time it reconnects us to the actualities of the past, working with the surface of the film to create a temporal folding of the original filming in 1905, with Jacobs re-filming in 1969 and the present of viewing. In *Tom, Tom*, Jacobs' form of animation creates tensions between stillness and motion; showing a single image and then re-animating it into motion. The relationships between the stillness and the kineticism of animated frames, create a tension between the illusionism of cinematic motion and the nature of duration as a material element in the cinematic experience. At other times, the film is seen sliding continuously through the gate of the projector showing the actual movement of the film strip, with its discrete frames. In other sections the film moves between the original representational image and its magnification of the surface of the film, revealing the actual trace of emulsion, its grain, contrast, distresses from age, often vibrating and swirling as it moves from frame to frame. All of these processes allow the viewer to access aspects of image that often go unnoticed or unperceived, creating new awarenesses of what else exists to be seen and experienced with this apparatus.

As part of Jacobs' focus on animating these latent histories of anachronistic images and their technologies, he has worked with early pre- and proto-cinematic devices, such as magic lanterns, stereoscopes, and a range of 3D devices. Jacobs, with Flo Jacobs, his wife and sometimes collaborator, also invented and built their own Benjaminesque 'cine-brooding devices,' called *The Nervous System*. This hand made projection system of dual 16 mm analytic or 35 mm film strip projectors are able to advance strips of film one frame at a time. The projection device is outfitted with a custom-made external shutter that alternates and blends together the two different frames from each projector and creates an intense flicker as the external shutter alternates between the two images that are superimposed on

231

each other.[6] Jacobs performs the *Nervous System* device, and each live performance is a unique event. Using film strips of the same images, the identical frames are moved in and out of sync with each other. The pulsing flicker essentially *re-animates* the still frames as the device alternates between the two original film strips. When performed, *The Nervous System* creates a kind of spatio-temporal disparity as the two strips constantly move in and out of phase with each other during projection. The shutter turning at varying speeds causes the brain to perceive motion as its flicker activates an autonomic psycho-visual perception, creating images not actually seen, or visual equivalents of harmonic overtones.[7] In these works, the cinematic shutter is the key to creating the flicker that tricks the brain into seeing motion. By working with different lengths of black between the still picture frames, Jacobs is able to bombard the viewer's body, with light smashing onto the retina. The flicker pulses affect the body on a metabolic level, shocking the nervous system in a psycho-visual perception too uncomfortable to be hypnotic. The throbbing light of the flicker, in effect, induces *haptic* vision — an embodied response to the images that touch the body as the force of the light reflecting off the screen creates a physical encounter between the body, its perceptional processes and the film phenomena being encountered. The indexicality of the image is no longer stable simply as a trace of a past moment; rather the brain's optical system creates other kinds of images that are synesthetic or hallucinatory. The changing rhythms and light pulses *re-animate* these archaic, inert, ghostly traces on our living bodies through the physical force of projected light, creating embodied vision.

Such haptic images are phenomena of the present moment of reception in which the inside and the outside of perception are, in the Deleuzian sense, *folds* of each other as *The Nervous System* breaks down lines between what the film image, the projection apparatus and the brain are creating in the viewer. Following Deleuze's account of the production of subjectivity, in which interiority and exteriority are no longer seen as simple binaries or antinomies, but rather as *folds* of each, perception is at once constituted by both the external world and interior experience (*The Fold* 1993). This doesn't suggest that they are indistinguishable, but that they are *of* one another— co-generative. In this sense, Jacobs' *Nervous System* is a *fold-machine*, in which the flicker of the shutter, and the two strips of film, moving in and out of phase, create a variety of other *folds* in which *mind/body, body/screen, actual/virtual, light/darkness, animate/static, trace/hallucination, live performance/recording* are *folds* imbricating each other, while remaining distinct and singular.[8] The discomfort of the intensely flickering light, is also a *fold*, as Jacobs reclaims the modernist desire from an earlier moment to *shock* the viewer awake to the present, through an encounter with the multiplicity of temporalities materialized by the flickering projected light of the performance. The deep politics of the *Nervous System,* then, is the modernist strategy of shocking the

mind awake, re-sensitizing perception through its embodied encounter with vision, and it is a key work for understanding Jacob's politicized aesthetics, as he turns to digital filmmaking.

V.

In the last decade, as motion picture processes have become economically prohibitive, Jacobs has turned to the digital platform as much out of necessity as with a desire to engage with the continuing evolution of moving image technologies, and specifically to explore this relationship between the indexical trace and haptic reception. In Jacobs' digital films, the focus on medium specificity of his earlier work such as *Tom, Tom, the Piper's Son*, and what makes one medium's perceptual processes distinct from another, seems to be less central than in the ways it has transformed the artist's working process. For Jacobs and other artisanal filmmakers who began working in photographic motion pictures, in which each element of production—editing, sound, titles, color and exposure timing, matting and superimpositions—would take weeks of painstaking work, digital technology can now do much of this instantly. In this sense, the digital has revitalized Jacobs' work, allowing him to be more spontaneous and to invent new ways of working with materials from a range of different media. Importantly, Jacobs' engagement with the digital platform has created another *fold*—a *technological fold*—between the analog and digital and the photographic and electronic, opening a particularly productive chapter in an already astoundingly prolific body of work.

Ironically, Jacobs' move away from the medium specificity of his earlier work with photographic film to the post-analog medium of computer image compositing has caused an even deeper engagement with the complexities of the film medium and the indexical meanings of the images he is exploring. As Rosalind Krauss, in her important essay on the "post-medium condition" writes, "specificity of mediums, even modernist ones, must be understood as differential, self-differing, and thus a layering of conventions never simply collapsed into the physicality of the support ..." while on the other hand, she continues, "it is precisely the onset of higher orders of technology—robot, computer— which allows us, by rendering older techniques outmoded, to grasp the inner complexity of the mediums those techniques support" (1999: 53).

Following Krauss, the shift from analog to digital forms of filmmaking, in which digitally created moving images are replacing the photographic image, has given rise to a broad reconsideration of the place of animation in film history from a perpetual novelty to one of its central forms. On the digital image platform, it can be argued that all cinema is animation—constructed pixel by pixel, layer by layer, keyframe by keyframe—allowing motion pictures to be made in ways only alluded to in pre-digital film. Digital technology has allowed artists to deepen relationships between

still images and their artificial movement created *between the frames*—the very definition of animation. We see this as Jacobs shifts from *The Nervous System*'s two separate projectors, with separate motors and light sources that superimpose two separate strips of film, to the computer composite in which digital code produces a folding of the two. The distinctions between the two images are no longer part of the dynamic of reading the image. It is with the digital platform, as we will see, that Jacobs is able to fully realize the kinds of image composites that *The Nervous System* suggested.

The problem of medium and its historicity emerges even more powerfully as a central formal concern for Jacobs as he begins to blend the digital with photographic technologies. This opens the composite beyond the spatial, toward the temporal. Now able to turn a range of very different materials across different historical moments into code, grain and pixel not only begin to merge, *they become images themselves*. This digital blending of images and their formats from different periods produce what I am calling *digital temporal composites*, each format now becomes a signifier of a particular historical moment. As digital code eliminates the physical indexicality of the material, it still maintains its temporality as a material trace. The compositing of the different technologies brings together multiple time planes into a single image. Many have claimed that digital image-making embodies the post-historical moment, since there is no longer an indexical trace of the past in the image that verifies the moment in time when the image was made.[9] I am using *digital temporal composite* as a way to make a distinction between other terms that have been used to talk about film images constructed to create cinematic temporal multiplicity, and new forms that digital technology may make possible. In analog cinema, terms such as 'flash-back', 'superimposition', 'dialectical image' represent separate, but related moments in time thrown into relief. The *digital temporal composite* however, like Jacobs' Nervous System, is also a *fold*. Pasts and presents of events, and technologies and materials—analog/digital, photographic/digital are already present within each other. Each medium and moment in time are at once distinguishable, singular, and of one another—co-present and extensions of each. In his book *The Fold: Leibniz and the Baroque*, Deleuze explores the term *extension* as one of the components that defines the event. He writes:

> Extension exists when one element is stretched over the following one, such that it is a whole and the following elements are its parts. Such a connection of whole-parts forms an infinite series that contains neither final term nor a limit …. The event is a vibration with an infinity of harmonics or submultiples …. (Deleuze 1993: 77)

The *digital temporal composite*, like Jacobs' earlier use of freeze frame and flickers now digitally folds grain and pixel, extending the event across time, to generate new relations, thought and experience across time. For Deleuze there are no beginning or end points of an event, each aspect of a history is

a fold of another. Jacobs' *digital temporal composites* deepens the sense of the eventness of history creating an 'infinity of harmonics', as one element becomes part of another. Such temporal composites bring us closer to a sense of how history works as multiplicity, simultaneity, and juxtaposition.

Rather than simply supplanting the past, new technologies cause older ones to re-emerge, as artists begin to look more closely at the antecedent media forms as a way to understand how one might use the new. As Benjamin suggests, new technologies powerfully connect us with the phantasmagoria of preceding ones (1999, Exposé of 1935: 893). Each successive technology always contains the hope that it is capable of actualizing the unrealized potentials of earlier ones. In this sense, whenever a new technology emerges, it is as history, causing the past to return as a fold in the present. Jacobs, in his digital films, connects us with the phantasmagoria of animation—the desire to make the inert come alive—as he simultaneously creates a new way of looking at the photo-index of history.

VI.

In *Return to the Scene of the Crime* (2008, 92 min), Jacobs returns to his 1969 film *Tom, Tom, the Piper's Son*. More a digital sequel than a remake, Jacobs' feature-length work revivifies that 1905 short credited to Billy Bitzer from which he made his own *Tom, Tom, The Piper's Son*. Returning to the same strip of film he spent so much time with 40 years ago, Jacobs looks for what this digital editing platform can reveal about it for the present. In a kaleidoscopic, intertextual condensation of the different textures of image media that become signifiers of history, Jacobs' 2008 work reaches back to his 16 mm

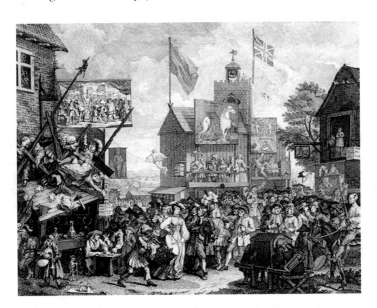

Figure 9.1
Southwark Fair, William Hogarth 1733, etching.

235

(a) (b)

Figure 9.2

(a) Still: *Tom Tom the Piper's Son* credited to Billy Bitzer, 1905, 35 mm.
Courtesy of Ken Jacobs. (b) Still: *Return to the Scene of the Crime,* Ken Jacobs,
2008, digital composite. Courtesy of Ken Jacobs.

work from 1969, back to Bitzer's 35 mm film from 1905, and, much earlier
than both, to a 1733 etching of William Hogarth's 1732 painting *Southwark
Fair* on which the tableau of Bitzer's short film was originally based (**See
Figure 9.1**). Bitzer's 1905 film dramatized the children's rhyme "Tom, Tom,
the Piper's Son" within the Hogarthian carnival tableau for the newly
emerging motion picture camera (**See Figure 9.2a**). Hogarth's etching is a
scene of a carnival, an extraordinary mass cultural event in the seething
urban center of pre-industrial London with a chaotic mix of circus, theater,
music, dance, and mural-like paintings; these seen through today's eyes,
resemble nothing less than billboards and projection screens.[10] Jacobs
mobilizes each iteration of this scene in the present, digitally compositing
these images (**See Figures 9.2b** and **9.3**). In this work, Jacobs is at once

Figure 9.3

Still: *Return to the Scene of the Crime,* Ken Jacobs, 2008, detail, color. Courtesy
of Ken Jacobs.

forensic pathologist and cine-brooder, using current digital technology to frame and reframe this artifact through the spectacle of the image technologies themselves—from painting, etching, theater and photography, to film, video and digital compositing.

Return to the Scene of the Crime is a meta-essay, in which Jacobs is reanimating himself, reanimating Bitzer, reanimating Hogarth. In each iteration, we can imagine, and even see, the pre-figuration of a future. It is extraordinary to notice the two figures in *Southwark Fair*, who are peering into a proto-cinematic apparatus in the lower right corner of the scene. This double-sided peep show box is clearly a pre-figuration of the stereoscope of a century later. As Jonathan Crary suggests in his writing about this etching, "These immobile and absorbed figures, interfacing with the window of the peep show, anticipate one of the primary pathways that popular culture will trace out of the eighteenth century into the nineteenth and eventually even into our own time" (2002: 8–9). Crary traces this shift from the uncontrollable sensory all-at-onceness of the public space of the carnival toward a more isolated, self-disciplining activity of the peep show and other primarily visual attractions that required social restraint, sensory isolation and focus. While the modern cinema opened up the single views of proto-cinematic viewing machines to group spectatorship of the film theater, it also insisted on an immobilized spectator sitting together with others singly focused on the screen—"an individualized and self-regulated *spectator*" (Crary 2002: 11). In many ways, the emergence of digital technology returns us to individualized spectatorship of the peep show device, each person now peering into his individual screen.

In *Return to the Scene of the Crime*, Jacobs' digital reanimation of Bitzer's restaging of the *Southwark Fair* etching revisits Hogarth's image of the fair as at once a pre- and post-cinematic attraction. The crime scene that is returned to is multiple: the story Bitzer tells in his *Tom, Tom, the Piper's Son*, of young Tom who "stole a pig and away he ran". The crime of the displacement of film as attraction by the emplotted cinema after 1905, the return to the scene of Jacob's own obsession with this material from 1969, allows him to move across and into history. Finally, it is the crime of the rise of twenty-first century mediatized corporate capitalism of America that Jacobs allegorizes through Tom's crime. Throughout the film, Jacobs has inserted a series of satiric intertitles that grafts onto these historical images a very contemporary and pointed satire about American politics, about how Karl Rove, the Republican Party and the religious right have used the media to take over America. Jacobs blends this range of image textures and texts, which now signify different historical moments, to allegorize the original etching continuing the spirit of Hogarthian political satire for our own time. This admixture of film and art historical reference, contemporary political commentary, close visual analysis of the film and its movements, digital image processing and animation transforming the original film,

237

Figure 9.4

Still: *Return to the Scene of the Crime,* Ken Jacobs, 2008. "Video Juggling". Courtesy of Ken Jacobs.

Return to the Scene of the Crime returns us to Hogarth's anarchic pre-modern fairground through a post-modern 'digital-cinema of attractions'. By shifting the focus in Bitzer's photo-play from its narrative, to graphic elements of line, shape and color, to pure digital abstraction, an engagement with what electronic imaging technology does to the images, Jacobs transforms the film into a cinema of attractions of "exhibitionist confrontation rather than diegetic absorption" (Gunning 1986: 66) **(See Figure 9.4)**. Its politics continue Eisenstein's still radical demand of a montage of attractions that frees cinema from the weight of "illusory imitativeness and "representationality" (Eisenstein 1974: 79), central to political modernism. *Return to the Scene of the Crime* suggests a history of how one medium carries the history of another as a way to speak about the present. From Hogarth to Fox News, Jacobs returns to the scene of the crime of cinematic technology that has been used to manipulate people and distort the reality of their lives and offers an alternative experience of digital cinema, one that holds the possibility for critical and experiential engagement with the past and present.

Less satiric and self referential, but more even more politically pointed, is *Razzle Dazzle: The Lost World* (2006–2007, 92 min). Using a strip of film from A. C. Abadie's 1903 one-minute short made for the Edison Film Company of children taking an early amusement park ride, and a series of nineteenth century stereoscopic photographs dramatizing the horrors of the First World War, *Razzle Dazzle: The Lost World* is a wordless epic history of the USA in the early years of the twentieth century leading up to the First World War. Using many conceptual ideas originating from his *Tom Tom the Piper's*

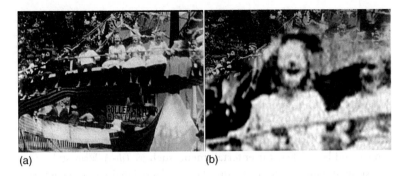

(a) (b)

Figure 9.5

(a) Still: *Razzle Dazzle*, A. C. Abadie dir., Edison Film Co., 1903. Courtesy of
Ken Jacobs. (b) Still from *Razzle Dazzle: The Lost World*, Ken Jacobs 2006.
'Ghosts' detail. Courtesy of Ken Jacobs.

Son, some 40 years earlier, Jacobs digs into the footage through magnifica-
tion, breaking it apart, freezing and repeating motion, peeling back the sur-
face of the material to see component elements—photographic grain and
digital pixels. In 2007, Jacobs explores this footage through the digital
medium and the digital medium through the footage. He uses various dig-
ital processes, software filters and templates including compositing, color-
ization, layering, stretching and squeezing the images, transforming them
into other graphic forms and abstract shapes allowing us to see these images
through the digital era (**See Figures 9.5** and **9.6** and **Plate 26**). In doing this,
he causes us to see anew a lost world of a seemingly innocent America,

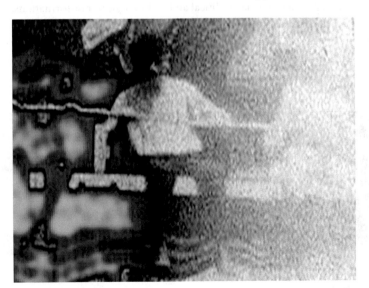

Figure 9.6

Still: *Razzle Dazzle: The Lost World,* Ken Jacobs 2006, "From Grain to Pixel",
color. Courtesy of Ken Jacobs.

which is now re-figured as a Dantean image of hell. Jacobs, frame-by-frame, re-animates the faces of the children in this Edison film to explore the ambiguities between pleasure and fear as they spin around and around.

From the artifacts of early cinema, we see the twentieth century emergence of hi-tech leisure time amusements, in which the controlled thrill of danger of the amusement park ride begins to parallel the development of technologies of warfare as they also emerge in the first decades of the century. The popularity of high velocity amusement park rides that created danger and bodily fear for entertainment, such as *Tilt-A-Whirl*-style rides that spun at high speeds, or the simulation of aerial flight and the defiance of gravity in rides that took people high above the ground to view the landscape from the air before dropping them with tremendous g-force to the ground, similar to the *Cyclone* or *The Switchback Gravity Pleasure Railway*. As these early film images begin to be reformed as digital imagery with visible pixels, electronic compositing, colorization and recognizable digital effects (**See Figure 9.7** and **Plate 27**), *Razzle Dazzle* can be seen as an allegory for the present in which digital imaging technologies of modern entertainment, such as computer games and movies designed by Hollywood directors and graphic artists, have become the digital interfaces for today's push button bombing and drone warfare.[11] By connecting the wonder of the emerging cinema technology to the specularization of warfare, Jacobs is not only using digital compositing to connect different moments of political history as an allegory for the present; he also insists on placing that history in the context of an art historical formal evolution that is at once contingent upon and parallel to social, political and technological transformations.

Both *Return to the Scene of the Crime* and *Razzle Dazzle* animate the relationships between aesthetic form and the representation of social history; we see each medium used, with its particular textures and resolutions, being as much a document of that history as what it is representing. In this way

(a) (b)

Figure 9.7

(a) Still: *Razzle Dazzle: The Lost World*, Ken Jacobs 2006, color. Image shredded. Courtesy of Ken Jacobs. (b) Still: *Razzle Dazzle: The Lost World*, Ken Jacobs 2006, color. Red & green detail. Courtesy of Ken Jacobs.

aesthetic shifts can no longer be seen as autonomous evolution, but as integral parts of the social and political consciousness of the times. Through this temporal compositing of media from different moments in time, Jacobs asks us to think about the relationships between the body politic of American culture and the transforming image world that has emerged over the last century. Now like a crime scene investigator, Jacobs exhumes and brings to our attention these long buried photographic artifacts of the early twentieth century, creating what he calls, on a title card in the film, *forensic cinema*, which speaks to the possibility that the materials reveal evidence of their historical moment.[12] Going beyond the purely aesthetic aspects of their deconstruction, in *Return to the Scene of the Crime* Jacobs attempts to connect with the social and political energies of the film objects through allegorization.

In *Capitalism: Child Labor* (2006, 14 min),[13] Jacobs returns once again to pre-cinema technology, digitizing a double image stereoscopic photograph from the late nineteenth century. These images often explored the ways people all over the world lived and worked. In the video, Jacobs uses a stereo photo of a scene taken in a turn of the century textile sweatshop in which children are laboring at giant weaving machines. The stereoscopic photograph has two images of the same space that are slightly out of phase with each other, (the stereoscopic camera had two lenses side by side, creating a parallax view) **(See Figure 9.8)**. Jacobs re-films the images, intercutting them in one, two and three frame intervals, often using black frames to create a flicker. This rapid cutting back and forth between the two images has the effect of creating three-dimensional spaces on the screen. It also animates the image, creating a strong illusion of movement both within the frame, as the figures appear to spring to life, as well as the sense that the camera itself is in motion, tracking around the figures, both

241

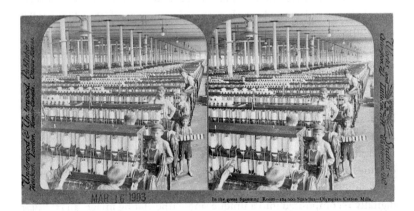

Figure 9.8

Capitalism: Child Labor, Ken Jacobs, 2006. Original Stereoscope photo card, 1903. Courtesy of Ken Jacobs.

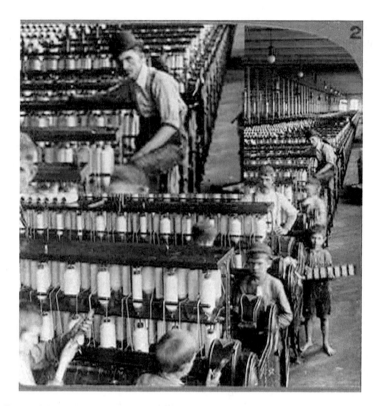

Figure 9.9

Capitalism: Child Labor, Ken Jacobs, 2006. Composite detail. Courtesy of Ken Jacobs.

throwing the entire image into motion. Through this digital compositing, Jacobs begins to cut up the image into details and enlargements. In this way it creates a new image that emphasizes particular spaces and sets of relations between objects and people within the photograph (**See Figures 9.9 and 9.10**).

In both *Razzle Dazzle* and *Capitalism: Child Labor*, Jacobs digitally simulates the flicker of the cinematic shutter to create a persistence of vision, which tricks the brain into seeing motion. By working with different lengths of black between the still picture frames, Jacobs is able to engage the viewer's body with the force of the light smashing onto the retina (a similar effect as his *Nervous system* performances). The animation of the stereoscopic slide haptically activates the image as cinema, while restoring the photographic qualities of the original stereoscopic presentation with its illusion of heightened dimensionality. At the same time, the image is fragmented and then digitally recomposited into a unique single undulating image, an *oscillating animation*, the result of the immateriality of digital code. The energy of light as it flickers on and off blasts the past of the image into the present, bringing with it the specter of contemporary exploitation. The digital film at

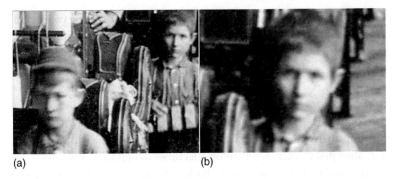

(a) (b)

Figure 9.10

(a) *Capitalism: Child Labor*, Ken Jacobs, 2006. Detail. Courtesy of Ken Jacobs.
(b) *Capitalism: Child Labor*, Ken Jacobs, 2006. Close up of revivified boy
looking across history. Courtesy of Ken Jacobs.

once fragments and composites the image to release the virtuality of the
mechanistic experience of the earlier industrial age. What is so powerful
here is the relationship between the indexical image of the original photo-
graph as a trace of an historical moment of injustice and the digital code; it
is transformed into something that has little relation to that trace, but yet
seems to bring the body of the exploited back to life. The energy of the film
creates an embodied experience of history that can be equated with that
life itself.

 Capitalism: Child Labor projects us into the scene of industrial labor. We feel
the mind-numbing repetitions of the unending time of factory work. Jacobs
focuses on the hands and feet of the children, the repetitive motion of the
images mirroring the machines themselves. The digital movements create
a three-dimensional deep space, as our eyes wander around the machines
that give no indication of a world beyond them. Jacobs also produces spatial
relationships between the adult foremen and the children that emphasize
the power they have over them, at times the flickering turns the children
into flat cutout objects. The gaze of the overseers is an image of capitalist
hierarchy and is at the center of Jacobs' recombinant image in the film.

 As such, death permeates the image. The space feels haunted by the
absent bodies of those who worked in such factories, yet Jacobs is not one
of those "agents of death" as Roland Barthes (1981: 92) characterized pho-
tographers; rather, he is a re-animator, mixing elements of the photo-
graphic and digital to bring the dead back to life. As the boys look back at
us through time, in their bare feet and rags, we feel on our skins the misery
of their lives—then, and now. The insistence of their twitching move-
ments testifies to their exploitation in this charnel house from the history
of capitalism, in which the image of vibrating sewing machine bobbins
hovering over their heads at times look like the stacked skulls of some
ancient catacomb of the dead.

This haptic experience of child labor raises as a virtuality the thought of a new social system, a new society in which such exploitation is intolerable. In so doing, *Capitalism: Child Labor* becomes the shadow side of Dziga Vertov's utopian image of the industrialization of the early twentieth century in *The Man with a Movie Camera* (1928, 68 min) where we see an image of the cybernetic worker of revolutionary Russia, who has ecstatically become one with her weaving machine. Vertov used the technology of cinema to show the utopian image of the socialist hope and aspiration for a world in which non-alienated workers ran their own factories to build a new society.

In contrast, Jacobs' revivified children from the nineteenth century bring us back to our own knowledge of the present day exploitation of global child labor. Even as they depict the past, the images cannot but evoke this ongoing reality. Watching, we become uncomfortably aware of the very clothes we wear as we watch the film, still today the product of children's hands, the distance no longer of time but of space. By bringing together these two moments in history, *Capitalism: Child Labor* creates its temporal composite between past and present as an image of the continuing failure of capitalism to overcome human exploitation. As a temporal composite, it raises the thought of a new social system, a new society in which such exploitation is intolerable. *Capitalism: Child Labor* is a howl of anger at the persistence of injustice, not some rationalized showing of photographic documents of the conditions of the distant past— or for that matter, of the spatially distant present of contemporary sweat shops.

VII.

To return to the question of the possibilities for a continuing politics of radical form in the digital age, does digital technology, and with this I include digital animation technologies, revive the possibilities for radically formal and materialist explorations of the film image as a means for thinking and exploring the history of the present? The question of whether or not digital image technologies produce a new kind of cinema that could or could not be done with chemically-based motion picture technology remains open. And while today many of the strategies and aesthetic debates that have characterized political modernism in cinema, including alienation effects such as boredom or interrupted, fractured and incomplete narratives, often seem exhausted. Nonetheless, perhaps images produced through digitally-based media practices that work between the indexical trace photograph and the non-referential code of the digital can open onto a new politics of form. The emergence of digital image-making technologies causes us to once again look at the notion of medium and the crucial ways it is also its content, as well as to reconsider techniques that have been marginalized in the past. In doing so it renews the promise of politically engaged media practices and revives debates about what it means to make digital media politically.

Jacobs' recent works use the ever-changing image-making technologies as signifiers of different historical moments, while foregrounding the haptic physicality of each medium that places the viewer in the flow of time. In doing so, he creates a new image of the history of the present. These works create a continuum between earlier practices of aesthetic explorations that are medium specific while encountering and converging with the digital realm. This has created new ways of working that allow another kind of creative agency, opening up processes for discovery and indeed a new kind of politics and ethics of media production. Thinking about Jacobs' recent work as a hybridized form, a folding of the analog and digital, photographic and electronic, live-action cinema and frame-by-frame animation, past and present, historical documents with aesthetic creation raise the question of medium and what it can open or foreclose for us. Let us call this medium animation.

Finally, the bleakness of Ken Jacobs' vision of digital America is undeniable. But at the same time, the use of the different media and techniques that he engages to create powerfully affecting images are at once physically and intellectually stimulating to the point of revelation. Are these images of a world that has died, something that is in the past, but nonetheless refuses to go away? Or are they virtual images of something that is not yet born, premonitory shadows of something that is in a potential future, even before it has arrived? Jacobs makes sure that they are both.

notes

1. This is not to suggest that "cartoons" are inherently incapable of raising insightful questions about the worlds we live in or to make social and political critique. But for the most part, the popular cartoon form is understood to be a simplified, exaggerated, and often stereotyped view of the world that often hides or disavows its ideological basis, and is sold to entertain rather than to critically engage viewers. This has relegated those works that *do* attempt to use cartoon forms in more challenging ways to the margins of film culture, which, like avant-garde film, is rarely accessible outside of animation festivals and educational institutions. See Suzanne Buchan's introduction for a more detailed discussion of distinctions between cartoons and other animation.
2. Quoted in Colin McCabe, *Godard: Images, Sounds, Politics*. London: Macmillan, 1980: 19.
3. See Benjamin's description of the figure of the "ragpicker" (Lumpenproletarier) in *The Arcades Project*. Cambridge: Harvard University Press: J68, 4, 349. For a more in-depth Benjaminian reading of the uses of "found-footage" in avant-garde film, see my book, Skoller 2005.
4. *Direct image of time* is a central concept that defines Deleuze's notion of the Time-Image and is defined variously throughout his *Cinema 2: The Time-Image*. See also Rodowick's *Gilles Deleuze's Time Machine* (1997), in which this concept is discussed at length.
5. Jacobs writes in his description of the found film: "Original 1905 film shot and probably directed by GW 'Billy' Bitzer, rescued by Kemp Niver via a

paper print filed for copyright purposes with the library of Congress. Reverently examined here, a new movie almost incidentally comes into being" (1989).

6. For an annotated filmography and performance history of Jacobs' work, see Rose 2011.

7. This can be seen as a visual equivalent to the musical pieces by composers such as Steve Reich and Alvin Lucier, who found new harmonic overtones in musical instruments, when repetitive patterns were moved in and out of sync with each other. Reich's influential composition *Violin Phase* from 1967, is an example.

8. This conception of the fold as the loss of the boundary between the inside and outside in the construction of subjectivity is figured by Deleuze in relation to baroque architecture in his book *The Fold* (1993). Especially relevant to this conception of subjectivity is his allegorical discussion of Leibniz's montage of a baroque house, "that moves between the lower floor, pierced with windows, and the upper floor, blind and closed" (4); and the chapter 'What is Baroque?', pp. 27–38.

9. For some of the most lucid discussions of the relationships between the indexicality of the photographic and digital and its implications for historicity from a film studies point of view, see Rodowick, DN (2007) *The Virtual Life of Film*. Cambridge: Harvard University Press and Rosen, Philip (2001) *Change Mummified: Cinema, Historicity, Theory*, Minneapolis: University of Minnesota Press.

10. William Hogarth (1697–1764) was an English painter, printmaker, political satirist, social critic and editorial cartoonist. His work ranged from realistic portraiture to comic strip-like sequential of pictures called 'modern moral subjects'. This part of his work can be seen as pre-figuration of various forms of mass image culture, from political cartoons to billboards to proto-cinematic screen culture and peep shows, all of which elides distinctions between high and low culture. In writing about Hogarth's *Southwark Fair*, Jonathan Crary (2002) finds "an image in which we can see forms of pre-modern and modern culture coexisting side by side ..." and how with "inversions of high and low it parodies and profanes official forms, how it suggests a teeming mix of sensory modalities, the tactility of bodies mingling, sounds and smell, all at least coequal with vision." This image of a transitional cultural and technological moment in Hogarth's time, connect him with both Bitzer and Jacobs and similar moments of transition in their own times.

11. For more detailed discussions of the relationships between the entertainment industry and the military, digital animation technologies and the aesthetics of video games, and war, see Halter, Ed (2006) and Dyer-Witherford and de Peuter (2009).

12. This is not to be confused with 'forensic animation or multi-media'. a branch of forensic science in which animation and other audio-visual technologies are used to make recreations and simulations to illustrate or clarify legal evidence. Such recreations are increasingly used in courtrooms to aid judges and juries in their understanding of events, crimes being litigated. In an ironic reversal of the idea of the so-called objectivity of scientific knowledge and the artifice of aesthetic practice, Jacobs' notion of "forensic cinema," is just the opposite, which is to examine, probe and dissect already existing film and photographic materials to find aspects of

the past from which they emerge. Thanks to editor Suzanne Buchan for making me aware of this scientific-legal practice.

13. Part of a series of short videos that includes *Capitalism: Slavery* (2006: 3 min). Similarly, this uses an early stereoscopic photograph in which we see black slaves picking cotton with a white overseer on horseback behind them.

references

Barthes, Roland. 1981. *Camera Lucida: Reflections on Photography*. Trans. Richard Howard. New York: Hill and Wang.

Benjamin, Walter. 1999. *The Arcades Project*. Trans. Howard Eiland and Kevin McLaughlin. Cambridge, MA: Harvard University Press.

Crary, Jonathan. 2002. Géricault, the Panorama, and Sites of Reality in the Early Nineteenth Century. *Grey Room 09*, Fall: 5–25.

Deleuze, Gilles. 1989. *Cinema 2: The Time-Image*. Trans. Hugh Tomlinson and Robert Galeta. Minneapolis: University of Minnesota Press.

——— 1993. *The Fold: Leibniz and the Baroque*. Trans. Tom Conley. Minneapolis: University of Minnesota Press.

——— 1995. *Negotiations*. Trans. Martin Joughin. New York: Columbia University Press.

Dyer-Witherford, Nick and Grieg de Peuter. 2009. *Games of Empire: Global Capitalism and Video Games*. Minneapolis: University of Minnesota Press.

Eisenstein Sergei. 1974. Montage of Attractions. For Enough Stupidity in Every Wiseman. Trans. Daniel Gerould. *The Drama Review* Vol. 18.1, March: 77–85.

Gunning Tom. 1986. The Cinema of Attractions: Early Film, its Spectator and the Avant-Garde. *Wide Angle* Vol. 8, Nos 3–4: 63–70.

Halter, Ed. 2006. *From Sun Tzu to Xbox: War and Video Games*. New York: Thunder's Mouth Press.

Jacobs, Ken. 1989. Film description in *NY Filmmakers Cooperative Catalogue #7*. New York: 270–271.

Krauss, Rosalind. 1999. *A Voyage on the North Sea: Art in the Age of the Post-Medium Condition*. London: Thames & Hudson.

Leslie, Esther. 2002. *Hollywood Flatlands: Animation, Critical Theory and the Avant-Garde*. London: Verso Press.

McCabe, Colin. 1980. *Godard: Images, Sounds, Politics*. London: Macmillan.

Rodowick, D. N. 2007. *The Virtual Life of Film*. Cambridge: Harvard University Press.

——— 1997. *Gilles Deleuze's Time Machine*. Durham: Duke University Press.

Rose, William. 2011. *Rose in Optic Antics: The Cinema of Ken Jacobs*. New York: Oxford University Press: 263–275; also see *Nervous System Performances*, 270–272.

Rosen, Philip. 2001. *Change Mummified: Cinema, Historicity, Theory*. Minneapolis: University of Minnesota Press.

Skoller, Jeffrey. 2005. *Shadows, Specters, Shards: Making History in Avant-Garde Film*. Minneapolis: University of Minnesota Press.

animated documentaries

aesthetics, politics and viewer

engagement

t e n

n e a e h r l i c h

introduction

The documentary turn in contemporary visual culture and the ascension of documentary hybrids such as Reality TV, Mockumentaries and Docudrama reveal the persistent ambiguity and many unresolved anomalies in documentary definitions. Animated documentaries and animated documentary games, a new challenging phenomenon based on virtual interactive engagement with documentary and educational materials, can nonetheless seem oxymoronic. However, as will be shown, these new and relatively unexplored sub-genres actually depict two new agents of the documentary field.[1] By utilizing critic and filmmaker John Grierson's well-known definition of documentary as "the creative treatment of actuality" (1966: 13), the analysis of these sub-genres focuses less on the binary opposition between fact and fiction and concentrates instead on assessing the documentary quality of the works to understand their representational viability. In the second half of this chapter they provide excellent sources of evidence for comprehending animated documentaries' political significance and the continually shifting ideas about documentation.

Animated documentaries, straddling the realms of art, film and gaming, raise a myriad of ethical-political questions in regard to representation: How does animation as a new documentary aesthetic modify and interrogate assumptions about film theory's photography based notions of realism?[2] What are the cultural circumstances and advantages of using animation to engage with and document sociopolitical realities? Does the novelty of animation in documentaries aestheticize information to a degree that the animated image overshadows political content? Does animation, as a stylistically varied visual language that breaks with photography, disrespectfully 'obliterate' protagonists? By focusing on these questions, an understanding will emerge of how viewers' documentary experience is altered in contemporary animated documentaries and how this influences the political significance of the works.

authenticating animated documentaries as anchored in sociopolitical realities

The complexities of viewers' acceptance of animated documentaries as authentic must first be understood. As Lev Manovich explains, "[c]inema is the art of the index" (2001: 295), which explains how cinema, since its emergence, has taught viewers to accept its representational form as reality (Lister et al. 2003: 141). According to Hélio Godoy's interpretation of Peircean Semiotics, an index is a sign that provides anchoring in the material world through a causal link between the material world and its representation (2007: 110). As such, the documentary is expected to embody a direct correlation to its physical referent as an evidentiary act (Enwezor 2010: 10). However, an index can also indicate a referent without being physically linked to it. Unlike photography, which directly records the physical referent, animation can visually denote without necessarily basing the image on a physical connection to its referent. Animation's severed link to its physical referent, its obvious visual constructedness and multi-layered relation to indexicality thus challenge pre-existing assumptions about credible documentation.

Nonetheless, it is important to keep in mind that even photographic visual evidence is no longer unequivocal. The home video images of Rodney King's attack by Los Angeles policemen in 1991 were deemed insufficiently authentic in court to hold the perpetrators legally responsible. According to Frances Guerin and Roger Hallas, "[b]y stressing the limitations of the image, the defense was able to reframe the meaning of what the image actually captured" (2007: 3). Furthermore, the pre-digital technological inability to impeccably manipulate imagery strengthened its perceived authenticity. Instead, and increasingly so, tension ensues between the persistence of the customary truth value allocated to physically indexical visual forms with a growing suspicion of image manipulation, which

destabilizes the validity of photographic imagery.[3] Moreover, as styles, technologies and platforms of documentary change, indexicality and its relation to an aesthetic of realism becomes even more intricate. The index as linked to the material referent is complicated when the referent does not physically exist. Such is the case in animated documentaries where memories or dreams are visualized, as in Ari Folman's 2008 *Waltz with Bashir* about soldiers' recollections of war. A similar case occurs when digital online experiences that are immaterial and exist visually only in animated form are documented, as seen in Douglas Gayeton's 2007 *Molotov Alva*, the video diaries of an avatar in the online game *Second Life*. The complexity increases when the technologies of representation are not based on physical traces as is the case when digital, rather than analogue, technologies are used. On the other hand, when animated forms are used to represent data based on physical referents, such as the visualization of one's location on a GPS monitor, animation becomes a direct physical index.

The evolving nature of the index as concept[4] has led some documentary theorists to argue the necessity of moving away from a primary focus on the indexicality of the documentary image.[5] But if physical indexicality is no longer an authenticator of imagery, what is the relation between a sense of realism and the documentary? Realism is the relationship between representations and the real world. It does not capture the presence of the real, rather it is an articulation of it.[6] 'Realism', since the mid-nineteenth century, has been applied to art that aimed to reproduce nature and humanity without any ideal, theological determinations or preconceived notions. However, as Paul Ward explains, 'realism' is a difficult concept to determine because it is often understood in relative rather than absolute terms: "Realism" he says, can refer to capturing "a close approximation of ... the world exterior to the representation" or judged against what "has already gained the status of the 'realistic' (a particular form of cinematography, for example)" (2002: 125). In other words, realism can be understood in relation to proximity to direct vision, technology or ideology. John Ellis claims that there is no realism but instead realisms in plural (1982: 8). As I will show, there is a variety of methods that strengthen a sense of realism in animated documentaries and consequently, the truth value recognized in the work.

As notions of both realism and documentary works have transformed, it is crucial to understand the cultural circumstances and advantages of using animation as a documentary language in contemporary culture. First of all, desensitized viewing in the current image-saturated technologized world, available to those with access to lithium-based internet technology, demands novelty to attract attention. Animation's visual variety and its creators' ability to create unusual and iconic imagery enhance its popularity. Secondly, animation techniques increase the animator's agency by easily eliminating or adding visual elements to enhance a message.

This characteristic elucidates animation's informative potential and explains animation's frequent use in educational contexts and historical propaganda. This also clarifies animation's efficacy to communicate cross-culturally, as seen in many airline in-flight safety films, rendering it a global visual language and thus one of the most important creative forms of the twentieth and twenty-first century. Third, animation's many uses in online games, music videos, and advertising contexts mean that despite the possibility of being considered 'inauthentic' in a documentary context, animation can be seen as a covertly disarming accessible and appealing mode of representation. Finally, the options of representation in animated form are limitless. Subsequently, as documentaries animation can bring about the visualization of absent, missing or censored materials. In a contemporary visual culture characterized by the abundance and richness of visual imagery, viewer expectations for visual aids can be satisfied by extending animated visuality to photographically un-representable and/or non-physical aspects. Apart from the previously mentioned examples of *Waltz with Bashir* and *Molotov Alva* animation has also been used to depict missing footage as well as to evade restrictions of censorship, as seen in Ali Samadi Ahadi's 2010 *The Green Wave* about Iran's Green Revolution where live-action footage was widely censored by the regime. In other words, animation provides extreme power to creators and as such facilitates documenting with minimal restrictions, be they technical, legal, or other.

Animated documentaries' unique characteristics explain their potential and recent proliferation. However, new documentary aesthetics raise important questions about the political-ethical ramifications of their use in documentary representation. Okwui Enwezor, art theorist and curator of *Documenta 11*, claims that the amalgamation of arts and politics tend to "transform ethical concerns into aesthetic devices and vice versa … the critical ability of such actions to effect change remains, thus far, in remand" (2008: 77). According to this view, using animation instead of photographic imagery risks masking the political urgency of many documentaries. Furthermore, by severing the link to the physical body of the documented protagonists, questions about the representation of documented 'others' arise.

Animation can be seen as creating quasi-generic depictions, which may be construed as demeaning or racist.[7] In a documentary context this reading may be strengthened by the enhanced control of the animator and a sense of absence by the visual masking or effacement of the allegedly unseen, in a physically indexical manner, protagonist. Animated representation can thus be interpreted as a denial of self-representation, maintaining political invisibility of those often unseen or marginalized in society and eradicating the ethical stance that a more direct encounter with an individual in a similar situation may evoke. The politicization of contemporary art seen in the rising interest in documentation, the documentary turn, highlights the correlation between socio-political realities and their

representation: Giorgio Agamben focuses on the refugee as the central figure of our political history, and his concept of *bare life* accentuates the importance of those "invisible" in the existing sovereign structures. *Homo sacer* or *bare life* describes the condition where human rights belong to the citizen, not those excluded from the nation state and consequently stripped of political representation.[8] According to Jacques Rancière, the organizational system of law "separates those who take part from those who are excluded, and it therefore presupposes a prior aesthetic division between the visible and the invisible" (2007: 3). Rancière asserts that in order to destabilize existing systems of control, those who are denied visibility and political presence must be reinserted and "seen" (3). Enwezor claims that new documentary artwork configurations raise new relations of ethics and aesthetics because instead of presenting the viewer with non-negotiable facts, they create a "truth process" by creating "a possible space for an ethical encounter between the spectator and the other" (Lind and Steyerl 2008: 19).[9] Enwezor describes such encounters as based on human rights and demanding "a common ground within an unevenly globalizing world" (20).

The idea of political documentary artworks, both animated and other, as encounters can be understood as ways with which to engage the viewer to be 'present' and/or involved in the subject matter and people depicted. Socially engaged contemporary artwork and the mounting interest in documentation thus explain the rise of participative-based practices aiming for social and political engagement. If the notion of an encounter promotes involvement, an engaging experience for the viewer is essential. Also, if a sense of encounter with a documented 'other' whose often traumatic experiences portrayed in political documentaries are foreign to the viewer, can prevent the desensitized spectatorship of others' pain that cleanses the viewer's sense of responsibility, the following questions arise: What methods can create a sense of encounter with the political subject matter for the viewer of animated documentaries? In other words, what variations on realism can anchor animation in the 'real' world so that a documentary, rather than aesthetic, mode of spectatorship is generated? Similarly, what can evoke viewer compassion with an animated character to prevent an inured gaze? In my view, despite an argument that could be made about animation being an obliterating or effacing aesthetic, the following analyses of an animated documentary film and documentary game illustrate the contrary. These different modes of animated documentaries demonstrate how animated representation can in fact lead to increased immersion in the subject matter and the protagonists' experiences.

slaves by david aronowitsch and hanna heilborn

The 2008 Swedish film *Slaves* by David Aronowitsch and Hanna Heilborn is an animated documentary about child slavery in the civil war of

Southern Sudan. The work is based on audio interviews with Abuk and Machiek, aged 9 and 15, who talk about their abduction and enslavement by government sponsored militia. In order to understand this work as anchored in actual events, what are the authenticating strategies used to promote documentary spectatorship?

First of all, *Slaves* brands itself an animated documentary in the opening credits of the work. Although an obvious and perhaps insufficient tactic to rely on, Noël Carroll claims that (most) films arrive already labeled so that we know how to accept them (2003: 169). Second, the work relies on documentary film conventions in order to validate its status. Textual information about the civil war in Southern Sudan is presented alongside photographs of African children in the opening scenes, placing the film in its sociopolitical context. In a sense, the use of photography anchors the film in the actual or real world and, by following these conventions, viewer acceptance of the work as a reliable documentary is encouraged, by relating the supposedly artificial animated visual form with real world events.

Audio interviews further base animated documentaries in documentary conventions, as seen in Bob Sabiston's *Snack and Drink* (2000) and Chris Landreth's *Ryan* (2004). In *Slaves*, animation visualizes the children's testimonials alongside every sound picked up by the recording device. The fact that the audio soundtrack was not edited to delete disruptions such as the small child sneezing or the dialogue between the interviewers at the beginning about how to fix the malfunctioning microphone, contributes to authentication. *Slaves* thus manages to diminish the sense of animation's constructed perfection, linked to the constructed nature of animation that guarantees artistic freedom and omnipotence on behalf of the animator, and instead includes interruptions and unexpected supposedly spontaneous footage.[10] This creates a resemblance to cinema verité stylizations, which consequently enhance a sense of veracity, shifting the emphasis back to the content rather than merely focusing on its visual form.

Using non-indexical and non-hyperrealist animated styles does not mean that a sense of realism cannot be induced through character design.[11] This is apparent in the highly expressive and realistic, albeit not photo-indexical, representation of the children's characters in *Slaves*. The younger child is portrayed blinking frequently and whose recurring eye movements add a sense of human-based naturalism. It is important to realize that even if stylized and perhaps novel in appearance, animated forms, whether representing humans, environments or objects from the natural world, still share many characteristics with photographic imagery to which viewers may be more accustomed (**See Figure 10.1**). Early drawn and painted animation, such as the 1930s Mickey Mouse films, were defined by what Sergei Eisenstein termed a "plasmation" or a theory of "plasmaticness" where characters were stretched and squashed "like quicksilver scattering and rolling back into a cohesive little ball" (1988: 69). Since the rules

253

Figure 10.1
Slaves by David Aronowitsch and Hanna Heilborn, Story, 2008.

of physics did not apply, the animated spaces seemed like separate spheres from the physical world.[12] However, as animation production developed, attempts to resemble reality in different ways advanced.[13] What is central is the degree of plausibility the image evokes, producing an engagement with the animated visuals that can engross the viewer in its content.

Finally, an important authenticator in animated documentaries is the extended index or indexical chain (Poremba 2011: 49). Since every object relates to many others, there is vast indexical potential beyond visual resemblance. Indexicality corresponds to the semiotic role by which signs signify their object, creating an anchor, a reference to the world. For this reason, pure icons that do not signify anything in the world are impossible. Cynthia Poremba explains an "indexical chain", as "a set of links contingent on a set of causalities that bring together the representation and the world" (49). Extended indices are evident in animated documentaries' reliance, both in form and/or subject matter, on viewers' inter-textual knowledge to enhance truth value. *Slaves* and *Darfur is Dying* (2006), the two works discussed here, are about the war in Southern Sudan, the existence of which would be known to viewers through other, less questioned, media coverage.

A different form of indexical chain occurs when animation references recognizable photographic imagery. This is precisely the case in the serious game (I will clarify this term later) *9/11 Survivor*[14] in which an instantly recognizable, albeit animated, image of a man falling/jumping from the World Trade Center is included. Through the indexical chain, the animated image is bestowed with the associations of the actual photograph it so vividly and automatically brings to mind. This re-indexing reaffirms the reliance on viewers' inter-textual knowledge but can also provide a fresh and re-sensitizing encounter with well-known imagery despite repetitive media exposure. The *9/11 Survivor* Falling Man image is clearly an index of the well-known image but, unlike the photograph, it dramatically situates the viewer *within* the Twin Tower buildings, representing the event from above,

situating the viewer where no camera was present. In other words, an indexical chain can make the depicted content in animated documentaries seem viable since it is based on existing knowledge but can meanwhile emphasize new insights and meaning through innovative representation. Consequently, despite the artificiality of the animated graphic representational form, the subject matter is still related to 'real' world events and thus, obliteration of the content by the form is prevented.

If documentary content can be anchored in realities in various ways, how can documented protagonists be represented, so as to prevent their visual effacement and maintain their human dignity? Animation is not confined by what can be photographed and therefore is an excellent technique with which to portray personal perspectives and subjective accounts. For this reason, stories depicted in animated documentaries are often very personal, exemplified by Ruth Lingford's *Little Deaths* (2010) about experiences of orgasm and Ann Marie Fleming's *I Was a Child of Holocaust Survivors* (2010). In *Slaves*, viewers are presented with a visualization of the children's worst memories, fears and nightmares, each styled differently. In the depiction of the child's nightmare about the loss of his mother, the highly expressive and realistic animated form used for the interview sequences is exchanged for elementary colors and basic shapes symbolizing a human form. The harsh contrast between the almost blindingly white head-shape on the black background manages to visually render the tension and anxiety of the dream, while the elementary colors and shapes seem to befit the sensation depicted, the most primal horror of losing a mother. The scar shapes on the protagonist's face act as befitting visual metaphors for the pain and trauma described (**See Figure 10.2**).

The highly intimate oral exposure contributes to the viewer's sense of the individuality of the speakers. Even if an animator (rather than the

Figure 10.2
Slaves by David Aronowitsch and Hanna Heilborn, Story, 2008.

protagonist) designed the visuals, we are nonetheless tempted to accept the visuals as seeing inside the minds of the speakers, 'stepping into' their inner-most thoughts. A central topic in visual culture and identity politics, it is true that a sense of 'owning' depictions of minorities by someone not from that minority can be argued by the one-sided disclosure to a voyeuristic audience.[15] However, since the interviewed protagonist is not seen, and rather an animated graphic 'stand-in' or avatar is used, their anonymity is easily preserved and their dignity maintained. Revealing personal stories encour-ages viewer empathy and involvement through inter-human identification on a very personal and emotional level despite the inability to see the speak-er's physical appearance. In this sense, reading the animated character as 'generic human' may actually facilitate identification rather than inhibit it.

Just as animated depictions may create stereotypes that submit to dynamics of power that categorize people arbitrarily, the opposite is also true. Animation can defy visual classification systems by designing non-human forms representing the (usually heard) protagonists. By depicting protagonists as fish, trolls or stick figures viewers are denied the visual information they are accustomed to in live-action documentary films, which is read hastily and used to classify information and/or people. Instead, animation can create a sense of equality and humanity by depict-ing everyone in the same way, as fish or stick figures for example. What remains is to listen to the individual 'behind' the image. Combined with the sound track, this visually indirect representation of information demands active viewing where a 'truth process' of reflexive and active interpretation is generated. Not only does this deny an aestheticized perspective that overshadows content and a sense of absence of the pro-tagonists, as may initially be suspected; it also creates an engrossing specta-torship experience involved in the content conveyed and individuals perceived, evoking a new form of encounter for the viewer. As I will explain below, this characteristic requires renegotiating assumptions about docu-mentation and realism but is also a reflection of wider contemporary cultural and technological tendencies.

viewer engagement

In an image-saturated era, images attract our attention; act as conveyers and verifiers of information. The centrality of images in contemporary information systems persists despite the previously discussed uncertainty regarding their representational veracity. The prevailing uncertainty of imagery is contextualized by filmmaker Hito Steyerl who argues "the only thing we can say for sure about the documentary mode in our times is that we always already doubt if it is true" (2007: unpaginated).

The general mistrust and popular skepticism of visual information sheds light on the development of the animated documentary sub-genre.

Through its obviously constructed visual form that breaks with photography and emphasizes the creative freedom of the animator, animation inherently foregrounds mediation. Blatant and unapologetic emphasis of constructedness in documentaries questions authority and authenticity of representation, confirming animation as a more honest form of documentary work. As Paul Ward explains, arguments in live-action expository documentaries are actually "covert rather than overt. [The information] is not presented as an 'argument' to be weighed up, mulled over, and possibly disputed, but rather as a 'statement of fact'," whereas "animated films, by virtue of their 'difference' from live-action, will not be watched in the same way" (2008: 19). By emphasizing mediation, animated documentaries acknowledge the viewer's centrality in the process of categorization, authentication and interpretation of the work. Viewers must, first and foremost, self-reflect about their own internalized values that influence their acceptance of certain types of evidence and decide if they wish to suspend disbelief and accept the constructed imagery as valid.

Advanced viewer involvement in the comprehension and production of information is a characteristic of contemporary technoculture, where viewing is replaced with interactive using and 'surfing', so that the spectator transforms into viewer/user, accessing, collecting and navigating in a wealth of 'too much information'.[16] Interaction in the contemporary online participation culture means that individuals generate and disseminate ideas more than ever before, choosing where to search, what to share and how to construct their own narratives of 'truth'. In fact, User Experience (UX) and User Interface (UI) are central concepts in web usability that emphasize interfaces as evolving representations of information in regard to the experience of the user.

The centrality of the viewer/user experience has also influenced the field of contemporary documentary that shifts the focus to the viewer's experience of the documentary work. Film theorist Paul Rotha offers a viewer-oriented approach to documentaries, claiming that "[d]ocumentary defines not subject or style, but approach It justifies the use of every known technical artifice to gain its effect on the spectator" (Ellis 1989: 7). Joost Raessens suggests documentary theory has moved towards the viewer's role in the reception of the work because documentaries are received as such if they succeed in indicating that a "documentarizing lecture"[17] should be practiced, rather than a fictive one, to influence the viewer's mode of reception of the work (2006: 220). Finally, as Dai Vaughan claims, "[w]hat makes a film a 'documentary' is the way we look at it; and the history of documentary has been the succession of strategies by which filmmakers have tried to make viewers look at films this way" (1999: 84–85).

A focus on the viewer's documentary experience may not only be limited to animated documentaries, although animated documentaries have risen to the challenge of accentuating the necessity of developing new

viewer-oriented authenticating strategies that do not depend on an aes-
thetic of photo-realism. If documentaries rely on the idea of a record and/
or testimony, then ways in which to include the viewers in the events as if
they themselves have witnessed them, can potentially act as a 'documen-
tarizing' perspective for viewers, which will influence how the work will be
remembered and regarded in the future. To be part of the event requires a
sense of inclusion or encounter or at least a simulation of witnessing, as I
will show occurs particularly in documentary games. Whereas in the past
photographic imagery may have simulated a sense of 'being there' by
seeing what would have supposedly been seen if actually present, in an era
of interactivity and participation culture, a different form of simulated wit-
nessing is needed. In order to theorize on the evolving nature of contem-
porary documentaries in regard to interaction Arnau Gifreu uses Katherine
Goodnow's different modes of interactivity: cognitive function, the act of
understanding and interpreting, and physical activity that is required in
some interactive documentaries to navigate within the material or to
explore alternative storylines (Gifreu 2011: 357). These two modes corre-
spond to the two case studies covered here, which leads me to the second
form of animated documentaries to be discussed: documentary games.

animated documentary games

Animated documentary games, also known as serious games,[18] are "games
used in areas such as education, training, and politics that go beyond mere
entertainment purposes" (Neys and Jansz 2010: 230). They are "games that
attempt to place the players in specific historical moments" (Fullerton
2008: 215). Documentary games are a rapidly growing genre in the field of
documentary and part of the developing category of interactive documen-
taries, or I-Docs.[19] I-Docs combine the documentary genre with interactive
digital media, drawing from the growth of digital online informational/
educational platforms and the exponential popularity of the gaming
industry.

A recurring issue in game studies is whether games should be exam-
ined as narrative works, the narratology approach, or as unique structural
systems with specific characteristics, the ludology approach.[20] Although I
will focus on the unique ways in which games create a documentary expe-
rience for viewers, it is useful to consider Michael Renov's purposes of
documentary filmmaking to explain the documentary value of these
games, despite the possible difficulty of placing them in strict taxonomies
of documentary theory. According to Renov, the functions of the docu-
mentary are to record, reveal, or preserve; to persuade or promote; to ana-
lyze or interrogate; to express (1993: 21–25). Similarly to animated
documentaries, although documentary games do not record physical
realities directly, they can *reveal* information by depicting aspects otherwise

not visualized, such as experiences of war that are not photographed due to the dangerous circumstances, and can *preserve* the information by raising awareness to the depicted situations. Animated documentary games can *persuade* by promoting specific perspectives on an event and, by facilitating a first-hand experience of a simulation, do so quite convincingly. The game *Darfur is Dying*,[21] as will be shown, enables the player to assume the role of a refugee avatar seeking water for the camp and attempting to escape the Janjaweed militias. By creating the character of a modern day refugee, the game developers strive to present refugees not as 'illegals' or 'threats' but as heroes who fled life-threatening situations and have now become victims of immigration systems, thus *promoting* a specific ideological stance. Renov's third function of documentaries is the *analysis* and *interrogation* of an issue. Unlike most digital games, many documentary games are not commercially distributed, but are available online for free download and include forums, discussion areas and external links about the topic presented. Games create new experiences for information representation but are also part of larger platforms for learning, discourse and action. Documentary games are thus interfaces connecting players and databases for further analysis of the topic. The final function of documentaries according to Renov is *expression*. Animated documentary games enable an immersive interactive experience that can potentially empower viewers as active agents and, by being highly stylized and interpretive, facilitate prominent expressive power.

Although films and games differ in many aspects, the documentary value of games is important because, for people who are inexperienced gamers, they introduce new documentary formats that, as I will explain, inform in an incredibly personalized and engaging manner. For experienced gamers, however, for whom the simplicity and straightforwardness of animated documentary games may seem unexciting and only justify their one-off consumption, some documentary games become similar to once-viewed films acting as informational platforms. Whether for experienced or inexperienced gamers then, these new works hold great documentary potential.

As Manovich explains, all computer media is interactive since "the user [controls] the computer in real-time by manipulating information displayed on the screen" (2001: 55). Although interactivity is therefore not exclusive to online/video games, it does link a central characteristic of contemporary culture to the emerging form of documentary seen in documentary games. This differentiates between viewers of time-based documentaries and players/users of documentary games. Janet Murray explains that for a heightened sense of immersion, rather than merely interactive experience, environments must be meaningfully responsive to user input, consequently describing the pleasures of navigation in a potentially infinitely expandable space in video games (2000: 127–129). The joint

sense of exploration in a game's virtual space and parameters alongside the control facilitated through program manipulation and differing game trajectories explicate the potential, although varying, immersive quality of documentary games.[22]

The non-linear and/or open-ended narrative in documentary games could be argued as decreasing their documentary value. However, the degree of open-endedness varies and is limited by the game's parameters' design so that although different trajectories of events are possible, the significance of the narrative is usually transparent. Furthermore, since digital data can be customized in response to viewer input, the entire online activity process is based on variability where following links produces a particular version of a document/website (Manovich 2001: 36–45). It therefore makes sense that as technologies change and forms of interaction with information vary, documentary traditions and theories change accordingly. The open-endedness or flexible variability of the documentary narrative in these games is thus a reflection of wider cultural tendencies. Similarly to the active user and navigator of information in the internet age, the documentary player becomes an almost quasi-director calling upon available information parcels and in-game choices. In a desensitized viewing culture the variability of the work enables the player's decisions and actions to influence the plotline so that an adapted version of the game is received. I would argue that the open-endedness creates a participatory and therefore more immersive experience, which provides added political-value to the work through the viewer/player's personalized experience of the depicted information.

The unique characteristics of animation in a documentary context are relevant to games as well but possess additional significance when applied to the simulation of current events, especially in comparison to non-animated interactive documentaries such as *On the Ground Reporter*, which also covers the crisis in Darfur but uses photographic stills.[23] Whereas interactivity can create a powerful engaging experience, animated visuals in games not only guarantee a sense of life through moving-image depictions of otherwise difficult to represent scenes, such as the escape from the Janjaweed; they also create an interesting tension between immersion and distanced viewing. A sense of distancing can occur because the animated visuals depict information in a novel manner, supposedly creating a fictional world or at least one different from the 'actual' world where the events occurred. On the other hand, a familiarity with animation from childhood as well as the variety of uses of animation in contemporary visual culture such as games, music videos and advertising makes it an accessible and un-antagonistic representational form that expedites 'entering' fictional worlds, even if the simulation is one of horror and hardship. I will show how this tension culminates in a complex comprehension of the work, which actually strengthens its documentary value by creating

variations on realism that further destabilize photo-indexicality as visual evidence and instead introduce realism based on player/user experience where identification and ethical responsibility are central.

darfur is dying

Darfur is Dying is defined on its website as a documentary game whose creators travelled to refugee camps near Sudan and, to develop it, worked closely with humanitarian aid workers with on-the-ground experience.[24] The game website describes it as a documentary based on information collected by students. The game enables players to assume the role of a refugee avatar out of eight named male and female characters ranging from ages 10–30. Similar to *Slaves,* in order to set a documentary tone, *Darfur is Dying* presents textual information about the conflict in Darfur and the living conditions in refugee camps. The website (darfurisdying.com) includes links for additional information and possible courses of action available to users to aid the crisis.

What is the advantage of using an animated gaming platform to highlight a political situation?[25] Uri Rapp claims that games facilitate the testing of situations and their outcomes, shaping the human as a social being by assuming different roles in order to explore what is not immediately available or directly exists elsewhere (1980: 23). Despite the depiction of documented characters in game mode as embodying an almost double absence because the humans they are based on are neither directly seen nor heard (since no interviews are included), the sense of a personal connection on behalf of the viewer can nonetheless be achieved. Research on avatar-player connections sheds light on the power of such experiences. Through the avatars, documentary games place players 'in' someone else's real-world 'role', enabling players to experience, albeit virtually, what would otherwise remain distant and completely inaccessible. By playing someone else and embodying their gestures, a different insight, an embodied knowledge, is gained. This claim may understandably raise counterarguments about the difference between real physical experiences and virtual simulations, but a curious tension exists between a player's obvious awareness of the artificiality of simulations alongside the often very visceral fear and anxiety such games may evoke.

Many game studies theorists have argued that virtual experiences are acceptably becoming part of the 'I' of the player. Matthew Lombard and Theresa Ditton explain virtual reality and simulation immersion as creating a sense presence by an illusion of non-mediation where "the medium can appear to be invisible or transparent and function as would a large open window, with the medium user and the medium content (objects and entities) sharing the same physical environment" (1997: unpaginated). In fact, in the early 1990s it was Julian Dibbell who already

declared that what happens in virtual worlds "is neither exactly real nor exactly make-believe, but profoundly, compellingly, and emotionally meaningful" (1993: 39–40). An 'emotional truth' may be the basis of understanding what makes documentary games acceptable as a documentary work for viewers, 'ringing true' both in content as well as remembered emotions. These emotions alongside a sense of presence elucidate the potential of documentary games to create an interesting connection between the player and avatar and, indirectly, between the player and actual Darfurian the avatar represents.

While online digital games are often engrossing epic systems seen as "Magic Circles",[26] many documentary games like *Darfur is Dying* that aim to raise awareness are quite simple and straightforward.[27] The graphic and conceptual simplicity of the in-game goals guarantees that even inexperienced players may effortlessly become immersed. In fact, what occurs is a supposedly contradictory experience. On one hand, the immersive playing simulates a sense of presence and thus of non-mediation, whilst on the other hand, the use of animation alerts awareness to mediation through the overt visual constructedness of the non-photographic representational form. The minimalistic visual style of the game includes details such as a dead cow when the avatar flees the militias to enhance realism and/or create atmosphere, but little else besides strips of blue sky and beige sand (**See Figure 10.3**). Feeling immersed whilst aware of mediation and having inter-textual knowledge that the game content is based on the 'real' ruptures the non-thinking in-game action trance and adds political significance to the experience.

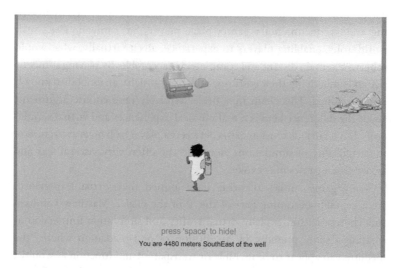

Figure 10.3

Darfur is Dying by Susana Ruiz, Ashley York, Mike Stein, Noah Keating and Kellee Santiago of the University of Southern California, 2006.

Documentary games evoke a multifaceted mode of spectatorship as user-player-viewer: as a detached user engaging with an onscreen application; as a player identifying with the selected avatar and engrossed in the mission of the game; as a 'documentary mode' viewer familiar with the event described and aware of the complexity of the relationship between the game's subject matter and representation. The opening screen of *Darfur is Dying* addresses these three different roles of the viewer: The title *Darfur is Dying* is both the name of the game but also an address of the documentary viewer, introducing and contextualizing the game's subject matter; "Start your experience" refers to the player about to engage in the personalized experience of the game; "Help stop the crisis in Darfur" addresses the 'removed' user whose power extends beyond the game and who can, through links provided on the darfurisdying.com website, act to further aid the situation represented (**See Figure 10.4**).

When the player is unsuccessful in *Darfur is Dying* the "Game Over" screen presents the following message: "You have been captured by the militia. You will most likely become one of the hundreds of thousands of people already lost to this humanitarian crisis". Depending on the avatar selected, probable outcomes of the capture are listed on-screen such as rape, abuse, kidnapping and murder. The use of the word "you" in the "Game Over" information addresses the player but also acts as interpellation that blurs boundaries between the 'I' playing and the 'I' presented by the avatar. Such effects disrupt the diegesis of the game, removing the distancing effect or masking 'screen' of animation as non-naturalistic visual representation.[28] Instead, urgent political significance and documentary

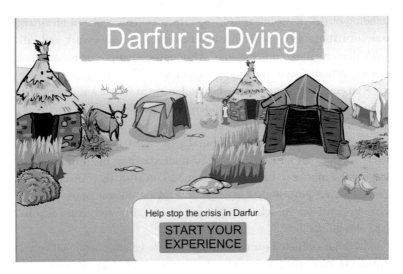

Figure 10.4

Darfur is Dying by Susana Ruiz, Ashley York, Mike Stein, Noah Keating and Kellee Santiago of the University of Southern California, 2006.

knowledge are inscribed into the supposedly fictional animated world and experience of play.

By blurring the boundaries between player and avatar, the player becomes linked, by proxy, to the actual Darfurian refugee as well. As a result, a form of encounter is made possible for and between the player and the Darfurian documented. This further blurs the boundaries between the role of player and that of documentary viewer who realizes the real-world significance of information portrayed. Through the links that appear at the end of the game that advocate possible actions to aid the situation in Darfur, the viewer/player is forced to also acknowledge her internet 'user' status, which places her in an ethical position (whether acted upon or not) that is based on recognition of her responsibility towards people whose similarity to her own she has just experienced. Identification and ethics, as I will show Vivian Sobchack claims, constitute a documentary mode of viewing.

A useful lens with which to understand the effect of games like *Darfur is Dying*, where the depiction of a real death and fictionalized death appear in the same story-telling frame, is the term "ferocious reality" explained by Sobchack as occurring in a film context when the reality of one death becomes clear in comparison with the fictionalized other death (2004: 283). The realization of a "ferocious reality" evokes both a bodily responsiveness and "an empathetic recognition of [one's] own material and mortal possibilities" (283). Sobchack discusses Jean Renoir's *Rules of the Game* (1939) in which the actual death of a filmed rabbit ruptures the film's fictional nature, demarking the different orders of an existential and a cinematic space (268–270). The rupture is the realization that the death is not fictional but occurs in the same world in which you exist as viewer, an understanding of the protagonists as living creatures. This evokes a break and transformation of the generality and fictional status of a work and calls forth documentary consciousness. Although empathy can occur when viewing fiction as well, the unique experience of documentary film viewing is an empathy that evokes ethical judgment as well, a sense of responsibility stemming from the understanding of similarity with the protagonists, a grasping of the "onscreen space as ... contiguous with her or his own material, mortal and moral being" (284). Although Sobchack refers to film, her ideas are useful for understanding the importance of heightened immersion to inspire identification with the viewed and, in games, played protagonists in order to evoke a documentary mode of viewing based on an acknowledgment of similarity and, consequently, ethical responsibility.

Although animated games can be argued to be grim, exploitative and distancing platforms, they prove to be successful documentaries that engage viewers in the content in new ways using media-specific methods. Over the past decade, viewing avatars as mere representational proxies in virtual realms has become increasingly problematic. Instead, a holistic

approach that combines the player, the representation and the medium is necessary. Alexander Galloway argues that although an imaginative aspect of the expressive action exists within the game diegesis, a physical translation and aspect of the same act also occurs (2006: 25). This is often used to suggest that the actions re-created through game rules are in fact *real*, or at very least, partially real. Interactivity, or participation, can thus be seen as a form of realism, endorsing a connection between one's role in 'real' (non-game) experiences as in game environments. Participation as a developing aspect of realism overrides the artificiality of the image by providing a heightened sense of engagement. The sheer amount of experiences regularly received or facilitated via screens in contemporary culture makes this statement somewhat less bizarre than it would have been even as recently as the 1990s, when there seemed to be a separation between 'real' life and technologically constructed circumstances and/or actions. Today, online digital actions and experiences are part of the 'real' as well as part of the viewer/user's self.

Animated documentaries contribute to this blurring of boundaries by virtually embodying the player within the scenario. As Tracy Fullerton claims in her analysis of the 2003 Playstation 2 game *Medal of Honor: Rising Sun*, this means that players become "virtual veterans" of events that otherwise they would not have been able to experience via a personal connection (2008: 220–221). Fullerton's argument demonstrates that in the case of documentary games, it is not only a connection to an avatar that is produced for the player but a reconnection to an historical/current event. The "then and there" of the documented event virtually becomes a "here and now" experience for the viewer, making distant occurrences part of one's proximity and present.

Although new forms of representation do not assure an utter transformation of a documentary's ability to inspire action in the viewer, innovative forms of representation are potentially capable of creating a jerking wake-up effect in a numbed culture so accustomed to images of atrocities.[29] Statistics reveal that playing political serious games does impact on players' knowledge and opinion of the game's subject matter and that "the construction and expression of a 'political self' through the act of playing a political game may have consequences in the real world" (Neys and Jansz 2010: 227). In September 2006 Susana Ruiz, creator of *Darfur is Dying*, stated in an interview:

> According to mtvU's traffic numbers, more than 800,000 people have played the game over 1.7 million times since its launch on April 30th. Of those, tens of thousands have participated in the activist tools woven into the gameplay – such as sending emails to friends in their social networks inviting them to play the game and become informed about Darfur, as well as writing letters to President Bush

and petitioning their Representatives in Congress to sup-
port legislation that aids the people of Darfur. (Parkin 2006:
unpaginated)

Putting the player 'in' the virtual Darfur creates an encounter between the
experiences of the actual survivors and the documentary game player.
Although perhaps not directly inter-subjective because of the multi-fac-
eted mediation, players are nonetheless subsequently invited to negotiate
their own sense of 'self' and relationship to these 'others'. In regard to the
ethical-political role of animated documentaries and the relation between
an aesthetic vs. political viewing of novel forms of representation, recogni-
tion of one's 'other' that is being documented is vital for change and polit-
ical transformation. "Only in such a world where the citizen has been able
to recognize the refugee that he or she is," Agamben writes, "is the political
survival of humankind today thinkable" (2000: 22).

conclusion

Focusing on animation in films and games widens the conceptual frame-
work with which to theorize on formal, narrative and interactive shifts in
contemporary political documentaries. Although perhaps initially appear-
ing oxymoronic, the advantages of using animation as a documentary aes-
thetic include the ability to reach new and multi-cultural audiences,
engage with topics otherwise visually un-representable and, through
unique formal characteristics, influence viewer reception of a work. The
examples I discussed demonstrate that physical indexicality or photo-
indexical imagery as authentication of represented information demands
rethinking, thus varying notions of realism and representational veracity.
In an era of widespread image manipulation and consequent uncertainty
of images, not only are new languages of representation welcome and
needed, but new aesthetics of realism must be considered. I have shown
that even though animation breaks with photo-indexicality there are
varied stylistic choices and documentary conventions employed to
enhance the animated documentary's representational viability and pre-
vent the absenting or obliterating effect of the documented, yet physically
'unseen', protagonists.

Despite a concern about novel forms of aestheticized documentaries,
stated by Enwezor in the outset of this chapter, that aesthetic value will
supersede political significance, analysis illustrates that animation in docu-
mentary films and games cannot be easily disregarded as a substantial form
of documentary representation. I argue that although animation can be
used to create a documentary aesthetic that distances viewers from the
events and people portrayed, it essentially acts as an informational 'boo-
merang'. The representational novelty and foreignness may create a sup-
posed division between 'actual' and represented worlds, but engagement

with the difficult political content is thus facilitated alongside a potential to draw viewers' attention in a highly visual information age. The use of graphic forms rather than representations from the natural world as documentary demands engaged interpretation to make sense of the uncustomary visual information, the gaps between the non-naturalistic form and documentary content as well as the game-mode participation and 'virtual veteran' experience. By working through these, the viewer/player becomes more involved in the content and empathy towards the physically 'unseen' animated characters is evoked.

Accentuating the central role of the viewer and player and creating heightened viewer involvement encourages new insights into the documented political information. As such, despite what may seem to be an initial distancing effect, viewers/players are brought full circle back to the subject matter at hand, albeit only after going through intricate processes of cognitive and/or physical interactivity that enhance their engagement with the content and protagonists' experiences. A new form of realism in documentaries is thus introduced, which is largely based on engagement and the ability to identify with the documented protagonists as well as recognize one's ethical responsibility towards them, which, as Sobchack explains, is part of a documentary mode of viewing. The eventual rupture of the separate and supposedly fictional animated world and its reconnection to actual events, the boomerang effect, strengthen the work's representational viability and documentary value. The novel documentary aesthetic and platforms thus do not overshadow the political content of the work but actually contribute to its foregrounding by involving viewers/players in new ways.

As such, interesting questions arise for future research about evolving notions of realism in a visual culture questioning the truth status of photo-indexicality: Is a new form of realism emerging that is based on, or confused with, empathy? What does this mean about the directions of new documentary aesthetics? In animated depictions of events as well as in game design, animators/designers enjoy heightened ideological power to create entire worlds for the viewer/player. Will viewers continue to be as aware of animation's constructedness or, as viewers become more accustomed to a variety of animation techniques appearing in myriad fields of their daily lives, will animation as a documentary aesthetic seem less bizarre but also less suspicious, enhancing the agency of creators over viewers? Furthermore, if empathy and the viewer's documentary experience become principal, how will documentary works change and how will growing manipulation of viewers' experiences influence viewer/player agency? Will the characteristics of animated documentaries that promote engagement actually act to disguise the ways in which these works become more authoritarian in their documentary and informational tone? In other words, in what directions could the relationship between the agency

of the viewer and that of the animator and/or game designer develop and what could be the subsequent ethical and political repercussions of this new stage of documentary works and experience?

notes

1. Here, the animation I discuss refers to 2D animation techniques, both hand-drawn and digital.
2. As theorized by Siegfried Kracauer, André Bazin, and Stanley Cavell. The concept of realism will be discussed further later on.
3. This is not to say that photographic material is no longer powerful but, due to image manipulation, viewer fatigue and a startling acceptance of the pornography of horror, new forms of representation may certainly be needed.
4. Suzanne Buchan's explanation about the photo-index in this book's introduction further reflects upon the changing nature of the index and its growing centrality in animation and film studies.
5. For further reading, see Raessens, Joost. 2006. Reality Play: Documentary Computer Games Beyond Fact and Fiction. *Popular Communication,* Vol. 4: 213–224.
6. An interesting discussion of the tension in classical and contemporary film theory between a realist approach that focuses on cinema's capability to photographically copy physical reality and what might be termed the formalist outlook, which stresses cinema's capacity for reorganizing pro-filmic reality appears in Prince, Stephen. 1999. 'True Lies': Perceptual Realism, Digital Images, and Film Theory. In *Film Quarterly: Forty Years—A Selection*, eds Brian Henderson, Ann Martin and Lee Amazonas. Berkeley, Los Angeles and Oxford: University of California Press: 393–408.
7. For more on this, see Felperin, Leslie. 1997. The Thief of Buena Vista: Disney's Aladdin and Orientalism. In *A Reader in Animation Studies*, ed. Jayne Pilling. London: J. Libbey: 137–142.
8. See Agamben, Giorgio. 1995. *Homo Sacer: Sovereign Power and Bare Life.* Stanford: Stanford University Press.
9. Such as works by Walid Raad or Chantal Akerman that create reflexive, analytic and not only mimetic works with an ethical stance.
10. For a discussion of the emerging relations between the new visual language of machinima animation and photography and the role of the animator/photographer, see Ehrlich, Nea. Virtual Documents: Animated Depictions of the Non-Existent? In the forthcoming *Blackwell's Companion to Animation,* ed. Paul Wells.
11. For more on the differing concepts of realism in regard to animation, see Wells, Paul. 1998. *Understanding Animation.* London: Routledge; and Rowley, Stephen. 2005. Life Reproduced in Drawings: Preliminary Comments Upon Realism in Animation. *Animation Journal,* Vol. 13: 65–85.
12. For further reading, see also Leslie, Esther. 2002. *Hollywood Flatlands.* London and New York: Verso.
13. See Bouldin, Joanna. 2004. Cadaver of the Real: Animation, Rotoscoping and the Politics of the Body. *Animation Journal,* Vol. 12: 7–31.
14. *9/11 Survivor* was created in 2003 by Jeff Cole, Mike Caloud and John Brennon. Although it is no longer available, more information can be found at http://www.selectparks.net/911survivor/index.html

15. For further reading on the identity politics of representation, see Araeen, Rasheed, Cubitt, Sean, Sardar, and Ziauddin. 2002. *The Third Text Reader: On Art, Culture, and Theory*. London and New York: Continuum.

16. This can be understood as a contemporary development of Roland Barthes' argument regarding the death of the author and consequent birth of the reader.

17. Joost Raessens uses Roger Odin's term to explain the way spectators view works through a documentary or fictionalizing perspective, which can be produced by individual spectators depending on the information/experience they wish to gain from the film, or by the textual and contextual instructions indicated by the film, which stimulate certain viewing lectures. See Odin, Roger. 1995. A Semio-pragmatic Approach to the Documentary Film. In *The film Spectator: From Sign to Mind*, ed. W. Buckland. Amsterdam: Amsterdam University Press: 227–235.

18. Additional names include news games, persuasive games, and Games for Change.

19. Other names include documentary games, interactive entertainment, computer games, interactive games, digital games, educational games, simulation, virtual reality, alternative purpose games, edutainment, digital game-based learning, immersive learning, simulations, social impact games, games for good, synthetic learning environments, new media documentaries, digital documentaries, interactive film, database narrative, online forum, digital art pieces, serious games, news games, 3D worlds, educational product, and more.

20. For more Game Studies research from a narratology perspective, see Janet Murray and Lev Manovich's work and for the ludology perspective, see Espen Aarseth and M. Eskelinen.

21. *Darfur is Dying* was created in 2006 by Susana Ruiz, Ashley York, Mike Stein, Noah Keating and Kellee Santiago of the University of Southern California.

22. For further reading on the complexity and differing forms of immersion in serious games, see Bogost, Ian. 2007. *Persuasive Games*. Cambridge, MA: MIT Press.

23. The game *On the Ground Reporter* is created by Butch & Sundance Media and is available at: http://www.radiodabanga.org/darfurgame/english/index.html

24. *Darfur is Dying* is available online at: www.darfurisdying.com and was the winner of the Darfur Digital Activist Contest launched by mtvU in partnership with the Reebok Human Rights Foundation and the International Crisis Group at the G4C conference in October 2006.

25. For further reading on uses of virtual reality and gaming simulations for military training, see Crogan, Patrick. 2006. Logistical Space: Flight Simulation and Virtual Reality. In *The Illusion of Life 2*, ed. Alan Cholodenko. Sydney: Power Publications: 368–399.

269

26. The term is accredited to Huizinga, Johan. 1955. *Homo Ludens: A Study of the Play Element in Culture*. Boston: Breacon Press. Huizinga argued that playing a game meant the entrance into a "magic" circle, a separate sphere or second order reality. The use of the term in the context of virtual realities and online games belongs to Salen, Katie and Eric Zimmerman. 2004. *Rules of Play*. Cambridge, MA: MIT Press.

27. This differs from serious games that propose modes of action and demand increased in-game concentration and creativity, such as *World Without Oil* which analyzes the current uses of energy sources in order to predict

potential future scenarios and their solutions or *FoldIt*, a game that lets players contribute to scientific research in protein folding.

28. For more on the masking effects and uses in and of animated documentaries, see Ehrlich, Nea. 2011. Animated Documentaries as Masking: When Exposure and Disguise Converge. *Animation Studies*, Vol. 6, http://journal.animationstudies.org/category/volume-6/ (Accessed April 4, 2012).

29. See Sontag, Susan. 2003. *Regarding the Pain of Others*. New York: Picador.

references

Agamben, Giorgio. 1995. *Homo Sacer: Sovereign Power and Bare Life*. Stanford: Stanford University Press.

—— 2000. Beyond Human Rights. In *Means without End: Notes on Politics*, trans. V. Binetti and C. Casarino. Minneapolis: University of Minnesota Press.

Carroll, Noël. 2003. *Engaging the Movie Image*. New Haven, CT: Yale University Press.

Dibbell, J. 1993. A Rape in Cyberspace or How an Evil Clown, a Haitian Trickster Spirit, Two Wizards, and a Cast of Dozens Turned a Database Into a Society. *The Village Voice*, December 21.

Eisenstein, Sergei M. 1988. *Eisenstein on Disney*. ed. Jay Leyda, trans. Alan Upchurch. London: Methuen.

Ellis, Jack. 1989. *The Documentary Idea: A Critical History of English-Language Documentary Film and Video*. New Jersey: Prentice Hall.

Ellis, John. 1982. *Visible Fictions*. London: Routledge.

Enwezor, Okwui. 2008. Documentary/Vérité: Bio-Politics, Human Rights, and the Figure of 'Truth' in Contemporary Art. In *The Greenroom: Reconsidering the Documentary and Contemporary Art*. eds Maria Lind and Hito Steyerl. Los Angeles: Sternberg Press: 62–102.

—— 2010. Rules of Evidence: Text, Voice, Sight. *Berlin Documentary Forum Web Magazine*, http://www.BDF_magazine_web_e.pdf (Accessed July 4, 2010).

Fullerton, Tracy. 2008. Documentary Games: Putting the Player in the Path of History. In *Playing the Past: History and Nostalgia in Video Games*, eds Zach Walen and Laurie N. Taylor. Nashville: Vanderbilt University Press: 215–238.

Gifreu, A. 2011. The Interactive Documentary: Definition Proposal and Basic Features of the Emerging Genre. In *McLuhan Galaxy Conference Proceedings,* eds Ciastellardi, Matteo., de Almeida, Cristina Miranda, and Carlos A. Scolari, Barcelona: Universidad Oberta de Catalunya: 354–365.

Godoy, Hélio. 2007. Documentary Realism, Sampling Theory and Peircean Semiotics: Electronic Audiovisual Signs (Analog or Digital) as Indexes of Reality. *Doc On-line* 2: 110–117, http://www.doc.ubi.pt (Accessed April 4, 2012).

Grierson, John. 1966. *Grierson on Documentary,* ed. Forsyth Hardy. Los Angeles: University of California Press.

Guerin, Frances and Roger Hallas. 2007. *The Image and the Witness*. London: Wallflower Press.

Lind, Maria and Hito Steyerl. 2008. *The Greenroom: Reconsidering the Documentary and Contemporary Art*. Los Angeles: Sternberg Press.

Lister, Martin, Jon Dovey, Seth Giddings, Iain Grant, and Kieran Kelly. 2003. *New Media: A Critical Introduction.* London: Routledge.

Lombard, Matthew and Theresa Ditton. 1997. At the Heart of It All: The Concept of Presence. *Journal of Computer-Mediated Communication* Vol. 3, No. 2, http://jcmc.indiana.edu/vol3/issue2/lombard.html (Accessed January 12, 2012).

Manovich, Lev. 2001. *The Language of New Media.* Cambridge, MA: The MIT Press.

Murray, Janet. 2000. *Hamlet on the Holodeck.* Cambridge: MIT Press.

Neys, Joyce and Jeroen Jansz. 2010. Political Internet Games: Engaging an Audience. *European Journal of Communication,* Vol. 25, No. 3: 227–241.

Parkin, S. 2006. Interview – Darfur is Dying. *Eurogamer,* September 4, http://www.eurogamer.net (Accessed June 5, 2010).

Poremba, Cynthia. 2011. Real/Unreal: Crafting Actuality in the Documentary Videogame, PhD diss., Concordia University.

Raessens, Joost. 2006. Reality Play: Documentary Computer Games Beyond Fact and Fiction. *Popular Communication* Vol. 4: 213–224.

Rancière, Jacques. 2007. *The Politics of Aesthetics.* London: Continuum.

Rapp, Uri. 1980. *The World of Play.* Tel-Aviv: Ministry of Defense.

Renov, Michael. 1993. *Theorizing Documentary.* New York: Routledge.

Sobchack, Vivian. 2004. *Carnal Thoughts.* Berkeley: University of California Press.

Steyerl, Hito. 2007. Documentary Uncertainty. *A Prior, 15,* http://www.aprior.org/articles/28 (Accessed March 20, 2009).

Vaughan, Dai. 1999. *For Documentary: Twelve Essays.* Berkley: University of California Press.

Ward, Paul. 2002. Videogames as Remediated Animation. In *ScreenPlay: cinema/videogames/interfaces,* eds Geoff King and Tanya Krzywinska. London: Wallflower Press: 122–135.

——— 2008. Animated Realities: the Animated Film, Documentary, Realism. *Reconstruction: Studies in Contemporary Culture* Vol. 8, No. 2: 1–27.

display, process and

practice

take the b train

reconstructing the proto-cinematic

apparatus

george griffin

introduction

Media saturation: so ubiquitous, so ingenious. The newest crop of block-busters (and by extension, every little experimental animation ever made) is being delivered via streaming, Video On Demand, YouTube, file sharing, handheld devices of all sizes, speeds and colors. The delivery methods in effect tether viewers to a domestic entertainment pod or to a miniature gadget. What follows here is a glimpse into non-mediated, concrete, physical animation, situated in a unique space; you have to seek it out (see Griffin 2007: 261–63). Concrete animation shares with film and video installation a non-theatrical site-specificity, but its presence is experienced spatially as a very specific type of kinetic sculpture, one which is created only within 'synthetic time',[1] through the tricks of intermittent perception. Instead of being diffused to passive viewers of media 'eye candy', concrete animation demands active, mobile, concentrated attention.

back to basics

Despite profound changes in the landscape of animation production, since the advent of the computer, certain processes remain recognizable. Without attempting to advance a particular definition of animation, they are still dependent on a rapid display of consecutive images: sequence drawings for 2D character animation, sequential phases for 3D animation. This essential process is the same for William Kentridge and Pixar today as it was for Émile Cohl more than 100 years ago. Whether these images are the result of digital computation, based on live-action, or the painstaking estimation of an 'in-betweener', the process involves individual decisions governing two flows of segmented time: past and future. Choices affecting acceleration and tempo, subtle attitudes, and degrees of inertia occur at this in-between stage. It is also the moment when unconscious impulses, pencil wiggling, hesitations, erasures, etc. conspire to shape the image, the single phase of motion, the "privileged instant" (Bergson 1998: 331).[2]

This conscious rendering of a phase of time, from a fungible universe of possibilities, since the era of the cartoon studio, has been considered the boring, time-consuming, technical aspect of animation, no different from the mechanical recording and projecting of images. The creative energy at the heart in this period of animation was shunted off to a dimly lit utility room where obsessive loners (unionized, highly-specialized tradesmen and women) stitched together a synthetic alternate reality. Disdain for these engineers of animation has historically informed conventional wisdom ("so much work"), elite art-critical prejudice ("if it moves, it's not for us"), and the bottom-line orientation of management ("if only we could eliminate this costly labor"). Today, despite increased public interest in animation and awareness of stylistic distinctions in long-standing popular TV series and the never-ending plethora of feature films, there still remain indifference and antipathy toward the process of animation.

Animation has become so intertwined with other media through its convergence with live-action, its facile rendering of hyperrealism, and its universal distribution through packets of digital data, that one is liable to overlook its fundamental exceptionalism, its paradoxical antagonism to cinema. Though historically sharing photographic/cinematic tools and theatrical venues, animation has always been devoted to creating realms of synthetic time, imaginary events rather than recording and playing back actual events. By regressing and narrowing the focus to brief episodes of such events, brought to life by perceptual engineering, I will illustrate an emerging artistic practice in our art's shifting evolution.

Step off the A Train—animation's mainstream express bound for mass entertainment, the Cotton Club of the mind. Instead, take the B Train. It passes through an alternate territory inhabited by Gregory Barsamian, Eric Dyer, and Bill Brand: three artists, among many others, who design

and make objects of enchantment which come to life under a variety of conditions, using a wide range of technology as old as the zoetrope and as new as wearable LCD shutter lenses. The territory is not geographically literal (though Brooklyn is home to one artist, a past home to another and the site of a public art sculpture by a third), but more like an experimental, tinkering attitude toward the engines of perception. The work is unmediated, literally confined to actual space and time, without the benefits or drawbacks of distribution, transmission, and duplication. It must be sought out in museums, galleries, and other public spaces. There are certain parallels to proto-cinema[3] but it is incorrect to see the work as nostalgic or traditional: as we will see, it has one foot in the past, one in the future.

gregory barsamian: comic, craftsman, material philosopher

An artist whose studio is a machine shop, Gregory Barsamian makes kinetic, sculptural objects to exacting technical specifications, which come to life when lit by an intermittent strobe light (See Plate 28). While he uses a computer to map its physical design and electronic schematics, Barsamian's practice is literally manual labor—not the filming and editing of digital data we now associate with video and filmmaking. Apart from its utterly guileless simplicity, its purpose is to re-invent a new architecture for experiencing animation, one that re-focuses the eye and mind away from the shadowy illusion of flat images to behold the reality of a concrete object in space, fixed in a series of momentary glimpses. The shock and pleasure of viewing his work suggest the allegory of Plato's Cave, like averting your gaze from shadows and images cast on the wall to peering out into the real world to see something tangible, familiar, yet as if for the first time. Suzanne Buchan, in conversation with Barsamian, thoroughly develops the concept of "extracinematic animation" (Buchan and Barsamian 2008: 288–305).

Viewers may need to categorize Barsamian's spectacles as grotesque, surreal, or disturbing, but the response is most often astonishment, complemented by laughter; a reaction Henri Bergson considered in 1900 (Bergson 2003: unpaginated). As would Freud, Bergson admits the unflattering and unacceptable implications of laughter, e.g. reaction to pain of others, deformity, violence. But instead of a "comic of words" (Bergson 2003), Barsamian stresses its physics: inflexible, machine-like behavior, gestures, mimicry; hyperbolic, dynamic materiality, metamorphosis; and significantly, repetition. We laugh at the *Runner* (2007), Barsamian's little bronze man skipping on the teeth of a rapidly rotating circular saw blade, just as we would while watching a comedian from the silent era slipping on a banana peel and falling. Both actions are examples of Bergsonian "mechanical inelasticity" (Bergson 2003); both are artificial contrivances, not accidents; both are inevitable and repeatable, unlike the conscious

277

adaptability of natural motion. This is the soul of slapstick, from Chaplin to Jerry Lewis. And Barsamian fits easily into this ageless, universal tradition, distilling the comic, through his mechanistic virtuosity, to a higher level of philosophical wit.

The experience is also frightening. One could say awesome if the adjective still retains its visionary, ecstatic connotation. It might compare to audiences' first reaction to the Lumière Brothers' train entering the *Gare de La Ciotat* in 1895, due more to that iconic film's illusion of deep space devoured by a steel behemoth, than to its documentation of kinetic properties. Barsamian's steel machines contain a similar array of gears, switches, and armatures, whizzing about at rapid speed. You feel air currents and vibrations and hear industrial clattering; there is a disturbing compulsion to reach out, to touch it, counter-balanced by sobering lessons from childhood experiments. It would certainly lead to injury and the machine's damage or even destruction.

With few exceptions, Barsamian's works are freestanding, visible from almost any point along their perimeters. The observer's view of the constant movement is arrested by the instance of its illumination. This kinetic theater in the round—and often in the dark—offers a rich reading of actual space, as every facet of the three-dimensional figures is visible depending on one's (theoretically infinite) points of view. Unlike the zoetrope or cinema, Barsamian's persistence of vision phenomenon is not merely a function of a momentary shutter; it is produced by a finely-tuned, powerful strobe light, pulsing synchronously with the rotating motion, yet for a much shorter duration, thus freezing the motion like a fast shutter speed on a still camera.[4] Shortening shutter time and increasing illumination (related inversely to photographer Edward Weston's strategy for super-sharp still-life studies, using an f/64 diaphragm compensated by increased exposure), both freeze the motion and enhance the resolution and depth of field because the eyes' pupils are contracted. The duration of the strobe flash is between ten and 25 microseconds rather than the comparatively pokey standard for cinema. The 'Barsamian effect' is hyper-realistic, fixing a sharper, more vivid virtual image on the retina; and the temporal performance of these successive glimpses is otherworldly, preternatural. The spinning contraption produces an exhilarating rush, as if driven closer to one's eyes by centrifugal force, similar to that of an amusement park joy ride. All conspire to "create disturbance in your mind".[5]

Each Barsamian piece is a unique machine, not a prototype for mass-production—and while it is possible to document his work with film that records the sculpture in motion, the animation cannot be accurately replicated: it must be experienced *in situ*. Each piece is fabricated entirely by the artist, not sub-contracted to specialists, as is often the case in fine art production. Barsamian has mastered a broad panoply of self-taught skills to fashion wood, glass, metals (cutting, casting, forging, bending, drilling,

milling, welding) and knowledge of electronic circuitry to make the mechanisms operate flawlessly. However, they do not function as a modernist parody of machinery, like Robert Breer's or Jean Tinguely's witty kinetic sculptures.[6] Each possesses a high level of finish, craftsmanship, even sincerity. Karl Marx imagined that the worker in a socialist, classless utopia, freed from wage slavery, division of labor, and alienation, would have time to devote to art. But could he have imagined an artist using tools and processes appropriated from the assembly line? Maybe yes, if he had lived long enough to witness the industrial arts movements, like the original Bauhaus, built on a hands-on approach to design, craft, and technology. The hot-rod, Radio-Shack, DIY ethos of the America's post-war years, culminating in Stewart Brand's *Whole Earth Catalog*,[7] encouraged a generation of other directed middle-class youth to take up working-class tools and construct their own utopias. Barsamian's work stands as a philosophical pillar amidst these diverse sources. It runs counter to the modernist tradition of inversion and irony, which covertly mocks well-crafted objects; it by-passes the conservatism of post-modernism; it collapses the art/craft dichotomy.

concrete contraptions

If contemporary architecture could be reduced to two tendencies, they might hinge on the role of engineering and the degree to which the artist conceals or demonstrates the process of construction. At one pole is Frank Gehry, whose flights of fancy remain miraculously aloft due to the genius of Rick Smith, his barely acknowledged structural engineer. At the other, is Santiago Calatrava, whose aesthetic is unified with the elegance of his mechanical process. Barsamian's work tends toward the latter. One is compelled to see its naked structure; the design of the sculptural 'characters' shares the stage with the armature which transports them. This sharply contrasts with the traditional hierarchy of animated film, which privileges design and narrative over the techniques which bring them to life. The structure is always a constantly pivoting sculpture which takes one of two forms: a horizontal or vertical plane divided into discrete sculptural sectors or a helix which adds a third dimension to allow cycles of multiple sculptures to climb or fall through its internal space, as if transported on a Coney Island rollercoaster. There are generally 12–24 phases in each cycle, i.e. different objects arranged along a rotating path, such that the last in the series links back to the beginning to form an endless loop of transforming sculpture.

Barsamian explicitly states that his work is an attempt to recreate his dreams, to access the subconscious well to counteract the "chauvinism of consciousness,"[8] which is so busy excluding the rich data we absorb everyday. He says, "We need to listen a little more closely to this portal into the lost, the feared and the ignored. Here we experience things not through

the drip, drip of the conscious mind but rather the full torrent brought to us by all our senses."⁹ And yet, the experience is as much about how you see as what you see. The two could be considered contingent insofar as dreams are unique experiences demanding an exceptional method of recreation which word and image can barely satisfy. To reclaim his dream-life, Barsamian creates figures and things ripped from context, like all dreams recalled, and reassembled, like something out of a Max Ernst collage expanded to the third and fourth dimension. In *Dipping Digits* (1991), a pair of green hands scoop into an open book and haul up a fresh catch of tangled letterforms in the form of a lizard, then the hands begin to scoop again. The visions can be cycles or metamorphoses, or a combination of the two: in *Putti* (1991) a squadron of cherubs circles overhead while morphing back and forth (in a visual loop) into helicopters; a claustrophobic room is invaded by a crumbled newspaper which retreats, leaving behind a discrete turd (*Coprophagia* 1991); a monochrome head screams its pink mouth open to consume itself (*The Scream* 1998). And in a tour-de-force—*Die Falle* (1998)—a sleeping head (like many of Barsamian's sculptures an animated self-portrait) emits a blob thought-balloon that, ever ascending in a jack-knife, becomes an acrobatic human form, a curling larva, a tire, finally a human settling down to sleep on a giant mouse trap, a titular pun on trap and sleep.

The observer stares at this kinetic dream world, sculpted out of malleable material like clay, plastic, or industrial strength material like steel mesh, or even venerable materials like wood and cast bronze. The action can be parsed as a narrative or as thread of movement connected in space or as autonomous glimpses. The sequential forms retain the primitive imprint of the artist's fingers and tools that retain a direct, tactile innocence. The process is gestural and idiosyncratic, personal yet without straining to impose a signature style. It is both surreal and wonderfully artless.

artifact and runner

In 2010, Barsamian's most recent sculpture, *Artifact,* previewed at The Boiler in Brooklyn's Williamsburg, before opening at the Museum of Old and New Art in Tasmania, which commissioned it. In the installation, the cavernous brick and iron industrial space is lit by intermittent beams emerging from minute fissures running throughout an enormous, stationary, recumbent steel head, 12 feet in diameter at its greatest span. The compound curves of each skull-shard were hand-formed by the artist on an English wheel, a massive tool with two rollers (one of which is called the anvil) used to shape auto body prototypes or ship hulls. The cracks are seams intentionally left open between welded tacking points, suggesting a shattered skull; they paradoxically lend a feeling of flexible fragility to the hulking mass.

The initial effect is eerie. It is much larger than the Colossus of Constantine or Ron Meuck's self-portrait, *Mask II* (2001–2002), but stripped of all detail, save the staring eyes; more in the spirit of Brancusi's *Sleeping Muse* (1909): meditative, distracted, conscious, yet spellbound. This is not a self-portrait. And it is the first major piece in which Barsamian has concealed the animation within a casing, a façade of smooth, polished metal (a stunning exception to his usual 'Calatravan' practice). The viewer is drawn forward to discover what's inside the twinkling head. Seven oval openings of varying dimensions and heights, each with a glass blister molded to follow the head's convex contour, are portals to the unconscious. They reveal a thicket of disconnected events: a falling apple becoming a red pepper landing and disappearing into a bright green hand, or a glistening yam-like shape birthing a yellow bird which then seems to be fluttering everywhere (**See Plate 29**). A falling book, a staring purple head sporting bright red lipstick, an up-turned fedora—all exist in pulsating, transformative confusion. The only other orifices, the nostrils, allow one to hear (and feel the wind created by) the whirring internal mechanism, a rotating armature of twisted steel tubing that supports the animated objects. When it catches the strobe light this jumble becomes a chaotic field suggesting randomly firing synapses, a dynamic inner-ground for the morphing multi-hued forms welded to their arcing loops.

Runner (2008), created before *Artifact* and exhibited with it at the Boiler, has a modest scale and deceptively simple premise. A tabletop wooden cabinet, designed like a 1920s radio, gracefully rounded at the top has a four-inch diameter window on the front where one might expect a dial or speaker grille. Peering into the hole, the observer sees a vision of comic futility. A tiny bronze man is running in place on the teeth of a 10-inch carbon-steel rotary saw blade, spinning fast enough to give the scene a hint of momentary disaster, continual threat and avoidance (**See Figure 11.1**). The strobe freezes the blade's spin making it appear to be practically stationary but inching ominously forward toward its prey. The flickering irregularities of the surface (dings, nicks, spots) hint at the blade's high speed, its relentless danger. The little man, a cycle of twelve figures, each about four inches high, is cast as a primitive, anonymous everyman, anatomically correct, without distinguishing facial characteristics—a sprightly, seemingly unperturbed homunculus. The contrast between fine art (bronze figurines as might be found in a vitrine) and industry (a practical steel tool, part of every carpenter's kit) is typical of Barsamian's genial dialectics. This relationship is to be found in the contradiction between the industrial and the artisanal aspects of Barsamian's art: precision machinery harnessed to the handcrafted, hallucinatory content of his sculpture. We should also consider the art world's historical antipathy toward kinetic art, photography, cinema, particularly film animation, based on their reliance on impersonal technology contrasting with high art (for art's sake) as the

Figure 11.1
Runner, Gregory Barsamian, 2008. Photo courtesy of George Griffin.

expression of a singular, personal vision. These strictures may now seem moot in the contemporary art embrace of Kentridge,[10] but still may factor into the work of two other artists riding the B Train: Eric Dyer and Bill Brand. Both began and continue to work in the context of experimental film rather than solely in sculpture, drawing, or animation as such. Dyer's background in science and music videos, and Brand's in avant-garde and structural film, speak to the diversity of platforms from which concrete animation springs.

eric dyer: bicycling futurist, cinetropist, pixellator

Animation festival audiences were startled in 2006 by *Copenhagen Cycles* (2006), a film that re-animates footage shot from a bicycle along the baroque streets and canals of Copenhagen. This is no ordinary 'rotoscope trope', one of myriad techniques which can translate live-action into frame-by-frame animation. Nor is it a photocopied time collage like Virgil Widrich's *Fast Film* (2003). Dyer has printed, cut-out, and mounted his captured frames to build elaborate multiplane zoetropes which he then re-constitutes in real time by shooting continuously through the shutter slits. The result has a dizzy push-pull effect, sandwiching the animator's obsessive concern for that privileged instance between video's dogged pursuit of real-time documentation. It is a beautiful, multilayered tone poem that sways in and out of abstraction. The film is a mesmerizing, well-edited, satisfying work, complemented by composer John Adams's *Phrygian Gates* (1977). Dyer cut his teeth in the world of music video, TV, and experimental film[11] before embarking on the meta-cinematricks of *Copenhagen*. At the Platform Festival of 2007 in Portland, Oregon, he installed three of

the "cine-tropes,"[12] with simultaneous live video feeds projected on screens, which surrounded the viewer within a 270-degree cyclorama. By displaying the concrete machinery of illusion, simultaneously driving an environmental, cinematic experience Dyer fundamentally advances the staid gallery practice of video installation. Instead of a black box presentation he creates a performance which delightfully joins the nineteenth century to the twenty-first, and lets the viewer compare self-contained zoetrope space with a video surround.[13]

The title of Dyer's latest completed work, *The Bellows March* (2009), suggests the energy-sustaining power of injected air (**See Figure 11.2**). It uses an array of high-tech processes to ratchet up animation engineering and perception into a scientific fantasy on morphology. First, he designs and animates CGI figures which wiggle and contort through evolutionary and scalar phases. Many are designed using an accordion motif recalling a Slinky,[14] the perpetually loping children's toy. These shapes are sculpted by 3D laser-cutting printers[15] to achieve an exacting microminiaturization, then are hand-painted to achieve chromatic transformations. The figures are arranged on revolving lazy Susan platters, often stacked high like elaborate multi-tiered wedding cakes—a solid mass similar in structure to Barsamian's open helical arrangements.

Dyer employs staff and students of the Image Research Center at the University of Maryland, Baltimore County, where he has been a professor since 2004, to render each phase of the production. The final vision, where everything springs to life in real space, is achieved by LCD shutter glasses

Figure 11.2
Looking through goggles, illustrating a *Bellows March* cinetrope, 2009, at rest and in motion. Photo courtesy of Eric Dyer.

similar to those used in commercial features with two important differences: the lenses blink simultaneously, not alternating left to right, and the speed can be fine-tuned to synchronize with the rotating platter. (Symmetrical blinks refresh both eyes to successive phases of the moving diorama, while asymmetrical blinks force each eye to view alternating 2D stereo images in rapid succession to simulate 3D.)[16] The controllers driving Dyer's special lenses are prototypes, at the cutting edge of expensive experimentation.

The optimal viewing conditions require intense light flooding the platter and a close proximity to the spinning sculpture (about one to two feet) to marvel at the tiny objects mobilized into mysterious actions. It is a lapidary, hyper-realistic phenomenon, similar to Barsamian's, of actual objects defying expectations by moving in synthetic time. The spectacle is enormously complex, as hoards of life forms swarm and wiggle through their permutations in variable perspective: the viewer's eye may pan from an elevation view up to a bird's eye view as if airborne. And the cycle is consistently seamless. At this intimate proximity, one is tempted to reach out to pick up one of these squirming creatures to feel its form and bristling texture, which appear to be pulsating in impossible, random rhythms. As with the flat bottom panel of the traditional zoetrope drum, often embellished with spiraling designs, Dyer's sculptural masses reference biological development based on the Fibonacci Sequence, the essence of the golden spiral by which some flora and fauna grow without altering their shape.[17] Although using different methods to achieve intermittency the visual experience is similar to Barsamian's but there are distinct differences. Dyer's sculpture, like the photography of *Copenhagen Cycles*, is flawlessly rendered, while Barsamian's is idiosyncratic, bearing his gestural hand-print; Dyer develops his cinetropes into developmental chapters while Barsamian's pieces are stand-alone; Dyer's work thus seems scientific, while Barsamian's explores the subjectivity of the unconscious.

As with *Copenhagen Cycles*, Dyer has translated his sculptural inventions of *The Bellows March* into an exquisite, eponymous film. The spectacle is based on all 18 platters blended into a delirious life-cycle narrative. Beginning with jaunty marching concertinas, hinting at Oskar Fischinger's cigarettes,[18] yet here undercut by the stark, metallic nightmare of jackbooted fascism, *Bellows* ultimately transforms into a polychrome Garden of Eden. Emerging from primordial ooze, writhing buds become larvae, then flowering forms, which dance in complex patterns before resolving into ranks of abstract tubes and semaphores. The gaudy, pastel palette (hot pink and lime green) reminds one that this menacing hybrid species is purely synthetic, with slight chance of survival in a real jungle. The off-kilter 'squeezebox' music of Nik Phelps adds a mood of unsettling whimsy.

Dyer the sculptor is constantly planning ideal settings for the cinetropes, such as improvisational 'happenings' with live musicians. Dyer the

filmmaker sees his work as an effort to extend his "waterfall of loops and spirals"[19] into a linear narrative structure. He says his *Copenhagen* cinetropes were "thrown together quickly" as a means to an end, but with *Bellows*, sculpture and film attained equal footing: "separate experiences, different audiences."[20] Capturing a concrete animation spectacle with video, either as a 2D document for a website (*viz.* Barsamian) or for theatrical projection, may seem a limitation as it is indistinguishable from 'stop motion' animation on film. This push-pull contradiction between an autonomous sculptural animation and a video translation is an issue affecting duplication and marketing too. Artists are confronting the choice of selling unique objects and small editions to elite collectors and institutions, or distributing short films within an unstable yet potentially universal network of viewers.

Dyer's current project, *Short Ride*, now in development with the National Film Board of Canada, may address the audience issue by allowing an interactive, open-ended walk-through navigation in a controlled animated environment. He has designed a giant cinetrope, a 20-foot long spinning tunnel, which visitors will traverse on a footbridge wearing shutter glasses to view spiraling, sculptural forms. The film version will be shot in stereo 3D which will be edited by Dyer and projected using synchronous LCD shutter glasses, the same technology as mainstream 3D films such as *Avatar* and *Hugo*. Dyer hopes the substantial cost of his experimentation will soon abate so the actual sculpture may be seen more widely. His hopeful optimism extends to medical research for a cure to his degenerative eye disease, retinitis pigmentosa.[21] This artist who has conceived and produced a continually evolving, ever more complex, concrete animation project, increasingly has trouble viewing its full 3D effect. Where Dyer and Barsamian design and build kinetic, sculptural objects that occupy unique gallery spaces, to be viewed in the round, Bill Brand, long before, discovered and exploited another radically primitive and obvious spatial context for viewing concrete animation.

bill brand: subway surrealist, linear zoetropist, avant-gardist

The literal B Train refers to the visionary work of Bill Brand, *Masstransiscope*, completed in 1980 and restored in 2008 to its original, bright, cartoony exuberance (**See Figure 11.3**). It is the first work of art commissioned by New York's Metropolitan Transit Authority (MTA), and without doubt one of the most successful works of kinetic public art ever built. Yet, like 'proto-cinematic' cave drawings, it still remains nearly hidden from view. Finding it requires a patient navigation of the subway system, and an alert, dedicated response at just the right moment. It is also an unobtrusive gift to the everyday Manhattan-bound commuter who may casually peer out the subway window as the express train hurtles by an abandoned local stop. Suddenly the gloom is pierced by a luminous, animated sequence of 220

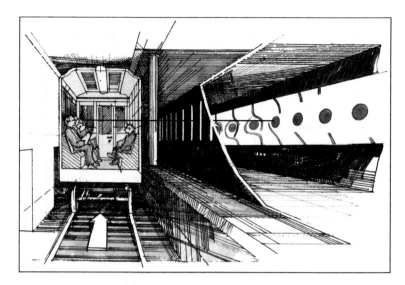

Figure 11.3

Illustration of *Masstransiscope*, Bill Brand, 1980. Courtesy of Bill Brand.

paintings (abstract doodles of angular planes, shapes and funky blobs snaking into a child's version of a rocket blasting off). Brand concedes there may be an "epic narrative about biological, cosmological, social and human development," but he says this with a twinkle in his eye.[22]

Following the first peak of the subway graffiti art movement of the 1970s (yet preceding Keith Haring's subway drawings of the 1980s), Brand's project came to life when the New York subway system (and the city government) was in financial distress. It shares with graffiti art a bold graphic sensibility, a non-commercial disdain for the art market, and an involvement in appropriating public and/or forbidden spaces. Fortunately Brand was able to sell his rejuvenating concept to the MTA on its artistic merits alone, without having to stress the content's civic virtues or its potential as a revenue-producing scheme. Indeed, as a permanent installation free of any mechanical system of movement it is resistant to tampering. It is truly public, accessible for the price of a subway ride, and is detached from, even antithetical to, the curatorial standards of the art world or cinema programming. One could classify Brand's work as a passive installation, animated solely by a moving vehicle, contrasting with Barsamian's and Dyer's which depend on activation by electro-mechanical controls located within the sculpture itself.

The jolly compound title, *Masstransiscope*, references nineteenth century pre-cinema optical gadgets. And it is seen from a train, that rich symbol of modern life, which was then reaching its apogee under the consolidating monopolies of transcontinental rail tycoons like Leland Stanford, Eadweard Muybridge's first patron for his motion studies.[23] The locomotive was able

to propel humans at astonishing speed to create distant panoramas and close-ups of flickering sequences like telegraph poles, blurred yet possibly refracted in a row of windows, suggesting, like a flipbook, the potential for animation. And the gleaming rails, streaming by like a waterfall, were pinned by successive crossties that jerked and blinked relentlessly, just like frame-lines.

Brand had his eureka moment[24] while riding Chicago's elevated Loop which transports riders in broad daylight past dense blocks of urban architectural monuments. The hypnotic effect of row upon row of flickering steel columns and girders catalyzed ideas already set in motion as an undergraduate at Antioch College, in Ohio, where his teacher was experimental, structural filmmaker Paul Sharits. Brand collaborated with Sharits on *Sound Strip / Film Strip* (1972), the seminal four-projector installation of one continuous line scratched on film, projected horizontally.[25] The result had a major impact on Brand's thinking about the materiality and synthetic temporality of cinema. His own student film, *Moment* (1972), re-composed footage of mind-numbing oscillations of advertising signage, using an innovative front-screen projection system.

Branching out of the minimalist, conceptual avant-garde context and reaching a broad audience is one of Brand's goals. *Masstransiscope* transforms the abstract to the literal, playing with perceptual phenomena like image expansion and contraction, depending on the speed of the moving train. The threads of precedence for such public art include the great twentieth-century Mexican muralist movement, specifically the work of Diego Rivera, and the visionary work of Stan VanDerBeek, the renaissance man who juggled animation, from flipbooks to computer graphics, within sculptural space to make installations by projecting films where least expected: onto the ceiling of his geodesic dome, or onto a wall of artificial steam clouds.[26] And Brand's own earlier work—cartoons in the mode of Robert Breer and Len Lye, personal-political documentaries, and optical film effects created by a range of geared contraptions of his own design, which rotated and tilted mirrors and cameras—formed a mature base in experimental cinema.[27]

Bearing these earlier influences and concepts in mind, Brand's methodology for *Masstransiscope* is based directly on the venerable, circular zoetrope, with slits acting as shutters, which Brand flattens into a linear scheme, with sequence paintings on the back wall and a black shutter-wall positioned at the edge of the subway platform, i.e. between the art and the viewer. As the train passes the station, the images are seen intermittently through the slits in the black wall. Both the black shutter-wall and sequence art wall comprise the *scope*, which can only be viewed as animated by riding on the train.

Like film, Brand's *scope* is theoretically of limitless duration, kept in check by the subway platform length, just as Muybridge had a limited

supply of cameras that determined a finite length of ground for his chronophotographic motion series. Each shutter slit has a full-spectrum fluorescent tube with an electronic ballast, which keeps the array of panels of sequence paintings continuously well-lit in otherwise total darkness. Brand further enhanced the luminosity by painting on retroreflective sheeting used for highway speed limit signage which bounces light back to motorists at night. This material was first used for film special effects in Stanley Kubrick's *2001: A Space Odyssey* (1968).[28] The image is thus brightest on the narrow axis, where the shutter aligns with the art and the viewer; it is telegraphed directly to the eye. The experience, based as it is on static, permanent artwork, differs from film projection's intermittent stream of images, as well as the work of Barsamian and Dyer, in that it makes no effort to freeze the direct perception of continual movement; it's still a zoetrope—a little blurry. Brand's spectacle reclaims abandoned public space, it reclaims the mobile energy of the passing train to generate the necessary continuous transport and, aside from replacing the light bulbs, it requires no maintenance. It is art based on sustainability, long before the term percolated into public consciousness, but more important, it's stealthy and it's cool. Referring to the experience of his *Masstransiscope*, a spectacle glimpsed out of the corner of the mind's eye, Brand says, "all media is fleeting and concrete; kinetic work may be the most fleeting!"[29]

three chapters on the same page

Concrete animation reflects a multilevel dialectic within art practice and within the culture of cinematic animation (the 'A Train'). By working in a context of speculative experimentation, these artists challenge the conventional tools and formulas of cinema. By rethinking the pre-cinematic roots of perception they make the old seem startlingly alive. Created outside an entertainment business context, their work is nonetheless easily appreciated as both public and fine art. The content often has a hand-made, archaic quality yet is propelled by technologies from both the industrial and the digital age. The most basic contradiction proposed by concrete animation is to skew our definition of 'stop motion' to include real time motion arrested in order to drive movement in synthetic time.

These artists have found different ways to tinker with the intermittent nature of perception. Instead of photochemical or digital representation, they offer brief, vivid glimpses of real things, sculpted from a wide range of material, either by hand or by computer, or simply painted on a public wall. All of them make unique constructions of continually flowing space, decisively interrupted at privileged instants. In the installations, it is the perception of a palpable object in real space (not a projected image of the object) brought to life by the varying types of directional, systematically timed photon beams in the same exhibition space, and by the viewer's own biological optical system, that sets concrete animation apart from the

cinematic experience of screen projection. These processes are transplanted from earlier eras, rooted in steel machines, gears and levers, appropriated from unlikely inventories of urban infrastructure, or stolen from the latest digital technologies driving the juggernaut of mass entertainment. Brand's single, influential installation has survived over 30 years underground and will last as long as the trains are running, to be discovered by successive generations. Dyer makes intricate optical machines for art space installations, then records and edits the performances into a single channel movie for a broad spectrum of performance venues. Barsamian dives into the past worlds of industry and handcraft to draw us back into a world of the unconscious, where objectivity comes unhinged. Each artist in his own way is exploring where his audience is located: art gallery, public space, urban forbidden zone, even theatrical cinema. Those of us making animation and/or writing on the form, perennially struggling to re-define our place within or without cinema, could do worse than to study and appreciate these radical in-betweeners.[30]

notes

1. See Griffin, George. 2005. The Anxious Pencil. In *Trickraum:Spacetricks*, eds Suzanne Buchan and Andres Janser. Basel: Christoph Merion Verlag. Synthetic time is meant to suggest the artifice of animation in contrast to the essential documentary process of cinema, which records and plays back real time events. Using myriad techniques animators piece together sequences of discrete images or objects to build either an imitation of continuous motion or an indifference to continuous motion based on strategies of discontinuity. In either case, the result is not a record of an actual performance.
2. A delicious term coined by Henri Bergson in *Creative Evolution* ([1911] 1998, Minneola, NY: Dover Books: 331). The term as theorized by Gilles Deleuze as referenced by Rosalind Krauss (110) and reconfigured by Steve Reinke (12), both in *The Sharpest Point*. Toronto: YYZ Books: 2005.
3. A portmanteau term referring to nineteenth century mechanical devices such as Phenakistoscopes and the sequence photography of Eadweard Muybridge and Jules-Étienne Marey, both regarded as precursors of the Lumières' invention based on persistence of vision. "Proto-cinema" has recently been used by Werner Herzog in his 3D documentary film *Cave of Forgotten Dreams* (2011) to describe an even earlier precursor: the pre-historic cave drawings of animals with extra legs, in Chauvet, France.
4. The cinema apparatus captures and projects a static image at a tempo of 24 frames per second, each frame for a duration of about 1/60 of a second, which introduces a slight motion blur, smoothing and tapering the action. The projector shutter disc is often divided into 3–60 degree openings to blink the single image three times, which further smoothes out the discontinuities between frames. See St George 2009.
5. From the lyrics of the song *Ooh Poo Pah Doo*. Jessie Hill, 1960.
6. See a short documentary on Jean Tinguely and his work at: http://vodpod.com/watch/16081161-u-b-u-w-e-b-film-video-jean-tinguely-sculpture-mouvante-1981 and a report on Robert Breer's 2011 retrospective at Museum Tinguely, Basel, http://www.youtube.com/watch?v=IlHLe_CE1eE

289

7. Portola Institute published the catalogs from 1968 to 1972. Thereafter, it was compiled and published by various editors and presses. Subtitled "access to tools" and printed on newsprint, the *Catalog* was a manifesto for the 1960s counter culture oriented toward ecology, communication, and practical scientific processes. It illustrated and provided sources (e.g. plans for building a stream-powered electrical generator), but did not sell products. Its original edition clearly heralded the personal computer, the internet, and the interstices between technology and the arts.

8. From Buchan et al. 2008: 298.

9. Gregory Barsamian's 2010 statement on the artist's website, http://www. gregorybarsamian.com (Accessed January 1, 2012).

10. Another example of this revisionism was the 2007 Pace Wildenstein exhibition "Picasso, Braque and Early Film in Cubism", an argument for reversed influence. Catalog editor, Bernice Rose.

11. For example, *Kinetic Sandwich* (2002), *Chopin's Bicycle* (2003).

12. As described on the artist's website, http://www.ericdyer.com

13. Griffin explores a similar theme in *Block Print* (1976), in which he photocopies (using a Xerox microfilm printer) every frame of a single-take live-action 16 mm documentary walking around a city block. The copies are then mounted as pages on a mutoscope and re-shot while traversing the same route: an animated re-enactment.

14. http://en.wikipedia.org/wiki/Slinky

15. A precise Zcorp printer based on a subtractive process also used in Aardman's sprightly film, *Nokia Dot* (2010).

16. For an explanation of liquid crystal shutter glasses, see: http://en.wikipedia. org/wiki/Liquid_crystal_shutter_glasses.

17. For an explanation of The Fibonacci Number, see: http://en.wikipedia.org/ wiki/Fibonacci_number

18. *Muratti Greift Ein* (1934). See: http://www.oskarfischinger.org/EFZoetrope. htm and http://userpages.umbc.edu/~dyer/Eric_Dyer/Films.html

19. E-mail letter to Griffin, 2011.

20. Ibid.

21. Ibid.

22. Conversation with Griffin, 2011.

23. See Rebecca Solnit. 2004. *River of Shadows: Eadweard Muybridge and the Technological Wild West*. New York: Viking Penguin. Solnit makes provocative connections between capitalism, information technology, and time/space travel in nineteenth century California, at the dawn of cinema.

24. Conversation with Griffin, 2011.

25. Ibid.

26. For more on VanDerBeek's works, see Mark Bartlett, guest ed. 2010. Special Issue: Re:Animating Stan Vanderbeek. *animation: an interdisciplinary journal*, Vol. 5, No 2.

27. Brand's website, www.bboptics.com, offers a complete description and history of his Masstransiscope, experimental films, and information on his professional services in film restoration.

28. See: http://en.wikipedia.org/wiki/2001:_A_Space_Odyssey_(film)

29. E-mail letter to Griffin, 2011.

30. For further examples of contemporary concrete animators, such as Mat Collishaw (*Garden of Unearthly Delights*, 2009) and Toshio Iwai, see: http:// www.matcollishaw.com and http://www.awn.com/mag/issue3.11/3.11pages/ morseiwai.

references

Bergson, Henri. 1998. *Creative Evolution* [1911]. Minneola, NY: Dover Books.

—— 2003 [1900]. *Laughter: An Essay on the Meaning of the Comic*. Project Gutenberg E-book, http://www.gutenberg.org/files/4352/4352-h/4352-h.htm (Accessed April 6, 2012.) Original title *Le Rire. Essai sur la signification du comique*, Paris: Félix Alcan.

Buchan, Suzanne and Gregory Barsamian. 2008. Extracinematic Animation: Gregory Barsamian in Conversation with Suzanne Buchan. In *animation: an interdisciplinary journal*, Vol. 3, No. 3, November: 288–305.

Griffin, George. 2007. Concrete Animation. In *animation: an interdisciplinary journal*, Vol. 2, No. 3, November: 259–274.

St George, Paul. 2009. Using chronophotography to replace Persistence of Vision as a theory for explaining how animation and cinema produce the illusion of continuous motion. In *Animation Studies,* Peer-Reviewed Online Journal for Animation History and Theory. http://journal.animationstudies. org (Accessed April 4, 2011).

spaces of wonder

animation and museology

e d w i n c a r e l s

> Space is now not just where things happen; things
> make space happen.
>
> O'Doherty 1999: 39

introduction

The days that animation was the guilty pleasure of a limited group of cine-
philes and discreet art devotees are over. Finally? What is at stake when ani-
mation leaves behind the limited confines of the cinema screen to surface
in the white cube or a museum wing? Purists may consider the new, warm
embrace by the art world as a suffocating gesture. What is the compensa-
tion for—on average—a serious loss of projection quality and an intense,
collective experience? From a historical point of view however, there are
several good reasons to argue that animation does belong to the exhibition
space, and that the development of animation as an artistic practice actu-
ally precedes the cinema by at least three centuries, starting with the magic
lantern. From its origins, animation can be understood both as a method

(a technology) and as a metaphor (a strategy for provoking interpretation). From the earliest days of museology, via the modernist white cube and the ubiquity of electronic images in the digital era, there is the recurring ambition to turn the site of an exhibition into a 'space of wonder,' an actualization of the historic *Wunderkammer* (curiosity chamber), where the visitor is positioned in a dynamic constellation that plays with the parameters of time and space. Yet, the practical manifestations of animation in the field of visual art often manifest a rather different, more derivative character.

animating art spaces

Since a number of short films by William Kentridge were selected in documenta X in 1997, his career took a decisive turn and the doors of major galleries, musea, art festivals and even operas, opened. This example was soon followed by younger artists, although with often less thematic richness or formal ingenuity. Since the turn of the century, the gallery world is being besieged by a new generation of assertive animation artists; and also big public institutions are opening themselves up to the legacy of animation. From PS1's *Animations* (New York 2001) to Drawing Room's *Shudder* (London 2010) and from *Il était une fois Disney* at the Grand Palais (Paris 2006), to the prestigious world tour of *Pixar, 20 Years of Animation* starting from the Australian Centre for the Moving Image (with a stop at the New York Museum of Modern Art 2006): this sudden upsurge of interest can hardly be coincidental.

From an art critical point of view, animation's popularity may be understood as an extension of the art world's recent reappraisal of craftsmanship and inclination towards design. To this, animation brings along its own set of questions about the status of the artefact, the dynamics of drawing and the allure of materiality (plasticine, inked cels, etc.). In this era of ubiquitous digital reproduction technologies, the question of hardware and physical manifestation obviously plays a role. As Lev Manovich observes: "Today, while outside one finds LCD and PDA, data projectors and DV cameras, inside a museum we may expect to find slide projectors, 16 mm film equipment, 3/4-inch video decks" (2006: 14). Yet, it is unlikely that so many musea would turn themselves into safety havens for obsolete media out of a strict concern for technological conservation.

The intervention of different media technologies in the relationship between viewer and screen(s) in the art space has become common practice. Artists and musea no longer simply offer the viewer something to look at, but place him or her inside a space that incites exploration. The question now poses itself to what extent the practice of animation brings in its own set of 'problems' or paradigms, and whether these are really new, or rather practices rooted in the past. To determine the actual relevance of animation (as confirmed by so many contemporary exhibitions), it is

293

important to retrace the evolution of museological display. The example of some emblematic artists here under consideration brings to the surface a parallel history of animation. Each of these artists has developed a distinct practice that can be called animation beyond animation, a way of presenting images that ties in with the tradition of animation before the history of cinema even started. More than purely a filmic practice, animation thus needs to be understood as the staging of an agency: the manipulation and interpretation of intervals, not only between film frames, but also between images and objects in space. As with the earliest optical toys, the animated image can only occur thanks to physical action and physiological response, always mediated by the observer.

This concept of agency, combined with notions such as scripted spaces (Norman Klein), devices of wonder (Barbara Maria Stafford) and the evolutive concept of the white cube (Brian O'Doherty), is essential when trying to grasp different manifestations of animation in the context of the *Wunderkammer*, the magic lantern performance, early avant-garde animation, kinetic art, structuralist cinema and digital animation. From a media-archaeological approach (re-interpreting the past in the light of the present, with a healthy disregard of the notion of history as progress)[1] the topicality of animation appears symptomatic of an even larger development in visual culture and what is now best described as data culture (comprising all sorts of text-, sound- and image-based manipulations of electronic information). Animation is currently no longer understood as a subset of film history, but rather the inverse: as technically older as well as culturally more significant for our media-saturated society.

Yet it is often anachronistic, handcrafted animation that is cultivated by artists for its particular aura. While the range of electronic media is expanding at incredible speed, a conversion to 'old fashioned' animation (or sometimes just an electronic emulation of it) can thus be understood as the desire of young artists to tap into a tradition on their own (technically often quite naive) terms. Crude plasticine creatures, rudimentary silhouettes, the soberness of a simple felt pen or some straightforward graffiti marks: Nathalie Djurberg, Kara Walker, David Shrigley and Robin Rhode are successful examples of artists who revive techniques and strategies that often go back to the earliest days of animation film. Whatever their style, these artists all embed their short film works in installations. The unavoidable curatorial question—whether or how to present linear works as permanent loops—again ties in with the genealogy of animation, before the advent of cinema. With, on the one hand the magic lantern, and on the other the thaumatrope, a linear and a looped mode of display already was in place long before the filmstrip occurred. Mary Ann Doane situates such a dialectic in a variation on this opposition: "It could be said that the cinema, immaterial product of a beam of light, is haunted by optical toys; by the miniature, touchable, manipulable, opaque image" (Doane 2009: 152).

The most distinctive feature in comparison with live-action cinema is that animation is above all the art of producing, not re-producing time. But when discussing animation within the domain of visual art, the main question to be addressed is how this manifestation of an autonomous time-regime is stored and then released again in a given space. What is animation, other than film? Time taking place? Where can animation take place? Where does animation exist, if not on film? This inevitably leads to questions about scenography. "Any narrative, object, relationship or action has to be or take place somewhere," Suzanne Buchan writes in the catalog to her *Spacetricks* exhibition, co-curated with Andres Janser for the Museum of Design Zurich (2005: 6). Buchan underlines that animation film "has the unique quality to create spaces that have little in common with our lived experience of the world: in animation, there is a preference for presenting fantastic, invented and often impossible places" (6). Yet how can this characteristic be retained in the realm of actual space? How can an exhibition on animation signify more than a comment on the actual film, like an extra on a DVD? It is not because Disney auctions their animation cels as autonomous art works, that this effectively implies an artistic relevance for the pro-filmic material to exist next to a finished film. Obviously, art history offers legitimate arguments to value a sketch as much as a finished piece, and to promote an artefact as art 'after the fact.' But when dealing with spatial effects, then the agency of the architecture of the exhibition room needs to be addressed as well, since exhibition space always has been an important marker of meaning for modern art. How does the artwork 'function' in the space, how does its manifestation make sense?

A good example of the challenge, intricate to this question of the spatialization of a time-based medium, was the *Watch Me Move: The Animation Show* exhibition (The Barbican Art Gallery, London 2011). Clearly, the organizers wrestled with the problem of how to equate artistic integrity with the integral viewing of so many canonic titles. With its ambition to introduce a wide-ranging selection from the history of animation to a broader audience, it allowed the audience to move freely from one projection to another. Only one intermediary space showed objects rather than moving images: a quite random mix of antique optical toys, vintage merchandise and contemporary artworks. There was also a room where film-fragments and clips from TV series were projected on two huge, opposing surfaces. Emphasis however clearly lay on the narrative short film, presented either in modules for straightforward viewing, or in stylized, designed spaces. The earliest historical examples in this film-museological trajectory were to be found on screens floating freely in space, surrounded by suggestive, semi-transparent curtains of loose black threads. The idea was perhaps to return the visitor to a viewing situation before the nickelodeon, when the cinema was just one among many attractions on a fairground. However, instead of rivalling for attention with the live attractions in a historical

amusement park, here the screens seemed to be competing among each other. The cacophonous collage of so many films led to some incongruous combinations, such as the Quay Brothers' *In Absentia* (2000) sandwiched between a *Jurassic Park* clip (Steven Spielberg 1993) and William Kentridge's *Shadow Procession (1999)*. *Watch Me Move* was an exhibition with many key figures present, but the intervals between them did not provoke an interesting dynamic. A fundamental concept in the technique of animation is the 'key-frame,' a crucial position of a figure. The in-betweener is then the one who fills in the necessary intermediary steps of that figure to complete its movement. In the case of an exhibition, one could consider the artist or curator as the one who determines the keyframes, inviting the visitor to do the 'in-betweening'.

Traditionally, in the museum, the visitor is free to move among images that are static; in the movie theater, it is the opposite. And although the eyes are free to scan the screen, there is no control over the order of the images and the duration of the observation. This fundamental difference in freedom of movement (both phyically and mentally) is allowing the museum visitor to bridge the gaps between the works according to his or her own tempo, in other words: to choose one's own keyframes, to animate *en passant* the intervals and to determine the duration of the visual experience. To look at art in a cinematographic way was the explicit prem-ise of Philippe-Alain Michaud with his 2006 Pompidou exhibition *Le Mouvement des Images*. In the catalog he writes:

> Nowadays, at the dawn of the 21st century, while we are witnessing a massive migration of images in motion from screening rooms to exhibition spaces, a migration borne along by the digital revolution and prepared by a twofold phenomenon of dematerialization of works plus a return to theatricality of the art scene, it becomes possible, not to say necessary, to redefine the cinema beyond the experi-mental conditions which governed it in the 20th-cen-tury—that is to say, no longer from the limited viewpoint of film history, but, at the crossroads of live spectacle and visual art, from a viewpoint expanded to encompass a gen-eral history of representation. (Michaud 2006: 16)

Matching modern art to the model of cinema (instead of vice versa), and recognizing *a posteriori* how a paradigm can already be operative long before it is recognized as such: this is also applicable to the praxis of animation. Focussing on four sets of artistic practices, the following text puts to the fore a range of curatorial approaches. What these artists essentially have in common is that they all 'think out of the (black) box', not only by demon-strating an expanded notion of animation and engaging in a dialogue with their surrounding setting, but also through a resolute destabilization of the space around their work, thereby according a central role to the viewer.

Although clearly distinct from each other, each case consciously engages in a museological discourse, linking the notion of animation to either a historical, a modernist or a post-modern notion of museum practice. From wandering around the installation work of the Brothers Quay, grounded in the pre-modern history of museology (the peepbox and diorama), we shift to the white cube surroundings of Robert Breer's revolutionary yet discrete kinetic sculptures, moving on to the disorienting, multidisciplinary manifestations of 'Annlee' (an avatar temporarily owned by Pierre Huyghe and Philippe Parreno), to end up standing in the middle of a *Line Describing a Cone*—the famous expanded cinema piece by Anthony McCall. The way these artists have conceptualized their work around the notion of animation as a method and/or a metaphor, provides a useful context to develop some more general insights on the potential of animation for the contemporary exhibition space.

keyframe one: animating history (the brothers quay)

> The bristling curiosity cabinet is the spectacular embodiment of the ancient, force-filled microcosm and the modern, 'chaotic' cosmos …. When opened, the geometry of the chest's structure dissolves, its multimedia fragments spilling into adjacent spaces. (Stafford 2001: 2–3)

Since they combined their anamorphic fairy tale excursion of *The Comb* (- *From the Museums of Sleep*, 1990) with a more explanatory, but no less suggestive documentary on the same phenomenon of visual distortion (*De Artificialia Perspectiva*—or *Anamorphosis*, 1991), the Brothers Quay have continued to warp the distinction between filmic and museum spaces through a string of commissioned films in which they explore particular collections, typically approaching these through the eyes of a solitary, night-time visitor in a *Wunderkammer*.[2] These recent documentaries are no less anamorphic in the sense that each is made from a radically singular viewpoint, and rather mystifies than elucidates. Like their painting predecessors from the mannerist epoch, the Brothers Quay systematically build in disorienting signals as ironic commentaries on the notion of 'true vision'. In 1997, they started applying this approach to installation-work and objects for the museum space, involving the visitor in a carefully choreographed interplay between objects and sightlines.

Before musea became clearly defined spaces and canonized artworks were aligned to become a frame of reference, the seventeenth century *Wunderkammer* was a demonstrative place, where the heterogeneity of a collection was matched with the curiosity of the privileged guest. The whole space functioned like the optical toys of the nineteenth century (also called 'devices of wonder'): as a playground for experimentation. With the gradual consolidation of the museum model, the proximity and active

involvement of the visitor within these semi-scientific spaces was traded against accessibility for larger audiences. As a consequence, the objects on display were no longer kept within reach, but presented either framed or in vitrines. This led to the classic paradigm of all musea: to conserve in order to display, aimed at a purely visual decoding of artworks and artefacts.

By putting things in a room or in a box, musea became instruments to direct our gaze. Confining the space around objects created a systematic focus, and the format of presentation became increasingly systematized. In the course of the twentieth century, the convention of the white cube became the guiding principle to exhibit contemporary art: "Unshadowed, white, clean, artificial, the space is devoted to the technology of aesthetics" (O'Doherty 1999: 15). With his influential essay *Inside the White Cube* Brian O'Doherty famously demonstrated how the history of modern art correlates with changes in that space and the way we position ourselves within. Already in 1976, he observed "We have now reached a point where we see not the art but the space first" (1976: 14). Not only did the actual objects on display become secondary to a narrative of spatial experience of the interior. Since the Seventies, attention has also increasingly shifted towards the exterior of the building, the experience of the space outside the museum, as epitomized by the so-called Bilbao-effect: all over the world, the most reputed architects are solicited to turn musea into optical boxes of gigantic dimensions.

Everything begins with mobilizing the individual viewer, a technique Norman Klein calls "scripting space" (2004: 2). In his book *The Vatican to Vegas: A History of Special Effects,* Klein describes a variety of public spaces that are scripted such that the spectator assumes the position of a central character in an imaginary story. The script Klein alludes to is not a literal, but a visual one. He demonstrates how the parameters of film production have their roots in Baroque culture:

> By 1620, technology to support a kind of 'cinema' was in place: much finer lenses, theatrical lighting, mirrored projectors to bounce an image from place to place; manuals on geometric systems, from math to mapmaking, to building 'chariots' for actors to ascend or descend. 'Camera' then amounted to a 'cinematic' room. The room ran movies of a kind. The movies relied on convergence. Optical, sculptural, and theatrical illusion were squeezed inside the same space. (Klein 2004: 61)

The contemporary dialectic between animation, cinema and the museum thus has its roots in the mid-seventeenth century, when the principle of the camera obscura was inverted and the first magic lantern slides were projected.[3] And as the evolution of the optical toy in the early nineteenth

century illustrates, the manifestation of animated images as an autonomous art ran parallel with the elaboration of visual strategies within the newly developing format of the autonomous exhibition space (as opposed to the private collection).[4] For Klein, the prototypical notion of animation, as a manifestation of spatialized special effects, is first and foremost an architectural phenomenon. Stafford on the other hand, allows the viewer (or user) a much freer position. He or she is less the object of immersion, and more an autonomous subject, investigating from the outset a view of the outside world on a reduced scale. In her essay *Revealing Technologies/Magical Domains*, she describes how, long before there was a museum setting as such, the mutable *Wunderschrank* (curiosity cabinet) already invited a "sensory structuring of common experience" (Stafford 2001: 11). For her exhibition *Devices of Wonder—From the World in a Box to Images on a Screen* (2001), she significantly shifted the focus from the traditional museological marker of the *Kammer* (chamber) to the *Kabinet* (cabinet), linking these sixteenth, seventeenth, and eighteenth century contraptions even further back to the tradition of the *memory theaters*: "The *Wunderschrank* belongs to a whole gamut of hollow furnishings awaiting the incorporation of far-fetched contents that rely on the user for activation" (Stafford 2001: 7). As the discriminating choices between big projection and small monitors in the *Watch Me Move* exhibition clearly demonstrated, this dynamic tension between the space and its contents, and the experience of different scales (from looking up to big rooms to looking down into small cases), is still a major concern in contemporary exhibition design.

loplop's nest

This interplay between the agency of the visitor and the seductive coercion of an exhibition space (the tension between freedom of movement and the fixed, unique vantage point that allows to decode an anamorphic image) is precisely a central motif in the work the Brothers Quay. Despite their fairytale-like figures and decors, they intrinsically make experimental films, confusing the viewer with a disorienting frenzy of audio-visual impulses. The problematization of a strictly visual translation of the sensation of space and the tactile sense has been a crucial concern in all their work. Their favorite lead character is a passive *flâneur* roaming Benjaminian passages, just like the visitor of a historical panorama who is both free to move, yet unable to really grasp the image. On some occasions they conceive their 'dramatis personae' much like a secret nighttime museum visitor, transgressing the rule not to touch.[5]

Never 'just' filmmakers, the Brothers Quay always induce a sense of calligraphy in their typographies, book covers, stage designs, exhibitions and theatrical *mise-en-scène*, prolonging curvaceous traces in the sets and props through the choreographed gestures and trajectories of

their protagonists.[6] In opposition to the standard visual grammar of narrative film, their camera never transcends itself to place the viewer in the position of an ideal and unseen witness. It rather operates as a participating character on the set. Within an installation space however, this becomes a matter of choreographing the gaze of the viewer rather than that of a camera.

One of the most widely seen projects by the Brothers Quay as installation artists has been *Dormitorium*.[7] In 2006, they began exhibiting the miniature sets of their films as a configuration of two dozen small dioramas. The impact of this ensemble has frequently been compared to a curiosity cabinet. In their non-linear configuration, filling a whole exhibition space, the status of the ensemble of the 'sleeping' *Dormitorium* sets transcends that of a presentation of original pro-filmic objects. Behind glass, the collaged still lives lose their documentary character, and become Joseph Cornell-like boxes.

Since the opening scene of *Street of Crocodiles* at least, the Brothers Quay have cultivated a fascination for visual contraptions that require an active approach by the viewer, in the lineage of peep shows and optical boxes. When the caretaker of a dilapidated theater triggers an automaton by spitting some saliva into a wooden 'oesophagus'—resembling a mutated version of an Edison mutoscope—the film liberates its central character to follow his desire for sensory experiences. Transposing the logic of their cinematographic universe into actual space, the Brothers Quay lure their visitor into a similarly extrapolated optical device, where movement is free, and yet steered by spatial guidelines. In the first installments of *Dormitorium*, filling a complete exhibition space, the visitor was already obliged to choose at the entrance between starting from the left or the right side. The trajectory through the presentation was explicitly non-linear, thus immediately raising an awareness of ambulation in space. In their installations, they inverse the restrained frenzy of their animated films (rhythmic movements of the camera, elliptic editing, and a hypnotizing flicker) into a threatening calm. Yet in both configurations, the viewer becomes part of the optical mechanism and is instrumentalized to activate the space, to become the animator of curved lines, dead objects or still frames.

This was already the case with their first autonomous museum project, the mysterious optical box *Loplop's Nest* (1997). This anachronistic *Wunderkabinet* functioned as both a deconstruction and a reconstruction of their short film *Rehearsals for Extinct Anatomies* (1988), combining glimpses of visual motifs of their film with mystifying text signs as surrealist intertitles.[8] To grasp what was inside *Loplop's Nest*, one had to bend one's knees, stand on one's toes, and walk around the box (**See Figure 12.1**). Confronted with a dozen lenses and viewfinders that abstract rather than actually reveal the inner sanctum of this incongruous piece of furniture (a large scale wooden chest on a pedestal), it was up to the viewer to imagine what

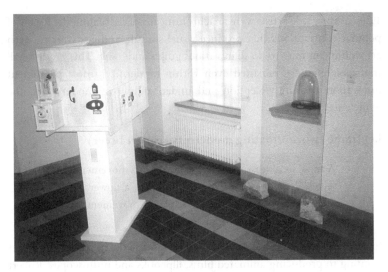

Figure 12.1

Loplop's Nest, Brothers Quay, 1997. Installation shot (with 'Please Sniff' object in background) at Kunsthal Sint-Pieters, Gent, 1998. Photograph: Edwin Carels.

was lurking inside, to move from peephole to peephole and mentally animate the intervals between the glimpsed insights (**See Plate 30**). Or as Stafford describes the interaction with *Loplop's* historical predecessors: "The cosmos as displayed in the *Kunstkammer* was not so much a static tableau to be contemplated as it was a drama of possible relationships to be explored" (Stafford 2001: 6).

Whereas in the particular case of the Brothers Quay, the interest in peepshows may be linked to their fascination for miniature universes and puppet theater, the reconsideration of early formats of optical entertainment and visual display has meanwhile become a wider phenomenon. Precisely around the time when digital media and wearable gadgets like smartphones and global positioning systems started to alter our perception of space and distance, musea showed a renewed interest in the archaeology of optical contraptions. In most of these exhibitions, the relationship with contemporary art is made explicit or at least alluded to. They imply a continuity that has run parallel with the development of the museum concept: from the magic lantern to avant-garde cinema, and from the peepbox to contemporary mixed media art. But rarely do these illustrations move from the comparative to the conceptual level, in a way that Marcel Duchamp already demonstrated early on in the twentieth century.[9] Wittier than most of his successors in contemporary art, Duchamp understood why optical toys historically had been considered at once as philosophical toys, and were applied both as a method (for visual effects) and a metaphor (for the relativity of sight).[10] Indeed, when modernity first peaked in the

1920s, avant-garde artists were anachronistically accentuating the legacy of popular contraptions that produce visual stimuli, and post-war modern art would continue to do so in various guises and—*isms*. This 'traditional' frame of reference persisted even within modernity's most prominent innovation to our perception and understanding of modern art: the white cube.

keyframe two: animating modernity (robert breer)

> A small local feast, an object defined by its movement and which does not exist except through it, a flower which fades the moment it stops, a pure play of movement just as there are pure plays of light. (Sartre 1949)[11]

In the mid-1950s, a young American in Paris made the move from abstract painting to producing animated films, flipbooks and mutoscopes. Robert Breer orbited around the Galerie Denise René, and even had the opportunity to invite Marcel Duchamp for a studio visit. "Very nice, but don't you think they're a bit too fast?" was his first reaction when Breer showed him his early films.[12] The most explosive one of them (*Recreation* 1956) was aimed at the least possible feeling of continuity, presenting with nearly each frame an entirely different image. Prior to this meeting, both artists were included in *Le Mouvement*, the notorious show that in April 1955 claimed kinetic art as a collective movement and launched the careers of Victor Vasarely, Jesús Rafael Soto, Pol Bury and others. Alexander Calder and Duchamp were included to ground the show in the historical avant-garde. In hindsight, the importance of this configuration of artists proved to be a key moment for conceptually expanding the presentation of the animated image and its expansion into the gallery space. Breer was contributing rather discretely with 'just' a flipbook. Yet historically, this *Image par Images* is arguably the first folioscope to be commissioned by a gallery as a valid medium for contemporary art, elevating a century-old optical toy into the realm of modernity. From then on, Breer continued throughout his career to alternate between filmmaking and constructing kinetic objects and sculptures, without any hierarchical distinction.

The discussion on the definition of kinetic art (at the time still referred to as *dynamism* by Denise René[13]) still resonates. How to deal with art that needs to be put in motion by the visitor? Is the mobility of the visitor in the gallery also part of the kinetic aesthetic? Do the mechanics of kinetic art also comprise cinema? Or vice versa: can cinema, including animation, be considered as a substrand of motorized, kinetic art? In 1955, a yellow handout was released at the occasion of *Le Mouvement*, but behind this collective stance—positing that color, light, movement, and time would form the foundation for the future development of kinetic art—there was a multitude of rivalling notions, even among the main organizers of the

show (Vasarely, Hultén, René). Roger Bordier, the author of the so-called 'yellow manifesto' (*Manifeste Jaune* 1955) even suggested to put theater, dance and Baroque light shows in the category of kinetic art (Bordier 2010: 9).

motorized minimalism

After this first momentum of kinetic art, various other 'movements' followed, such as Op Art and the widely publicized, touring exhibition *The Responsive Eye* (MoMA, New York 1965). In the mid-1960s, Robert Breer created several abstract geometric sculptures that, when reproduced on photographs, are completely in tune with the distilled, stripped down aesthetics of minimalism, then also dominating the art discourse. As with a typical Carl Andre or Robert Morris sculpture, the visitor is free to walk around or along Breer's sober, geometric constructions. However, their essential characteristic is that they hide a motor inside, which allows the sculptures to move extremely slowly across the floor, thus adding a particularly subtle *coup de théâtre* once the visitor notices the changed positions of the works. Their motorized, usually hardly perceptible displacement endows Breer's pieces with an extra sensation of the passage of time and destabilizes the white cube's apparent neutrality.[14] His modernist looking mono-volumes (*Floats*, or *creepies*, as he called them generically) often carry titles that provoke ironic connotations. Discarding the pedestal to let the sculptures explore the ground surface of the gallery meant opening up a democratic dialogue between viewer and artwork: "This changes the role of the viewer completely from the one assigned to him in front of an immovable statue or, in fact, in front of a kinetic work. Not only do the viewers stand—because of the missing pedestal—on the same level as the work, but the artwork also competes for their (living-)space" (Holl 2011: 102). Breer's strategy has always been one of balancing between complementary positions. Combining systemization with unpredictability, he has produced all types of animated art, from hyperfast films to extremely slow sculptures, challenging the viewer to use his or her feet to explore them in full detail, thus allowing them a sense of agency.

Throughout a career spanning five decades, Breer has consistently adapted 'primitive' animation formats such as the mutoscope (**See Figure 12.2**), the folioscope, the stereoscope and the diorama to his own absurdist logic. In the last period of his career, his subversion of the space extended from objects in the room to motorized clouds on the ceiling, to the experience of the wall itself. His *Panoramas* are wall-mounted objects made from multi-layered cut-outs in wood, that incite the viewer to walk closely along a film-less film in order to 'activate' it by mentally joining all the glimpses visible through holes in his oblong construction. Breer also added a life-size section of a white cube to his ensemble of *Floats* (**See Plate 31**).

Figure 12.2

Mutoscopes, ©Robert Breer, 1964. Photograph: Edwin Carels.

Imperceptibly his *Floating Wall* (2009) lurks on the gallery visitor, the mobile white wall continuously altering space and perspective, and adding an sense of composition in time to the space. The effect is not merely visual but also directly physical. The 'impurity' of Breer's approach is clearly intent on a physical, not a purely optical experience. His kinetic works always address an embodied viewer. Always focused on the experience of movement as an autonomous value, not limited to a particular medium, Breer chose never to adhere to any particular art movement but preferred, as already apparent in the group show of 1955, the position of an active bystander.

As the inclusion of Duchamp's motor-driven *Rotary Demisphere* (1925) in *Le Mouvement* already made clear, the history of animation cannot be dissociated from larger developments within twentieth century avant-garde art, just as the genealogy of the museum, the parallel evolution of both architectural and technological strategies of visualization and presentation is part of the history of animation. Prolonging the legacy of optical toys to

critically engage with what he dismissed as 'retinal art' was a consistently recurring strategy in the oeuvre of Duchamp. In 1926, Duchamp continued his exploration of impossible dimensions in animation with his film *Anémic Cinéma*. When in the 1920s the feature film industry absorbed animation as a subgenre within its serial production process, the intrinsic methodology behind animation at the same time lay at the foundations of experimental cinema. It was adapted on the one hand to provoke or even subvert the conventional art circuit, on the other hand it also allowed to

expand on abstract painting. Through Surrealism, but also Bauhaus, and Constructivism: animation was always part of the equation in terms of avant-garde strategies. Robert Breer's work is to a large extent indebted to the abstract and conceptual avant-gardes of the 1920s, that critically explored notions of space and time, already taking into account the physiology of the viewer.

And yet, many art movements later, regardless profound technological developments, the white cube remains the prevailing format to present contemporary art. In the era of electronic spheres and virtual space, the empty environment of the white cube is still offering opportunity to reflect upon (and commodify) artist's responses to culturally important dynamics and processes. In parallel with the popularity of animation and devices of wonder in the museum world, the historical examples of kinetic and optical art are currently given prominence again, after many decades of gathering dust in the darkness of storage spaces.[15] From programming the agency of a machine to composing a space for the viewer to respond to: in our set of examples the focus thus shifts from the object, to the space, to the interval or in-between, and finally to explore the manifestation of agency as such.

keyframe three: animating postmodernity (parreno, huyghe, and 'annlee')

> Installation art can be used as a barometer for the historical relationship between avant-garde art and the museum.
> (Reiss 1999: XV)[16]

In the era of social media and non-stop upgrades of audiovisual applications, the art of the moving image is understood in a much wider sense, and hence within a much longer tradition. Film and media classes converge, history books are rewritten and in the musea the oldest and newest technologies complement each other. William Kentridge had already started expanding his vocabulary in 2004 with his own interpretations of antiquated optical devices such as anamorphic mirrors, phenakistoscopes and stereographs, or even as early as 1999 if we consider his *Shadow Procession* to be an automated form of *ombres chinoises*. Through exhibition titles such as *Seeing Double* (2008) and *What We See & What We Know* (2010) it is obvious that Kentridge intentionally problematizes the notion of perception. His main theme however, remains the evocation of lived memory, history and the inner life. In combination with his style of graphics, the impact of referring to outdated technology is often quite literally a trigger for nostalgic effect. Artists such as The Brothers Quay, Robert Breer or Philippe Parreno make use of optical contraptions, but, unlike Kentridge, less to deal with history than with the experience of time in the actual 'now', the interpretation of the interval, the distance between the image and the eye, the lived moment.

Understanding animation as an aesthetic strategy to produce a different and yet physiologically experienced time regime, the crux of the process lies in the interplay between consecutive images or frames, bridging a difference at each step. In animation jargon: it is a question of in-betweening, filling in the gaps between two keyframes.

animating the museum

Philippe Parreno pushes this principle to the extreme, producing with each exhibition a temporary autonomous zone that comes with its own parameters of time and space. On a small scale for instance, he invites visitors to come back day-after-day, to the same gallery, to be able to observe minute changes or variations of a large cell-drawing on a lightbox (e.g., *What Do You Believe, Your Eyes or My Words? Speaking Drawing* 2007).[17] On a larger scale, as with his first retrospective *Alien Seasons* (Musée de l'Art Moderne de la Ville de Paris 2002), he scripts an entire museum space to follow a temporal partition, linking all components of the exhibition to each other, so the visitor appears to walk through a filmic montage. An even more radical play with intervals was his recent retrospective 'suite,' that interrelated Zürich (Kunsthalle 2009), Paris (Centre Pompidou 2009), Dublin (Irish Museum of Modern Art 2009–2010), and New York (Bard College 2009–2010). Only those who could add up all four locations (or keyframes) got the complete picture.

Treating the exhibition as a medium in its own right, Parreno systematically explores and expands its possibilities as an integral 'object' rather than as a collection of individual works. *The In-between* (2003) is also the title of a book on Anne Sanders Films, the production company around Parreno, Dominique Gonzalez-Foerster, Charles de Meaux, and Pierre Huyghe. This is also the 'studio' that has facilitated the collective *film d'imaginaire* project *No Ghost Just a Shell* (1999–2002) centered around a fictive character 'Annlee'. Referencing the classic 1995 anime film *Ghost in the Shell* (Mamoru Oshii 1991), in 1999, Philippe Parreno and Pierre Huyghe acquired the copyright for a graphic figure called 'Annlee' and her original image from the Japanese manga agency Kworks **(See Plate 32)**. 'Annlee' was not expensive, as she had no particular qualities, and so she would have disappeared from the Anime scene very quickly. The duo then offered 'Annlee' free of charge to a series of artists, to be used for their own stories. Fifteen participants gave 'Annlee' two dozen different emanations.[18] Each artist shaped a new chapter in 'Annlee's' non-linear history, complicating her existence as an empty sign, as well as complicating their own oeuvre with only a small segment of a collective project. After 3 years, Huyghe and Parreno formally (even legally) transferred the 'Annlee' copyright back to 'Annlee' 'herself'. To end the project the artists staged a disappearance in the sky through the *mise-en-scène* of a firework (*A Smile Without a Cat*, Art Basel fair, Miami 2002). And still 'Annlee' is not fully allowed an afterlife of

her own, as she was sold to the Van Abbemuseum (Eindhoven), where the entire ensemble of *No Ghost Just a Shell* found a permanent depository, allegedly the first group show to be bought in all its heterogeneous integrity by a museum. Comprising both a series of animated videoworks, posters, a neon drawing, a wooden sculpture, a book and even a painting, this constellation defies any simple categorization, posing again an avant-gardist challenge to the museum, albeit it with playful acceptance. The artist duo even conceived of a robot that follows a programmed pattern, moving about the wide white space like a kinetic sculpture to project the films on varying segments of the walls.

Manifestly a multi-media artwork, *No Ghost Just a Shell* does make sense to experience in small, individual portions, as long as conceptually the sense of an ensemble is kept in mind. The ideal presentation, according to the artists, would have been a simultaneous manifestation in as many different cities as there are pieces to show, forcing the viewer to bridge serious distances in order to mentally complete a picture. At once practicing and questioning ubiquity, network structures, globalization and disintegration, the most flagrant paradox remains that the readymade commodity 'Annlee' was never exploited as merchandise (T-shirts, stickers, etc.), as is normally the case with Disney, Pixar, or any similar enterprise. If anything, 'Annlee' was called into animated existence to militate for the principle of multiplication of the same as a form of difference.

augmented animation

The rhetorical question remains why Parreno and Huyghe did not dismiss the tension between the real and the art world altogether. They could have just as well conceived their whole project for the context of the internet instead. Technically, they were too early to come up with a solution like Chris Marker did for his online retrospective *Ouvroir* (2008), virtually opening up to the world via the online MMORG Second Life.[19] And yet, already in 1999 both architecture and avatars were also being constructed using the same keyboard and with similar algorithms. It was likely that Parreno and Huyghe's motivation was that this would not raise the same level of phenomenological doubt as when experiencing displacement in a physical 'space of wonder' where the viewer can actively partake in the animation of real intervals. As Lev Manovich concludes when he describes the shift from virtual reality (without ties to the physical world) towards the opposite, a hybrid, augmented experience within reality itself: "I suggest that the design of electronically augmented space can be approached as an architectural problem. In other words, architects along with artists can take the next logical step to consider the 'invisible' space of electronic data flows as substance rather than just a void—something that needs a structure, a politics, and a poetics" (2006: 237).

From introducing their film language in a museum context (Brothers Quay) to transcoding the museum as a filmic experience (Breer), to mediating reality by artistic means (Parreno/Huyghe): the question always revolves around the configuration of space, technology and the embodied gaze. Whereas animation can dispose of film as well as the screen as mediators for its inventive language of artificial time, it cannot do without any wider technological framework, a visual configuration, a viewing device. From the earliest optical toys before the cinema, to the animated applications of the multi-media era, a viewing experience always happens in a particular spatial constellation and involves an interaction with technology. This staging of agency implies a string of museological codes and conventions that are explicitly confronted by the individual artists here under consideration, but that have also been critically addressed in a more structural way, at the time when artists approached avant-garde film, animation and installation art on a more explicitly analytical, even theoretical level.

keyframe four: animating light in space (anthony mccall)

> A house that has been experienced is not an inert box. Inhabited space transcends geometrical space. (Bachelard 1994: 47)[20]

Every artist craves for an accommodating context for his work, because only then can it come into existence: in the eye of a public, an individual viewer first of all. More than any other visual medium, animation always depends on this participation of the observer to link the individual frames together. And this time-based experience needs to be located. No matter how inventive a new generation of media artists' works is, embracing both the language and legacy of animation as a natural part of their artistic vocabulary, most still address their works with this other, architectural machine of vision in mind: the gallery or museum. It is this realm of authority which turns their creations into 'apparitions'. Jean-Louis Déotte suggests, "The museum is the type of institution that has the power to reveal a novel object; the work of art, a new subject: the aesthetic subject, and a new relationship between the two: disinterested contemplation" (2011: 10).[21] The basic script for a museum is to create space around time; it is a time-machine where different eras and centuries share the same spatial coordinates, a place where things are put in a historical perspective, scripted by the powers that be.

The emergence of the museum as a public spectacle at the end of the eighteenth century coincided with the introduction of the first animated multi-media entertainment in the audiovisual arts. In 1793, the Louvre opened its doors to the general public; in 1797, Etienne-Gaspard Robertson started with his *fantasmagories*, which he advertised as *résurrections à la carte*. In an abandoned Capucine convent near the Place Vendôme in Paris, he

scripted the space with an innovative audiovisual mix that is now considered a form of expanded cinema *avant la lettre*, and thus laid the foundations of our contemporary hybrid and highly immersive multimedia culture.[22] With death—and the guillotine—as his main source of inspiration (it was the aftermath of the French Revolution), he offered the citizens an opportunity to bring back their beloved lost ones by projecting familiar faces on a curtain of smoke during theatrical, heavily ritualized performances. There was a strong sense of interaction and the experience of the moving image surpassed the boundaries of the screen, as magic lanterns were either hidden behind a translucent screen, or carried around the room to project from unexpected angles. Laurent Manoni stresses the innovative use of a magic lantern on wheels: "This invention transformed the frame, perspective and scenic space of the projection. The traditional procession of images, used since Huygens' time, was abandoned: now animated figures cross the screen in all directions, loomed up from the base of the screen, came towards the viewer at an astonishing speed, and then disappeared suddenly. The combination of the movable lantern and the moving slide were an essential step forward in the history of 'moving' projection" (Manoni 2000: 141). Almost exactly a hundred years before the notorious Lumière film of an arrival of a train at the Ciotat station was presented to a panicking public, Robertson already proved the impressive dynamic of a moving image, seemingly coming straight towards the audience.

para-cinema

Since the original *fantasmagoria*, animating images through projection on a dynamic, ephemeral fogscreen was not developed much further until in 1973, when Anthony McCall wanted to show a white dot of projected light slowly growing into a (nearly) complete circle on a black background. He used a rostrum camera[23] to make the resolutely minimalist animation *Line Describing a Cone*, which he presented on a freestanding 16 mm-projector in the middle of a gallery space. Instead of using a screen McCall filled the empty space with circulating smoke, originally coming from tobacco or incense (**See Figure 12.3**). Conceived as a solid light sculpture, the viewer gradually sees a delineated cone of light, hanging in midair and modulating the space around it (**See Figure 12.4**). As Philippe-Alain Michaud summarizes:

> The displacement of emphasis from the projected image toward the projection phenomenon results in the following: the geometricization of space: the gallery's homogenous and omnidirectional space replaces the cinema's heterogenous space, formed as it is by different, qualitatively distinct place (screen, theater, projection booth). (Michaud 2011: 13)

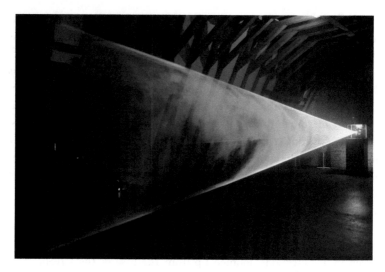

Figure 12.3

Anthony McCall, *Line Describing a Cone*, during the 24th minute, 1973.
Installation view at the Musée de Rocheouart. Courtesy of Sprueth
Magers Berlin/London. Photography by Freddy le Saux.

And as this animated 'sculpture' is transversing the whole space, the viewer
cannot but interact. The cone of light provokes the agency of the viewer: to
experience the cone, one is even invited to walk through the projected
light beam and stare into the projector.

At the time, McCall (whose visual vocabulary also includes real flames,
large pencil drawings and time based actions of 24 hours) was one of many
artists who represented the Structuralist film movement, deconstructing
the medium into bare essentials, such as movement, light, wavelengths,

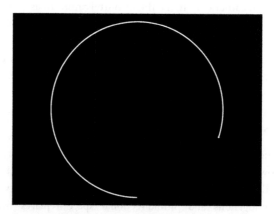

Figure 12.4

Anthony McCall, *Line Describing a Cone*, during the 24th minute, 1973
(drawing). Courtesy of the artist and Sprueth Magers Berlin/London.

mechanics and optics. Individual parameters of the cinema were isolated and thematized in what Ken Jacobs in 1969 coined as *para-cinema* (Pierson 2011: 11). Jacobs himself revived the praxis of the magic lantern performance, projecting or rather animating a film strip frame-by-frame, by manipulating the interaction between the filmstrip and the shutter. A host of experimental filmmakers in the 1960s and 1970s started to analyze the *dispositif* of cinema even before theorists focused on 'apparatus theory' the same way and around the same time as for instance the artist Marcel Broodthaers demonstrated his institutional critique before it became an academic discipline.[24] "If the white wall cannot be summarily dismissed, it can be understood. This knowledge changes the white wall, since its content is composed of mental projections based on unexposed assumptions". (O'Doherty 1999: 80).

In the mid-1970s, around the time O'Doherty was formulating his critique on the white cube, a different terminology was introduced by Jean-Louis Baudry to discuss the technology and the operations necessary to produce the cinematic effect in the viewer, and thus to induce subjectivity: the 'basic apparatus' and the '*dispositif*'.[25] With the former, he indicated the technological constellation of the film stock, the camera, the editing process and the screening conditions. He understood the untranslatable term '*dispositif*' as the immaterial effect of the work of the cinematic apparatus, pointing at the 'agency' of both the machine and the ideologies that steer them: the screening conditions that situate the subject. This critical approach of the conditions of film viewing were developed further and varied upon by other post-structuralist thinkers (notably Gilles Deleuze and Jean-François Lyotard), and then transposed to the electronic moving image (by for instance Raymond Bellour and Serge Daney). But it was Michel Foucault who immediately demonstrated a much wider potential for concept of the *dispositif*, to talk about subjectification in both visual and architectural arrangements.[26] Foucault also addressed the institutions of cinema and the museum, among many other isolated, parallel places that he labelled with the term 'heterotopias': non-hegemonic places were different timeframes are juxtaposed and the experience of space is illusory (Foucault 1984: 46–49). Neither here nor there, they form a space of otherness.

Some 30 years later, a multitude of new media is pervading our audiovisual culture and thus making up new kinds of *dispositifs* and producing new subjectivities. Meanwhile, a new generation is discovering anew *Line Describing a Cone* in comprehensive thematic exhibitions on the legacy of the moving image, either in New York (*Into the Light: The Projected Image in American Art 1964–1977*, 2001) or London (*Eyes, Lies, Illusions*, 2004) or Berlin (*Beyond Cinema: the Art of Projection*, 2006.) After the 1990s wave of artists' cinema, a revival of the historical expanded cinema followed, and McCall's animated circle became one of the most celebrated pieces. However, the critical,

ideological examination of *dispositif* and the historical nature of aesthetic judgment is no longer the bias. The emphasis now lies on the purely aesthetic exploration of the perceptual field of cinema, expanded to the gallery space: the reversal of fixed positions, freedom of movement, the performative and participatory aspects of the projection. As in the case of Breer's Floats and the peepboxes of the Brothers Quay, the viewers' participation consists primarily of freely moving about to explore the animation from different angles and distances. McCall multiplied *Line Describing a Cone* into a whole series of 'solid light films', and meanwhile also adapted his approach to newer technologies (comprising video and fog machines). From the perspectival geometry of conventional cinema, to the ambient projection within a gallery environment, McCall has moved on to transform projection from a performance into a permanent installation. This shifts the experience from a minimalist sense of narrative suspense (watching the circle draw to a close) towards a more ambient immersion into a visual, yet intangible dimension of looped duration. The film has been transformed back into the logic of an optical toy.

Since the 1970s, the critical bias of Foucault's use of the terms *dispositif* and heterotopia has also evolved and now meets with a more constructive understanding. The crucial question remains whether the museum can function as a critical engine in a positive sense. As Beth Lord argues: "Museums today for the most part no longer aim to 'accumulate everything' or to 'constitute a place of all times that is itself outside time" (2006: 4). To her understanding, the real content of the museum is not objects, but interpretation:

> As a space of representation, the museum *is* a space of difference. Foucault's museum is not a funeral storehouse of objects from different times, but an experience of the gap between things and the conceptual and cultural orders in which they are interpreted. (Lord 2006: 7)

Following Lord's notion of interpretation as the relation between things and the words used to describe them, one can indeed interpret Foucault's *dispositif* as a concept of 'in-between', or in his own terms, the connection that exists between heterogenous elements. In other words: animation as a metaphor. Instead of imposing an importance, a value, a judgment, Lord observes how contemporary musea invite people to fill in the gaps, allowing varying interpretations and appreciations. Conceiving the museum as a *dispositif* for activation rather than consolidation, is bringing it back to its origins, to the *Wunderkammer* and—cabinets, where the visitor was assumed to play an investigating part, instead of being passively subjectivified. More than cinema, animation always implied this constructive way of looking and decoding, as there is no reality effect (as in live-action film) to be reconstructed.

activating space

The impact of animation on the gallery or museum space can be thus a lot more meaningful than the dislocation of a screening from the darkened theater to a black box or to monitors inside a white cube. And it definitely has more potential than simply displaying pro-filmic artefacts (cels, sketches, objects) as autonomous art. Confronted with an aesthetic of the interval, between individual frames, peepholes and objects, between the objects and the surrounding space, between human and technological movement, between the gallery space and the 'real' world, each visitor enters an exhibition as a space of wonder, where the integral *mise-en-scène* is part of the experience, not 'just' the artworks, but also the space in between and around them. He or she goes there to animate and to be animated, to interpret and to be guided, to see and to complete one's perception, to actively engage with the *dispositif*. Without a motivated 'reader,' any scripted space remains a dead zone. Without an inhabitant, any constructed space remains a purely geometric artifice.

With her media archaeological exhibition project *Devices of Wonder*, Barbara Maria Stafford equally insists on the importance of the space in between, the gap, the interval, and the critical potential of reflecting on older media within a contemporary context:

> We need an analogical concept of technology, one that
> restores awareness of the long and tangled lineage of appa-
> ratuses. As tools for transformation and revelation, visual
> technologies expand human consciousness, allowing
> people to see their material connections to larger ideas,
> forces, and movements. Instead of an apotheosis para-
> digm—in which the disembodied user is abruptly joined
> to the superior intelligence of a machine—the substance-
> filled gap implicit in the word *media* (from *medius*, 'middle')
> has to be recaptured. This is the lesson of legacy instru-
> ments for futuristic devices. (Stafford 2001: 112)

Animation was never solely the domain of filmmakers. The Brothers Quay give prominence to the viewer through a *mise-en-abyme* of the *Wunderkammer*. Robert Breer's work activates the viewer by dynamizing both the floor, walls and ceiling of the white cube around him. Philippe Parreno's invites the viewer to edit a group show or artworks interspersed at great distances in time and place into a single narrative. Anthony McCall requires the viewer to interact and even interrupt his animated beam of light. Now animation is leaving behind the confines of the cinema to surface in exhibition spaces, their practices (no matter how divergent) systematically point out the legacy of earlier forms of visual animation and demonstrate its relevance for the present. Animation beyond the animated film, implies a return to animation before the movie theater.

notes

1. For a general introduction in this field, see *Media Archaeology—Approaches, Applications and Implications*, eds Erkki Huhtamo and Jussi Parikka. Berkeley: University of California Press; 2011, and Jussi Parikka's *What is Media Archaeology?* Cambridge: Polity Press, 2012.

2. These commissioned museum films comprise *The Phantom Museum—Random Forays Into the Vaults of Sir Henry Wellcome's Medical Collection (2003)* and more recently *Inventorium of Traces (2009)* on Jan Potocki's Castle at Łańcut—Poland, and *Through the Weeping Glass—on the Consolations of Life Everlasting—Limbos and Afterbreezes in the Mütter Museum (2011)*, shot at The College of Physicians, Philadelphia.

3. The French historian Laurent Manoni gave his 2009 catalog exhibition and publication *Lanterne Magique et Film Peint*, the subtitle '400 ans de cinéma', arguing that cinema had started already in the seventeenth century.

4. For an evolutionary description of the museum interior, see Charlotte Klonk's *Spaces of Experience—Art Gallery Interiors from 1800 to 2000*, Yale University Press; 2009.

5. For one museum film that never materialized, the Brothers Quay took their cue from a Balthus painting: *The Card Players* (collection museum Boijmans van Beuningen, Rotterdam). The script of this film was published under the title 'Nightwatch'. In *Conjunctions 46. Selected Subversions: Essays on the World at Large*. New York: Bard College; 2006.

6. The first major retrospective of the Quay Brothers works, *On Deciphering the Pharmacist's Prescription for Lip-Reading Puppets*, was held at MoMA, New York August 12 2012-January 7 2013.

7. The *Dormitorium* project was originally produced in Amsterdam, by the Holland Festival in 2006. It was co-produced by and reprised during the International Film Festival of Rotterdam in 2007, before it started to travel, in varying constellations.

8. For a well-illustrated documentation on this—now lost—object, see my essay 'Crossing Parallels', published in the artist's magazine *COIL 9/10* (Proboscis, London; 2000). The titles added to each peephole suggested an entirely different kind of narrative, for instance: Everyday Gardening; At the Edge of this Forest the Text is Waiting; The Interior of Sight; Loplop's Speech—in front of a Magnetized Epidermis; The Pull of the North (formerly) Travellers into the Total; Up Yours—the Illustrious Forger of Dreams, etc.

9. Culminating with his *La Mariée mise à nu par ses célibataires, même (The Bride Stripped Bare by Her Bachelors, Even (The Large Glass*, 1915–1923), leading to his final revelation: the room-sized peep-box *Étant donnés: 1° la chute d'eau, 2° le gaz d'éclairage . . . (Given: 1. The Waterfall, 2. The Illuminating Gas . . .*, 1946–1966).

10. Rodney Graham is a positive example of a contemporary artist who consistently refers to similar prototypes of visual contraptions in his work.

11. Sartre's definition of a mobile—In Jean-Paul Sartre 1949. *Situations III*, Paris: Editions Gallimard: 1949: 37.

12. Cited in Robert Breer: Interview on the Occasion of the Exhibition 'Le Mouvement' from Cinema to Kinetics, in the catalog, *Le Mouvement—vom Kino zur Kinetik*, Museum Tinguely, Basel, 2010: 149.

13. See Roland Wetzel: 'Einleitung', in the catalog *Le Mouvement—vom Kino zur Kinetik*, Museum Tinguely, Basel, 2010: 7.

edwin carels

14. O'Doherty's argument goes precisely against this apparent neutrality: "If the white wall cannot be summarily dismissed, it can be understood. This knowledge changes the white wall, since its content is composed of mental projections based on unexposed assumptions." *Inside the White Cube* 1999: 80.

15. One of the first symptoms of renewed interest was the exhibition *Force Fields—Phases of the Kinetic* (Hayward Gallery 2000). Some examples of more recent exhibitions: *Movement in a Square* (*The Square in Painting, Kinetic Art and Animation* (Stuttgart 2006); *Op Art* (Frankfurt, 2007); *Sons et Lumière* (Pompidou, Paris 2004); Lye exhibitions at the Australian Centre of the Moving Image (Melbourne) and at the Ikon Gallery (Birmingham). Since 2006, Breer has had solo shows in Annecy, Rotterdam, Bordeaux, Norwich, Basel, and was prominently featured in Artforum in the November issue of 2010.

16. Julie H. Reiss. 1999. *From Margin to Center—the Spaces of Installation*, Cambridge, MA: MIT Press: XV.

17. For an insightful comment on Speaking Drawing: … (2007) and other works by Parreno, see: Verina Gfader, 2008. Nervous Light Planes. *animation: an interdisciplinary journal,* Vol. 3, No. 2: 147–116.

18. Henri Barande, Francois Curlet, Liam Gillick, Dominique Gonzalez-Foerster, Pierre Huyghe, Pierre Joseph, with Mehdi Belhaj-Kacem, M/M (Mathias Augustyniak and Michael Amzalag), Melik Ohanian, Philippe Parreno, Richard Phillips, Joe Scanlan, Rirkrit Tiravanija and Anna-Léna Vaney, all (re-)animated 'Annlee'.

19. Acronym for 'massively multiplayer online role-playing game'.

20. Gaston Bachelard. 1994. *The Poetics of Space.* Boston, MA: Beacon Press: 47. Originally published in 1958 as *La Poétique de l'Espace* by Presses Universitaires de France.

21. "Le musée est cette institution qui a la puissance de faire apparaître un nouvel objet; l'oeuvre d'art, un nouveau sujet: le sujet esthétique, et une nouvelle relation entre les deux: la contemplation désintéressée" (my trans). Déotte argues that the museum is a site for free aesthetic experience, not ideological subjugation.

22. See for instance Oliver Grau. 2007. Remember the Phantasmagoria! Illusion Politics of the Eighteenth Century and Its Multimedial Afterlife. In *MediaArtHistories*, ed. Oliver Grau. Cambridge, MA: MIT Press: 137–161.

23. Belonging to experimental animator George Griffin.

24. Broodthaers frequently addressed the *dispositif* of the cinema as well, and made at least one animated film: *Une seconde d'éternité*—MB, La signature ou une seconde d'eternité d´après une idée de Charles Baudelaire, 1970. See: Marcel Broodthaers Cinéma, Fondacio Antoni Tapiès, Barcelona, 1997.

25. French philosopher Jean-Louis Baudry developed this concept in his two essays: "Ideological Effects of the Basic Cinematic Apparatus" (1970) and "The Apparatus: Metapsychological Approaches to the Impression of Reality in Cinema" (1975), which became hallmarks of the so-called "apparatus theory". First publications: Jean-Louis Baudry. 1970. Effets idéologiques produits par l'appareil de base. *Cinéthique*, Nos 7–8: 1–8. And Jean-Louis Baudry. 1975. Le dispositif: approches métapsychologiques de l'impression de réalité. *Communications*, Vol. 23: 56–72.

26. Foucault first uses the term in *Histoire de la sexualité*. Vol I: La Volonté de savoir Paris: Gallimard, 1976) and explains it in "The Confession of the Flesh" (1977) interview. *Power/Knowledge Selected Interviews and Other Writings,* ed. Colin Gordon, 1980: 194–228.

references

Bachelard, Gaston. 1994. *The Poetics of Space*. Boston, MA: Beacon Press. Originally published in 1958 as *La Poétique de l'Espace* by Presses Universitaires de France.

Bordier, Roger. 2010. In *Le Mouvement — vom Kino zur Kinetik*, eds Roger Bordier, Robert Breer, Roland Wetzel, and Thomas Tode. Heidelberg: Kehrer Verlag.

Breer, Robert. 2010. Interview on the Occasion of the Exhibition 'Le Mouvement' from Cinema to Kinetics. In *Le Mouvement — vom Kino zur Kinetik*. Heidelberg: Kehrer Verlag: 147–150.

Buchan, Suzanne and Andres Janser, eds. 2005. *Trickraum : Spacetricks*. German/ English. Zurich/Basel: Museum für Gestaltung Zürich and Christoph Merian Verlag.

Déotte, Jean-Louis. 2011. Le Musée n'est pas un dispositif. *Cahiers Philosophiques*, Vol. 214: 9–22.

Doane, Mary Ann. 2009. The location of the image: cinematic projection and scale in modernity. In *Art of Projection*, eds Stan Douglas and Christopher Eamon Ostfildern. Hatje: Cantz Verlag: 151–166.

Foucault, Michel. 1984. Dits et écrits, *Des espaces autres* (Conférence for Cercle d'études architecturales, March 14, 1967). In *Architecture, Mouvement, Continuité*, Vol. 5: 46–49.

Holl, Ute, Andres Pardey, Laurence Sillars, Roland Wetzel. 2011. *Robert Breer*. Published on the occasion of the solo exhibition *Robert Breer* at BALTIC, Gateshead and Museum Tinguely, Basel. Bielefeld: Kerber Verlag.

Klein, Norman M. 2004. *The Vatican to Vegas: A History of Special Effects*. New York: The New Press.

Lord, Beth. 2006. Foucault's museum: difference, representation, and genealogy. University of Leicester. *Museum and Society*, Vol. 4, No. 1: 1–14.

Manoni, Laurent. 2000. *The Great Art of Light and Shadow — Archeology of the Cinema*. Devon: University of Exeter Press.

Manovich, Lev. 2006. The Poetics of Augmented Space. *Visual Communication*, Vol. 5: 219–240.

Michaud, Philippe-Alain. 2011. Line Light: The Geometric Cinema of Anthony McCall. In *October 137*. Cambridge: MIT Press: 3–22.

——— 2006. *The Mouvement of Images*. Paris: Editions du Centre Pompidou.

O'Doherty, Brian. 1999. *Inside the White Cube — The Ideology of the Gallery Space*. Berkeley: University of California Press.

Pierson, Michelle, David E. James and Paul Arthur, eds. 2011. *Optic Antics — The Cinema of Ken Jacobs*. New York: Oxford University Press.

Reiss, Julie H. 1999. *From Margin to Center — the Spaces of Installation*. Cambridge: MIT Press.

Sartre, Jean-Paul. 1949. *Situations III*. Paris: Editions Gallimard.

Stafford, Barbara Maria. 2001. Revealing Technologies/Magical Domains. In Barbara Maria Stafford, Frances Terpak, eds. *Devices of Wonder: From the World in a Box to Images on a Screen*. Los Angeles: The Getty Research Institute Publications.

animation studies as

an interdisciplinary

teaching field

t h i r t e e n

p a u l w a r d

introduction

A cursory glance at the range of animation produced demonstrates
its breadth and startling range; animation appears in the art gallery,
on television (in TV shows as well as adverts and interstitials/channel
idents), in films both mainstream and experimental, in videogames. It is
obvious and blatant on the one hand—the flow of cartoons on Nickelodeon
or Cartoon Network, or the steady release of features by Disney, Pixar,
or Dreamworks—and invisible and subtle on the other—the ways in
which animation plays a role in the visual effects industry, where skilled
animation graduates learn how to blend their craft so seamlessly with live-
action footage that many people are not aware they are watching a kind of
animation at all. The field has also grown exponentially over the past
30 years or so—in no small part due to the emergence and consolidation
of digital technology and the aforementioned games and visual effects
industries, both of which offer a massive range of employment options to
animators.

Before moving on, it is worth sketching out some of this context in more detail. A recent report by industry group Animation UK, *Securing the Future of UK Animation*, notes that while the UK animation industry appears to be "only of moderate size"—with the authors noting revenues of £300 million per year and a workforce of 4,700—it is also clear that "its impact and influence are felt much more widely [with] substantial spill-overs to other sectors of the creative and retail economy" (Kenny and Broughton 2011: 16). The cross-fertilization between animation and other areas such as games, visual effects and advertising are considerable, with skilled animators playing a vital role in powering those sectors. The authors go on to note that post-production/visual effects in the UK alone generates £1.4 billion in revenue and games around £1 billion (17), with the global revenue generation obviously being considerably higher than this. Additionally, animation's stimulation of 'downstream' markets is enormous, with the UK market alone accounting for £140 million worth of children's DVDs in 2009, £473 million of children's books (2010 figure), and £730 million of toys and models (2009 figure) (18). Finally, animated character-based content contributes to the global market in television brand licensing—a sector that was considered to be worth an astonishing £115 billion in 2009—in many important ways. If for no other reason than this—the sheer economic 'weight' of animation production for the creative industries—a nuanced understanding of how animation is taught and understood as a field of knowledge and practice is utterly crucial.

The questions I would like to ask in this chapter are seductively simple and straightforward: how might we think of animation as *an object or field of study*? What constitutes 'animation knowledge?' How do we—and how might we—*teach* it? And what are the consequences of thinking through these epistemological and pedagogical questions? My modest (and some might say obvious) proposal is that, as well as powering parts of the economy, animation underpins a vast number of disciplines and subject areas; it is the missing link, the glue, the universal touchstone and meeting place for a very wide range of theorists, historians and practitioners working within contemporary moving image culture.

But what does saying this mean in the practical world of teaching animation? By 'teaching animation' I mean not just the teaching of 'how to' approaches—the craft, the vocation—though this is of course a vital part of it and something I shall discuss in due course. I also mean giving students the tools for a critical and historical understanding of what they, and others, are doing and how it connects meaningfully to other fields of knowledge. These are questions that I have addressed elsewhere (Ward 2003; Ward 2006). The former article examined the ways in which animation can appear to be a network of 'nodal' points (or 'nests') both within and between existing and more established subject areas. This goes some of the way to explaining why animation can appear to be everywhere-at-once

and how a seemingly diffuse set of individuals can in fact constitute a coherent 'community of practice.' The latter article examined in more detail notions of communities of practice and how they relate to animation—in particular, the role of computer technology and how it 'recontextualizes' traditional animation skills. At the heart of both articles is a belief that animation as a cultural practice and animation studies as its institutionalized educational field are strongly interdisciplinary and influence a wide range of other disciplines and practices.

Alongside practical questions of what animation *is*, and how we *teach* it, therefore, there is also a more fundamental philosophical question to be raised about how animation actively 'animates' more traditional disciplinary knowledge—in other words, what does it mean to label animation as 'interdisciplinary?' This inevitably means we need to examine the nature of disciplines and how animation fits within (and between) them. After briefly offering some definitions of key terms, I intend to map out some of the debates about how disciplinary knowledge can be hybridized, focusing on discussions that have centered on media studies and cultural studies. An analogy shall be drawn with the interdisciplinary shifts that resulted in the formation of contemporary performance studies, a dialogical process that radically recast that field. I shall also examine how notions of practice and vocationalism/training have tended to shape some of the discourses used in relation to animation, with animation-as-craft and the role and function of industry playing especially important roles. Finally, I shall look at some examples of how animation is taught and conceptualized, and how it can be seen to 're-animate' teaching and learning.

defining (inter-)disciplinarity[1]

Paradoxically, it can be argued both that interdisciplinarity is *overstated*—everyone is doing it, or wants to do it, or should be doing it—and *understated* and misrecognized. As Julie Thompson Klein points out, however "Some activities flourish most readily, in fact, when they are not labeled as interdisciplinary" (2010: 7). This is certainly the case with areas that are already interdisciplinary—the examples that Klein gives, like geography or medicine, consist of different sets of knowledges, thinkers and skills but tend not to be thought of as interdisciplinary in the way that the term has come to mean in commonsense language. Advocates of interdisciplinarity differ over their definitions of what it means and why it matters. For example, Allen F. Repko summarizes some of the differences between notions of interdisciplinarity, suggesting that there are two tendencies—the "generalist" and the "integrationist" (2012: 4). The former position is one that defines interdisciplinarity loosely as a dialogue or interaction between disciplines where the individual disciplines gain something, and knowledge is accumulated, but there is little in the way of *synthesis* and *challenge* to the

disciplinary forms of knowing. The integrationist approach, on the other hand, is one where the interdisciplinary work leads precisely to a synthesis and change of approach. But there is clear controversy over exactly how this happens and to what extent.

Liora Salter and Alison Hearn describe such difference of opinion from a slightly different perspective, when they say,

> the literature about interdisciplinarity can be marked by clear divisions. For the most part, authors concerned specifically with theoretical issues, epistemology, pedagogy, and the disciplining of knowledge stand in direct opposition to those writers who advocate a more instrumental and pragmatic approach to interdisciplinarity, focusing largely on its function as a problem-solving activity that may be designed to cater to the demands of industry and government. (Salter and Hearn 1997: 29)

On one level, then, while the attraction of interdisciplinarity seems self-evident—who *wouldn't* want a world where cognate disciplines talk to and dispute one another? Or a world where those from apparently different parts of academia (e.g., the arts and sciences) collaborate and produce new and hybrid knowledge?—the problem is that this overlooks some of the thornier issues to do with how people define and defend their field, how things are funded, and how they are recognized by academics, the government, industry and the public at large. Or, to put it another way, as Salter and Hearn intimate above, there are those who are interested in interdisciplinarity for its epistemological or pedagogical dimensions, and there are those who see interdisciplinarity as a pragmatic marriage of convenience, with different scholars, practitioners and other interested parties (industry and government) coming together to find solutions to a specific problem. (This dichotomy will be important later when I discuss the role and function of different types of animation teaching.)

The notion of what happens when disciplines come together is therefore less straightforward than it sounds, but appears to be predicated on some sense of activity at meeting points—or the boundaries or margins. Repko, summarizing Klein's thinking on the subject, notes the following:

> The pattern by which the boundary work of interdisciplinary studies operates occurs in this way: (1) researchers detach a subject or object from existing disciplinary frameworks; (2) they fill gaps in knowledge from lack of attention to the category; and (3) if the research attains critical mass, researchers "redraw boundaries by constituting new knowledge space and new professional roles." (Repko 2012: 6–7; summarizing Klein 1996: 36–37)

Likewise, as Klein points out

> the term 'boundary rhetorics' ... describe[s] the rhetorical strategies that create interdisciplinary discursive space. They include establishing intertextual links between separate disciplines though citations, translating the findings of one discipline into the terminology of another, suppressing differences in order to emphasize points of contact, finding common enemies, and juxtaposing different research genres dialogically in the same textual space.
> (Klein 1996: 220)

Animation studies, as the academically situated, institutionalized work within animation—both practical and theoretical—is an interesting field precisely because it has emerged from a disparate set of practices and discourses. Rather than the interdisciplinarity suggested by two or more well-established disciplines 'joining forces' to interrogate a research topic, Animation Studies' interdisciplinarity stems from its *inherent* hybridity as a form of cultural practice. It is also important to note that many of the interdisciplinary currents in the field of Animation stem from the craft, practice, production and professional orientations of those involved in the field, rather than specific/traditional research questions per se. (This is something I return to in more detail below.)

Therefore, when it comes to understanding how animation studies operates as an interdisciplinary field, we need to recognize the fundamental point that the production of knowledge takes place in contexts that play a role in *shaping* the knowledge. As John R. Hall states:

> [we need to] understand ... inquiries in cultural terms—as structured practices with roots in shared discursive resources that facilitate communication about the sociohistorical world ... sociohistorical research is a craft activity carried out in professional worlds oriented to inquiry.
> (Hall 1999: 7)

At the risk of verging on the tautological, this makes an important point: that "inquiry" is carried out in places "oriented to inquiry." In short, the contexts in which knowledge is produced, by whom, and for what purpose, are vital in our understanding of both the knowledge produced and the people and institutions producing it. It is important to note that knowledge about animation can emerge from a variety of contexts—traditionally academic, or relating to craft, technology, industry or training. Hall's overall thesis is one that talks of the move: "From Epistemology to Discourse in Sociohistorical Research" (the subtitle of his book). By this, he means not that knowledges are all relative to one another—i.e., that they are all discourses, competing for space—but rather that they must be

evaluated and analyzed in ways which take full account of their social context. In short, we need to recognize the shift "from foundationalist Epistemology to 'small e' epistemology" (9).

Such a shift is important in the context of this discussion because I am going to argue that whilst animation studies most definitely exists as a field, it should not be seen as a 'discipline' in the conventional sense of the term. Although the designation 'animation studies' inevitably implies a recognizable and coherent arena in which inter-related inquiries are conducted, I would suggest that animation studies, such as it is, is actually a diverse set of *nodes* of inquiry (Ward 2003). Indeed, Repko argues that areas labeled as 'studies'

> in general represent fundamental challenges to the existing structure of knowledge ... and a recognition that the kinds of complex problems facing humanity demand that new ways be found to order knowledge and bridge different approaches to its creation and communication. (Repko 2012: 9)

As the term 'studies' suggests, there is a composite, plural, perhaps provisional nature to them—a tentativeness that allows for an open relationship to knowledge production.[2]

There is of course a very close relationship between animation and film and media studies, but animation also has disciplinary connections to fine art, graphic design, architecture, and many other fields. It is important to note that any sense of disciplinarity that animation might have is as a consequence of its relationship with other disciplines. This is something I have argued at length elsewhere (Ward 2003). In that essay, I made a case for seeing animation's apparently dispersed identity as something that could actually be a strength, if one takes on board the idea of *discursivity*—the way in which animation 'speaks to' other fields of knowledge. This also allows us to talk about an identifiable field of knowledge without it becoming essentialist or falling into some of the traps of medium specificity. Andrew Darley's polemical discussion of the study of animation notes some of the problems of trying to identify its 'essence'. He also makes clear that some of the features of animation that are held up by its champions as unique or specific to it—or as what makes animation *superior* to other media—are actually *common* to a good deal of other media (2007: 65–68). Such common ground is precisely what makes a discursive and avowedly interdisciplinary approach both necessary and, I would argue, unavoidable. So, the connections that animation has (as a process) with drawing, art, illustration, media, film, technology and the myriad other relevant forms of practice and knowledge become a network of discourses through which we can more effectively understand animation. But these are not arbitrary interdisciplinary connections: they stem from animation as a production process.

Moreover, the self-consciously critical—what I term discursive—way in which animation as a knowledge field connects with other forms of knowledge, as well as its relative youth as a discipline, mean that it is well-placed to offer a constructive and penetrating analysis of the so-called 'knowledge economy'.

Of particular relevance to the current discussion—in the ways that disciplinary discourses meet, speak to one another and (perhaps) hybridize—are notions of culture and cultural studies. In some quarters, there is a strong suspicion of postmodern thinking on education and epistemology (Hill et al. 2002). Not only because the 'postmodern turn' has led to a debilitating skepticism with regard to Enlightenment concepts such as truth, objectivity and the like, but also because much of this theory is depressingly apolitical, despite any apparent radicalism. As Douglas Kellner puts it, the 'postmodern turn' in cultural studies

> resolutely severs cultural studies from political economy
> and critical social theory ... there is a widespread tendency
> to decentre, or even ignore completely, economics, history
> and politics in favour of emphasis on local pleasures, consumption and the construction of hybrid identities from
> the material of the popular. (Kellner 1997: 20)

Despite (or rather, because of) this, it is not hard to discern why a critically-minded epistemology is so strongly linked to teaching in the area of culture. As Kellner suggests, the arena that constitutes cultural studies is the vibrant site of theorizing about "forms of culture, society and everyday life" (24). As such,

> The major traditions of cultural studies combine—at their
> best—social theory, cultural critique, history, philosophical analysis and specific political interventions, thus overcoming the standard academic division of labour by
> surmounting arbitrary disciplinary specialization. Cultural
> studies thus operates with a transdisciplinary conception
> that draws on social theory, economics, politics, history,
> communication studies, literary and cultural theory, philosophy and other theoretical discourses
> Transdisciplinary approaches to culture and society transgress borders between various academic disciplines.
> (Kellner 1997: 25)

One can apply Kellner's outline of cultural studies to animation as an area of inquiry. Animation is studied in a very wide variety of contexts and the knowledges produced in its name are equally diverse. Far from being a straightforward subject or discipline, what we find under the rubric of animation is a multi-faceted (and multi-sited) set of knowledges. In order to

fully mobilize and understand these knowledges, therefore, we need an understanding of how, exactly, they meet or overlap. The key to this, as I have suggested above, is to concentrate on the *critical* and *discursive* dimension: the ways in which those working in these fields negotiate and debate the epistemological problems they encounter. This leads us away from seeing the diversity and apparent diffuseness of animation studies as a symptom of a postmodern fracturing of knowledge, and takes us to a more informed understanding of how knowledges work. This should never be seen as a call for sterile abstractions of what knowledge may or may not be, but rather a call for a materialist account of knowledge production. Animation studies as a putative inter-discipline is a model for understanding what happens when diverse scholars, researchers and practitioners come together.

the case of performance studies

An interesting comparison can be made with the contemporary field known as performance studies in order to tease out some of the ways in which animation studies has developed thus far and how it might develop in the future. Performance studies in many people's eyes would be synonymous with theater studies or drama and it does indeed include these. But it is much else besides and has been described as an "inter-discipline" by Richard Schechner who adds "[a]ccepting 'inter' means opposing the establishment of any single system of knowledge, values or subject matter. Performance studies is open, multivocal and self-contradictory" (2002b: 19). Theater studies scholar Joseph Roach emphasizes this when he refers to how his research has been "redefined by the expansive interdisciplinary or post-disciplinary agenda of performance studies" (1996: xii).

The shifts seen in studying performance, certainly in terms of what it has become in the contemporary moment of twenty-first century performance studies, can be traced to interventions by people such as Schechner and Victor Turner in the 1970s and into the 1980s, with its roots traceable to the symbolic interactionist theory of Erving Goffman (1990 [1959]). There was a move, prompted by Schechner, to see 'performance' as encapsulating all manner of acts and not just the formal, framed performances that we might otherwise term theater or acting in the specific disciplinary sense of drama. Playing, rituals, sports and other events, and all kinds of other everyday activities came within the purview of performance studies.

This radical shift had two major consequences. First of all, it decentered the object of study of the discipline; in effect, the whole of human existence became the object of study, because *any* human action could be read performatively, *as a performance*. Second, and related to this, it made the discipline itself a pervasive set of inter-connections—which could be seen as liberating or infuriating, depending on one's position. On the one hand,

for those who would want to identify a central core to any discipline, performance studies' shift was unnerving, as it *denied the need* for a core. As Schechner puts it: "Performance studies is fundamentally relational, dynamic and processual. Such rigorous indeterminacy and openness make many uncomfortable about PS" (2002a: x). On the other hand, the radical idea that performance was something that should exercise a very wide range of people—historians, anthropologists, sports psychologists, linguists or folklorists as well as dramatists or (professional) performers like actors—was an exciting notion, and one that is firmly predicated on the notion of pervasiveness and interdisciplinarity.

Performance studies, in its incarnation seen mainly in the USA since the 1970s, has certainly encouraged interdisciplinary 'border crossings'. This is important because it emphasizes a point made earlier: that the *way* we study things, the *way* that knowledge about a given area is recorded, disseminated and (mis)understood, plays a significant role in shaping the *kinds* of knowledge that are sought and given precedence, becoming part of canonical knowledge that is then passed on in a recognized curriculum. A world where performance studies means merely studying theatrical performances of plays (with, perhaps, the performances in films deferred to film studies, or the performances on television deferred to television studies) would by definition *limit* itself (and some people would not necessarily see such limitation as a bad thing). By removing (or, at least, loosening) the boundaries and allowing the borders to be crossed, however, it irrevocably alters the status of knowledge in that field.

vocationalism, craft, production: debates about animation practice and theory

In common with the "relational, dynamic and processual" arena of performance studies, animation's status as a nodal interdisciplinary field means it has dialogues with many other knowledge areas, but one of the abiding ways of understanding animation and how it is taught is by seeing it in practical or applied terms. This raises very important points about the relationship between practice and theory (and how they are taught), as well as compelling us to think about concepts such as production, craft, industry and vocationalism. Historically, many disciplines have emerged from developments in professional training and applied knowledge about a specific field. For example, the academic discipline of law has grown out of the *practicing* of the law and, as Stefan Collini notes, a sense of professors of law "constantly turning into legal historians and legal philosophers and even social theorists more broadly" (2012: 26). He goes on to note that such "sub-disciplines" and specialization point to a subject area becoming "more recognizably 'academic'—a tricky, loaded word, but one which here suggests the pull away from the practical to forms of enquiry with their own

protocols and ambitions" (27). At the same time, it is obvious that any discipline, once established, will seek to formalize the professional standing of the academics working within it (e.g., via university chairs or professorships in the field, or recognized centers for teaching and research). More recently, there have been significant moves towards the academic institutionalization of established professions (or what some would dub 'trades') with a proliferation of courses in subjects like journalism, screenwriting, and leisure management. Clearly, some of these courses are identified as professional 'upskilling' (sometimes referred to as Continuous Professional Development or CPD) and are offered on a purely vocational basis, where people learn the practicalities but are not expected to engage with the critical discourses one finds in academic contexts. However, there is an increasing dialogue emerging between professions and trades and their academic incarnations, with critical reflection on notions of craft and vocationalism being central to this dialogue.

So, how have discourses of craft and vocational training impacted on animation as a knowledge area? Central to understanding this is a careful delineation of how practice and theory interrelate. There can still be problems with how theory and practice are integrated, with some forms of practice straightforwardly 'emulating' existing forms without interrogating them, and other forms of practice 'illustrating' theory. Dan Fleming identifies this problem in relation to media practice more generally, couching it in terms of a tension between the heuretic and the hermeneutic. As Fleming suggests, media courses need to transcend

> the sterile tension between, on the one hand, [their] critical, interpretive and analytic intentions and, on the other, media practice as mere technical or production training …. What has been missing, perhaps, is the concept of a heuretic practice to set alongside interpretive and analytical work—in other words, a use of media technologies and forms of production in a critically *inventive* mode. (Fleming 2000: 389–390, original emphasis)

For Fleming, this goes to the heart of the role of practical work on media studies courses (and, I would argue, on a wide range of other courses that involve practice, from animation to fine art to graphic design and beyond), suggesting that a use of practice that merely 'backs up' or illustrates the interpretive or analytical work is hardly making the most of the potential of practice. As well as the interpretive (hermeneutic), what is needed is an inventive/creative mode (heuretic). As Fleming notes, the central point of the heuretic is that of *development*: "[w]ithin the heuretic tradition … it is the continuing process of invention and elaboration that matters" (390). In this respect, he proposes "devising *genres* of practice that carry, or dramatize, the heuretic intention" (391, original emphasis), so that we can avoid

students falling back on simple emulation of genres such as the pop video, mock-documentary—or, in terms of animation, resorting to clichéd use of cartoonal tropes and aesthetics.[3] At the same time, however, Fleming is highly critical of the position where "learners somehow use their practical work to explore what they have learned theoretically [which can lead to] portentously intellectualized practice" (391). Such a tendency to reduce practical work like this can lead to some interesting work, but it will fall into the category of formal experiment (or, more damningly, formalism), where creativity is hidebound by the 'rules' set out by the theory. As the term 'heuretic' implies, there has to be some sense of *developing*, discovering, inventing or going beyond what has been learned in another context.[4] As Mike Wayne argues, in sketching a typology of practitioners: "[p]ractice has to be understood as sensuous and concrete ... it exceeds what was already known. Practice is labour, production, activity, not a passive mirror held up to 'theory'" (2001: 31). The key difference between what Wayne terms the "theoretical practitioner" and a truly "critical practitioner" resides in how they orient themselves to the theoretical possibilities and the practical choices available to them, and how all of this is understood as part of a broader set of contexts (30).

The main problem is that animation as a practice is strongly tied to notions of craft—which can sometimes lead to a limited sense of its scope and potential as a form of knowledge. There is an obvious assumption that undertaking a practice-based course in animation should teach you how to animate. Of course this is a basis of it, and I am not for a moment suggesting that animation courses should relinquish their practical roots. But, as implied above, and I will go on to elaborate below, there are reasons for (and consequences to) practice being rooted and framed in specific ways. For example, links with industry are vital for many animation courses, but could feasibly lead to the courses becoming perceived as mere training for particular companies or simply in order for the graduates to fulfill specific roles. Conversely, the perception of individualistic, auteurist practitioners, animating outside of the apparent strictures of a profession or (mainstream) industry is arguably just another manifestation of artistic practice as transcendence, where art (in this case, animation) appears to transcend or work around the social contexts of which it is inescapably part.

One way into clarifying the problem of practice-theory relationships is to recognize that the notion of theory being 'real' knowledge, while practice is simply the 'application' of that knowledge, its concretization, is only a partial conception. As Mark K. Smith points out, it is a mistake to think, "Theory is 'real' knowledge while practice is the application of that knowledge to solve problems. In many ways, this is a legacy of Aristotle and his three-fold classification of disciplines as theoretical, productive or practical" (Smith 2011). In other words, there is a distinction between the 'practical' and the 'productive' with the latter associated with craftspeople

actually making something, while the former is more to do with the ethical aspects of everyday life, and the practical knowledge regarding specific situations and the actions that one should or should not take. This echoes some of the points made earlier about how practice should be seen as sensuous and concrete, as a form of productive labor, but also suggests a related problem—the ways that practice and production can be conflated. (For example, there are plenty of degree courses that use the two terms interchangeably, or have modules/units called variously 'media practice' and 'media production', when they are doing virtually the same thing.) In defining praxis, Smith underlines the *difference* between production and practice. Praxis

> is not simply action based on reflection. It is action which embodies certain qualities ... [it is] not merely the doing of something, what ... Aristotle [describes] as *poiesis*. Poiesis is about acting upon, doing to: it is about working with objects. *Praxis*, however, is creative: it is other-seeking and dialogic. (Smith 2011)

Again, this returns us to Fleming's call for practical work that falls into the heuretic tradition: rather than being simply productive (or "acting upon, doing to"), the approach he advocates is one of media praxis, where creativity and development of ideas are central. As such, it is other-seeking (which I understand as meaning it is interested in *evolving new ideas*, going *beyond existing knowledge*), and dialogic (which I understand as meaning it engages *dynamically and critically with existing forms of textual production*).

Nils Lindahl-Elliot likewise argues that many of the misconceptions surrounding theory and practice are based on not fully understanding the complexities of the relationship between them. He usefully introduces two "modalities" in relation to courses that use media production: (a) vocational modality and (b) autonomous modality. "Vocational" means "courses which teach media (or other) theories and practices to prepare students for work in the media production market" and "autonomous" means those courses "which teach them to develop what can be described as a critical disposition towards the media (or more widely towards popular culture)" (2000: 19). This seems straightforward enough, but he then further subdivides the vocational modality into (a) critical-vocational and (b) market-oriented. The market-oriented courses are those where "the main objective ... is to provide students with the knowledge necessary to compete for employment in one or more of the fields of media production" (19). In critical-vocational courses, however, there is an "attempt to educate critical producers—producers able to critique, and to avoid reproducing, such ideologies as sexism, racism, ethnocentrism, nationalism or scientism" (19). The key word here of course is *attempt*. Indeed, much of the point of Lindahl-Elliot's analysis is to contest the ease with which it is

asserted that students can simply be educated in this way, to work in a manner where theory informs their practice, and thereby magically makes them critical. Certainly, the institutional pressures on any practitioner can militate against them being critical or trying new things.

Central to this debate is the notion of expertise or specialization, and how it functions within the wider labor market, something that Antonio Gramsci examines in his work on education. He notes

> each practical activity tends to create a new type of school for its own executives and specialists and hence ... create[s] a body of specialist intellectuals at a higher level to teach in these schools ... [Thus], a whole system of specialised schools, at varying levels, has been ... created to serve entire professional sectors, or professions which are already specialised and defined within precise boundaries. (Gramsci 1971: 26)

Gramsci further subdivides the types of schooling available. There is a "fundamental division into classical and vocational" with the attendant split in who goes into which category: the former for the "dominant classes and intellectuals" the latter for "the instrumental classes". Historical developments led to the need for a third type of school, the "technical (vocational, but not manual)" (26). Here, we can make some useful comparisons to Lindahl-Elliot's categories, noted above, of "autonomous" (which Gramsci would recognize as "classical"), "market-oriented-vocational" (the Gramscian "manual-vocational") and "critical-vocational" (the Gramscian "technical-vocational"). In those instances of animation studies that inter-relate with areas such as film studies (theory and history) or the study of cultural artifacts more generally, it is clear enough that the classical or autonomous modes are in operation. For such a practically-oriented and technologically-based form as animation, though, it is not at all surprising to find a strong tendency towards varying degrees of vocationalism, though there are considerable nuances and shades of gray in how this is articulated, as even this necessarily brief summary suggests.[5]

Take, for example, the range of online courses that exist—the very successful Animation Mentor (http://www.animationmentor.com/), CG Mentor (http://www.cgmentor.com/), or The ACME Network (http://www.acmeanimation.org/) being notable examples. Such courses offer a way for animation students to interact with—and have their work critiqued by—animation professionals. Despite the critical and evaluative dimension here, the overriding rationale appears to be that people are learning to animate in order to break into the industry and emulate the very people who are critiquing their work. That said, the philosophical idea of a mentor is of course to lead, to induct, to direct and shape someone's development across a considerable number of years. Moreover, a mentor

should be someone who has a holistic view of the person's development and, in the context of higher education, someone who inducts the student into the broader contexts (philosophical, theoretical, historical, professional) in which their future work will operate. One can discern a reductive way of talking in some of the discussions of mentoring, where the securing of the 'dream job' or what can often be seen as a simple and straightforward emulation of the mainstream industry, appears to be the main objective. For example, one online animation forum states the following in relation to the founding of Animation Mentor:

> in 2005, three talented guys working in the animation industry were troubled to see that most traditional art schools did not teach the art behind what makes the craft so special. Animators were only gaining generalist skills that weren't focused on character animation and weren't learning the important things that studios are looking for when hiring new animators. They approached the issue with one core question in mind: "If we were to start over again how would we want to learn?" The answer: To build a school from the ground up with a philosophy that the best way to learn is through the time-tested practice of apprenticeship. (Sheady 2011)

It is also important to note however, that while the learning of professional processes via on-the-job 'live briefs' (or an on-course simulation of these) is a crucial part of learning 'the trade', this is also an area which can be open to charges of exploitation. With talented students learning how to do things, what could be better than having experience of working on major projects? In one sense, there is not a problem with this, and it could be seen as merely a repurposing of the apprenticeship for the twenty-first century. On the other hand, there is a grim inevitability to the ways in which the role and function of students is taken to an apparently logical conclusion in a knowledge and skills economy dominated by outsourcing and the relentless driving down of costs, especially when animation studios and visual effects houses become directly involved in educating. For example, John Textor, the CEO of Digital Domain, the animation and visual effects house founded by James Cameron, Stan Winston and Scott Ross in 1993, recently caused a furor in the animation community when, in talking about the Digital Domain Institute (the company's training facility in Florida) he made the following claim:

> 30% of the workforce at our digital studio down in Florida, is not only going to be free, with student labor, it's going to be labor that's actually paying us for the privilege of working on our films. (*VFX Soldier* 2012)

It is hard not to see a move such as this as a way for a large corporation to get hold of promising young talent whilst simultaneously saving money and increasing profits (which Textor would no doubt argue is his *raison d'être* as CEO of a large corporation). In this respect, it *is* a repurposing of apprenticeships for the twenty-first century: an apprenticeship where, instead of an ongoing and deeply-rooted relationship between trainer and trainee being forged, employer investment and commitment are minimized and the whole enterprise is reframed as a high-risk game of short/fixed-term contracts and deregulated labor (in other words, the risk is placed firmly on the apprentice's shoulders). As Brian Wells and Laurence Arcadias point out, however, while acknowledging the importance of industry partnerships, "[t]he academy's purpose is not to provide worker bees for the economic wheels of big business" (2007: 72).

animation teaching as an interdisciplinary pedagogic device

Alongside these debates about practice-theory relationships, apprenticeships and the vocational framing of animation courses, particularly those that have links to the animation and visual effects industries, we also have to consider the other ways in which animation features in curricula.[6] There are clearly traditions of using animation as a device to teach other phenomena—in much the same way as an English teacher might show a film adaptation when teaching Shakespeare or a physics lecturer might show an animated film that represents a theoretical concept such as gravity. As noted elsewhere in this chapter, we also need to be mindful of the ways in which the teaching of practice—animation as a craft or process—can have various applications, not least when someone is training to be an animator.

What intrigues me is not so much the teaching of animation as a craft, in and of itself; nor the use of animation very much in the service of another discipline (i.e., in the English or physics examples given, the animation is merely an uninterrogated vehicle for what is really being studied), but the ways in which thinking through animation as a process plays a part in a truly interdisciplinary model of teaching. Ruth Hayes has written in some detail about her approach to animation teaching at Evergreen Community College, a liberal arts college in Olympia, Washington state, USA (Hayes 2007). Hayes identifies two tendencies in those students choosing her courses—on the one hand there are those students "who have an affinity for the most traditional and culturally accessible forms of animation," those who are most likely to go on and practice as animators in the industry. On the other hand, there are those "who don't have affinities with the animation they see in the American mainstream media, [those who] are not likely to think that learning to animate will benefit their creative, intellectual or professional pursuits" (24). The first group can tend to

uncritically echo or imitate the tried-and-true cartoonal approaches, avoiding more nuanced or contradictory forms of representation; the second group can tend to associate animation metonymically with the cartoon (which is of course the most dominant form of animation[7]) and this means they see it as not intellectually or creatively worthwhile. In both cases, of course, there is a *deficiency* in understanding, a limitation in terms of how animation as a field of inquiry and practice is conceived.

Hayes' approach is one that follows an integrative learning model that has its roots in the liberal arts tradition of the USA. The curriculum is regularly revisited and rewritten, based on thematic strands:

> Evergreen has no departments and students do not declare
> a major. Instead, faculty affiliate with different curricular
> planning areas that are loosely organized around related
> disciplines. Humanities faculty affiliate with 'Culture, Text
> and Language.' The math, biology, physics and chemistry
> faculty affiliate with 'Scientific Inquiry' [and so on]. (Hayes
> 2007: 26)

Hayes is within the 'Expressive Arts' planning unit, along with other media practitioners. Examples of interdisciplinary programs of study that have included Hayes' input are 'Emerging Order' (devised and taught with a theoretical physicist and a math scholar) and 'Marking Time' (devised and taught with a colleague from literature/performance studies and a colleague from religious and Islamic studies). The latter program of study examined human experience and construction of time, but this took on board concepts as widespread as memory, rituals and schedules, metamorphosis and specific performances such as dance. The interdisciplinary combination of time, space and performance is especially apposite as a model for understanding animation, and new synthetic knowledge is created by examining these concepts *through* animation as a practice.

Clearly the model that Hayes works within both teaches animation (*as* a practice) and uses animation to teach (concepts, *via* practice). It is also a model that actively utilizes the connections that might exist between seemingly disparate disciplines and teachers, and seeks to build connections where there might have previously been none. There is a clear attempt to use animation (and animation's relationship to other forms of practice) as a route into truly synthetic knowledge, and to work out how a complex form of 'boundary rhetorics' might function. It is in the creative juxtaposition of very different forms of knowledge that such an approach works, but my contention is that animation as a form is already well-disposed to play such a role, due to its 'discursive' nature and inherent hybridity. This is arguably most pronounced when animation is used to directly and specifically engage with the real world, in the form of animated documentary.

re-animating the (inter-)disciplinary field: animated documentary

As well as the liberal arts/integrative model from which Evergreen's approach is derived, a standard way of understanding teaching and learning is the experiential learning model of educational theorist David Kolb (1983). It foregrounds knowledge and learning about the world as part of a cycle, consisting of four interpenetrating stages (**See Figure 13.1**):

- Concrete experience (feeling)
- Reflective observation (watching)
- Abstract conceptualization (thinking)
- Active experimentation (doing).

Kolb's model suggests that learning styles can be mapped onto a grid, so that people can understand what kind of learner they are. For example, some people when learning how to do something will stand back, observe and watch carefully before trying it ("reflective observation"); others will leap straight in and try it out ("active experimentation"). Within any learning experience, however, each of these four modes or positions will feature at some point, but may have different emphasis from person-to-person and situation-to-situation.

I would argue that animation, and especially animation that deals in real world events and people is the ultimate in taking a step back and reflecting, re-conceptualizing and experimenting with how to represent instances of concrete reality. It certainly has the potential for that watchword of Modernist thinkers, *ostranenie*, or 'making strange'—taking something familiar about the world and compelling viewers to see it in a new way; arguably, the very foundation of knowledge. For example, if we look at the short film *The Stitches Speak* (Nina Sabnani, India, 2010) we can see it

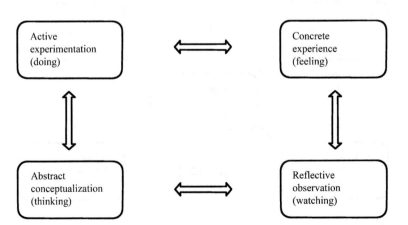

Figure 13.1
Kolb's model of experiential learning (adapted from Kolb 1983).

uses embroidery and textiles to tell the animated story of considerable pov-
erty, social upheaval, and war, while we hear those affected, who also pro-
duced the embroidery, on the soundtrack. This is a simple but extremely
effective strategy: making the basis of the animation textile and embroi-
dery work created by the people we can hear on the soundtrack (a similar
technique was used by Tim Webb in his landmark film from 1992, *A is for
Autism*, which used drawings by autistic people). This is a clear example of
images (and voices) being *reactivated through juxtaposition*: the creative practice
of the animation is actually a *synthesis* of different knowledges that brings
about *new* knowledge.

As previously suggested, talking here of pedagogy (teaching and learn-
ing) should therefore not simply be limited to how we teach *animation* (or
how we teach documentary) as craft. It should also include the ways in
which documentary and animation scholars, students and practitioners
can learn from how the other discipline or community of practice prob-
lematizes some of the things that they take for granted, as well as how
their theories and practices inter-connect or clash with a web of potential
interdisciplinary positions. I would therefore add a fifth stage or orienta-
tion to Kolb's model—that of 'critical juxtaposition', something that takes
elements of the other four (experience, observation, conceptualization,
experimentation) but looks to place them in highly productive tension
(**See Figure 13.2**). Animators are already masters of what I am calling critical
juxtaposition: myriad skills in life drawing; observation and distillation of
the essence of a scene or character; thinking about how particular actions
look as well as how they *feel* when acted out; experimenting with all manner
of mark-making; technical and digital know-how. To be an animator is
truly to be a remarkable all-rounder.

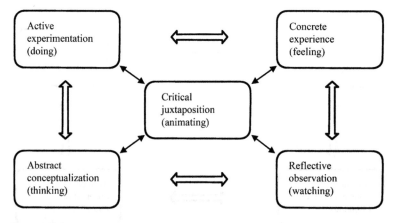

Figure 13.2
Kolb's model of experiential learning re-animated (adapted from Kolb
1983).

What it also demands is an ability to do something that the sociologist of education Basil Bernstein identified as "recontextualization"—simply put, an ability to "appropriat[e] other discourses and bring ... them into a special relation with each other for the purposes of their selection, transmission and acquisition" (1990: 183–184). Bernstein's theoretical and empirical work mapped out how the secondary school curriculum in the UK rested on a stratified "recontextualizing field," where practical knowledge (e.g. the skills and creativity of carpentry and joinery) became recontextualized as part of school-based teaching (in this case, the *limited* set of skills that is 'Woodwork' in the school curriculum). In this regard, Bernstein's notion of recontextualization could be seen as a pejorative— where 'real' knowledge and creativity is transformed or *diluted* into a 'school's version'. Of course, at a simple, instrumental level—where the knowledge of animation is reduced to *just* the market-vocational discourse noted earlier (i.e., animation = a 'set of skills' and nothing else) then it could be said to be a pejorative version of recontextualization. However, there is a definite sense of working towards a notion of pedagogic recontextualization as a *positive* force within animation studies, and this is derived from animation studies' interdisciplinary energy.

conclusion

Animation as a field of practice and academic inquiry has undergone enormous change in the past few decades. It has moved from being a craft-based industry, with apprenticed positions to induct people into the practice of animation, to a global industry worth billions a year. There are now a huge number of animation-related courses, ranging from short courses designed to impart specific skills, through BA degrees, to postgraduate research degrees. Animation is now part of the recognized academic landscape and infrastructure. However, it is important that animation teaching and learning is never simply put into the service of meeting industry needs—such a market-oriented vocational mindset may help students to secure jobs in the short term, but it is underselling the ways in which animation connects to and critiques other forms of practice and knowledge. A deep and thoroughgoing analysis of the many contexts in which we can understand animation (and understand *through* animation) necessarily means examining how animation is taught as a practice and a profession, but also means exploring its theoretical, philosophical and historical foundations and recognizing its essentially interdisciplinary nature.

notes

1. Some people might make the case for distinguishing between 'interdisciplinarity' and some related terms such as 'cross-disciplinarity', 'multi-disciplinarity' or 'trans-disciplinarity' but I prefer to see interdisciplinarity as a

spectrum of activity, with varying degrees or interaction or integration, as is outlined by Repko, Klein and others.

2. Repko also notes that "even the traditional disciplines (particularly in the humanities) are renaming themselves as studies, such as English studies and literary studies" (2012: 8).

3. Examples of such clichéd tropes and aesthetics would be an uncritical emulation of some of the conventions of Japanese anime, or a simplistic invoking of the chase scenario seen in many Hollywood cartoons (both of which can feature heavily in undergraduate work).

4. The definition of the term 'heuretic' originally derived from the branch of logic concerned with invention or discovery.

5. One of the main areas where more empirical research is needed is into the philosophies, curricula, aims and objectives and learning outcomes of animation-related courses in various contexts. This would include degree-level and postgraduate provision, but also 'short courses', on-the-job training or continued professional development (CPD), distance learning, and so on. It would also be invaluable to have an historical 'excavation' of the emergence and development of Animation Studies—something akin to Dana Polan's 2007 *Scenes of Instruction: The Beginnings of the US Study of Film.* As Polan's study indicates, the study of film predates the common (mis)conception of it starting with the institutionalization of Film Studies as a discipline, and emphasizes that disciplinary knowledge canonizes and marginalizes.

6. My main focus in this chapter is higher education/college courses, though it should be noted that research is also required into other instances of animation education—how it is taught (if at all) at pre-school and school levels, or in other contexts such as therapy or rehabilitation.

7. There is a wide range of writing on the American animated cartoon and those forms of animation it has influenced (some would say 'dominated'). See for example, Peary and Peary (1980); Klein (1993); Wells (2002).

references

Bernstein, Basil. 1990. *The Structuring of Pedagogic Discourse.* London: Routledge.

Collini, Stefan. 2012. *What Are Universities For?* London: Penguin.

Darley, Andrew. 2007. Bones of Contention: Thoughts on the Study of Animation. *animation: an interdisciplinary journal,* Vol. 2: 63–76.

Fleming, Dan. 2000. Mystory: Inventing a Genre for Practical Media Studies. In *Formations: A 21st Century Media Studies Textbook,* ed. Dan Fleming. Manchester: Manchester University Press: 389–393.

Goffman, Erving. 1990 [1959]. *The Presentation of Self in Everyday Life.* London: Penguin.

Gramsci, Antonio. 1971. *Selections from the Prison Notebooks.* Transl. and ed. Quintin Hoare and Geoffrey Nowell Smith. London: Lawrence and Wishart.

Hall, John. R. 1999. *Cultures of Inquiry: From Epistemology to Discourse in Sociohistorical Research.* Cambridge: Cambridge University Press.

Hayes, Ruth. 2007. Teaching Animation in an Interdisciplinary Context. *Animation Journal,* Vol. 15: 24–43.

Hill, Dave, Peter McLaren, Mike Cole and Glenn Rikowski. 2002. *Marxism Against Postmodernism in Educational Theory.* Lanham: Lexington Books.

Kellner, Douglas. 1997. Critical Theory and Cultural Studies: The Missed Articulation. In *Cultural Methodologies*, ed. Jim McGuigan. London: Sage: 12–41.

Kenny, Robert and Tom Broughton. 2011. *Securing the Future of UK Animation*, http://www.animationuk.org/report.html (Accessed March 5, 2012).

Klein, Julie Thompson. 1996. *Crossing Boundaries: Knowledge, Disciplinarities, and Interdisciplinarities*. Charlottesville, VA: University Press of Virginia.

—— 2010. *Creating Interdisciplinary Campus Cultures*. San Francisco: Jossey Bass and the Association of American Colleges and Universities.

Klein, Norman M. 1993. *Seven Minutes: The Life and Death of the American Animated Cartoon*. London: Verso.

Kolb, David. 1983. *Experiential Learning: Experience as the Source of Learning and Development*. Upper Saddle River, NJ: Prentice Hall, Inc.

Lindahl-Elliot, Nils. 2000. Pedagogic Discourse in Theory-Practice Courses in Media Studies. *Screen*, Vol. 41: 18–32.

Peary, Danny, and Gerald Peary. 1980. *The American Animated Cartoon: A Critical Anthology*. New York: E. P. Dutton.

Polan, Dana. 2007. *Scenes of Instruction: The Beginnings of the US Study of Film*. Berkeley: University of California Press.

Repko, Allen F. 2012. *Interdisciplinary Research: Process and Theory*, 2nd edn. London: Sage.

Roach, Joseph. 1996. *Cities of the Dead: Circum-Atlantic Performance*. New York: Columbia University Press.

Salter, Liora and Alison Hearn. 1997. *Outside the Lines: Issues in Interdisciplinary Research*. Montreal: McGill-Queen's University Press.

Schechner, Richard. 2002a. Foreword: Fundamentals of Performance Studies. In *Teaching Performance Studies*, ed. Nathan Stucky and Cynthia Wimmer. Carbondale: Southern Illinois University Press: ix–xii.

—— 2002b. *Performance Studies: An Introduction*. New York: Routledge.

Sheady, Ilan. 2011. Animation Mentor and the Future. *Skwigly*, June 20, http://www.skwigly.co.uk/animation-mentor/ (Accessed April 14, 2012).

Smith, Mark K. 2011. What is Praxis? http://www.infed.org/biblio/b-praxis.htm (Accessed November 7, 2011).

VFX Soldier. 2012. The 'Paying To Work For Free' VFX Business Model. *The VFX Soldier Blog*, March 26, http://vfxsoldier.wordpress.com/2012/03/26/the-paying-to-work-for-free-vfx-business-model/ (Accessed April 14 2012).

Ward, Paul. 2003. Animation Studies, Disciplinarity and Discursivity. *Reconstruction: Studies in Contemporary Culture* 3, http://reconstruction.eserver.org/032/TOC.htm (Accessed November 7, 2011).

—— 2006. Some Thoughts on Theory-Practice Relationships in Animation Studies. *animation: an interdisciplinary journal*, Vol. 1: 229–245.

Wayne, Mike. 2001. Problems and Possibilities in Developing Critical Practice. *Journal of Media Practice*, Vol. 2: 30–36.

Wells, Brian and Laurence Arcadias. 2007. Issues in Animation Education. *Animation Journal*, Vol. 15: 63–80.

Wells, Paul. 2002. *Animation and America*. Edinburgh: Edinburgh University Press.

contributors

Mark Bartlett is associate editor of *animation: an interdisciplinary journal*, for which he has edited a special issue (November 2008) on Stan VanDerBeek. His essay, "Socialimagestics and the Fourth Avant-garde of Stan VanDerBeek", may be found in *Expanded Cinema: Art, Performance, Film*, London, Tate Modern Publications, eds. David Curtis, Al Rees, Duncan White (2010). His book, *Newsreel of Dreams: Socialimagestics, Culture: Intercom, and the Techno-Poetics of Stan VanDerBeek*, is nearing completion.

Suzanne Buchan is Professor of Animation Aesthetics at Middlesex University and was previously a professor and Director of the Animation Research Centre at the University for the Creative Arts. Her research investigates interdisciplinary approaches to animation as a pervasive moving image form across a range of platforms and media. She is also active as a curator for festivals, galleries and museums. She is founder and Editor of *animation: an interdisciplinary journal*. Publications include The *Quay Brothers: Into A Metaphysical Playroom* (2011), *Animated 'Worlds'* (ed. 2006), journal articles, catalogs and chapters in books. She is currently working on her

wider 'Pervasive Animation' project that includes a curated exhibition at the Museum of Design Zurich.

Edwin Carels (1964) is a researcher in the arts at the KASK University College Ghent—Faculty of Fine Arts. His topic is 'Animation beyond Animation—a media archaeological approach to the use of animation in contemporary art'. For more than a decade, Edwin Carels has been active as a film programmer and curator for the International Film Festival of Rotterdam. He is also affiliated with the Museum of Contemporary Art in Antwerp, the M HKA, where he has curated thematic shows such as *Animism, The Projection Project*, and most recently: *Graphology*. Recent exhibitions have involved collaborations with Imogen Stidworthy, Dora Garcia, Luc Tuymans, Chris Marker, Quay Brothers, Robert Breer, Ken Jacobs, and others.

Sean Cubitt is Professor of Film and Television, Goldsmiths, University of London UK; Professorial Fellow in Media and Communications, University of Melbourne, Australia; and Honorary Professor of the University of Dundee, Scotland. His publications include *Timeshift: On Video Culture* (1991); *Videography: Video Media as Art and Culture* (1993); *Digital Aesthetics* (1998), *Simulation and Social Theory* (2001); *The Cinema Effect* (2004); and *EcoMedia* (2005). He is the series editor for Leonardo Books at MIT Press. His current research is on the history and philosophy of visual technologies, on media art history and on ecocriticism and mediation.

Nea Ehrlich is completing her PhD in the Department of Art History at the University of Edinburgh, Scotland. Her PhD thesis on contemporary animated documentaries links new media aesthetics with the documentary turn in contemporary visual culture. Her research straddles the fields of contemporary art, animation, film studies and gaming theory. Nea was head of the Education Department at the Ashdod Museum of Contemporary Art in Israel, co-organized the 2011 *Animated Realities* conference about animated documentaries in Edinburgh, and curated the accompanying 2011 *Edinburgh International Film Festival* screening program. She has published articles in edited volumes and journals and is co-editor of *Animated Realities*, a forthcoming anthology about animated documentaries.

George Griffin studied political science, went to New York City in 1967 and took up animation, first as a cartoon studio apprentice, then as a commercial producer and independent filmmaker. Influenced by John Hubley and Robert Breer, he has made over 30 experimental films (*Head, Viewmaster, Ko-Ko*), published numerous flipbooks, and *Frames*, a selection of statements and drawings. He has published essays in *Film Comment, Art+Cinema, EnterText*, has taught at Harvard, Pratt, NYU, and been a visiting

filmmaker at CAFA (Beijing) and KASK (Ghent). His practice has recently included sculpture and physical computing, such as digital mutoscopes, exhibited at the 2010 Site Santa Fe Biennial. Griffin is a Guggenheim and MacDowell Colony Fellow, a member of AMPAS and ASIFA, and his work is in the collection of the Museum of Modern Art.

Tom Gunning is Edwin A. and Betty L. Bergman Distinguished Service Professor in the Department of Cinema and Media Studies at the University of Chicago. He is the author of *D. W. Griffith and the Origins of American Narrative Film* (University of Illinois Press) and *The Films of Fritz Lang; Allegories of Vision and Modernity* (British Film Institute), and over a hundred articles on early cinema, film history and theory, avant-garde film, film genre and cinema and modernism. With Andre Gaudreault, he originated the influential theory of the "Cinema of Attractions". In 2009, he was awarded an Andrew A. Mellon Distinguished Achievement Award, and in 2010, was elected to the American Academy of Arts and Sciences. He is currently working on a book on the invention of the moving image.

Thomas Lamarre teaches in East Asian Studies and Communications Studies at McGill University. His books include *Uncovering Heian Japan: An Archaeology of Sensation and Inscription* (2000); *Shadows on the Screen: Tanizaki Jun'ichirō on Cinema and Oriental Aesthetics* (2005), and *The Anime Machine: A Media Theory of Animation* (2009).

Esther Leslie is Professor of Political Aesthetics at Birkbeck, University of London. She has written two books on Walter Benjamin, *Overpowering Conformism* (Pluto 2000) and *Walter Benjamin* (Reaktion 2007). She is the author of a study of animation and critical theory, titled *Hollywood Flatlands: Animation, Critical Theory and the Avant Garde* (Verso 2002), and a book on synthetic color production as a vehicle for exploring the poetics of science in the context of German history, *Synthetic Worlds: Nature, Art and the Chemical Industry* (Reaktion 2005). She co-edits three journals: *Historical Materialism: Research in Critical Marxist Theory*, *Radical Philosophy* and *Revolutionary History*. She runs a website together with Ben Watson, www.militantesthetix.co.uk

Joon Yang Kim is the author of *Animation, Alchemy of Images* (2001) and *Empire of Images: Animation on the Japanese Islands* (2006). The latter was awarded the Poranabi Prize from the Japan Foundation. He received a fellowship for his research project on Japanese animated mechanical bodies until *Astro Boy* from the same foundation in 2012. His interests include the correlation between anima and movement, through experiences of the animated medium, particularly in terms of natural philosophy and calculus. He is an associate editor of *animation: an interdisciplinary journal* and the editor of *The Japanese Journal of Animation Studies*. He is currently conducting his research

project in Tokyo Zokei University and is also a visiting fellow of the Institute for Japanese Studies, Seoul National University.

Jeffrey Skoller is a writer, filmmaker and has made over a dozen films that have been exhibited internationally. Screenings include: The Pacific Film Archive, Berkeley; Museum of the Moving Image, NY; JP Getty Museum, Los Angeles, Whitney Museum, NY; P.S. 1, NY; Flaherty Film Seminar, NY; Arsenal Kino, Berlin; Mannheim Film Festival, Germany; The Latin American Film Festival, Havana; National Film Theatre, London. His articles on experimental media have appeared in books, artist catalogs and in journals, including: *Film Quarterly; Discourse; Afterimage; animation: an interdisciplinary journal, Cinematograph,* among others. He is the author of two books *Shadows, Specters, Shards: Making History in Avant-Garde Film* (University of Minnesota Press) and *POSTWAR: The Films of Daniel Eisenberg* (Blackdog Press). Skoller is currently Associate Professor of Film & Media at UC Berkeley.

Paul Ward is Professor of Animation Studies in the Faculty of Media and Performance at the Arts University, Bournemouth, UK. He has published widely in animation and documentary fields, with work appearing in numerous anthologies, as well as journals such as *animation: an interdisciplinary journal; Historical Journal of Film, Radio and Television; Animation Journal,* and *Illuminace: The Journal of Film Theory, History and Aesthetics.* He serves on the Editorial Boards of *animation: an interdisciplinary journal* and *Animation Studies* and is a member of the UK Arts and Humanities Research Council Peer Review College with special interest in animation and documentary research proposals. He is also the current President of the Society for Animation Studies, and was the inaugural Fellow of the Holland Animation Film Festival (HAFF) in 2012.

Siegfried Zielinski holds the chair for Media Theory: Archaeology & Variantology of the Media at the Berlin University of Arts. He is Michel Foucault Professor for Techno-Culture and Media Archaeology at the European Graduate School Saas Fee, and he is director of the International Vilém-Flusser-Archive in Berlin. He has published numerous books and essays. His most recent monograph in English is *Deep Time of the Media* (Cambridge, MA 2006); his latest monography, *[After the Media]: News from the Slow-Fading Twentieth Century* is being translated for Univocal. In 2004, he founded the international research unit *Variantology—On Deep Time Relations between Arts, Sciences and Technologies,* which includes the publication of a 5-volume-book-series, published by Walther Koenig, Cologne from 2005 to 2011. Zielinski is a member of the Academy of Arts Berlin, the North-Rhine-Westphalian Academy of Sciences and Arts, the European Film Academy, and the Magic Lantern Society of Great Britain.

about the american

film institute

The American Film Institute (AFI) is America's promise to preserve the history of the motion picture, to honor the artists and their work and to educate the next generation of storytellers. AFI provides leadership in film, television and digital media and is dedicated to initiatives that engage the past, the present and the future of the motion picture arts. The *AFI Film Readers Series* is one of the many ways AFI supports the art of the moving image as part of our national activities.

AFI preserves the legacy of America's film heritage through the **AFI Archive**, comprised of rare footage from across the history of the moving image and the ***AFI Catalog of Feature Films***, an authoritative record of American films from 1893 to the present. Both resources are available to the public via AFI's website.

AFI honors the artists and their work through a variety of annual programs and special events, including the **AFI Life Achievement Award, AFI Awards** and **AFI's 100 Years...100 Movies** television specials. The **AFI Life Achievement Award** has remained the highest honor for a career in film since its inception in 1973; **AFI Awards**, the Institute's almanac for the

21st century, honors the most outstanding motion pictures and television programs of the year; and **AFI's 100 Years…100 Movies** television events and movie reference lists have introduced and reintroduced classic American movies to millions of film lovers. And as the largest nonprofit exhibitor in the United States, AFI offers film enthusiasts a variety of events throughout the year, including the longest running international film festival in Los Angeles and the largest documentary festival in the U.S., as well as year-round programming at the **AFI Silver Theatre** in the Washington, DC metro area.

AFI educates the next generation of storytellers at its world-renowned **AFI Conservatory**—named the #1 film school in the world by *The Hollywood Reporter*—offering a two-year Master of Fine Arts degree in six filmmaking disciplines: Cinematography, Directing, Editing, Producing, Production Design and Screenwriting.

Step into the spotlight and join other movie and television enthusiasts across the nation in supporting the American Film Institute's mission to preserve, to honor and to educate by becoming a member of AFI today at AFI.com.

American Film Institute

Robert S. Birchard
Editor, *AFI Catalog of Feature Films*

index

Note: 'f' following a page number indicates a figure, 'P' preceding a page number indicates a plate and 'n' following a page number indicates the note.